THE OFFICIAL PHOTODEX® GUIDE TO PROSHOW® 4

James Karney

Course Technology PTR

A part of Cengage Learning

Australia, Brazil, Japan, Korea, Mexico, Singapore, Spaln, United Kingdom, United States

COURSE TECHNOLOGY

The Official Photodex[®] Guide to ProShow[®] 4 James Karney

Publisher and General Manager, Course Technology PTR: Stacy L. Hiquet

Associate Director of Marketing: Sarah Panella

Manager of Editorial Services: Heather Talbot

Marketing Manager: Jordan Casey

Acquisitions Editor: Megan Belanger

Development Editor and Copy Editor: Bud Paulding

Technical Reviewer: Terrence Karney

Editorial Services Coordinator: Jen Blaney

Interior Layout Tech: Bill Hartman

Cover Designer: Mike Tanamachi

CD-ROM Producer: Brandon Penticuff

Indexer: Larry Sweazy

Course Technology, a part of Cengage Learning

20 Channel Center Street Boston, MA 02210 USA

Printed in the United States of America 1 2 3 4 5 6 7 11 10 09

© 2010 Course Technology, a part of Cengage Learning.

ALL RIGHTS RESERVED. No part of this work covered by the copyright herein may be reproduced, transmitted, stored, or used in any form or by any means graphic, electronic, or mechanical, including but not limited to photocopying, recording, scanning, digitizing, taping, Web distribution, information networks, or information storage and retrieval systems, except as permitted under Section 107 or 108 of the 1976 United States Copyright Act, without the prior written permission of the publisher.

For product information and technology assistance, contact us at Cengage Learning Customer & Sales Support, 1-800-354-9706

For permission to use material from this text or product, submit all requests online at **cengage.com/permissions**. Further permissions questions can be e-mailed to **permissionrequest@cengage.com**.

Photodex, ProShow, CompuPic, Photodex PictureCD, ViewSafe, and ClickSearch are registered trademarks of Photodex Corporation.

Microsoft, Windows, and Internet Explorer are either registered trademarks or trademarks of Microsoft Corporation in the United States and/or other countries.

All other marks are property of their respective owners.

Photographs by James Karney and TriCoast Photography photographers Mike Fulton and Cody Clinton. Permission to reproduce or use images other than as part of personal exercise in conjunction with the material in this book requires the express permission of the photographer.

Library of Congress Control Number: 2009924523

ISBN-13: 978-1-59863-969-8

ISBN-10: 1-59863-969-2

Cengage Learning is a leading provider of customized learning solutions with office locations around the globe, including Singapore, the United Kingdom, Australia, Mexico, Brazil, and Japan. Locate your local office at: **international.cengage.com/region**.

Cengage Learning products are represented in Canada by Nelson Education, Ltd.

For your lifelong learning solutions, visit **courseptr.com**.

Visit our corporate Web site at cengage.com.

To the Karney family: my siblings Tim and Annelle, my son Terrence, and my daughters Shannon, Arywn, and Rhyannon.

Foreword

"Why do we take photos?" is a question with a very simple answer, no matter the photographer's subject or level of expertise: "So someone can see them." Just as the digital camera is replacing film, digital presentation is fast becoming the way our photographs fulfill their purpose. The complementary relationship between digital photography and personal computing creates a synergy that is producing a powerful revolution in presentation.

When our team began working on ProShow in early 2000, we knew the market was evolving past "slide shows," which were merely a series of pictures on a screen.

ProShow presentations are at the leading edge of digital media: robust productions with professional quality and high-resolution output. The challenge was to create a program easy enough for a novice to use, with the features professionals demand at an affordable price. The challenge is ever expanding, as the users' expectations in functionality and complexity grow just as quickly as computing power expands.

Watch a professionally produced television commercial closely. The best demonstrate a polished quality that is both exciting and easy on the eyes. Matching that kind of flow and feel with a presentation is easier said than done. There are hundreds of tricks that aren't immediately apparent to the novice. Timing, adjustment effects, the composition of images, and the flow of information must be carefully woven together. That takes skill and the right tools.

ProShow offers the tools. Mastering them requires learning. It isn't just a matter of choosing a prefab style in a combo box and clicking "Create Slide Show." A quality presentation is more than just images and transitions. This book is an excellent guide to teach not only the basics but also a wealth of tips and tricks the pros use all the time. The first step is to know what you are trying to do. Once you know that, the techniques presented in this book will help you make the most of your presentations.

We are very pleased to work with James Karney in bringing this book to you. His well-paced writing style and clear examples make even the most complex features of the software easy to follow. As a bestselling computer author, educator, and an experienced professional photographer, he has the experience required to write *The Official Photodex Guide to ProShow 4*.

After learning from this book, many of you will change your approach to the creative process. Instead of taking photos and then figuring out how to present them, you'll start taking photos to use within high-quality presentations. That's a good thing, because that's the future of sharing.

Paul Schmidt
President, Photodex Corporation

Acknowledgments

A book is always a project and only comes to the reader's hands with the help of friends and a professional staff. Thanks to fellow photographers Mike Fulton and Cody Clinton of TriCoast Photography for the images used in most of the exercises. Bud Paulding, Georgia Brown, and Terrence Karney devoted time above and beyond the call of duty to offer suggestions to make the text more readable, the exercises more useful, and to ensure they were technically accurate. ProShow wizard Jennifer Weeks (VidQueen on the Photodex sharing website) shared valuable insights from her long experience with the program.

The Photodex team provided excellent support during the project. President Paul Schmidt gave insight into the company's vision for the project. Amanda Sahliyeh was an unflagging point of contact who (as always) managed to find just the right person or resource to keep the project on track. I'd also like to thank Leslie, Min, Evan, Brandon, and the entire Photodex support team for the exceptional help they provided with this project.

Megan Belanger oversaw the project and helped shaped its focus with her keen understanding of the publishing industry. It's always a pleasure to work with her. Thanks also to the production team: Dan Foster, Bill Hartman, and Larry Sweazy; and also to Brandon Penticuff, who assembled the disc that accompanies the book.

About the Author

James Karney brings his unique viewpoint to this book—a viewpoint developed from his experience as an author, professional photographer, and educator. His work has appeared in *PC Magazine, Computer Shopper, Windows Magazine,* and *Internet World.* His books include *Mastering Digital Wedding Photography* (named a Book of the Year by *Shutterbug* magazine), the Golden-Lee bestseller *Upgrade* and Maintain Your PC, Power of CorelDraw!, and the Microsoft Press A+ Certification Training Kit and Readiness Review.

His professional photography experience includes weddings, photojournalism, medicine, and a tour as a photographer in the U.S. Marine Corps. He developed and taught the 18-month photography certificate program at South Georgia Tech and continues to teach computer technology and graphics at the college level.

He is a graduate of the U.S. Naval Photographic School, holds a bachelor's degree in communications from Excelsior College, and a Master of Science in computer technology from Nova Southeastern University.

Contents

Introduction
Chapter 1 ProShow Fundamentals—a World of Sight, Sound, and Motion 1
The ProShow Editing Workspace and Basic ProShow Skills
Building Our First Show and Creating Slides Using
Drag and Drop
More Slides, a Transition, and a Soundtrack
Arranging Slides, Timing, and Previewing a Show9
Previewing a Show
What's "In" a Slide?
The Slide Options Window
Getting Fancy with Slide Styles
A Moving Backdrop
A Special Effects Primer
Captions with a Bit of Style 21
Up Next

Chapter 2 Beyond the Basics—It's All About Time 25

Slide and Transition Timing
Not Just for Slides—Timing Layers in Producer
A Closer Look
A Brief Moment-Layer 2 and the Flash Effect
Layer 1's Late Entry 35
Using the Multi-Layer Keyframe Editor
A Few Words about Editing in the Precision Preview Window 38
A Simplified Show

Customizing the ProShow User Interface
Setting ProShow's Operating Preferences
Appearance
Colors for Program
External Editors
Keyboard and Remotes
Internet Preferences
Miscellaneous Preferences
Organization: ProShow's Trilogy of Slides, Shows, and Projects 49
Saving, Finding, and Collecting Show Files
Why Files "Go Missing" 51
Locating Missing Show Files 51
Collecting Show Files
Up Next

Chapter 3

Frames, Motion, and the Layered Look	55
The Slide as a Stage	. 55
Framing Images: A Working Demonstration	. 56
The First Slide—a Simple Invitation	. 58
A Closer Look at the Layers List and the Preview Pane	. 59
Tailoring the Preview Display for Working with Layers	. 62
Adjusting Layers within the Frame.	
Interactively Manipulating Layers Using the Mouse	
Motion Basics—Getting from Point A to Point B in	
Four Dimensions	. 66
The X and Y of Zooming	. 67
A Few Moments with the Keyframe Timeline	. 69
Adding and Placing Multiple Layers Efficiently	. 70
Duplicating the Design	.71
Understanding X and Y Coordinate Positioning	. 73
Adding and Ordering the Other Image Layers	.74
Adjusting Size and Rotation	. 75
Getting Things Moving	. 79
Beginnings and Ends: Motion Effects Demystified	
Setting Layers into Motion	. 83
Working with Rotation in Motion	. 85
A Quick Recap	. 87
Smooth Moves: ProShow's Acceleration Styles	. 89

125

Matchmaking, and Moving Outside the Box91	Ĺ
Putting It All Together	3
Two Slides, Two Backgrounds, Eight Layers, and a	
Disappearing Act	ł
Matching Motion Speed between Layers	ł
Who Says We Have to Start at the Beginning-or the Middle?97	7
Up Next)

Chapter 4 Adding and Editing Soundtracks

Adding and Editing Soundtracks	101
Working with Audio Files	. 102
Adding, Removing, Positioning, and Previewing Audio Files	. 102
Using Simple Audio Synchronizing Tools	. 104
A Closer Look at Soundtracks	. 105
Going Interactive: Advanced Sound Controls	. 106
Mastering the Audio Trimmer	. 107
Scaling and Positioning the Waveform	. 109
Setting the Start and End Points	. 109
Adjusting Fade In and Fade Out Intervals	. 110
Editing Soundtracks Using the Timeline	. 111
Adjusting Offsets, Fades, and Volume Using the Timeline	
Tools	. 112
Creating a Crossfade Effect with the Timeline	. 115
Recording Slide Timings—Precise Transition and	
Soundtrack Synchs	
Menu-Based Volume, Fade, and Offset Controls	
Adding Audio Tracks from a CD	. 120
Adding Soundtracks and Voiceovers to Individual Slides	121
Up Next	124

Chapter 5 Caption Fundamentals: More Than Just a Way with Words

Adding Another Slide and Caption
Making Captions Move Using Text Effects
Alignment and Anchor Points 143
"Automatic" Captions: the Power of Macros
Inserting Special Characters into a Slide with Macros 146
Show Captions, Globalization, and the Art of Invisibility 149
Adding a Global Caption
All Captions Are Not Created Equal
A Closer Look
Up Next

Chapter 6 Getting Fancy: Advanced Caption Tools and Keyframing Basics

Keyframes Defined, Captions Redefined 158
ProShow Producer's Caption Window
Keyframing, Caption Motion Effects, and the Magic of Timing 168
Working with the Keyframe Timeline
Adjusting Keyframes and Text Effects
Working with Multiple Keyframes
Adding and Adjusting Keyframes
Keyframes Move More Than Words
Adding New Slides
Setting Adjustment Effects 177
Adding and Adjusting the Captions
Using the Multi-Layer Keyframe Editor
Up Next

Chapter 7 Advanced Motion Effects Using Keyframes

185

157

A Traffic Control Lesson
The Smoothing Effect
Getting Things in Proper Order 190
Simple Keyframe Effects: There and Back Again
Adjusting Keyframe Timing and Position
Zooming In for a Closer Look
Locking and Manually Setting Keyframes

Working with Precision Preview
Experimenting with Rotation and Precision Preview
Motion Keyframing with Multiple Layers
Managing the Preview Area
Multilayer Motion Effects Workflow 202
Placing and Adjusting the Images
Setting the First Layer's Keyframes
Adjusting the Layer 1 Transitions 207
Adding the Remaining Keyframes
Creating Layer 2 Keyframes 208
Setting the First Three Keyframes
Swapping Positions: Keyframes 3, 4, and 5 212
Adding a Little Spin: Adjusting Keyframes 5, 6, and 7 213
Designing Complex Motion Effects: The Real Deal
A Quick Shuffle, and Laying Down the Cards
Examining the Table Background
The Staggered Entry Transformed into a Second Collage 219
Up Next

Chapter 8

Adjustment Effects and Advanced Editing	223
Adjustment Effects Controls	223
Working with the Colorize Controls	226
The Oz Effect: Black and White to Color	226
Combining Adjustment Effects with Layer and Motion	222
Techniques	
Opacity: It's Not Just an Adjustment Control	234
Smooth Moves: Creating a Composition with Opacity	
and Transitions	237
Creating an Overlay with Opacity	241
Hue Adjustments: Playing with Color on the Move	
Setting Up the Layers	243
Motion and Adjustment Effects: An Intricate Dance, with	
Some Sleight of Hand	246
A Closer Look at Layer 1	247
Cloning the Effects and Adjusting the Keyframe Timeline	249
Variations on a Theme	251
A Horse of a Different Color	253
Up Next	256
*	

Chapter 9 Advanced Layer Techniques: Masks, Vignettes, and Chroma Key

0 /	
The Alpha Channel and a Spotlight on Masking	О
Creating a Simple Transparency Mask	0
Combining Transparent Masks with Vignettes	4
Isolating Portions of the Frame with Transparent Masks 267	7
Intensity Masking: White Reveals while Black Conceals	0
Slide 1: a Simple Stencil 270	0
The New Slide 1: a Role Reversal	4
Combining Adjustment Effects with Intensity Masking 276	6
Alpha Channel Masks and a Selective Bit of Color	7
Working with Multiple Masks 279	9
Life on the Border: Vignetting	1
It's Not a Mask, It's a Vignette	3
A Final Spotlight on Vignettes and Masking	6
Chroma Key: More Than Just a Green Screen	
Setting the Key Color Using an Existing Color	
Adjusting the Effect	1
Employing a Traditional Green-Screen Chroma Key	
Fade to Black Reconsidered 294	
Fast-Moving Clouds: Using Video Clips with Chroma Key 29	6
Working with Video Clips in ProShow	
Setting Up Slide 1's Chroma Key Transparency	8
Slide 2: The Same Clouds, but Not the Same Sky	0
Up Next	1

Chapter 10 Templates and Live Shows

303

257

Working with Templates	4
Creating and Saving Templates 30	5
Adding Content to Template Layers	8
Template Planning and Workflow	9
Importing and Exporting Templates	0
Modifying and Using Templates	0

Producing Live Shows
Setting Up a Basic Live Show
Setting Playback Options 314
Creating an Executable Live Show
Creating Advanced Live Shows with Templates
Setting Fixed Slides and Content
Adjusting for Vertical and Horizontal Composition
Setting the Live Show Options and Placing the Content 319
The Camera Connection
Up Next

Chapter 11Creating Menus and Branding Shows323

Chapter 12 Getting the Story Out

Getting the Story Out 349	9
Show Output Basics	0
Choosing an Output Format and Understanding Common	
Settings Options	
Output Formats and Files Demystified	
Supported Output File Formats and Media Types	
Photodex Presenter Files and Plug-In	
Selecting Options for Different Output Formats	
DVD/VCD/CD Production	8

Autorun CD and Executable Files
Screen Savers
Portable Device Output
Creating Video Output Using an Existing Device Profile 366
Creating a Custom Device Profile
ProShow File Types and File Management
Show Files
Menu Files
Output Files
Up Next

Chapter 13 ProShow and the Web

371

Internet Hosting Basics
ISPs and Bandwidth
Copyright Considerations
Sharing Shows with a Free Photodex Account
Hosting Presenter Files on Other Websites
Sending a Show via E-Mail 379
Flash FLV Shows and the Web 381
The YouTube Connection
Wrapping Up 383

Appendix A

Proshow Keyboard Shortcuts	385
Appendix B Product Comparison Chart	387
Index	393

Introduction

This book is a shortcut to mastering one of the most interesting and exciting computer programs available today. Digital photography is changing the way we look at pictures just as much as the way we take them. Web sharing, digital frames, iPods, and DVD shows are making inroads on the venerable paper photographic print. Photodex is changing the way we see "slide shows."

ProShow offers incredible power in an easy-to-use program. It turns the average PC into a multimedia production platform. I use ProShow regularly as a professional photographer and included an entire chapter on using the program for online and DVD proofing in my book *Mastering Digital Wedding Photography*.

Why This Book?

Like many ProShow users, I quickly discovered that "easy to use" is not the same as "easy to master." The novice can create a slide show in minutes, but crafting a real multimedia production can't be done without learning how to use special effects, keyframes, and output formats. Today's viewers demand more from all types of multimedia—thanks in part to expensive commercials and movies rich with special effects.

The standard ProShow manual offers basic information on how to use the menus but provides only limited tutorials. Shortly after ProShow 3.5 was released my search of bookstores uncovered a surprising fact: There was nothing on the shelves that explained the basics of slide show production, let alone the really good stuff the techniques that make a show stand out from the crowd. The photographer in me was disappointed, but the author in me was excited. This is a subject worthy of a book. It took a couple of months to work out the details with my publisher and Photodex, and it took several more to learn (with the help of Photodex experts) all the advanced skills and figure out how to teach them in a book. The process was recently repeated to create *The Official Photodex Guide to ProShow* for the even more exciting version 4. The results are in your hands.

How to Use This Book

This book is written for novice and expert users alike. (Expert is a step below mastery. Mastery requires the development of personal style.) It covers all the features of both ProShow Gold and ProShow Producer. The material includes complete exercises with all the files you need (including images and designs) to explore every aspect of developing high-quality shows. The first two chapters serve as a foundation, introducing the basic concepts and terms needed to discuss the program and multimedia production.

The rest of the book is a hands-on seminar in a progressive format. If you are new to the program, or have yet to master keyframes, be sure to check out Chapters 1 and 2, which cover the basics of the ProShow interface, program setup, and proper workflow. Chapters 3 through 5 focus on the core features common to both ProShow Gold and Producer: working with slides, manipulating layers, and working with transparency; setting transitions, editing soundtracks, adjusting images, and working with text; and adding motion and special effects to a show.

Chapters 6 through 10 get into advanced features and special effects: masking, keyframes, adjustment effects, templates, live shows, advanced motion controls, vignettes, and Chromakey transparency. Chapters 11 and 12 detail output, from designing menus and setting copy protection to selecting the right type of media and file formats for a given application. Chapter 13 covers ProShow's ability to produce a variety of Internet-ready formats—even complete streaming video Web pages—and place shows directly on sites like YouTube and Photodex's Sharing section (www.photodex.com/sharing).

The best way to use the book is with ProShow open and the CD's exercise materials handy. You will need to copy the exercise files to your hard drive to use them. Working from front to back is the best way to really get the most out of the material. Skills build on the preceding exercises. Coming back to a topic is a good way to review and experiment with blending together different styles of effects. Most of all, have fun with the really incredible tools that ProShow offers.

Some Navigation and Formatting Notes

In many ways, ProShow is as complex as it is powerful. My longtime friend, copyeditor, and wordsmith, Bud Paulding, has designed a system of typestyles and typographical expressions to help you come to grips not only with the program itself but also with the sometimes complex series of screens and sequences of steps to get ProShow tamed to your needs and desires. **Bold type like this** is used frequently to get your full attention to a filename (e.g., **FramesLayers01.psh**); an important aspect of ProShow being discussed, such as the function of the **Create Menu**; or a process (Now **Preview the Slide**); or a feature (**Motion Effects**); or a part of a screen (the **Layers List**), or even to an important task you are learning about (Now **Scrub** the **Timeline**.) In other words, when you see a term in bold, I am trying to make sure you are following the explanation or the directions at hand. Sometimes it seems there is a blizzard of unfamiliar and technical names and ProShow-specific terms, so you can focus on an especially important point a bit better if it is standing out in bold.

That's the hope and the theory, anyway. As you begin to feel more comfortable with "ProShow speak" and are following an explanation or a series of steps, the bolded words, hopefully, will emerge as helpful mental handholds, or pointers to the location of a necessary control slider you have to find and adjust. Sometimes a term or process or feature will be bolded to help you recall a previous point or similar feature —in other words, to jog your memory about something that is not presently on the screen or part of an instruction. And when you need to reread a series of steps to make an exercise clear, there will often be a bold word or phrase to help you focus on the most important points.

Bold type is also used as a reliable way of directing you to specific menus or windows, because there are dozens of them, many are similar, and many are way down on another branch of the menu tree, so to speak. So you'll see directions like the following:

Open the Slide Options window, then go to Effects>Motion Effects.

Or even more efficiently:

Go to Slide Options>Effects>Motion Effects.

Translation: First you open that Slide Options window, and then you click the Effects tab or button, and then go to and click the Motion Effects tab, which will open the Motion Effects window. The bold and the ">" are giving you a sequence of actions to follow, which will quickly prove a huge timesaver. I take for granted that a major goal of the book is to help you find your way around this amazing but complex ProShow world, and keep on track as we go.

Another use of boldface (often used with the <> brackets for emphasis) is to indicate a specific action or specific input you need to make next, and make it stand out, such as:

Select Slide 1 and press < Control + F8 >.

Move Keyframe 2 to the start of the Slide Time.

The Ending Position should have a Rotation of -180 and a Rotation Center of 15x0.

The third example makes another point: There are scores and scores of ProShowspecific names for objects, operations, and actions. Just to help you remember when a term is specifically "ProShow-ese," *most* of the time they are Capitalized. When they need special attention, as you've seen, they will be in bold.

About the Photographs Used in the Exercises

TriCoast photographers Mike Fulton and Cody Clinton have been kind enough to allow use of their excellent images with the exercises contained in this book. I have also provided some images for you to use. All of these images are copyrighted by their respective photographers, who reserve all rights other than for your personal use with these exercises. Any other use, distribution, or presentation to others in any way is not permitted without the express written permission of the photographer.

ProShow Fundamentals a World of Sight, Sound, and Motion

The simple slideshow is a thing of the past. The age of true multimedia is here. Viewers expect sizzle. Movies, television, and even our cell phones and MP3 players bring high-quality video and eye-catching special effects into every aspect of our lives. Personal computers double as entertainment centers, showing HDTV programs and movies at home and at work. It's becoming impossible to catch people's eyes or keep them watching without professional polish.

Photodex ProShow is the solution for anyone needing to create polished presentations. It offers an incredible array of tools that allow you to blend sight, sound, and motion with incredible precision and clarity. It's a powerful, versatile, and deceptively simple tool for creating high-quality multimedia on virtually any current Windows computer. Simple, in that novices can quickly create a polished presentation replete with still images, video clips, fancy transitions, a soundtrack, and advanced special effects with only a basic understanding of the program. Skilled users use ProShow to craft high-quality professional productions. Figure 1.1 shows ProShow Producer open during an editing session. The basics of using the program are simple, and it's possible to build a complete show in a few minutes with little more than a few mouse clicks.

Really impressing an audience with your message requires understanding and taking full advantage of ProShow's advanced features, as well as developing a good

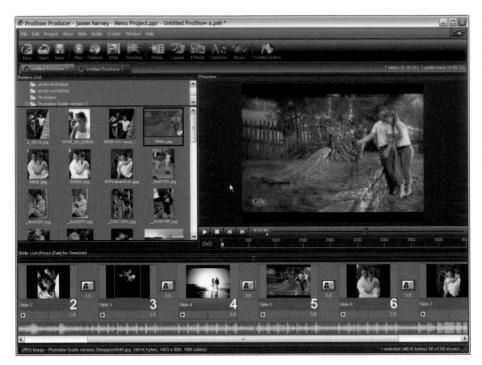

Figure 1.1 ProShow Producer offers all the tools needed to create professional multimedia output for virtually any platform, from iPods to wall-sized projection.

sense of design. This book's practical exercises will help you learn to work with layers, masking, and keyframing to spark your creative imagination and set your work apart from the crowd. The finished slides can be customized for your own shows and visual style.

ProShow is deceptively simple to use, but really taking full advantage of its features requires learning to use its advanced features and exploring the deeper regions of the user interface. This chapter provides the foundation needed to master ProShow's advanced features We'll explore the user interface, examine some slides to see how ProShow operates, and discuss key concepts. I'll also share some timesaving shortcuts.

Chapter 2 builds on this beginning, focusing on Producer's keyframing tools and advanced special effects. If you are new to ProShow, these two chapters will serve as an introduction. Experienced users will meet some of the exciting new features in Version 4. The goal right now is to learn how the program operates, and to become familiar with the user interface and understand important terms we'll be using throughout the book.

Please follow along with your own copy of ProShow up and running, rather than just reading the material and watching the videos. The more advanced features (and the exercises in the book that use them) will require Producer. I'll let you know when that's required. We'll cover all the features of both versions in this

3

guide. Fully functional trial versions of both Gold and Producer are on the CD, The latest updates can be downloaded at www.photodex.com. You should install the program before continuing into the rest of this chapter. Basic installation is as easy as running the setup file for the version you choose from the download page on the website.

We will be using content on the companion CD throughout the book, so have that ready as well. Be sure to copy the Chapter folder as you begin each chapter to a local hard drive. (The last two chapters are the only ones with exercise files on the CD.) ProShow requires read/write capability to operate properly. Also note that all the images provided on the CD are copyrighted by the photographers and the only use allowed is for personal and private use with the exercises in this book.

The exercises in the first four chapters will usually begin with features common to both editions, and so can be completed with either Gold or Producer. (When referring specifically to a version's features, I'll usually drop the ProShow part of the program name.) Some exercises, and all of the ones in Chapters 6 through 10, involve keyframes and ProShow Projects. Because of that, they require using ProShow Producer.

The ProShow Editing Workspace and Basic ProShow Skills

Both Gold and Producer use the same interface. Producer adds tools and windows to provide access to its expanded features. We're going to build a show as I introduce the interface, explain how ProShow works, and offer a few tips on workflow.

The main program workspace is divided into sections located underneath the familiar Windows-style arrangement of menu and tool buttons displayed on the top of the main window, as shown in Figure 1.2. I've added labels for the main sections of the default interface to the screenshot in red. It's possible to customize the main ProShow window layout, and you are welcome to do so. I'll use the default settings and color schemes for the figures in this book unless otherwise noted.

For this chapter you can use either Gold or Producer. (Using Producer will let you work with all the features we'll examine in the book.) Gold's interface theme is silver-toned (identical to the one used for both programs in Version 3). Producer's Version 4 default appearance has a black theme. That makes it easy to tell which one I'm using. Please open either now and follow along.

Think of the main ProShow interface as a workspace, a virtual multimedia production environment. We use it to organize content and place elements in a show,

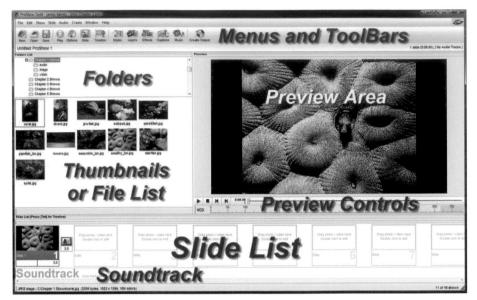

Figure 1.2

ProShow Gold with a show opened for editing. The Producer and Gold versions of the program look virtually identical, except Producer uses a black theme. Producer comes with more tools and dialog boxes.

We preview the production as we work, add captions, fine-tune soundtracks, and craft special effects. In the process we use an array of dialog boxes to manage slides, shows, and projects.

The menu bar and tool bar icons at the top of the window work the same as most other Windows programs. I'll cover their functions as we use them. Right now we are going to access some images and create some slides. The upper left-hand side of the program interface contains the Folder and File Lists. Choose a folder and the contents are displayed in the File List. You can navigate and select files in these sections the same way as with Windows Explorer.

Keep in mind that the File List shows only items that can be imported *into* a show. It won't offer show files or any unsupported file formats. (For example, you can see RAW files in Producer, but not in Gold, because only Producer supports them.) If your copy of ProShow is still using the default configuration, a set of thumbnails is displayed under the File List. If you right-click inside that area, a context-sensitive menu will appear that lets you choose to display either thumbnails or a list of filenames.

The **Folders List** works just like Windows Explorer. Use it to locate the **Chapter 1** folder and click on it to see its contents in the File List area. (Be sure to copy the entire folder to your hard drive first. ProShow requires that a show be on a device that can save the changes.) When the folder is selected you should see a collection of dive pictures. (As with all images in this book, the photographer still holds the copyright and reserves all rights. You only have permission to use them in conjunction with performing the exercises in this book.)

Building Our First Show and Creating Slides Using Drag and Drop

It's time to build our first show. We'll use some of my underwater images and design a simple presentation with several simple slides. (A simple slide is one that just contains one image. Slides can contain multiple images and video clips.) Creating a simple slide is easy. All we have to do is drag the desired image file onto the **Slide List**.

Use your mouse to drag and drop the close-up picture of the man holding the octopus (a octopus.jpg) from the File List to the first position in the Slide List as shown in Figure 1.3.

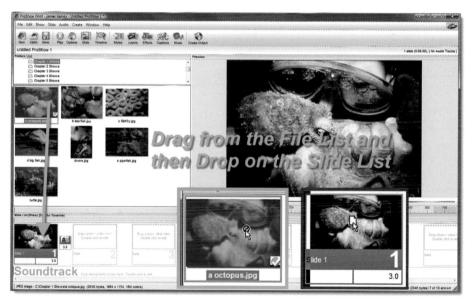

The **Slide List** is the horizontal row under the File List that extends all the way across the window. This interactive tool shows the slides, running from left to right, as they will play. Between the slides are transition icons that show the type of effect that displays as the show moves from one slide to the next. Just below the Slide List is the **Soundtrack** area. When a soundtrack is added to a show a waveform appears underneath the slides as a visual representation of the audio clip.

I've combined two screenshots and provided enlarged examples in the figure. As you move your cursor into position over a thumbnail, a circle with a line will appear next to the mouse pointer. As you drag, a copy of the thumbnail, slightly grayed-out, will move with the cursor. A page icon will appear with the pointer

Figure 1.3 Creating a new slide using the drag and

using the drag and drop method.

when the thumbnail is in position over an open spot in the Slide List. Release the mouse button and the new slide will be added to the Slide List. Once the new slide is in place, a green check mark is placed in the lower right corner of the image's thumbnail in the File List.

More Slides, a Transition, and a Soundtrack

We now have a one-slide show. Let's add three more slides at one time. I'll use Windows Explorer this time, to illustrate a point. Use it to locate the Chapter 1 folder on your hard drive and select the next three images for our show. They all start with a single letter in order: **b** starfish.jpg, c fishfry.jpg, and **d** big fish.jpg. Hold down the Shift key and click on each with the mouse, and then drag them directly from that window to the Slide List as shown in Figure 1.4. I've combined the screenshots again, so the new slides are already in place. There are also now green check marks next to the thumbnails in the ProShow Files List, just as if I had added the files from within ProShow.

Pulling in files with Windows Explorer can be a handy file management technique. I often create and name a new folder before working on a new show and place all the content—image files, video clips, and soundtrack—in it. That makes it easy to drag and drop from an external window. If the show is very long or complicated, subfolders make it easy to arrange the files for the design phase of the workflow.

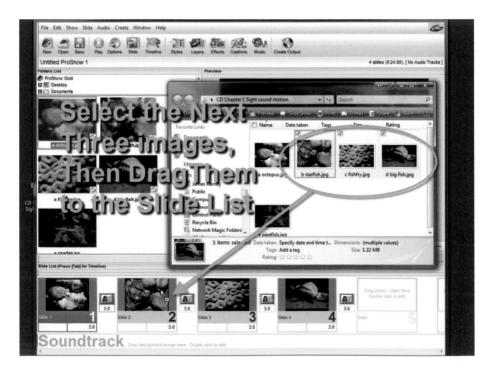

Figure 1.4

We can also drag and drop files from Windows Explorer into a slide show. ProShow only borrows files; they are not modified in any way when we bring them into a show. That's because the program only reads the data from the source. You can add the same file more than once to several slides or even duplicates on the same slide. (We'll use that handy trick in several exercises later in the book.) All the copies of the file will be drawn from the single source. If we use ProShow's built-in editing and special effects controls to make one or more copies look diffcrent, the source still stays in its original and unchanged form.

Transitions

The small icon between each slide in the Slide List represents the transition. Transitions are a cross between design elements and motion effects that occur as one slide leaves the screen and another takes its place. Without transitions, a show would jerk from one image to the next. ProShow comes with over 280 different transition effects. Changing one is easy; the entire collection is only a mouse click away. Right now all of our slides use an A/B fade, one image fades out as another fades in. This effect is like a navy blue blazer or basic black dress—it goes with almost anything, but isn't considered much of a fashion statement.

It's easy to choose a new transition and adjust the times using the Slide List and the interactive Preview tools. Be sure only the main ProShow window is open and click on the transition icon located between Slide 2 and Slide 3. The **Choose Transition** window, like the one in **Figure 1.5**, will appear. (I've circled the current, and default, **A/B Fade Transition** on the Slide List and in the **Choose Transition** window. Note that the current transition is highlighted in blue, just like the currently selected Slide on the Slide List.) Hold your mouse cursor over the Star-Out effect and watch the mini-preview in the lower-left corner of the Choose Transition window. You can choose a new Transition by clicking its icon in the **Choose Transition** window. As soon as you do, the window will close and the new transition will be in place.

Adding a Soundtrack

Now we are going to add a soundtrack to the show. The quickest way to add an audio file is to drag it. Use the mouse and drag the mp3 file in the Chapter folder named **Larry_Allen_Brown_Shenandoah.mp3** onto the soundtrack area, located just below the Slide List. Once the file is loaded, a green waveform should appear underneath the slides in the Slide List. Figure 1.5 shows the open folder window and ProShow Gold with the soundtrack already in place. A red arrow shows the drag path and I've circled the placement cursor in red.

We can drag supported audio files from an external window (like we just did with the three image files) from the Folders List inside ProShow, or by selecting the **Manage Soundtracks** option from the **Audio** menu. The last approach requires

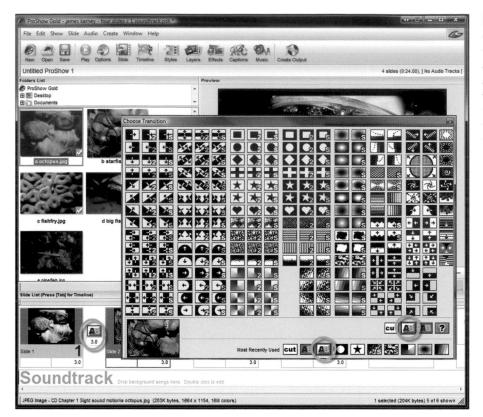

Figure 1.5

Choosing a new transition is easy. Just click on its icon and select the one you want. Then click in the box to adjust the time as needed to get the desired effect.

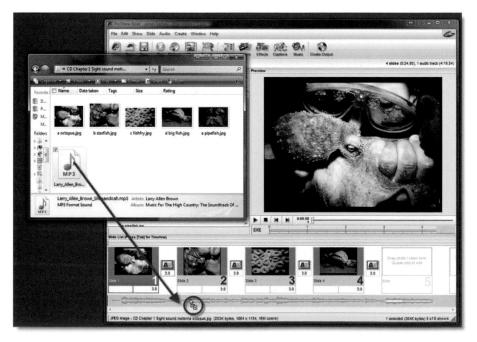

Figure 1.6

Adding a Soundtrack by dragging it into the main ProShow window. using the Show Soundtracks window to locate and select the audio file. The Plus and Minus icons are used to add and remove files from the Audio List (and hence the show), and the Up and Down arrows change a file's location in the stack. Figure 1.7 shows the window open with the soundtrack loaded. We'll cover the details of adding and editing audio files in shows in Chapter 4.

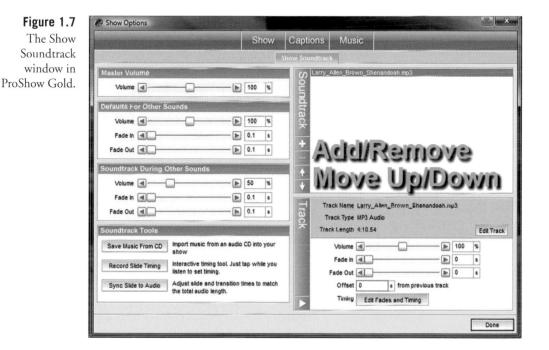

Arranging Slides, Timing, and Previewing a Show

We now have a basic show, replete with Slides, Transitions, and a Soundtrack. Right now all of the slides and transitions are set to the program default of three seconds each. We can use the Slide List and the mouse to rearrange the slides within a show, adjust the timing of the slides and transitions, and preview the production.

The slide list is an interactive arrangement of the slides and transitions in the order they appear within a slide show, ordered from left to right. The numbers below the slide number on the right side of the thumbnail show how long the slide will appear on screen in seconds and fractions of a second. The number underneath the transition's icon shows how long it will remain on the screen. Feel free to experiment with the Slide List location and times for the slides as I explain how to adjust the settings. This first show is just for practice.

Rearranging Slides

To shift a slide's location, first select the slide by clicking on it (or select multiple slides by holding the Control key as you click). The area below a selected slide will turn from gray to blue. Once a slide is selected you can drag it to the new location. Figure 1.8 shows Slide 4 selected, and I've dragged the selection location between Slides 1 and 2. Releasing the mouse places the slide in the new location. Slides to the right of that location will be shifted farther to the right.

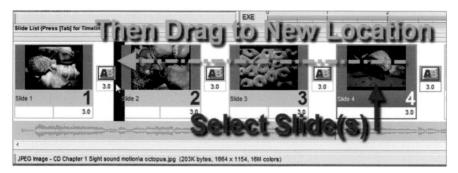

Timing: the Beat Goes On

Use your left mouse button and single-click on **Slide 2** in the Slide List. It will take on a blue outline, as seen in Figure 1.9. If you click on the time, circled in green in the figure, it will also be outlined in blue. Now you can change the time for that slide. The area in the blue circles around Slides 1 and 3 show how the Slide's time looks when it's not selected. The lower right corner of the border displays the amount of time the slide will be on-screen during playback. The time noted under a Transition's icons (circled in red) shows how long the effect will last. Transition times can be changed just like the Slide's.

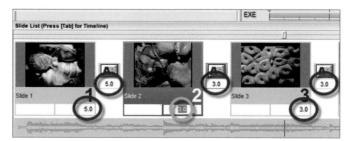

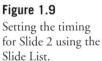

Previewing a Show

ProShow offers an automatic real-time preview of show as it is being created, and an interactive Preview tool that lets us repeatedly move backward and forward through a segment to evaluate how things will look to our viewers. The "ideal" time a Slide or Transition should stay on the screen varies with its content and importance in the presentation. For example, a slide with Captions needs to stay visible long enough to be read, but not so long as to slow the rhythm of the show. Special effects often have timing requirements based on the complexity of the design. The most reliable way to see how an effect or slide works is by using one ProShow's Preview options.

To the right of the Folder and File List area is the **Preview Area**. It displays the current selected portion of the show during editing as well as full-motion previews using the controls just below the preview image. Click on the **Play Button** (The left-most Preview icon circled in red in Figure 1.10) and the show will play either in the Preview Area or in Full Screen. You choose which by right-clicking in the Preview Area and enabling the desired option from the context-sensitive menu. The menu toggles a check mark in front of the Full-Screen Playback option.

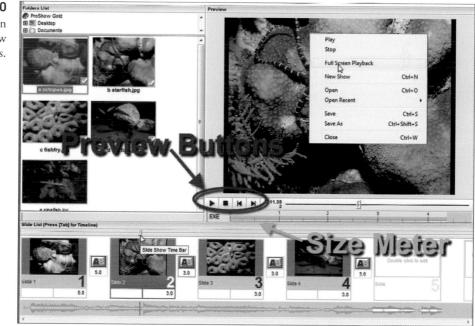

Immediately below the Preview Area's Playback controls is the **Size Meter**. It graphs the size of the current contents of the show based on the files and the type of output. (A Web version will take less room than a DVD, for example.) This is a very handy tool, allowing the user to track and adjust file sizes to meet the capacity of the output medium.

Scrubbing the Timeline

There are two small open rectangles circled in white in Figure 1.10a, with enlarged copies of each pasted to their right. Dragging either one to the left or right "scrubs" the **Timeline**. As it moves, an interactive preview is presented in the Preview Area, showing the exact appearance of the show at that specific point in time. You can move the rectangle forwards and backwards, fast or slow.

The vertical dashed red line as shown in the figure marks the point seen in the preview. As you can see, it shows Slide 1 fading into Slide 2 as the Transition progresses. Experiment a bit with scrubbing the **Timeline**. This is a very powerful tool and one that we will use often during exercises.

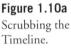

What's "In" a Slide?

A ProShow Slide is really more of a container than an object. It can hold multiple layers, each of which can hold an image file or a video clip. There is also a dedicated Background layer and one just for Captions. Slides can have their own individual sound clips. ProShow's Slide tools control the way each Layer looks, and the tools can be used to generate a host of special effects. Skilled Producer users can use layers to create entire shows with just one slide, and still present a variety of images and professional-quality effects. Each of those images can move independently, have its own custom timing and transitions, and even offer interactive links which let the user choose how the show behaves.

The Slide Options Window

The place where we do most of the magic is the **Slide Options** window. It's the gateway to many of ProShow's most exciting features. It's also a great tool for exploring the anatomy and functions of the ProShow Slide. We are going to just peak inside now and look closer at how slides operate their magic. Double-click on any show in the Slide List and the Slide Option window will open above the main ProShow window. Across the top of the window are tabs. The number will vary depending on which are currently active. Click on the Layers tab, at the very top of the window, and then the Layer Settings tab in the lower row. Figure 1.11 shows the Gold Slide Options window with the Layers and Layer Settings tabs

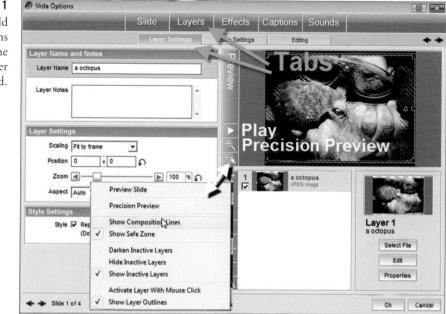

Figure 1.11 The ProShow Gold Slide Options window with the Layers and Layer Settings tabs selected. both selected. Each combination of tabs offers access to a different collection of tools. The basic features in this window are the same for both Gold and Producer. Producer offers more tabs and tools in its Slide Options window, and there are some differences in the way the tools are organized and minor appearances in some of the icons.

The icons in the Preview section of the center column include a Play button that previews the current slide (not the entire show) in the Preview Area to the right of the column. The Precision Preview Button opens another window that provides a larger work area tailored for designing Motion and Caption Effects. We'll use it often, starting in the next chapter. The final icon opens the menu shown on the left side of the window (I've connected the menu and the icon with a twosided white arrow).

The options in this menu control the Preview Area display and features. Rightclicking on many portions of the ProShow interface (including the Slide List, Previews, and even text entry boxes, open context-sensitive menus. Like the icons at the top of the main program window, all offer easy access and handy shortcuts to frequently used tools and commands. I'll introduce and explain their functions as we use them in exercises.

Compare Gold's Slide Options window with the Producer version shown in Figure 1.12. (I've added labels, arrows, and boxes to the screenshots to help identify the objects being introduced) The Preview Area and Layer List are identical, but

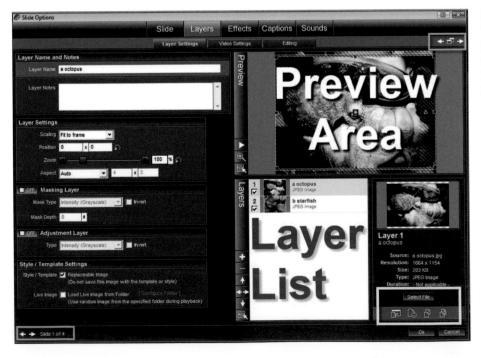

Figure 1.12 The ProShow

Producer Slide Options window in Layers>Layers Settings Mode. Producer offers a wider array of tools and slightly different icons. In the upper right corner of both versions are two arrows pointing left and right (boxed in green in Figure 1.12). These arrows change the currently active Slide Options tab. The arrow icons in the lower left corner of the windows (also boxed in green) change the currently selected slide. One click shifts the active slide one position in the Slide List in that direction on the time line.

The **Select File** button lets you designate the file that is associated with (and appears on) a Layer. Both Producer and Gold let you select and change the file at any time. The icons in the yellow box let you (in order from left to right) open the currently selected layer's file in an external editor like Photoshop, obtain a detailed Properties report on the file, Copy Layers to another Slide, and copy the Layers Settings to another Slide. (These specific icons don't appear in the same location in Gold, but that version provides alternate options for the same functions.) We'll cover all of them later in the book.

Getting Fancy with Slide Styles

Slide Styles are one of ProShow 4's most useful new features, letting even a novice user incorporate professional-looking effects into a show. A Style is a completed slide design. ProShow comes with a variety of ready-made Styles, ranging from simple layouts to designs with complex multi-Layer Motion and Adjustment Effects. Any Slide can be converted and used as a Style.

We're going to use a couple of Slide Styles to look closer at Slide design and see how multiple layers can create interesting effects. Both versions of ProShow offer the same basic controls in the Slide Styles window. Producer has more tools and more Styles, thanks to the power of Keyframes. We'll stick to the basic Styles now, and save introducing Keyframes and advanced effects for Chapter 2.

Let's open Slide 1 (the image of the diver holding the octopus) in the Slide Options window with the Slide>Slide Styles tabs selected. You can use either Gold or Producer. If you have ProShow's main program window open, just double-click on Slide 1 in the Slide List and it will open up in the slide options window. If you already have the Slide Options Window open, use the arrows in the lower left corner to select Slide 1, and then click on the Slide and Slide Styles tabs.

The right side of the window is just like the **Layers>Layer Settings** mode we just discussed. It shows the Layers in the current slide and offers a Preview Area. The left side of the window is where the Styles-specific tools and selections are located.

When working with Slide Styles the only difference between the two programs is the number of prepackaged styles included with the program, and the complexity of Slides that can be built and used as Styles. That's because Producer offers more powerful special effects. Figure 1.13 shows the **Slide**>**Slide** Styles window open in Producer. I've also clicked on the **Manage Styles** button (indicated by the green arrow), which can be seen on the right side of the Figure over the Slide Options window.

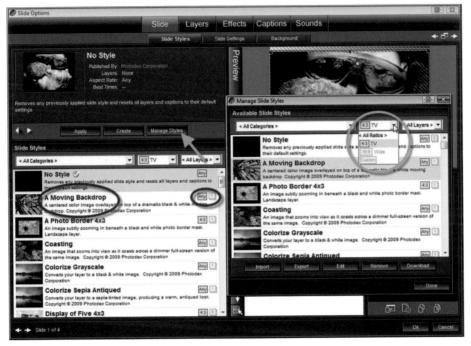

Figure 1.13

The ProShow Producer Slide Options window in Slide>Slide Styles Mode.

A slide style is a special file format that contains all the information about a slide, minus the files used in the Layers. We can save an existing Slide for use as a Slide Style by using the Export button at the bottom of the Manage Slide Styles window. The Import button lets us add Slide Style files to the list of available Styles, and the Edit button lets us modify information and options available in the Slide Styles list for a given Style. The Download button lets us go directly to the Photodex web site and download bonus content.

A Moving Backdrop

The second entry in the Slide Styles List on the left side of the window is titled <**A Moving Backdrop**>. The title is circled in red in Figure 1.13. I've circled the two boxes to the right of the listing in red. The box on the left has the word <Any> inside it. This tells us that the style is suitable for use with any display format's aspect ratio. The drop-down menu circled in green in the Available Style Styles window on the right side of Figure 1.13 shows the list of aspect ratios. They

include the "standard" 4:3 TV, 16:9 Widescreen, and Custom. If your show is being designed for a specific display format, you should use styles that match the aspect ratio of that device (or that show Any). The box to the right indicates the number of Layers included in the Style's design.

Use your mouse and click on the **A Moving Backdrop** listing. The listing will take on a blue background indicating that it is selected. See the example in Figure 1.13. I've used Gold for the screenshot. Now click on the **Apply** button located on the top of the left side of the window. The figure shows my copy of Gold after clicking the apply button. The Layers List now shows two layers both of the same picture of the man holding the octopus.

The Preview Area shows the finished result. We now have a Slide with two Layers—both copies of the same image. Layer 1 is reduced and centered in the frame. Layer 2 has been converted to look like a black and white image and is now a backdrop. Press the preview play button and you can see why it's called A Moving Backdrop. The smaller color image now grows as the backdrop Layer slides across the frame towards the upper left corner. We produced this effect with the click of a mouse thanks to the Slide Style.

A Special Effects Primer

ProShow provides a great collection of Special Effects tools—tools we will explore in detail throughout the rest of this book. Using them effectively requires knowledge of some basic concepts. Special effects involve a change in the appearance and/or position of one or more of a Slide's Layers during playback. Select the **Effects>Motion Effects** tabs in the Slide Options window. If you've been following along, Slide 1 should be visible in the Preview Area. If not, please Select Slide 1. There are two Preview Areas in this window. The Preview Area on the left side shows the appearance of the slide as it begins to play, the Starting Position. The Preview Area on the right side shows the appearance of the Slide as it ends its time on screen, the Ending Position. Figure 1.14 shows Slide 1 in the Motion Effects window with Layer 1 selected.

Change Over Time

Layer 1 grows in size during play. That's because there are separate settings for the Starting and Ending Positions. The Zoom setting determines the size of a Layer in the frame (the viewing area for the show). The Starting Position's Zoom is set to 50%. The green arrow links the setting and the Layer in the Preview Area. At the end of play, the Layer is zoomed up to 75%, and is twice as large as it was at the beginning.

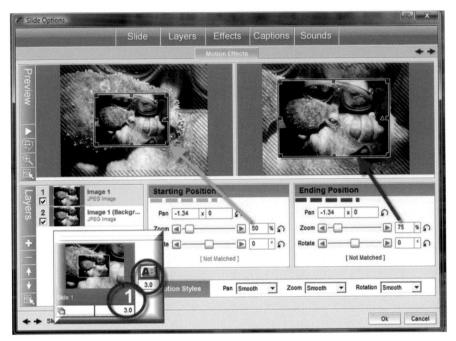

Figure 1.14 Using the Zoom controls in Motion Effects to increase the size of Slide 1's Layer 1 during play.

I've pasted in the slides thumbnail used in the Slide List in the main ProShow window. This slide is set to play for 3 seconds, with a three-second Transition. The amount of time the effect takes is the amount of time that the Slide is visible in the show. In this case, that's 4.5 seconds—the play time, plus half of the Transition time.

Layer 2: Pan, Zoom, and Color Changes

Select Layer 2, the grayscale backdrop image, by clicking on it in the Layers List. This Layer has a change both in its Pan and Zoom settings during play. The Pan control determines the location of the center of a Layer during play. If the Pan setting is the same for the entire Slide, the Layer will be still. If they are different, the layer will move. We will cover positioning and editing Layers in Chapter 3. Layers can be sized and positioned using the mouse or by setting numerical values for the desired control.

Select the **Layers**>**Editing** tabs with Layer 2 active. Your Slide Options window should look like the one in Figure 1.15a. These settings modify the basic settings for a Layer during its entire time on screen, without altering the actual appearance of the source file.

Adjustments include *Brightness, Contrast, White Point and Black Point.* We can also *Flip* Layers *Vertically* and *Horizontally*, as well as adding *Drop Shadows* and *Outlines.* This layer has been colorized. You can tell by the green tab and check mark for the Colorize control (The control is circled in Figure 1.15.) Uncheck the box and the Layer will be seen in color. The Set button lets us choose the color used by the Colorize tool.

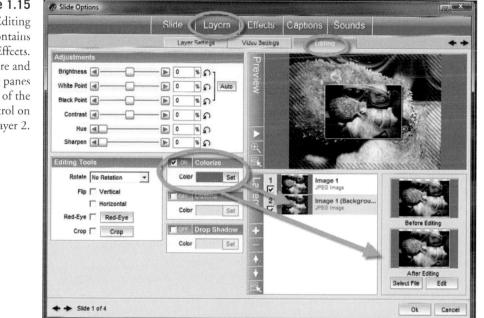

The thumbnails on the far right of the window show the image before and after editing. Notice the Edit button just below the After Editing thumbnail. This lets us use an external editor to modify a source file from within ProShow. After the desired editing has been completed, the image is reloaded in a show with the changes seen.

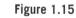

The Layers>Editing window contains many Special Effects. Here, the Before and After Editing panes show the effect of the Colorize control on Slide 1, Layer 2.

Scrubbing the Timeline

Before moving on to the next topic, please scrub the Timeline located below the Preview window in the main ProShow window. Drag the control to the right and watch how Slide 1 moves. (The control is circled in blue in Figure 1.16.) Just like a movie or television program, the show's illusion of movement and the special effects are created by a series of still images. ProShow generates a series of variations of the image based on the Slide's settings as the Preview progresses. Each of these pictures is called a frame, and the number of frames per second (fps) is called the *framerate*.

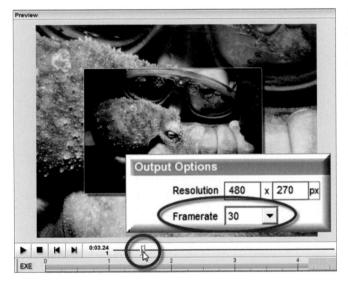

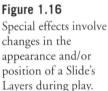

The Output Options box pasted over the Preview in the Figure 1.6 shows a typical resolution and *framerate* for a Flash movie generated by ProShow. The Starting Position and Ending Position for each Slide are *Keyframes*. The settings for these two points in time are used by ProShow to generate (the technical term is render) the images in between. So our slide, with a framerate of 30 fps for 3 seconds requires 90 frames.

In Gold each Layer has its own Starting and Ending settings, but they all happen at exactly the same point in the show. Producer gives us the ability to set and adjust individual Keyframes for each Layer, and to position them independently to any point in time the slide is visible on screen. In addition, each Layer has its own Beginning and Ending Transitions. That allows us to create different professionalquality effects for each Layer in a Slide.

Captions with a Bit of Style

ProShow offers a full array of caption tools, including font and size, color, drop shadows, outlines, and text effects. Just like image layers, Caption positions can be moved using the mouse or by entering location numbers. Choosing a font, setting point size, and text alignment, are all done using familiar word processing style menus and buttons.

A specific caption can be linked to an individual slide or the entire show. The program comes with a collection of visual effects that can be used to control how each caption enters the slide, behaves during play, and exits. For example, you can have one caption fade in, while a second scrolls up from the bottom of the frame, and then both fade out at the end of the slide's time on screen. Producer adds keyframing controls and advanced text alignment options.

You'll need to have Producer open to follow along with the next example, using a Slide Style to add both Layer and Caption Motion Effects to make both images and letters dance across the frame. I'll show several screen shots for readers who don't want to load Producer.

Start by choosing the New Show option in the File Menu. Next select any four vertical (portrait) images, located in the **TriCoast** subfolder in the **Chapter 1** folder, and then hold the **Control** key and drag them onto the Slide 1 position on the Slide List at the bottom of the main Producer window. Holding the Control key lets us add multiple Layers to a Slide at the same time. Set the time for the new Slide as 5 seconds, and the following Transition to 1 second. Click on the time in the lower right corner of the Slide's box to adjust its time, and click under the Transition icon to set that value. I've circled both locations in green in Figure 1.17. Now double-click on the new Slide to open the Slide Options window and make the Slide and Slide Styles tabs active.

Find and select the **<Images of Love> Style** in the Slide Styles List by clicking on it with left-mouse button. Then click on the Apply button. Click OK when the dialog box asks you to verify your action. Your screen should now look similar to the example in Figure 1.17. There will be slight differences in the appearance of your slide, depending on the pictures you use.

This Slide Style uses four captions, one for each letter of the word LOVE. Since they are individual letters, each one can have its own timing and special effects. Scrub the Preview several times and watch how they enter the frame in random order. ProShow provides a collection of predefined Text (Special) Effects, which work sort of like a Transition, to control the way a Caption enters and leaves the frame. They are called the Fly-In and Fly-Out Text Effects. A third Text Effect, called Normal, controls how the text looks between the end of Fly-In and the beginning of the Fly-Out.

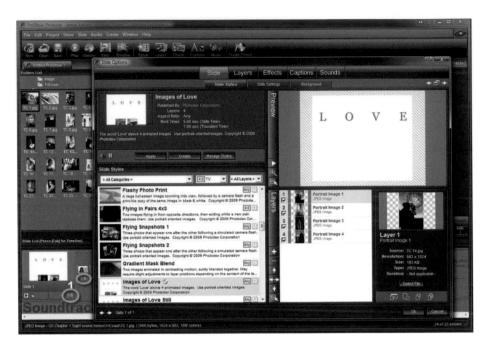

Figure 1.17

Captions can be more than just text on the screen. ProShow provides all the tools needed to transform words into polished design elements.

Figure 1.18 shows the upper portion of the Slide Options window with the **Captions>Caption Motion** tabs selected. The **Caption Placement** controls are used to adjust the visual appearance of the letters that make up a Caption. Gold provides a more limited set of Caption Placement tools and does not support keyframing or advanced Motion Effects with Captions. We'll cover captions in detail in Chapters 5 and 6.

This slide blends four images and four captions with complementary motion effects into a pleasing design. Scrub the Slide Timeline in the main Producer window and observe how the images make an X-shaped entrance from the lower portion of the frame as the letters that make up the word LOVE do their dance in the upper portion of the frame. Figure 1.19 shows the **Effects>Motion Effects** window with the left Preview Area showing the slide as the images just begin to open out, about 75 percent through the Slide's play time. The right side is a composition I made by adjusting the timing so that it could show the finished design.

Up Next

This chapter introduced ProShow's basic controls and the fundaments of how a show is assembled, complete with slides, soundtrack, captions, and the basics of special effects and timing. The next chapter goes deeper into ProShow's features, optimizing workflow, and setting ProShow's preferences to increase productivity.

Figure 1.18 Text Effects control the way a Caption enters and leaves the slide.

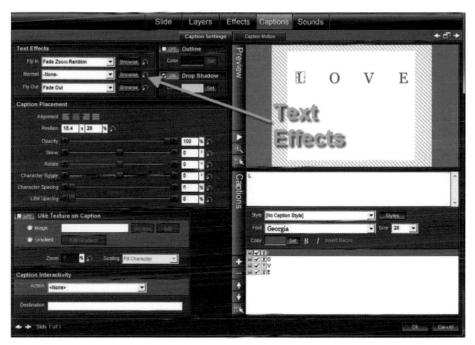

Figure 1.19 This design balances Images and Captions both in number and in the way Motion Effects are applied.

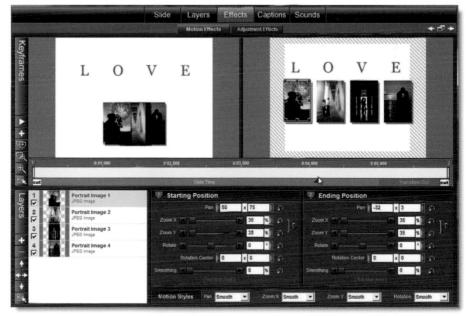

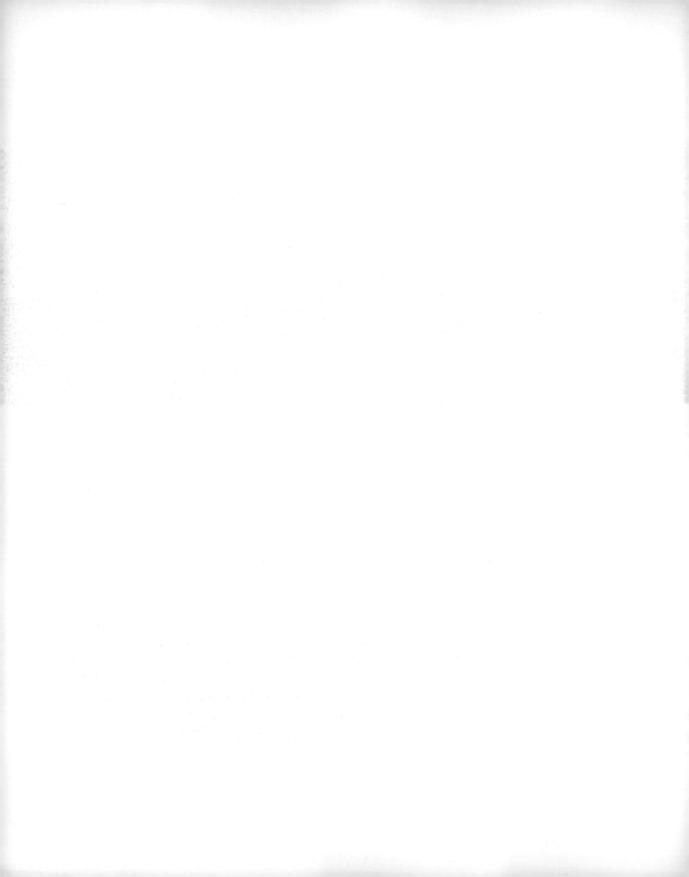

2

Beyond the Basics— It's All About Time

ProShow's drag and drop toolkit makes it easy to create a basic Show, even if you don't know the finer points of the program, or how to craft special effects. To get the most out of ProShow, and be able to craft professional-looking shows, requires understanding how Slides work, and knowing how to control their behavior on the screen.

You should copy the Chapter 2 folder to your C: Drive before working with the Exercises. You can use either version of ProShow for the first part of the discussion. Producer will be required when we work with Keyframes. Trial versions of both editions are located in the Software folder on the CD-ROM in the back of this book, are also and available on the Photodex website.

Let's begin by creating two identical Slides. Locate the **TC 17.jpg**> file in the **TriCoast** subfolder in the Chapter 2 folder. Drag it onto the **Slide 1** position on the **Slide List**. Set the Time for **Slide 1** to **5** seconds, and the following **Transition** to **2** seconds. The easy way to do this is to click on the current value, then enter the new value. (I've circled the places to click in Figure 2.1.) Next, right-click on **Slide 1**, choose the **Copy** Option on the menu, and then paste it into the empty **Slide 2** position to the right. I've pasted a portion of the menu into the Figure.

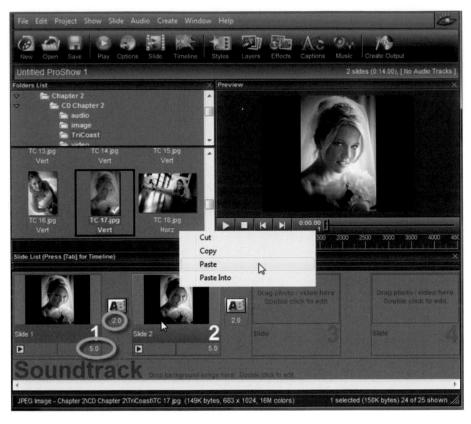

Figure 2.1 Copying and pasting the Slide.

Slide and Transition Timing

Understanding how Slide Timing and Transitions work together is fundamental to mastering ProShow and creating dynamic shows. Precise control of Timing is *critical* when crafting sophisticated special effects. Figure 2.2 shows a portion of the **Slide List** with **Slide 2** and the **Transitions** on either side. Below that is a diagram showing the total possible area in a Show's Timeline that a Slide may be seen during play. A **Gradient Fill** is used to represent the Transitions in the diagram, because they generally progress from showing the entire preceding Slide, to blending the two Slides, to showing the second Slide.

The total Slide viewing Time begins with the first moment of the preceding Transition, and all or part of it may be displayed right to the very end of the following Transition. Just how much or little depends on the type of Transition and the content of the Slide. For example, a **Cut Transition** does just that—it "cuts" from one visual to the next. Use a Cut, and the next picture will be shown at once. A **Fade** blends from one image into another. As we have seen, increasing the Transition Time on a Fade will lengthen the effect, and the image will appear more slowly.

Figure 2.2 A Slide's total visible time on screen includes portions of the Transitions on either side, as well as its own Time allocation.

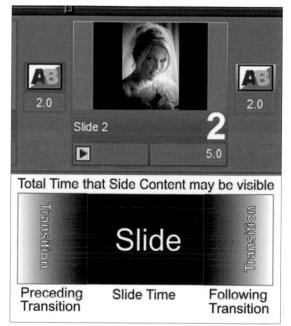

Between the two Transition Times, the visible content is completely under your control with the **Slide Options** settings. With simple, single-layer slides, controlling Slide Timing is easy. All you have to do is make sure that the bordering Slides and Transitions visually work well together. Complex Slides (multiple Layers, Keyframes, Caption Effects, embedded sound, etc.) require specific Timing for each element. The Exercises in the following chapters go into detail on each of those topics. Right now we are going to explore how to control ProShow's Timing controls.

To do that, let's create a significant difference in the way the two Slides look so we can easily see the changes. We'll use the **Colorize** tool to radically alter the color of **Slide 2**. (That's a handy trick any time you are working on tweaking timing.) Double-click on **Slide 2** to open the **Slide Options** window and select the **Layers>Editing** tabs. Figure 2.3 shows what we are going to do. Enable the **Colorize** checkbox and then click on the **Set** button. (I've circled both items in green in the figure.) In the three data entry boxes enter the values **241**, **16**, and **16**. (Refer to the settings boxed in green.) Now **Slide 2** should be dramatically red.

Return to the main ProShow window. Play the **Preview** by pressing the **Play** button in the lower-left corner of the main **Preview Area**. It's circled in green in Figure 2.4. Make sure the Preview time is set to **0:00:00**. Adjust the slider, boxed in green, all the way to the left if it is not. Watch how, in the middle of the 12-second Show (we won't count the ending Transition), the image shifts from full-color to red in

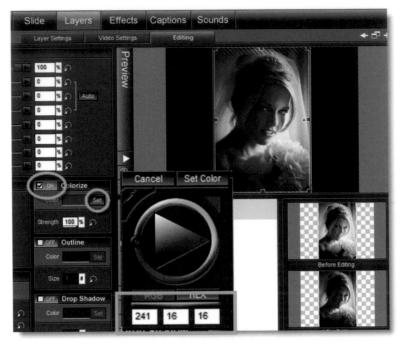

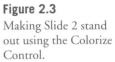

Figure 2.4 Viewing the effect by scrubbing the Timeline. the middle of the Show. The Timing and Transitions are set so that **Slide 1** is visible for **5** seconds. Then **Slide** 2 Fades In over a **2**-second interval. Finally, **Slide 2** is visible for another **5** seconds.

Now change the **Times** so that both Slides are set to **3** seconds and the **Transition** is **6** seconds long. Those settings are shown in Figure 2.4. Replay the Preview. Now the picture changes to red much more slowly, but the amount of time it is either in full-color or red is reduced.

Let's do one more modification. This time we'll adjust both the Time and the type of Transition between the two Slides. Change the Timing so that each slide is set to **2** seconds and the Transition is **1** second. Click on the **Transition** icon (It's indicated with the lower point of the double-arrow in Figure 2.5.) to open the **Choose Transition** window. Click on the **<CUT>** icon. I've circled it in green. It is one of the permanent Options in the lower right potion of the window. Preview the result. A CUT Transition produces an immediate shift from one Slide to the next. Now the effect is of a full-color image that is instantly rendered into a red-toned version.

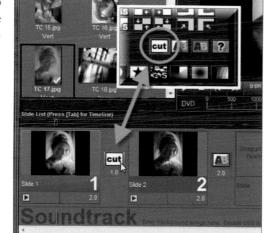

Figure 2.5 Changing the Transition.

Not Just for Slides-Timing Layers in Producer

The following Exercise requires Producer. It supports individually timing Layers, and Gold doesn't. Select **Slide 1** and press **<Control + Function 1**> to open the Slide Options window in **Slide>Slide Layers** mode. We are going to use the **Flashy Photo Print Slide Style** to quickly produce an example for our experiments. Select it from the **Slide Style List**. (It's the one selected and already applied in Figure 2.6.) Click the **Apply** button and you should then see three **Layers** in the **Layers List**.

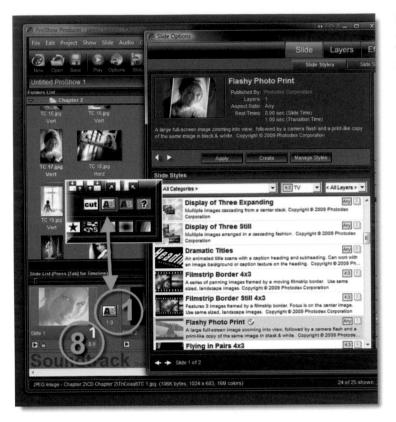

Figure 2.6

Changing the Slide's Timing and the following Transition.

Here's a neat shortcut. This Slide Style is designed for an 8-second Slide with a 1second Transition. Adjust the **Slide Options** window so you can see **Slide 1** and the following **Transition** in the main Work Area. We can actually adjust Slide Times and Transitions in the Work Area without closing the Slide Options window. Set **Slide 1** to **8** seconds and the **Transition** to **1** second. Then click on the **Transition** icon and change it to the **A/B Fade** as shown in Figure 2.6.

Preview the Slide. It begins with the original full color image, zoomed to be larger than the frame in the background. It moves with a slight Motion Effect, and slowly turns into a grayscale image that darkens. As it does, an effect like a camera flash occurs, and a black and white "print," complete with a border, spins into the frame.

A Closer Look

Producer can generate these kinds of effects thanks to **Keyframes**, which offer the ability to individually modify each Layer in a Slide at any point during Play. In addition, each Layer has its own **Beginning** and **Ending Transitions**. This offers incredible creative potential when coupled with Producer's Special Effects toolkits. If we don't make any adjustments, a Producer Layer works just like one in Gold. Our current Slide provides an example of the power Keyframes provide. Select the **Effects**>**Motion Effects** tab. This Slide has three Layers. The bottom one, **Layer 3**, is the original image file. The top one, **Layer 1**, the copy that spins in on top as the Slide plays. **Layer 2**, in the middle, is a solid fill that only appears long enough to produce the "flash" effect.

Let's look closer and see the combination of Keyframe Timing and special effects work. Click on the boxes in front of **Layers 1** and **2** in the **Layers List** to disable them. That way we examine **Layer 3** by itself. Click on **Layer 3** to select it. Don't disable its check box. (I've marked **Layer 3** with a blue star in Figure 2.7.) This Layer has three Keyframes. A **Keyframe** is a point in time that we can use to adjust the position or the appearance of a Layer. Each Keyframe has a **Marker** on the **Kcyframe Timeline**, showing when it occurs during playback. To help identify the Keyframes for **Layer 3** in the Figure, **Keyframe 1's Marker** is circled in green. **Keyframe 2** is circled in red, and **Keyframe 3** in white.

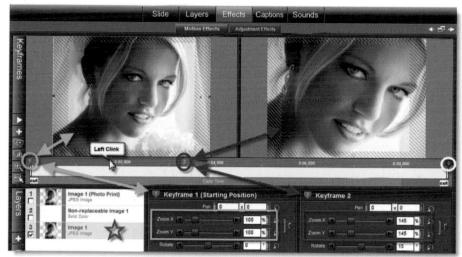

Figure 2.7 Layer 3 selected, with the first Keyframe Pair active, showing the Motion Effects settings.

Keyframe Pairs

Keyframes *always* work in Pairs—one at the beginning of a time segment, and the other one at its end. Notice how **Keyframes 1** and **2** have blue Keyframe Markers, and Keyframe **3's** is black. That's because **Keyframes 1** and **2** are the **Active Keyframe Pair**. We can also tell by the fact that the portion of the **Keyframe Timeline** between them is highlighted in blue. Left-click between the first two Keyframes on the top portion of the Keyframe Timeline to select them. I've placed a **Left Click** marker in Figure 2.7 for reference. Your screen should look like Figure 2.7, except for the added labeling.

The arrows drawn on the screenshot in Figure 2.7 point to the controls and Preview Areas for the active Keyframe Pair. The left-most selected Keyframe is on the left in green, and the right side is used for the second member of the Pair. See

how the image in the right-side Preview area is larger than the one on the left? That's Motion Effects at work. The green box outlines the **Zoom** setting for **Keyframe 1**. The red box on the right outlines the **Zoom** settings for **Keyframe 2**. They change from **100** percent to **145** percent. That means that in the interval of time between Keyframe 1 and Keyframe 2, the Layer will become 45 percent larger. We'll cover Motion Effects in more detail in Chapter 3.

We can move a Keyframe Marker on the Keyframe Timeline by dragging with the mouse, or by right-clicking it and entering a number into the dialog box that appears. Making the distance wider *increases* the amount of time controlled by that Keyframe Pair. Moving them closer together *reduces* the amount of screen time they control.

We can use the amount of time allocated for a Keyframe Pair to control the visual impact of a Motion or Adjustment Effect. Increasing the amount of Time between a Pair of Keyframes makes a special effect take place more slowly. If we shorten the time between two Keyframes and leave the settings the same, then the Effect for that segment will appear more quickly on the screen.

The Motion Effects for the Second Keyframe Pair

Select **Keyframes 2** and **3** by left-clicking between them, as shown in Figure 2.8. (I've placed a **label** showing where to click.) Now Keyframe 2 takes over the left Preview Area and settings column, and Keyframe 3 the right. Keyframe 1's Marker has changed to black, indicating that it is not selected. As you can see, the Keyframes are the same, but the Previews have changed. That's because Keyframes are assigned to the Layer, and the Effects settings are assigned to the Keyframe. **Keyframe 2** is now labeled with green (indicating the first Keyframe in the

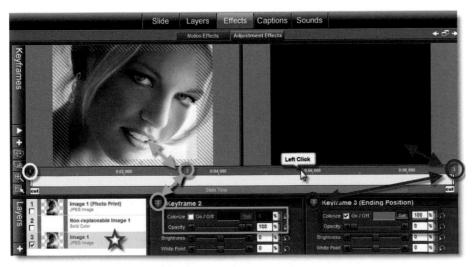

Figure 2.8

Layer 3 selected with second Keyframe Pair active, showing the Motion Effects settings. selected Kcyframe Pair), and **Keyframe 3** with red (for the second member of the Pair). **Keyframe 1** is circled in white, noting that it is not currently selected.

The Zoom settings for **Keyframe 3** are **135** percent. That means the Layer will shrink in the frame slightly (from **145** down to **135**) as the Slide plays through this time segment. The left Preview Area shows the Slide just as the Layer enters the Slide's **Ending Transition** phase, as I scrubbed the Keyframe Timcline. You can see the mouse pointer peeking out from under the red circle around the **Keyframe 3 Marker** in the Settings area.

The Adjustment Effects Keyframe Pairs

Select the **Effects**>**Adjustment Effects** tabs. Adjustment Effects control the appearance of a Layer, just as Motion Effects control a Layer's location. Chapter 8 is dedicated to working with Adjustment Effects. Select **Keyframes 1** and **2** by clicking between them. As you can see, the Keyframes are in the same locations (and have the same numbers) as in the Motion Effects window seen in Figure 2.8. That's because a Keyframe is assigned to a Layer, and the Effects settings are assigned to a Keyframe.

Select **Keyframes 2** and **3** by left-clicking between them as shown in Figure 2.8a. (I've placed a **label** showing where to click.) Now **Keyframe 2** takes over the left Preview Area and settings column, and **Keyframe 3** the right. **Keyframe 1's** marker has changed to black, indicating that it is not selected.

I've labeled **Keyframe 2** with green (indicating the first Keyframe in the selected Keyframe pair, and **Keyframe 3** with red (for the second member of the Pair). **Keyframe 1** is circled in white, noting that it is not currently selected. The head-ings at the top of each column of settings change to indicate the Keyframe it

Figure 2.8a The Adjustment Effects window open, with the Second Keyframe Pair active. controls. In Figure 2.7 the left heading said **Keyframe 1** (Starting Position). In Figure 2.8a the left column controls **Keyframe 2**.

This second Keyframe Pair is when and where the image is converted from fullcolor to black and white and fades from view. The settings in the colored boxes tell the tale. At the beginning of the segment, **Keyframe 2**, the settings are all at the default values. The **Colorize** tool is **Off**, and the **Opacity** is at 100%. **Keyframe 3** has been adjusted so that the Colorize tool is **On**, and it renders the image in grayscale. The **Opacity** setting of **0%** makes **Layer 3** transparent, allowing the Slide's **Background** to show through. Of course, this change occurs gradually as the as this portion of the Show is played.

A Brief Moment—Layer 2 and the Flash Effect

Layer 2 produces the flash effect, and illustrates how Layer timing works in the process. Make all **Layers 1-3** active by clicking their check boxes (boxed in blue for reference in Figure 2.9). That way we can see the entire effect when we scrub the Keyframe Timeline. Select **Layer 2**. There are only two Keyframes in this Layer, so they are automatically selected.

Figure 2.9

Layer 2 uses a combination of Timing and Opacity changes to produce the flash effect.

This Layer is only visible during the portion of the Slide's time that is within the Keyframe Pair. **Keyframe 1** is the **Starting Position**, and it can be moved to any point on the Slide's Timeline. The last Keyframe, no matter how many of them a Layer has, or where on the line they are placed, is in the Ending Position. Here the designer placed the **Keyframe Markers** well inside the play Time for the Slide, and moved them close together. That's why the flash effect happens well into play, and only lasts for about a second.

The flash effect looks perfectly white as it first begins. That's because it is a solidwhite Layer set to an **Opacity** of **100%** at **Keyframe 1**. Which means it totally hides **Layer 3** at that point in time. The **Opacity** at the **Keyframe 2** point is **Zero**. In between, the Layer becomes less and less visible until it completely disappears.

The left Preview Area in Figure 2.9 was captured as I was scrubbing the Keyframe Timeline. The green circle shows my mouse pointer. Use your mouse to scrub the Keyframe Timeline. I've placed a **label** to show where to place the cursor. You can drag back and forth to observe the effect.

Layer 1's Late Entry

Select **Layer 1**. This Layer contains the grayscale copy of the portrait that moves in from the upper right side of the frame. (I've circled it in green in Figure 2.10.) Its first Keyframe, and hence its entry into the frame, occurs well into the Slide's play Time.

Look closely at the bottom of the **Keyframe Timeline** in Figure 2.10. I've drawn colored boxes outlining the Slide Time (in green) and the Ending Transition (in red). The dashed green line shows the point in the Timeline where the Layer is first seen.

The yellow arrow spans the second Keyframe Pair, **Keyframes 2** and **3**. During this portion of play, the Layer sits still in the position shown in the right Preview Area. The red arrow spans the time controlled by the third Keyframe Pair,

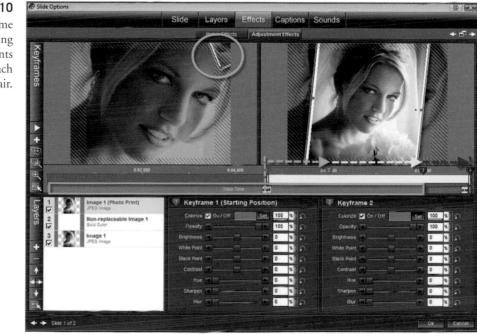

Figure 2.10 Layer 3's Keyframe Timeline showing the segments controlled by each Keyframe Pair. **Keyframes 3** and **4**. The red box shows that this portion of play actually occurs after the end of the Slide Time; it is all in the time allocated to the Ending Transition.

This Layer illustrates the use of an important design tool. Producer lets us place a Layer's Keyframes at any point on the Timeline, from the beginning of the preceding Transition, to the end of the following Transition. In short, at any time any portion the Slide can be seen on the screen. (Keep in mind that the Layer Transitions are separate design elements from the Slide Transitions.)

Scrub the Keyframe Timeline and you can see how the final Keyframe Pair works. Figure 2.11 is a capture made part-way through that portion of play. You can the following Slide, with its red colorization, as it begins to take over the screen.

Figure 2.11 The final Keyframe Pair being played at the Transition into

the following Slide.

Using the Multi-Layer Keyframe Editor

The Effects Windows—Motion, Adjustment, and Caption Motion Effects (which we cover shortly)—let us work with Keyframes one Layer at a time. Producer 4 provides a tool that lets us see and work with all the Keyframes in a Slide at once, the **Multi-Layer Keyframe Editor**.

Figure 2.12 shows the **Multi-Layer Keyframe Editor** in with the first Slide in the Show selected. Open it by left-clicking on the fourth icon from the top on the

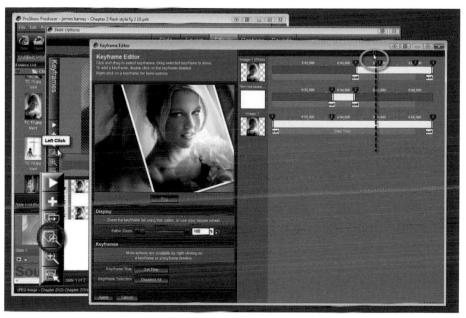

column to the left of the Preview area, in the any of the dual Preview Area-enabled windows. I've placed a left-click on it in Figure 2.12 and provided an enlargement of area of the screen with the icon circled in red.

As you can see in the Figure, each Layer's **Keyframe Timelines** are positioned, one under the other, on the right side of the Multi-layer Keyframe Editor window. This arrangement makes it very easy to see how one set of Keyframes relates to another. The mouse can be used to reposition individual Keyframes, add new Keyframes, or delete existing ones.

At the very top is a tool just like the one at the top of the Slide List in the main ProShow window. Dragging it from left to right scrubs the Timeline, just as it does in the Work Area. The blue dashed line was drawn to show how you can track all of your Keyframes in a Show at the same time with a single scrub of the Timeline. This is a very handy tool when trying to design special effects that involve Motion Effects or Adjustment Effects in more than one Layer. In the left column of the window is a Preview Area with a **Play** button directly underneath it.

Figure 2.13 is a composite view of a portion of the Multi-layer Keyframe Editor, with its context-sensitive menus both visible, and an enlarged overlay of the **Display** and **Keyframes** panes of the window. The menu, seen over the center portion of the Timeline of **Layer 1**, is accessed by clicking a Layer's **Timeline Bar** (which is shaded is in dark gray and light beige.) This menu lets you insert Keyframes and multiple Keyframes.

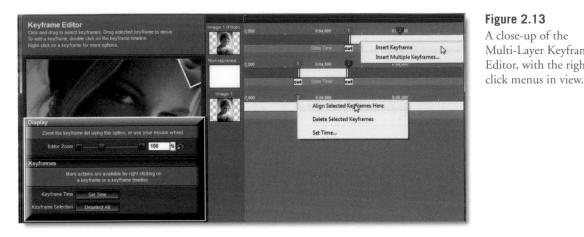

Figure 2.13 A close-up of the Multi-Layer Keyframe Editor, with the right-

The menu seen over **Layer 3** is accessed by clicking on a **Keyframe Marker**. This is used to align Keyframes, Delete Keyframes, and set Keyframe Timing. This is a really neat tool for precisely adjusting Timing for several Layers at the same time. Simply select the Layers you wish to align, and issue the Align command. Increasing the **Zoom**, either by using your mouse wheel or the Zoom slider, alternately stretches out or compresses the Keyframe Timeline for the Layers in the right column. Zooming can be very useful when you're trying to work with a precise amount of Time, or have a Slide with a very short Play Time.

A Few Words about Editing in the Precision **Preview Window**

We have one more specialized window to examine, and one more design to play with in this Chapter. The aim is to show you a few tools we will be using through the Exercises in later Chapters, so they become familiar. This Show also includes tools we haven't used yet. They'll be explained later. Once again, this Show involves Keyframes, so we'll need to use ProShow Producer.

Open the file **Bride.psh** located in the Chapter 2 folder. This show has one Slide, with one image Layer. Preview the Slide before continuing. The picture doesn't move, but there's no shortage of Motion Effects in this Show. Figure 2.14 is a screen capture as the Slide is playing. There are 65 Captions, all with Motion Effects and their own Keyframes. They fly into the frame and create the shape of a bridal gown; then the bridal portrait comes into view; and finally the frame darkens as the words fly out of the frame.

I've opened the Slide in the Multi-layer Keyframe Editor in Figure 2.14a. It easy to see how this can be a useful tool when there are this many Layers and Keyframes in a Slide and you are designing effects! The Multi-layer Keyframe Editor has some **Figure 2.14** Captions are a principal design element in this Slide.

Figure 2.14a It's easy to see how the Multi-level Keyframe Editor can be handy when trying to align this many Keyframes on Layers in a single Slide.

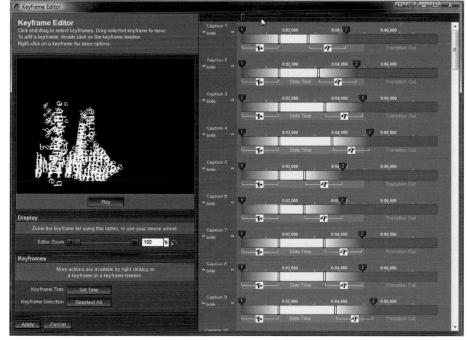

limitations, however. For one thing, we can't actually manipulate anything other than the Keyframes and their related timings in this interface.

Producer provides another tool for precisely positioning elements of the design to specific Keyframes. Open **Slide 1** in the **Slide Options** window. Double-click on the **Preview** area. The **Precision Preview** window (seen in Figure 2.15) will open. This works any mode of the **Slide Options** window, and any of its **Preview Areas**.

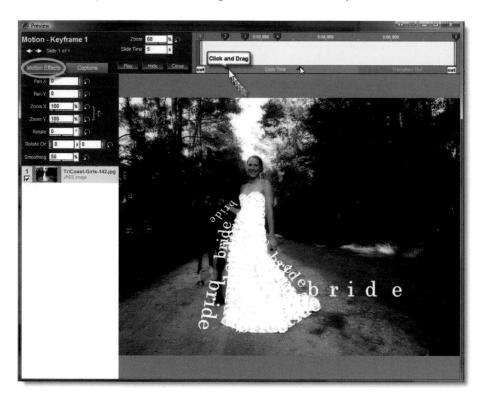

Figure 2.15

The Precision Preview window open with the Motion Effects tab selected.

I've drawn a green circle over the Motion Effects tab. Beneath the tabs are the standard tools used for creating and working with Motion Effects. (We'll cover Motion Effects later in the book; right now we're just focusing on the use of the Precision Preview window.) Beneath the tools is the **Layers List**, showing the Layers in the currently-selected Slide.

On the right side of the window above the Preview Area is a **Keyframe Timeline**. As you can see from the **label** I've placed there, we can scrub the Keyframe Timeline by dragging our mouse underneath the **Timeline Bar**.

Click on the **Captions** tab located to the right of the **Motion Effects** Tab. Your screen should look similar to the one shown in Figure 2.16.

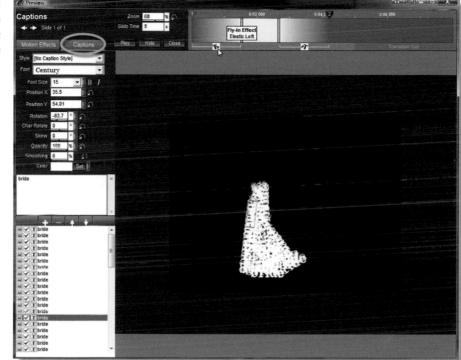

Figure 2.16 A close-up of the Multi-Layer Keyframe Editor with the Caption List in view.

Now the tools have been changed to those we used to work with Captions. (We'll cover Captions and Caption Motion Effects in detail in Chapters 5 and 6.) Underneath the Caption tools is the **Caption List**. In ProShow, all Captions for a Slide reside on a single Layer, in front of all the other Layers in the Slide.

The **Keyframe Timeline** in the upper-right-hand corner of this version of the Precision Preview window works just like Producer's other Keyframe Timelines. We can use it to add, delete, and manipulate Keyframes and their Timings.

A Simplified Show

An alternate version of the bride show, **<Bride Colored.psh>** is included in the Chapter folder. It is seen open in the Precision Preview window in Figure 2.17. Most of the Captions have been deleted, and the remaining ones colored to make them easy to identify. This version of the Show will lend itself to easier experimentation with the different controls discussed in this Chapter. Feel free to use it to explore the various tools and windows before moving on to the Exercises in the following Chapters.

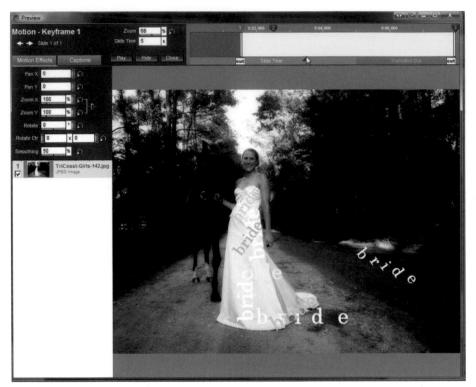

Figure 2.17 The Bride Colored Show open in the Precision Preview window.

Taking a bit of time to play with Slide Timing, Previews, and various Transitions is a great way to get a better understanding of how Slide Timing works and develop a sense of design. We'll review Keyframes and Keyframe editing beginning in Chapter 6. Working with Keyframes will be a major focus of the Exercises in Chapters 6 through 9.

Customizing the ProShow User Interface

So far, we have been using ProShow's default user interface as the **Work Area**. ProShow provides a number of features to tailor the program to suit your personal style of working. There are some important workflow issues to be aware of as well. Let's start with the User Interface.

ProShow has a variety of optional configurations to make it easier to sort, place, and edit slides; and Preview the results. I'll use the standard settings, primarily, for the Figures in the book. ProShow's designers included a lot of Keyboard Shortcuts (see Appendix A) and alternate ways to issue popular commands. Feel free to adjust the settings and use the tools that fit your methods best.

Almost every window, and many settings, offer handy menu short-cuts that are just a right-click away. Figure 2.18 is a composite screenshot, showing Producer open with alternate Work Area Layouts, and the various context-sensitive menus all displayed at once. Of course, you can only have one open at a time. The Figure is a composite screenshot. I'll cover the details of the menu commands as they are used in the Exercises throughout the book. Gold operates the same way, but some of the Options will be slightly different, due to its fewer tools and commands.

The **Window>Show** submenu, shown at the top of Figure 2.18, lets you choose which panes are visible. Then you can use the mouse to adjust how much space each pane uses inside the Work Area; just place the cursor over the edge of the pane so that it changes to a double-headed arrow shape, then drag the boundary to the desired location. The paragraphs below provide more details on the windows shown in the screenshot. Use the menu to open and close the various panes, and resize them with your mouse. When you are finished, the bottom Option in the primary Show menu, <**Default Window Layout**> is the easy way to get the Work Area back to its original configuration.

Figure 2.18 The ProShow user interface offers a variety of customization options to let you configure the program to suit your workflow needs and creative style. Each element provides context-sensitive menus to speed your workflow.

The Folders and Favorites Pane

The upper-left-hand corner of the Work Area in Figure 2.18 shows the **Folders** pane, which works just like the one in Windows Explorer. The **Favorites** pane looks the same, but can be configured to show only selected folders. This makes navigating to locate and place content a lot easier than having to navigate through the computer's entire file structure to locate images. One of the first steps I take in designing a Slide Show is to collect the content into folders and add them to the Favorites list. The procedure is simple: right-click on the desired folder in the File List and select the **Add to Favorites** option in the drop-down menu.

The File List

Below the Folders and Favorites panes is the **File List**. It can be set to show either thumbnail views or the names of the files in the currently-selected chapter. You can either drag into a Show from here, or use the menu Options to add files to your Slide Show. The File List menu provides an easy way to add Slides to a Show, sort images by their attributes (date, size, name, type, etc.), and adjust the thumbnail size. You can also add sound clips to the Show's Soundtrack.

The Light Box Slide View

The **Light Box Slide View** is located in the upper right side of the Work Area, and shows several rows of slides with Soundtracks. It works like the Slide List (which should be familiar from the last Chapter) that runs across the bottom of the Work Area. The Light Box is very handy when it's time for sorting images or working with a lot of slides, and can be expanded to cover the entire workspace. You can also use it to set Transitions and Slide Times. The associated context-sensitive menu also provides controls for Previewing the Show and opening the Show Options window.

The Preview Area, Slide List, and Audio Timeline

Notice how small the Preview Area is in Figure 2.18. You can resize most of the panes in the Work Area by dragging their edges. The **Slide List** can be turned on or off; but always takes up the same area when enabled. Pressing the **Tab** key changes that portion of the window to the **Audio Timeline**, which is used to adjust soundtracks. This Timeline is a very slick tool we'll explore when working with audio in Chapter 4.

Setting ProShow's Operating Preferences

The Work Area Display Options are only one of the ways we can tailor ProShow's operation. Open the **Edit** menu (in either Gold or Producer) and I'll walk you through the more popular settings, noting the few places where there is a difference between the Options available for the two versions. There are additional details available in the ProShow Help files.

Open the Edit menu and choose the **Preferences** Option. When the Preferences window opens, make sure the top Option in the column to the left is clicked (click on an option to select it). We'll go through each Option in order, so repeat the selection process with each item in this list as it is discussed.

Appearance

The Appearance Preferences (see Figure 2.19) control the details of how menu items, buttons, file and folder listings, as well as thumbnail text, are displayed in the program windows. In addition, you can set the Options for the names that the Slide List shows for each Slide in the Show. These Options take effect in real time as you check in the dialog box. That makes it easy to track variations. If you plan on modifying the different panes in the Work Area very often, it's a good idea to check the <**Add Close button**> Option in the **Buttons** section of the window. Most of the time, it's best to limit the number of items activated in the **Thumbnail Text** section to the ones you really need to display. Try checking several of the Options and see how quickly the listings get longer, and the thumbnails get smaller.

Colors for Program

The **Colors for Program** Preferences (see Figure 2.20) let you change the color for virtually every aspect of the user interface. The preset color configurations in the lower portion of the left column allow you to quickly set the entire interface

Figure 2.19 The Producer Appearance Preferences window.

Colors for Pro	gram		
Appearance Colors External Editors Keyboard & Remotes Internet Hiscelaneous Playback Stow Defaults	Preview	Colors	
	Header Header	When checked, the specified color will be use the color will be determined from your Window	
	Bar Text Bar Text	Headers 🔽	Set
		Header Text 🗹	Set
	Window Text 5	Bars 🗹	Set
	Enk Dialog Text 💿 Dialog Text	Bar Text 🔽	Set
	Using text Using text	Bar Text Highlighted 🔽	Set
	Window Text Ok	Window Backgrounds 🗹	Set
		Window Text 🔽	Set
	Color Configurations	Group Box Background 🔽	Set
	Green	List Backgrounds 🔽	Set
	Grey ProShow Gold	List Text 🔽	Set
	ProShow Producer Red	3D Bevel Highlight 🗹	Set
	System Colors	3D Bevel Shadow 🔽	Set
		Selection 🔽	Set
		Selection Text	Set
	Load Save Delete	Enk 🗸	Set
		Link Highlighted 🗹	Set

Figure 2.20 The Producer Colors for Program Preferences window.

to a predetermined style. You can make ProShow Producer look like ProShow Gold or vice versa with a couple of clicks of your mouse. You can also create a custom configuration and save it as a preset.

External Editors

Edits made *inside ProShow* using the programs controls to images files, audio clips and videos used in Slide Layers *do not modify the source file*. The External Editors Preferences (see Figure 2.21) let you set optional default image, sound, and video editors. Several ProShow windows offer Edit buttons that will launch the default editor for a file type (an image file or a video clip used in a Layer, or an audio clip used as a Soundtrack) when clicked.

You can then edit that file in the associated external editor, such as Adobe Photoshop, Audacity, or Adobe Premier. When you are finished with the edits, and the changes are saved, the file is updated automatically in ProShow. This feature is well worth enabling to speed up edits and streamline workflow. Keep in mind that *changes made using an external editor do permanently modify that file.* (Note that I'm not including the entire window. The function omitted is the <**Done**> button in the lower right of the window, used to apply any changes.)

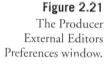

Preferences			
External Edit	Ors		
Appearance Colors External Editors Keyboard & Remotes Internet Miscellaneous Playback	Default Image Editor		
	Image Editor am Files (x88)/Adobe/Adobe Photoshop CS4/Photoshop.exe Browse		
	Specifies the default application to run for editing any photo or image file.		
Show Defaults Sound Effects	Default Sound Editor		
Startup	Sound Editor C1Program Files (x86)\Audacity\audacity.exe Browse	- Proventing and the second	
	Specifies the default application to run for editing any audio file.		
	Default Video Editor		
	Vrlen Editor Browse		
	Specifies the default application to run for editing any video file.		

Keyboard and Remotes

The Keyboard and Remote Control Preferences (see Figure 2.22) control the Keyboard Shortcuts and Remote Control functions (if your PC has a remote control for multimedia playback), used when PC Executable shows are played.

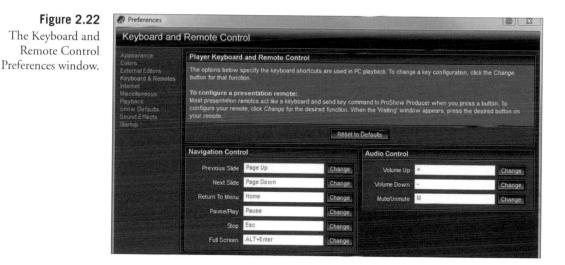

Internet Preferences

The Internet Preferences (see Figure 2.2.3) settings determine which browser is used as the default browser when used with Photodex Presenter. The entries for outgoing and incoming e-mail servers configure ProShow so you can email shows as attachments from within ProShow via the Create menu.

Preferences			
Internet Prefer	rences	and the second second second second	
Appearance Colors External Editors Keyboard & Remotes Internet Miscelianeous Playback	Web Browser	and the second second state state of the	
	Web Browser C:Program Files (x86)Unternet Explorer/EXPLORE.EXE Browse To configure your default web browser for use with ProShow Producer, enter the path your browser above or use the 'Browse' button to locate the application.		
Show Defaults Sound Effects	Outgoing E-Mail Server (SMTP)		A REAL PROPERTY.
	E-Mail Address	email@server.com	
	Outgoing (SMTP) Server	mail.server.com	
	Account Name	account name	
	Password	8992558#	
	Incoming E-Mail Server (POP3)		
	Incoming configurations are necessary if your internet	service provider requires a POP3 login to se	nd e-mail
	Incoming (POP3) Server	pop.server.com	
	Account Name	acount#server.name	
	Password	333759788	

Figure 2.23 The Internet Preferences window.

Miscellaneous Preferences

This is one window (see Figure 2.24) to be sure to configure! If at all possible, enable Direct Draw support. It speeds up ProShow's performance. If it's not already installed, check your video card manual or Windows Help for more information. Automatically checking for ProShow updates is handy. It goes almost without saying that Autosaves and Backups are a really good idea.

Preferences		
Miscellaneous	Preferences	
Appearance Coors External Editors Keyboard & Remotes internet Miscellancous Playbock Show Defnutta Sound Effects Startup	Direct Draw Support	
	Direct Draw is currently being used.	
	This option determines if ProShow Producer will use Direct Draw for viewing and general display. Direct Draw greatly improves the performance of ProShow Producer. If Direct Draw is enabled but is not being used, it is likely that your system is encountering a problem with the display drivers or configuration.	
	Prompts	
	Side Options V Prompt to save changes when closing Side Options	
	Customize Menu 🔽 Prompt to save changes when closing Customize Menu	
	Side Styles. V Warn about overwriting settings when applying a Side Style	
	Upgrades	
	Automatically check for updates.	
	Rémind me every 15 days	
	Autosave & Backups	
	Autosave shows every 300 s	
	Backup 10 versions of the show.	
	Favorites	
	Auto-fill Favorites List 🗹 Automatically track favorites based on file usage	

Figure 2.24 The Miscellaneous Preferences window.

Organization: ProShow's Trilogy of Slides, Shows, and Projects

ProShow organizes its content into three levels; Slides, Shows, and Projects. Think of them as a set of nested containers. I noted that ProShow is deceptively easy to use. In this Chapter we've only really explored the Slide level. It's possible to build working productions with little or almost no knowledge of how Slides, Shows, and Projects work. But gaining full use of the program's power demands an understanding of how they interact and function. In the next several Chapters, we'll explore all three levels as you enhance your skills. Some of the following is also a review of key points in this Chapter.

Slides, Shows, and Projects all have separate menus and tools. All three use a common interface, and many tools will work on more than one level. For example, Captions can be designed at both the Show and Slide levels, using the same tools.

Slides are the primary element of a show. Slides play in sequence, with a **Transition** before and after each one. Transitions are represented by the rectangular icons located between Slides. Skilled users sometimes craft an entire short production using a single Slide.

A single Slide can contain **Layers**, and a Layer can hold an image, a video clip, a **Solid or Gradient Fill**, or a **Caption**. Each Layer can be treated with its own set of **Effects**. The available Effects vary based on what the Layer contains, and which cdition of ProShow is being used.

Producer adds the ability to blend and transform objects using **Opacity** controls and **Masking** to hide and reveal objects on different Layers. It also provides **Keyframing**, which precisely controls the timing of events for every Layer in the Slide. An Effect can be set to interact with Effects on other Layers, with stunning results. We'll look at examples later in this Chapter, and learn how use them later in the book.

Show files are actually a set of instructions containing all the information needed to construct a complete Show. The program reads a Show file and assembles the collection of images, audio, video clips, or whatever you have. This is what we work with and see in the Slide List and in the Preview window. Show files can be output into a wide variety of formats, including DVD, CD, Flash, Photodex Presenter, and QuickTime. The Show file does *not* actually contain the content, but that's a topic for later discussion.

The **Show Options** window offers tools using the same basic interface as the **Slide Options** version. Clicking a tab opens a secondary window that provides a specific set of tools. Changes made here apply globally to all Slides in the show. (Some settings can be adjusted to exclude selected slides.) We'll explore these tools in detail later. **Project files** are collections of two or more Shows. When a Project is open, each Show in the collection is given a tab just under the menu bar. Projects are used to collect several files and place them, complete with fancy menus, on a single disc. It's also possible to copy and paste slices from one Show to another when they are part of a single project. Figure 2.25 shows ProShow Producer in Project mode. The Project has two Shows. The two tabs below the menu bar let us change between them.

Figure 2.25

Producer open with a Project loaded. The Show tabs are circled in red.

Saving, Finding, and Collecting Show Files

There are a few more basic points about ProShow's file handling before more on to the next Chapter. As already mentioned, ProShow only borrows files to use in its shows. When we save a show file using the Save command in the File menu, we are only saving the ProShow portion of the equation, not any of the images, soundtracks, and video clips. There are ways to save (and store or share) the entire collection. That's what we did in producing the Shows. That's also part of the reason we suggest moving the Exercise folders for each Chapter onto your C:\ drive before using them.

Why Files "Go Missing"

Copies of ProShow Show files with the **.psh** extension are linked to specific source files (jpcgs, mov, wav, etc.) in specific locations. If the name or location of any of those source files changes, then when you open the Show, the program issues a warning that some files are missing. If you ignore the warning, or fail to locate the files, then a **File Not Found** image is placed in each image layer with a missing source.

Figure 2.26 shows the dreaded "File Not Found" Slide. 1 forced its presence by deliberately moving the bride's portrait from the show we were just using. The words are actually from a placeholder file that is automatically created to replace the missing file on the Layer, if you don't take steps to reassign the missing file first.

Figure 2.26 The dreaded "File Not Found" slide.

Locating Missing Show Files

Figure 2.27 shows Producer open with the **Missing File** dialog box open in the upper left portion of the screen. Click on the **Yes** Button (circled in green) to open the **Find Missing Files** dialog box. It's visible on the right side of Figure 2.27. Select one of the files in the list in that box with a red check mark in front of the file name. (When a file is located the listing will have a green check mark.) A new window will open that is used to browse for the file. When you find it, click on the **OK** button in the browser window. That will return you to the Find Missing Files box.

When all of the files (or all of the files you can find) are located, click on the **OK** button in the **Find Missing Files** dialog box. The new location for the formerly missing files will be linked to their Slides and the Show will be ready for use. Figure 2.28 shows the **Find Missing Files** dialog box after the missing file was found.

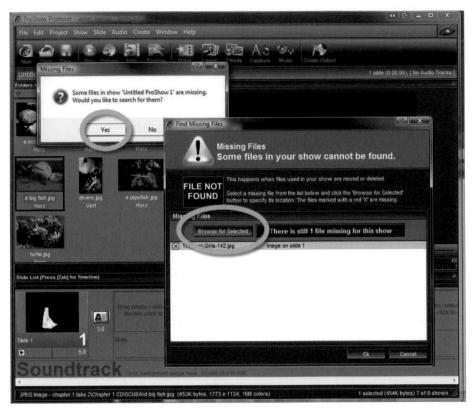

Figure 2.27 Locating missing files.

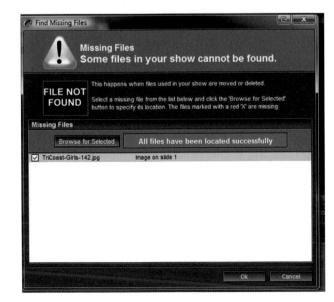

Figure 2.28 Success—the missing file is found.

The red bar noting that files were missing is now a green bar indicating success. You *can* click **OK** with files missing and rebuild the Show. The Slides with missing files will still have Layers that proclaim "File Not Found."

Collecting Show Files

The **Collect Show Files** command, located in the **File** menu, is used to assemble all the files used in a Show in one place. That includes the Show file, any other required ProShow helper files, and all of the images, video, soundtracks, backgrounds, ctc. You can have them copied to a folder on a drive or burned to a recordable DVD or CD drive.

Figure 2.29 shows the Collect Show Files window open and ready to collect the **bride.psh** files to a folder. The list towards the top of the box names all the Layer files being assembled, with their current locations. Below that to the left is an estimate of the amount of space required at the target location. Be sure that the location, be it a folder or a disc, has enough room for the job. Choose the target using the appropriate pane on the right side of the window. Then click the **Collect** button. You can also generate a list of all the files by choosing the **Save List** button. They are separate tasks, so if you want both a list and the collection, choose each Option in turn.

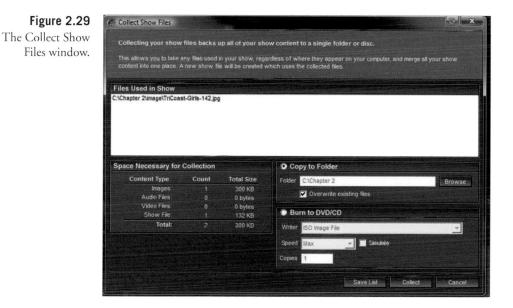

Up Next

Our introductions are over. It's time to dig deeper. We'll start the formal Exercises with a close look at how to use images, effectively position and work with Layers, and construct basic Motion Effects.

3

Frames, Motion, and the Layered Look

Harnessing ProShow's full power requires moving past the traditional definitions of "slides" and "slide shows." Technology moves faster than language. We still use the term *movie*, yet modern special effects have taken cinematography far beyond a string of jerky black-and-white "moving pictures" from the days of silent films into an era when we see virtual worlds populated with living actors in high-definition color. The word *movie* is a label, not a description.

The modern slideshow has also moved past the traditional series of still images projected onto a screen into a multimedia production platform. A skilled storyteller can use Producer to create shows with the same level of quality one expects from masters like Ken Burns. *The key to mastery is in seeing that the slide is much more than a simple picture, and developing the skills to exploit this new power.* This is a theme that runs throughout the book. We'll keep expanding our understanding and our ability to use ProShow's advanced features in each chapter.

The Slide as a Stage

A still image is a frozen moment in time. The viewer is limited to the vision the photographer saw at the split second the shutter opened. Old slide shows were just collections of stills played one after the other. That changed when modern multimedia slide shows first appeared during the 1967 International and Universal Exposition in Montreal. Producers used multiple slide projectors to blend images, transition slides, and special effects—combined with sounds—on a wide screen.

That broke open the concept of the slide as a simple picture, and designers started looking for ways to add effects and more eye candy to their work. Today's digital slide is more like a stage on which we can introduce a variety of visual elements and allow them to interact under our direction.

A ProShow production can consist of a simple array of single images played one after the other. That's not very visually exciting. We are going to go deeper and see how ProShow's Layer feature lets us Stack multiple images, each on its own Layer, in a single slide. Layers are one of ProShow's most powerful design features. You must have a firm understanding of how they work and how to use them to produce professional looking results. The boundaries of the display area become a frame, within which we can make the Layers move and do our bidding with special effects.

We can use Transparency in one Layer to reveal portions of underlying pictures and let multiple images share the spotlight at the same time. And we can make Layers move in relation to each other. (That's why both subjects are presented in a single chapter.) With Motion Effects, we can animate still images, drawing the viewer's focus to specific parts of the composition and adding vitality to the production.

I'll focus most of the discussion on features common to Gold and Producer and on the basics of working with Layers and Motion Effects. Advanced concepts like Keyframes, carrying Effects across several slides, and Producer's Masking capabilities will be covered later in the book. As we work, I'll point out some useful ProShow tools and workflow techniques. We will be moving back and forth through the slides as we explore various features in ProShow. That's good practice. Slides should work well together as they tell their stories.

Framing Images: A Working Demonstration

Let's begin by watching a short Show that uses Layers, image Transparency, and ProShow's Motion Effects to showcase a series of wedding and engagement photographs created by TriCoast photographers Mike Fulton and Cody Clinton. That provides a simple example of the effects possible when Layer Transparency and Motion are combined. After the Show finishes, we'll recreate portions of the production and learn to control Layers and how they move inside the frame.

Note

First, Copy the Chapter 3 folder on the companion CD-ROM to your hard drive. Then locate the file **FrameLayers_01.exe**. Double-click on it to run the file. The Show lasts for 28 seconds and has four slides. It's possible to make this Show using either Gold or Producer so you are free to use either version for the next Exercise. The transparent area on Layer 1 illustrates a useful point about working with ProShow Layers. It's sometimes easier to visualize a design as if the Slide was "lying down," with the Layers stacked one on top of another; and sometimes as a frame on a wall, which has Layers arranged one in front of another.

The Show's designer crafted slides using image files with transparent sections as frames, and placed other images bencath, then added Motion Effects to increase visual interest and draw the viewer's eye. The black frames with white Borders used in Slide 2 (shown in Figure 3.1) are an example. The pictures of the hand tying the bow and the ring-bearer move underneath (and appear to be visually inside) a static upper Layer.

Figure 3.1

Transparent areas on one Layer can be used to frame images within a Slide, creating a composite effect.

Note

Not all file formats support Transparency, and an external editor, like Adobe Photoshop, is needed to add Transparency to an image. Photodex provides a selection of prepared image files—some that include Transparency—with ProShow.

PNG and Photoshop **PSD** formats will generally produce better results when working with Transparency in ProShow. The **GIF** format has limitations that may reduce quality.

The First Slide—a Simple Invitation

The first step in mastering the use of Layers is to learn how the basic controls work for positioning and how position controls how Layers are displayed with the frame. Open ProShow and then load the **FramesLayers01.psh** Show file located in the Chapter 03 folder. Once the Show loads, double-click **Slide 1** to open it in the **Slide Options** window. Click the **Layers>Layers Settings** tabs so that your screen looks like the example in Figure 3.2 (Gold) or Figure 3.2a (Producer). I've included both so you can see how the basic controls are the same. Producer has all the tools available in Gold, and then more. The locations for the common tools vary somewhat between the two versions. When necessary I'll indicate where to find the appropriate tool in both versions or indicate which version is being used. (In some Exercises we'll have to use Producer, because only that version offers the needed features.)

The layout and navigation of the **Slide Options** window should be familiar by now. The two rows of tabs across the top provide access to the various modes of the interface and their tools. The **Preview** pane is at the top right. In the **Layers List** pane below the left side of the Preview, the currently selected **Layer** is highlighted in blue, and the properties of the file contained in the Layer are available below on the right. I'll cover the tools on the left side of the window as we work with them. Right now let's examine **Slide 1** in detail.

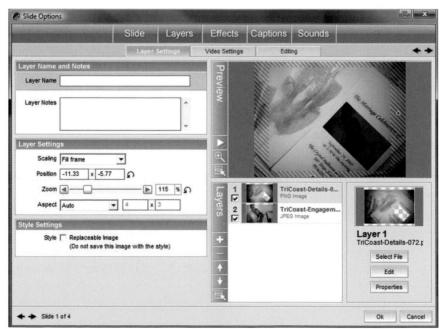

Slide 1 open in Slide Options with the Layers>Layer Settings window open in ProShow Gold.

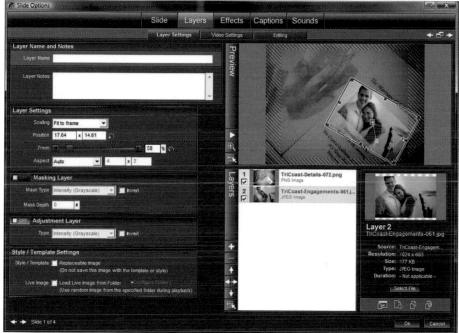

A Closer Look at the Layers List and the Preview Pane

The Layers List and the interactive Preview pane in the Slide Options window provide several tools for working with Layers. The **Icons** in the column to the left of the **Layers List** identify buttons used to **Add**, **Remove**, and **Position Layers** in the Stack—*and in the Slide at the same time*. The Preview pane provides interactive controls for Sizing and Positioning Layers within the frame. We'll explore each in turn.

Adding and Removing Layers in the Stack

We can add Layers to and remove them from the Layers List, using the plus and minus buttons located to the left of the Layers list. We can also drag a file directly from a Folder onto the Layers List (to drag from an external window, you'll have to have that window open on your desktop). If we are in the main ProShow window, we can drag a file directly onto the Slide List and create a new Slide, or hold down the Control key and drag a file onto an existing Slide to add a new Layer. Selecting multiple files and dragging them into a Slide or into the Layers List will add them all at once.

The Importance of Position in the Layer Stack

Slide 1 has two Layers. ProShow stack Layers are *stacked from the bottom up*, in the order they are added to the Slide, and order is important.

The top Layer is *always* **Layer 1**. If the bottom Layer is moved to the top, it becomes Layer 1, and the Layer that had number one gets the number assigned to that new position in the Stack. If it is now the sixth Layer down, it will become **Layer 6**. The position in the Stack is important for one reason: It determines, along with Cropping and Transparency, what can be seen and not seen in the frame.

Layer 1 is an image of a wedding invitation, with an area that has been rendered transparent in an external editor. It is the topmost Layer in the Stack. Layer 2 is an engagement portrait of a young couple. Since the couple is lower in Stack than the invitation, they are showing through the transparent portion of Layer 1. (Your images will look slightly different due to watermarks used to copyright-protect the pictures.)

As I said above, the buttons in the left-hand column of the Layers List are used to add, remove, hide, show, and reassign Layers. The number to the left of a Layer's Thumbnail image shows its position in the Layer, from top to bottom in the Stack. Let's swap the Layers in this Slide and see how it works. Click on Layer 2 (the one with the picture of the couple) to select it. Then click on the **Up Arrow** (noted with the green arrow on Figure 3.3). That will change its position in the Stack.

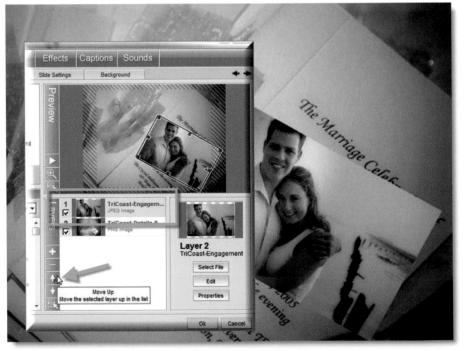

Figure 3.3

The Icons on the left side of the Layers List are used to add, remove, and position the order of Layers within the Stack. When you're finished, the Layer should be in the position noted by the green box in Figure 3.3. (You may notice a discrepancy, visible in Figure 3.3, whereby the **Layer number** does not always update itself correctly after you have moved its position in the Stack. Here we see that the file info pane to the right of the **List** still says **Layer 2**, even though the image is now on **Layer 1**. When the < **OK** > button is clicked, the numbers become congruent.)

The Preview visible on the right side of Figure 3.3 shows how the Layer's new location changes the design. Now the opening in the invitation is covered by the couple. Press the **Down Arrow** to return the Slide to its original design. We can see from this simple example that a Layer's position in the Stack can impact when that Layer can be seen, and how it interacts visually with other Layers.

The **check box** under the number turns the **Layer** on or off in the slide. Remember, ProShow only "borrows" the files used in Layers. When the box is unchecked, the program remembers all the details about a Layer, but since it does not use it in the Slide, the Layer vanishes from the Slide.

The following demonstration shows how it works. Click once on the check box in front of **Layer 2**, circled in green in Figure 3.4. (It should once again be the picture of the couple.) Now the transparent area is black. That's the Slide's **Background Layer** showing through. **Layer 2** is inactive and therefore invisible. Click the box to enable it, and the couple will reappear. Do that now, so we are working with the full design.

Figure 3.4 Disabling the check box for a Layer renders it inactive, and thus invisible in the Slide—but does not remove it from the actual design. The Layer's Outline will still be seen in the Preview.

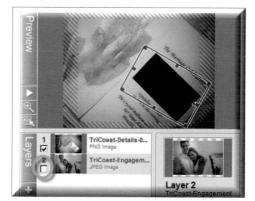

The active/inactive check box is handy for isolating Layers in complicated designs, when you want to fine-tune the position or appearance of one Layer. ProShow also offers **Preview** display controls that make it easy to see how a Layer appears when alone, or when it interacts with others in the frame.

Tailoring the Preview Display for Working with Layers

We can change the **Preview** display to make it easier to work with Layers in the frame. Right-click on the **Preview** pane and a context-sensitive menu appears. (You can also click the **Menu** Icon at the bottom of the gray bar on the left of the **Preview** border; it has a little arrow as part of its Icon. The choices are the same.) An identical menu appears if you click either **Preview** display in the **Layer Settings** window or the **Precision Preview** window, as in Figure 3.5. A check mark to the left of an Option in this menu means that it is enabled. Clicking an enabled Option disables it. Some Options alternate; enabling one disables the other.

Note

ProShow will typically "remember" what Options were enabled from the *immediately preceding* use. You may not remember those settings, and be a little surprised at what they are. It's always a good idea to makes sure these menus are set according to your needs at the moment.

Right now the **Preview** pane shows both Layers as equally bright; that's because the Preview has been set to display only the currently selected Layer at full brightness. Also, the sides of the frame have a set of ribbed lines boxing them; these lines show the **Safe Zone**. That is the portion of the frame that is sure to be seen by the viewer—based on the type of viewing device defined in the **Show Options**. (We'll cover those settings when we cover outputting shows in Chapter 12.)

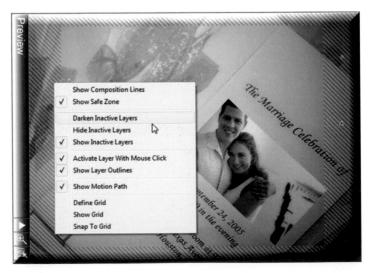

Figure 3.5

Right-click on the Precision Preview window to open the content-sensitive display menu. This one is in Producer; Gold's version has fewer Options, since it lacks some features Producer has. Feel free to experiment with the Options for the **Preview**. Each setting offers advantages. Which one is "best" depends on personal preference and the project at hand. When you want to work with just one Layer, and don't need to see the others, **Hide Inactive Layers** makes it easy to adjust the position and size of a Layer, but you lose the ability to see how it works with the other elements of the design.

I almost always leave the **Show Composition Lines** and **Show Safe Zone** Options enabled. They are handy for judging the overall placement of Layers in the frame. **Activate with Mouse Click** and **Show Layer Outlines** are also almost always on. That lets me quickly select and manipulate Layers, as you will soon see.

The settings for displaying the **Active** and **Inactive Layers** (**Darken**, **Hide**, and **Show**) are frequently changed, based on the task at hand and the complexity of the slide. The **Grid** can be a useful tool when you have to set up precise placement for **Motion Effects**, and can be fine-tuned to match a specific **Layout**. Figure 3.5a shows an alternate configuration, with the context-sensitive menu and the **Define Grid** dialog box visible.

Adjusting the **Preview** Options is really handy when a Slide has multiple Layers and a variety of special effects. I often shift the settings several times as I tweak a complicated design. Consider changing the settings as we work through the Exercises in the book, both to make adjusting Layers easier, and to see how the elements of the examples are constructed and operate. Now that we know how to add and see Layers in a Slide, it's time to learn how to move them within the frame.

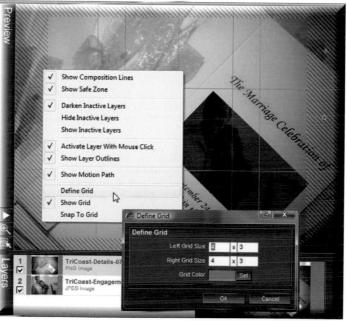

Adjusting Layers within the Frame

There are two arrows, pointing left and right, in the bottom-left corner of the **Slide Options** window and all its subsidiary windows (I've pasted them into Figure 3.6 and boxed them in red). One click on an arrow changes the active slide backward or forward one position on the Timeline. Click on the < **right-point-ing arrow** > three times. That will make **Slide 4** active and visible in the **Preview** pane.

This slide has two images: a frame on **Layer 1**, and a pair of wedding rings on **Layer 2**. Now click **Layer 2**. A blue box will appear. This is the **Layer Outline**, also referred to as its **Border**. We can interactively position, size, and rotate the Layer in the frame using **Border Controls**. Feel free to experiment using this Slide as the **Adjustment** tools are described; that's its only function in this Exercise.

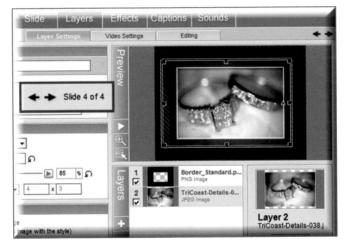

Figure 3.6

Slide 4 open in Gold with the Border visible. Using the mouse on it is the easiest way to quickly position and scale Layers within a slide. The pasted-in arrows, used to navigate to the previous or next Slide appear in the bottom-left corner of Slide Options and its related windows.

Interactively Manipulating Layers Using the Mouse

Moving a Layer

Place your mouse anywhere *inside* a Layer Outline, and it will change from the traditional pointer into a hand shape, as seen in the upper left-hand area in Figure 3.7. When the left mouse button is pressed you can drag the Layer to the desired location.

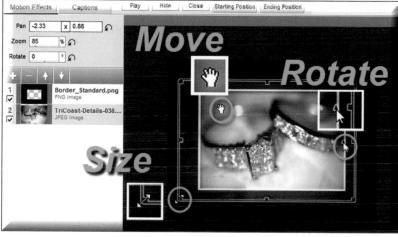

Sizing a Layer (Zoom)

There are two ways to resize a Layer using the mouse (thus also changing the Zoom setting for the Layer). One is rotating the mouse wheel (if any) to enlarge in one direction and reduce in the other, depending on your system's mouse settings. The other is by placing the mouse cursor over the little boxes in the corners or midpoints of a Layer's Borders to resize it. When you do, the cursor will change into a line with pointers on each end (shown in the lower-left of Figure 3.7). Drag the cursor to adjust the size.

Rotating a Layer

The small triangle located next to the middle of the right side of the Border is used to **Rotate** a Layer. Place the mouse pointer on it and drag up or down. As you drag, the Layer will rotate around its center.

Combining the three operations provides complete control over the size and appearance of a Layer within the frame.

Adjusting Layers with the mouse works fine when you don't need a high degree of precision; for that, we use *Position numbers*. Yep, numbers. Often the best approach is to use the mouse to get the Layer basically into place, and then finetune the placement using X and Y coordinates. It's not hard to master.

When we use the mouse to adjust the **Position** or **Zoom**, the numbers always reflect the changes; that's why many of the examples in this book have Layers with decimal place values. Don't worry; there isn't any need to worry about doing lots of math. I'll prove the point, and introduce some cool effects, with some examples.

Motion Basics—Getting from Point A to Point B in Four Dimensions

Change the active Slide to **Slide 2** by clicking twice on the < **Left Arrow** > in the upper-left corner of the **Precision Preview** window. This Slide has three Layers. **Layer 1** has two Transparent areas that frame the lower two Layers. **Layers 2** and **3** are positioned to show only the areas we want the viewer to focus on. Adding motion to the two lower Layers enables motion in relation to both the frame and to each other. Motion attracts the human eye. That makes it a powerful visual tool for adding interest and creating relationships between the elements of a Slide.

In the real world, motion is an action that takes place in time and space; the same is true for the movement of Layers in ProShow. In this case it is the amount of time that the Slide is seen in the Show, and the distance each Layer moves within the frame. Both time and motion can be described by the changes that occur between the Slide's **Starting Position** and **Ending Position**. The **Motion Effects** pane lets us define separate values for both of these points, and then ProShow automatically handles all of the details to produce the desired result when the Slide is previewed or played.

In ProShow Gold those two are *the only defined points, no matter how many Layers a Slide has.* In ProShow Producer, each Layer can have its own **Starting Position** and **Ending Position**, and many user-defined points in between. These points are called *Keyframes*, because the settings at this point in time and space determine what the Slide looks like at any point between them. Let's say a Layer moves halfway across the frame at a constant rate of speed during the time the Slide is shown. Then at the half-way point during playback, the Layer will be one-quarter across the frame—one-half its total movement.

Tip

Figures 3.19 and 3.19a provide a convenient comparison of the way equivalent Producer and Gold windows show the differences between the two versions. You may want to refer to them as we explore the differences.

For a handy combined illustration of the two versions of the two **Motion Effects** windows, see Figure 3.25.

A useful Summary of the primary **Motion Effects** is below in the section, **A Quick Recap**.

The X and Y of Zooming

As I said, Producer has the ability to create much more creative and dramatic **Motion Effects** than Gold, and we will take a few moments to briefly explain the differences in two key areas: independent dual-axis **Zoom** controls, and the "engine" of mind-stretching visual effects, multiple and separately controlled **Keyframes**. Gold users may want to read along to get a good idea of some major advantages of Producer. We will turn our use of our Exercise Show, **FramesLayers01.psh**, to explore these features, and suspend it for a special Exercise on **Zoom** controls. Then we will return to our primary Exercise and continue where we left off. If you wish to skip this section, go ahead to the section, Adding and Placing Multiple Layers Efficiently.

It's important to realize that *Layers are containers*, and that **Layer Controls** manipulate the way the contents of a Layer appear and move on the screen during the time a Slide is seen in a Show. Refer to Figure 3.8 to see the controls. In a moment I'll show you how they work. The **Pan** control setting determines *the location of the center of the Layer in the frame*. Adjusting the **X** and **Y** coordinates makes the objects on the Layer appear to move across the field of view. The first box in the **Pan** control (the **X-axis**) controls the horizontal position, and the second box (**Y-axis**) controls the vertical position. A value of $\mathbf{0} \times \mathbf{0}$ centers the Layer in the frame.

Layers in Producer offer a really neat **Zoom** feature, which also has the ability to independently adjust **X**- and **Y-axis** values. That lets us stretch either the horizontal or the vertical aspect of a Layer. The Zoom control changes the size of the

Figure 3.8

The green and red boxes show how varying the Pan and Zoom settings changes the position and closeness of the boy's hand during the time Slide 2 plays.

Keyframes 🔺 🕂 🖟 🕊 🕊		654		0.0 co		
Star	ting Positio 23.1	7 X	-8.64	2 Ending Positic a	1927.	G G F A F
	Pan 23.17	x -8.64	6	Pan 24.	32 x 12.4	۵ [8
Zoom X	<	80 %	[ດ]	Zoom X 🚽 🗕	90	× 01.
Zoom Y		80 %] ຄ] "	Zoom Y	90	* 2
Rotate		0 *	<u>م</u>	Rotate	0	<u>ا ا ا</u>
	Rotation Center	x 0	10	Rotation Center	x 0] ຄ
Smoothing	[Not Matched]	0 %	<u>م</u>	Smoothing	- []] 0	<u>م</u> ×

Layer in the frame as a percentage. The most common use is to adjust a background so it fills the frame. Zooming can also come in handy for tweaking a foreground Layer—especially a frame.

Remember: Gold does not allow separating the X- and Y-axes, and does not support or display multiple Keyframes, so most of these adjustments will work only in Producer. In ProShow Gold, adjusting the Zoom always changes the horizontal and vertical aspects of a Layer equally.

If the Zoom is set to 100%, the size of the Layer will be the same as the value set in the **Layer Setting** pane of the **Layers>Layer Setting** window.

Figure 3.8 shows sections of the screen with **Slide 2** open in Producer's **Motion Effects** pane with **Layer 2** active. The left side of the Figure shows the **Preview** pane and **Motion Settings** for the **Starting Position**, and those for the **Ending Position** are on the right side. I've drawn green (**Starting**) and red (**Ending**) boxes around the Layer **Borders**. We will see how the picture of the boy's hand moves lower in the frame and grows larger as the Slide is played. The numbers below show the settings used at each point.

Now we'll take the chance to really practice with Producer's powerful **Zoom** and **Keyframes**. This will give you a taste of these slick and sophisticated features, and pique your interest for the advanced Effects we'll take up in Chapters 6 through 9. If you wish to do this Exercise, *Save your Changes* and close the present Show. That way, you will still have the values we changed previously. We will return to the Show after this Exercise. If you wish, you can just watch the Executable version of this Exercise using Photodex Presenter.

The Chapter 3 Folder contains an Executable and a Producer Show, both named **zoom frames xy**. Both have a single example of the Slide we have been examining. Play it, or Open it in Producer—your choice. I've set the beginning of the Slide with the **Zooms** unlocked and set to different values. As the Slide plays, the settings change, so that at the end of the Slide they are the same and locked. The change in Zoom shifts the appearance of **Layer 1** as shown in Figure 3.8a.

Observe the **Starting Position** pane in Figure 3.8a. Circled in green are a "handle" and to its right, two tiny button-like objects. In this case there is a small space between the two buttons—which indicates that the **X** and **Y** settings are *unlinked*, and allow the different settings of **120** and **190**. Now the two axes are independent. Using it like this will distort the Layer—not a good idea for most people pictures! I used this **Zoom** feature to stretch the picture frame Layers to better cover the underlying Layers. Now look at the **Ending Position** pane, where you see the red circle around the symbols when the "buttons" are touching each other, indicating that these two **X** and **Y** settings are *linked together* and always will be the same setting. Changing one changes the other to the same value. Clicking the mouse on one of the little **buttons** toggles the link off and on. Figure 3.8a Producer allows adjusting the X and Y Zoom axes of a Layer independently as a Motion Effect. That can be a handy tool for stretching objects like frames and Backgrounds—not to mention generating interesting Motion Effects.

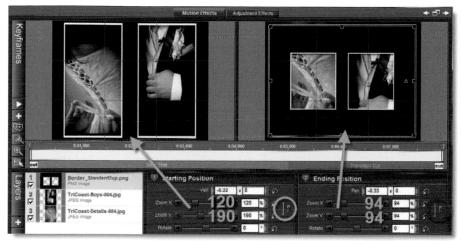

To practice with this useful feature, we are going to tweak the **Zoom X-Y Axis** controls to adjust the pair of picture frames on **Layer 1** of **Slide 1**. Confirm that **Slide 1** is in the **Motion Effects** window, and select **Layer 1**. Now click on a **button** symbol, shown in Figure 3.8a. This disables the **Zoom** aspect ratio link for the **Starting Position**. The frame on the left side is using *unlocked* settings. The frame on the right in the **Ending Position Preview** pane has the controls settings *locked*, and the values are automatically adjusted to stay the same.

Play with both controls. The **Zoom X** makes the frame grow or shrink from side to side, on the horizontal axis. **Zoom Y** adjustments make the frame grow or shrink from top to bottom, on the vertical axis. If you shrink the Layer too much, the sides will be too narrow to hide the Layers below. Too wide, and they lose the ability to completely hide the borders of the image below. If that happens, parts of the frames' white borders appear gray, just indicating that those portions of the Layer are outside the Safe Zone.

A Few Moments with the Keyframe Timeline

If you jumped ahead in the book, you may not be familiar with a handy tool Producer offers (and that Gold lacks) for working with **Motion Effects**: the **Keyframe Timeline**. It's the bar below the **Preview** panes in many modes of the **Slide Options** window, and is visible in Figure 3.8a. It's also available above the **Preview** pane in the **Precision Preview** window. This Slide doesn't use intermediate **Keyframes**, so the only ones present are the pair that mark the **Starting** (1) and **Ending (2) Positions**. They are symbolized by little numbered bluish triangles, resembling baseball's home plate, at either end of the blue-gray bar. Thesc also appear as indicators at the top of each of the two **Position** panes, so you know what points on the **Timeline** you are working with. Typically a Slide may have a total of several **Keyframes**, but since Keyframes always work in adjacent pairs, their numbers will always be adjacent pairs also.

Put your mouse at the very lower-left corner of the **Keyframe Timeline**, where it is colored light gray, just to the right of the **Cut** Transition Marker, and press the left button. Now drag the mouse to the right, and a red arrow will follow your movement. The **Preview** will play, and the arrow will show that precise point in the playback as you move it back and forth. If your images aren't exactly lined up, it's easy to see which one needs a correction. Use the mouse or numbers as needed. When you press the **Play** button and **Preview** in any window with a **Keyframe Timeline**, the red triangle will move as the Slide plays to show the exact point being displayed.

We will be using the **Keyframe Timeline** a lot more in the following Chapters. Right now it's just a handy Preview tool. The darker shaded area on the top of the **Timeline** shows the entire Time any part of the Slide is visible during play, including the Transitions. This is **Slide 1** in the Show, so the darker area starts all the way to the left of the Timeline. That's because there is no Transition before the Slide. The **Cut** Transition is a **Layer Transition**. In Producer, all Layers have their own beginning and ending Transitions, independent of Slide Transitions.

Notice the (dim) labels below the yellow bar, **Slide Time** and **Transition Out**. Those two areas are shaded in dark and light tones, respectively, and offer a visual reference.

Gold offers a simpler interface, with only thumbnails of the **Starting** and **Ending Positions** visible in the location of the **Keyframe Timeline** in the **Preview**. The basic design of the Slide is unchanged, but having the interactive **Preview** visible in the same window with the **Layer** and **Motion Effects** controls is a real timesaver.

This concludes our overview of Producer's powerful **Zoom** and **Keyframe** features. We will of course go into great detail in later Chapters. Now close the **zoom frames xy** Show.

Adding and Placing Multiple Layers Efficiently

Note

If you took our little detour with the Zoom and Keyframe practice Exercise, close that Show and reload the **FramesLayers_01.psh** Show we have been working on.

Use the **Arrow** to display **Slide 3** in the Show. I've labeled the Slide's Layers in the Preview, shown in Figure 3.9, along with the **Layers List**. The Slide's designer has used the same image in both **Layer 1** and **Layer 2**. They have been sized and positioned to create the impression of a single tabletop with four frames and two candles. The picture frames have been made transparent in an external editor, just like the area in the Invitation in **Slide 1** that revealed the engagement portrait of the couple on the lower **Layer**.

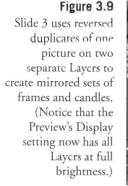

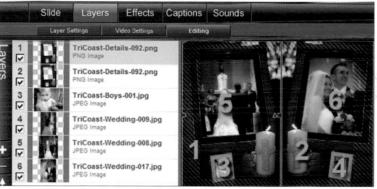

The remaining Layers are all arranged in the **Layer Stack** and the frame to provide images for each of the virtual picture frames and embellished with Motion Effects.

Duplicating the Design

We are going to make a second version of **Slide 3** from scratch, using different pictures under the frames, and gain some experience working with ProShow's **Layer Adjustment** controls and **Motion Effects**. If you already have the Show open, close any **Slide Option** and/or **Precision Preview** windows. The main Producer **Work Area** should have the **Slide List** enabled. If you have not been following along, please have ProShow open with the **FrameLayers_01** Show loaded and the **File List** set to display the content of the Chapter 03/Images folder. (If you have not already copied the Chapter 3 folder to your hard drive, please do so now.)

The quickest way to duplicate this Slide would be to Copy and Paste **Slide 3** into the **Slide 5** position. But that wouldn't let you practice adjusting and manipulating Layers, and we are not going to make an exact copy. Instead, let's drag and drop the thumbnail of the picture with the lighted candle and two picture frames into the location for **Slide 5**. (**TC-frames.png**, a PNG file, produced by editing a JPEG picture. JPEG images don't support Transparency.)

Now we need to make a second copy of **Layer 1** (making a new **Layer 2**) and reverse it. Double-click the new **Slide 5** and get it into **Layers>Editing.** Right-click on **Layer 1** in the **Layer List** and choose **Duplicate Layer** from the menu shown in Figure 3.10. (You could also accomplish the same task by holding down the **Control** key and dragging a second copy onto **Slide 5**.) We'll be adding the other Layers soon, but we'll get the first two arranged before doing that.

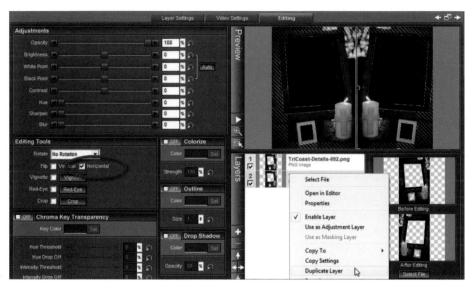

Adding a second copy of the image using the Duplicate Layer command, and then flipping the new Layer.

We now have two Layers, one on top of the other in the center of the slide. Our next step is to flip **Layer 2**. Make sure it is selected. Place a check mark in the **Flip Horizontal** box (circled in red in Figure 3.10) in the **Editing Tools** pane. The location will vary, based on which version of ProShow you are using.

You could use your mouse to drag both Layers into place and adjust their Zoom so as to properly fill the frame, but we'll set the values using numbers and the controls in the **Layers>Layer Settings** window. We want the slides to be side by side and the same size, so using numbers will save time. (The initial setup was actually done using a mouse, hence the fractional numbers.)

Make sure Layer 1 is selected. Its **Border** should be blue. In the Layer Settings pane of the Layers>Layer Settings window, set the Scaling value to Fit to Frame, the Position to -23.66×1.1 , and the Zoom to 105 percent (see Figure 3.11). The Aspect should be Auto.

Now select **Layer 2**. Its **Border** should be blue. Once again, In the **Layer Settings** pane, set the **Scaling** value to **Fit to Frame**, the **Position** to 28.71×-0.15 , and the Zoom to 105 percent (see Figure 3.12). The **Aspect** should be **Auto**. The two Layers should now be side by side, the same size, and just about centered in the frame. They are slightly offset to the right of the frame.

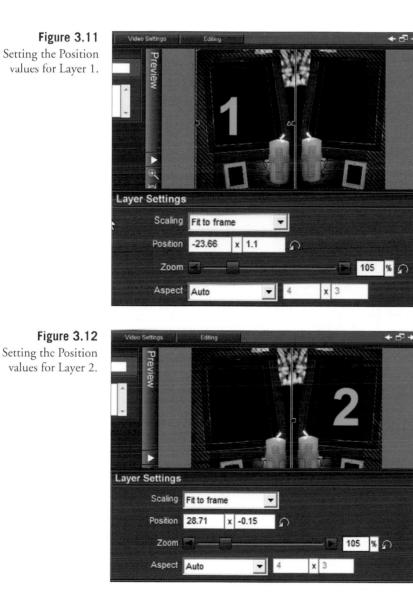

Understanding X and Y Coordinate Positioning

We've just used numerical coordinate positioning. The **Position Numbers** used in the ProShow system *place the location of the center point of a Layer, vertically and horizontally, relative to the center of the frame.* A **zero** value places the center of the image in the middle of the frame on the given **X** or **Y** axis. The values will change as the Layer moves when we position it using the mouse. If you move the image to the upper left corner, the **X** and **Y** numbers both will show negative values. If you drag the Layer to the lower right corner, they both become positive as the center of the Layer passes through the middle of the frame. Figure 3.13 has an overlay showing the X-Y quadrants.

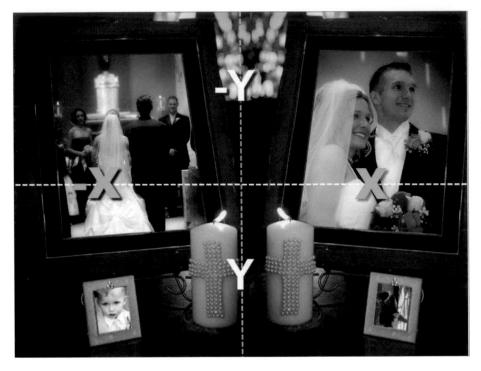

Figure 3.13

Using numerical coordinates is the best way to ensure exact Layer placement within a Slide. It's simple if you understand how the numbers work.

Adding and Ordering the Other Image Layers

Now it's time to add the other four Layers to **Slide 5**, as shown in Figure 3.14. Open the Chapter 3 folder and have the ProShow **Slide Options** window open as **Layers>Layer Settings**. Hold down the **Control** key, and drag the four images in the Chapter 3 folder that start with a number (**# TC.jpg**) onto the Slide, one at a time. The numbers at the start of each of the filenames match the destination Layer. So **3 TC.jpg** should be loaded first, so it becomes **Layer 3**. (The first two Layers are the **TC-frames.png** image that holds the frames.) If you drag and drop in numerical order, the **Layer Stack** number will match the number in the front of the file name.

If the Layers are not in the right order, use the **Up** and **Down arrows** to place the Layers in the right order. (The **Up** arrow is next to the mouse cursor and has a tooltip visible in Figure 3.14.) Place the image of the boy getting ready on **Layer 3**, the little girl in the doorway on **Layer 4**, the bride and groom from the back on **Layer 5**, and the bride and groom with the bouquet on **Layer 6**.

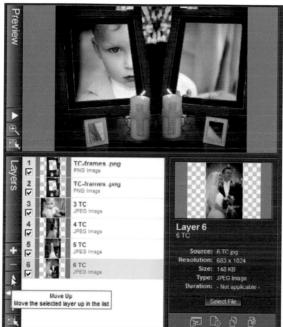

Layer order can be important when more than one object uses the same space on a Slide, when two objects have to move through the same space, or for special Effects involving **Masking** and **Opacity**. The reason **Layer 4** (the little girl) is on Layer 4 is so she won't hide the image on **Layer 3** when we add **Motion**, which is what would happen if their order were reversed. When you add Motion, any placement has to work the entire time the Slide is displayed. You don't want part of one Layer covering another at the wrong time.

Adjusting Size and Rotation

When you drop an image onto a Slide, the new arrival is automatically sized to fit the available space based on the current **scaling** defaults and is assigned a **Zoom** value of **100** (percent). Zooming changes the visual magnification of a Layer. A Layer can be Zoomed using the mouse wheel, or by setting a percentage in the **Zoom** box in the **Layer Settings** section. It can be entered as a number or adjusted using the slider, accessed by left-clicking the marker beneath the number in the box. Make the number larger than **100**, and the image gets larger; a **negative number** shrinks the Layer on the Slide. We are going to do both using the mouse.

Planning for a Move

The four new Layers are going to reside underneath the picture frames (Layers 1 and 2). We need to Zoom and Rotate them into their Starting Positions. We'll adjust the Ending Positions and create the Motion Effects after all four are in

place. Double-click on the **Preview** pane in the **Slide Options** window to open the **Precision Preview** window. I'm going to show you the easy way to place one Layer under another.

Right-click on the image in the **Precision Preview** to open the context-sensitive menu, shown in Figure 3.15, and adjust it so that only the **Show Inactive Layers** and **Show Layer Outlines** are active; uncheck the rest of the items. Now deactivate all the Layers—except **Layers 1** and **3**—by unchecking their boxes in the **Layers List**. Select **Layer 3**. Your **Preview** pane should now have only those two Layers visible. With these settings we only see the Layers we are working with, and only the selected Layer can be adjusted. That means that we can place **Layer 3** "under" the lower Transparent frame in **Layer 1** without having to bring it to the top of the Stack.

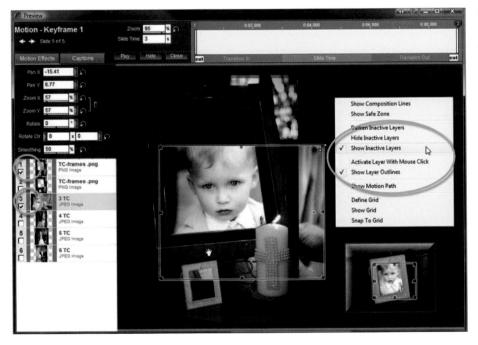

Figure 3.15

Reducing the number of Layers shown in the Precision Preview, and limiting mouse functions to only the selected Layer, speeds design when working with Slides containing multiple Layers.

Use the mouse to size and position the boy under the frame. As you work, the values for the Pan and Zoom will change. The final result should be about -27 Pan X, 38 Pan Y, and a Zoom 15 for both X and Y. I've pasted an "after" view of the lower frame with the boy's picture in place (bordered in red) in the lower right-hand area of Figure 3.15. Note that the above screenshot was taken *before* the picture of the little boy was adjusted to fit into the small frame. So the shot has the prior values of 57 for Zoom X and Y. Don't worry if the final readings of your settings are slightly off. As I have said, Producer makes its own corrections and

sometimes the numbers are a bit "off." Trust your eyes to tell you when things "look right."

Don't forget that the **Zoom** at the top of the **Precision Preview** window *controls the size of the frame in the Preview pane.* You can use it to aid in working with the **Positions**. The **Zoom** controls for adjusting the **Layers** are located under the **Pan** controls in that window.

Now select **Layer 5**, enable its check box, and adjust it to fit under the larger frame in the upper portion of **Layer 1**. (You can leave **Layer 3**'s check mark, since it won't get in the way.) We want the bride and groom centered in the frame as shown in Figure 3.16. The final settings for this Layer should be about -27 **Pan X**, -5 **Pan Y**, and a **Zoom 75** percent both **X** and **Y**. This takes care of the initial settings for the left side of the design.

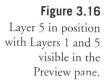

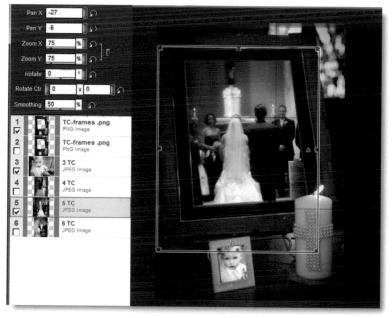

Enable the check boxes for **Layers 2** and **4**. Now you can see all four picture frames and both candles. The **Layer 4 Border** is centered in the Slide, with portions visible in the larger picture frames. (**Layer 3** is "above" **Layer 4** and hides it from the lower-left picture frame, and it's too narrow to be shown in the smaller frame on the right.)

Use the mouse to adjust Layer 4 so it fits inside the lower picture frame in Layer 2 as shown in Figure 3.17. The Pan X settings should be about 33, Pan Y 39, and both Zoom values at 20 percent.

Figure 3.17 Layer 4 in position with the settings superimposed above.

There is one more image to place. Layer 6 with the picture of the bride and groom goes inside the remaining large picture frame on Layer 2. Enable its check box for the Layer and adjust it to about the following settings: Pan X = 31, Pan Y = -6, and both Zooms at 70 percent. See Figure 3.18.

Figure 3.18 Layer 6 in position with the completed initial design.

Tip

Consider both source and output resolution when setting Zoom values. The resolution at the largest Zoom factor must still be sufficient to provide a good image when output on the most detailed display device. This won't be an issue with highquality images. Low-resolution sources may not look sharp if output to a larger, high-definition display device.

Getting Things Moving

One of the most effective eye-carriage tools is movement. We see it all the time in movies and commercials. Now we are going to use it to enliven our Show. First, a bit of background information. Your monitor, a TV set (no matter what kind), and a motion picture all use a similar technique to present information to our eyes. A series of images is presented at a set pace, ranging from about 25 to 60 frames per second. This is called the *refresh rate*. Consider a word processor while you are typing. Unchanged words already on the page just keep getting redrawn on the monitor. The cursor and any new or changed items are drawn just as soon as the graphics adapter sends the new image to the display device.

In TV and movies—and yes, ProShow productions—the changes between frames, as they are shown to the viewer, produce the illusion of movement. The images are all just still images, and our brains are fooled into seeing them move. The faster the frame rate, the smoother the Motion Effect. If the frame rate is too slow, or if the image is not precisely aligned between frames, the illusion is lost and the picture will seem to "jitter" or jump on the screen.

To create a **Motion Effect** we must define the location of the object, or objects, being moved at two points—both in time (on the **Slide Timeline**) and in space (within the Frame). These points are called **Keyframes**, because they are used to *key the Motion*, and define the course and speed required to produce the Effect within the frame. ProShow will then generate the intermediate images that are shown during the time the Slide is played.

Motion Effects make use of four possible attributes, which can be combined to produce complex effects. We have already worked with these controls to set the static position of Layers in the frame. Now we are going to increase our understanding of how they work and are used when crafting Motion Effects.

Panning is when we shift the *position* of a Layer within the frame as the Slide is shown, adjusting the X and Y coordinates. The objects on the Layer appear to move across the field of view. Panning is a technical term from the motion picture industry. It refers to the changing point of view as the camera follows the movement within the scene. Just as with a movie, the display device creates a fixed frame for our Show, and the subject appears to move in relation to the boundaries. Each pan has fixed **Starting** and **Ending Positions** that are described within ProShow using X and Y coordinates. In Gold, the Pan X and Y values must be the same; in Producer, we can set individual X and Y values for each Keyframe, on each Layer.

Panning creates the illusion of motion across the frame by changing the coordinates as the play progresses during the time the Slide is on the screen. We can also use it to show detail, by slowly panning across a wide scene that does not completely fit within the frame. Panning does not change the size of a Layer in the frame, just its position within it.

Zooming adjusts the magnification ratio (as a percentage) of the Layer as the Slide is being shown. We saw this effect in **Slide 2**, in Figure **3.8a**. Enlarging an object in size during playback can be used to increase its importance and focus the audience's attention on that part of the image. Pulling back to show a wider area, or reducing the size of objects, adds perspective or diminishes the importance of a subject. For instance, the beginning of a Slide might show the face of a single person, and then zoom out to show the entire crowd gathered in Times Square for New Year's Eve.

Rotation is the third tool. It can be used as a simple design element, like making a Caption spin into the frame. It can also be used to create the perception of "real" action. For example, we might make a propeller turn in front of an airplane or make the wheels turn on a car. Of course, such rotating elements must reside on Layers stacked above the stationary parts of the Slide.

Pace, the speed (controlled by Time on screen) at which a Motion Effect occurs, is the fourth variable. In Gold, we are limited to the Time the Slide is on the screen, since each Layer is linked to the display Time for the entire Slide. Producer lets us set multiple Keyframes for each Layer in a Slide with their own display Times, and even within Layers. With Keyframes, we can force an action to happen faster than the total Slide Time allots. If we wish for an effect to last longer, we must either increase the total Slide Time or carry the effect to the next Slide. (We will work with that technique when we deal with advanced Motion Effects and Keyframing, in Chapters 6 and especially, Chapter 7.)

Setting and coordinating Motion Effects attributes with the mouse is easier than describing them. ProShow does most of the work; all a user has to do is adjust a Layer's appearance at the beginning and **Ending Positions** of the display Time. Experienced users tend to use the same techniques with adjusting motion as they do with Layers. They develop a plan, get things started with the mouse, and then fine-tune the numbers as needed.

Note

Gold does not allow us to create Keyframes, and Slides in that version have only the two default **Starting** and **Ending Positions** on the **Slide Timeline**, shared in common by all Layers in the Slide. These actually are Keyframes, but unlike Producer, Gold does not let us set multiple Keyframes for each Layer in a Slide. The extra power that feature offers vastly increases our ability to craft special effects—as we will see in the Producer-only Chapters (6 through 9) that cover special effects with multiple Keyframes.

Beginnings and Ends: Motion Effects Demystified

Let's experiment to explore ProShow's Motion tools, by adding some **Motion Effects** to the **Slide 5** we added to the current Show. Make sure you have saved any changes if you are doing the Exercise, and return to the **Work Area** and the **Slide List View**. Now, neutralize the **Transition** that follows **Slide 5** by setting its time to 0 seconds. (Click on the time setting under the Transition's icon on the **Slide Timeline** and enter the new setting as **0.0**, so it won't be part of the equation.) That makes it easier to see the actual **Motion Effect** within the Slide when we Preview without the end of the Slide being modified by the Transition.

Now open **Slide 5** in the **Slide Options>Effects>Motion** window. We've already set the **Starting Positions** earlier in the Chapter, so all six Layers should be in the proper locations inside the frame for the start of our Effects.

It's possible that while adjusting the Layers, some differences between the **Starting Positions** and the **Ending Positions** crept in. The variations can skew an Effect, so matching the **Ending Position** to the **Starting Position** is a good habit to develop. Click on the **Copy Settings** Icon located on the left column of the window (noted with a green arrow in Figure 3.19, and then choose the **Copy Start to End (All Layers)** Option, noted with the mouse cursor in the Figure. Make sure the command worked by **Previewing** the Slide. All of the Layers should remain perfectly still. Now adjust the **Preview** display so that the **Show Inactive Layers**, **Show Motion Path**, and **Show Layer Outline** Options are enabled. The rest should be unchecked. Make all the Layers active and select **Layer 6** in the **Layers List**.

Staying in the Motion>Motion Effects window, Open Slide 5. (In Gold there is no **Effect** tab, just the **Motion Effects** tab, since that version lacks **Adjustment Effects**.) The **Motion Effects** window presents Previews of the current Slide at both the very beginning (the left **Preview** window) and the very end of its play

Figure 3.19

Setting Layers in Motion by adding Panning, Zooming, and Rotating Effects can all be done quickly using Producer's Motion Effects window and your mouse.

		L.	Notion Effects	1		+
				Alter -		
	oast-Deta *	Starting Positio	on		Ending Positi	on
PNG TriC PNG TriC PNG TriC PNG TriC PNG PNG PNG TriC PNG PNG	Image oast-Deta Image oast-Boy	Pan -23.66 x Zoom	1.1 D	05 ¥ Ω ° Ω	Zoom	(-0.44) 105 % 0 °) Not Matched]

Figure 3.19a

Gold's Motion Effects window offers the same basic controls as the more elaborate Producer version (shown in Figure 3.19). Notice the single Zoom axis slider, and that the Keyframe section is missing. Gold does not support editing Keyframes, and does not provide a Timeline or a Motion Path in the Preview pane.

(on the right) within the Show in Gold. In Producer, the two windows show the Slide at the point in time for the two currently selected Keyframes. The difference in the appearance of those two **Previews** reveals the total change due to any **Motion Effects**.

So we can set a **Motion Effect** by simply adjusting the position of a desired Layer in the two windows to match the **Starting** and **Ending Positions** of the Effect and then test the result by scrubbing the **Timeline** and/or Playing the Slide in **Preview** mode. ProShow automatically generates the intermediate frames and the Motion of the Layer in the Show. The Gold version of the **Motion Effects** window is shown in Figure 3.19a.

Setting Layers into Motion

We are going to adjust the Ending Keyframe (Ending Position in Gold) settings for the Layers that act as the pictures in the frames. I usually use the following sequence when setting Motion Effects. Before working on the end point, make sure the desired Layer is active and the Starting Position is exactly where you want it. Then either drag the center of the Layer to the desired new location, or enter the new Ending Position Pan settings. Then use the mouse wheel, slider, or Zoom data entry box to scale the image to the proper size. Finally, adjust the Rotation and Preview the result. When watching the Slide play, watch for the way the new Effect works with the overall design, and for any problems with the Effect that impacts other Layers (such as covering up part of another image or creating a visual distraction).

Note

You may have noticed that I haven't explained how to control the speed of a Layer's **Motion Effect** relative to the other Layers on a Slide. That's because it is a **Producer**only feature that requires the use of Keyframes. We'll examine it later in much detail, beginning in Chapter 6 with **Caption Motion Effects** using **Keyframes**.

Let's make things move. Select Layer 6 in the Layers List. Enter the following values: Pan 33×1.7 , Zoom (both X and Y) 88, Rotation 8 (see Figure 3.20). You can use any of the control methods to (the data entry boxes, the mouse controls, or the sliders) to make the changes. Play the Slide using the Full Screen Preview. As the Slide plays, the image will grow larger and move so that the bride's face moves toward the middle of the picture frame.

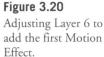

The line drawn on the selected Layer, and enlarged in Figure 3.21, is called the **Motion Path**. The two green boxes at either end mark the *starting and ending position of the Layer's center*. The box with the red frame and green center shows the Layer's center position at that point in the playback. In Figure 3.20, the red-bordered box shows the start point in the left Preview, and the **Ending Position** on the right. The red-only box is reversed, showing the other point. In the Producer **Precision Preview** (see Figure 3.21), *only the currently selected Keyframe is Previewed*, so the red-bordered, current-position marker always denotes that point in the **Motion Path**.

The Motion Path provides a visual cue to the relative speed of an Effect in relation to the amount of Time a slide is displayed during the Show. Consider our current example. This Slide is set to run for five seconds. The movement line is mostly vertical and is about one-fifth the height of the Slide. That pace will produce a relatively slow effect. A Layer with a horizontal line going all the way across the slide would have to move much faster. We can slow down an Effect by increasing the play Time for the slide, or by shortening the line. A basic rule: The longer the line or Slide Time, the slower the apparent Motion. The shorter the Slide's Play Time, or the shorter the Motion Path, the faster the apparent Motion will be on the screen.

Take another look at Figure 3.21. Notice how the blue rectangle, showing the full area of **Layer 6**, extends past the small picture frame underneath it for the end pre-

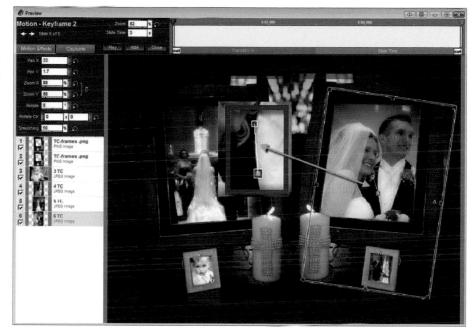

Figure 3.21

Slide 5 open in Producer's Precision Preview window with Layer 6 selected. The Motion Path has been Copied and is shown, enlarged, in a red box.

view? That's why we had to place this Layer below **Layer 4**, which shows in the smaller frame. If it were in front of Layer 4, during play it would zoom to cover the lower Layer and show in the smaller picture frame. (You can test that if you like by moving the image on **Layer 6** into the **Layer 4** position. If you do, re-locate it back into the **Layer 6** position before moving to the next part of the discussion.)

Now experiment on your own and add **Motion Effects** (both **Pan** and **Zoom**) to the two smaller frames in the Slide, the ones for **Layers 4** and **5**. Try **Zooming** one of them to be very large as it plays. That should make part of the image visible in the frame above it, obscuring a section of the image above it. *Motion Effects have to be designed within the limited space of the frame*. Sometimes we can crop an image or change the Layer position; sometimes we may have to limit an Effect or choose a different Layout or image to make a design work properly.

Another design consideration is the relative movement of all the Layers in the slide. *Motion Effects* have the ability to distract or confuse viewers as well as draw their attention.

Working with Rotation in Motion

Think of clay, centered on a potter's wheel. The clay rotates as the wheel turns, and the potter keeps the clay centered on the wheel. That is exactly the way the **Rotation** Effect in ProShow works. The **Axis of Rotation** normally passes *directly through the center of the Layer*. We can change the axis point by adjusting the

Rotation Center settings. They use the same number coordinate system as the **Pan** control. The left box will shift the horizontal placement of the center; the right will move the vertical. If the Layer is **Cropped**, the Rotation will be based on the *center of the visible portion* of the image.

You can rotate a Layer using the mouse and the little triangle Rotation handle, located on the right side of the Layer. (This position is the location for an unrotated Layer.) Pull it up or down to adjust the image. We can also enter number values based on a 360-degree circle, or use the **Rotate** setting slider to set the position. Just as with **Pan** and **Zoom Motion**, there are two settings for any Effect, a **Starting Point** and an **Ending Point**.

Figure 3.22 shows **Rotation** applied to **Layer 5** that literally turns the image upside-down as the Slide plays. I moved the slider to the left to adjust the value in the box to **-180** degrees. It would look exactly the same in the screenshot if the number had been set to (+)180 by not using the minus sign. There is a big difference in the way plus and minus values make the Layer rotate. The triangle-shaped rotation handle is now inverted on the left hand side of the Layer's border (circled in yellow in both **Preview** panes). Try it both ways; **Positive numbers** always rotate the Layer around the center to the right; **negative values** turn the Layer to the left as it rotates.

Adjust the **Layer 5** settings for the **Ending Position** to match the example. The Ending Position should have a **Rotation** of **-180** and a **Rotation Center** of 15×0 . Now double-click on the **Preview** to open the **Precision Preview** window. Scrub the **Keyframe Timeline** if you are using Producer, or play the **Preview** if you are using Gold. Watch how the bottom left corner of **Layer 5** crosses in front

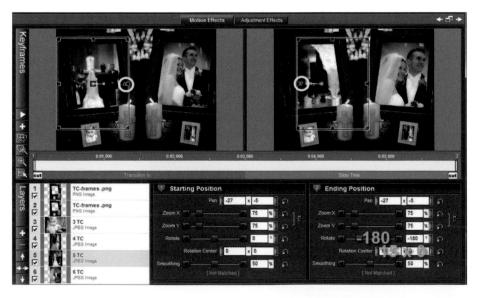

Figure 3.22

Negative Rotation settings make a Layer turn to the left; positive numbers turn the Layer to the right. The Rotation Center command determines the Axis of Rotation. of the area inside the big picture frame on the right side of the Slide about halfway through the **Slide Time**. I've circled the "offending" area in yellow in Figure 3.23, and I've drawn dashed white lines over the border of **Layer 5**.

As you can see, it's important to double-check the workings of a Slide when making changes to **Motion Effects** settings. A new setting can require adjusting other aspects of a design. In this case we might shift the order of the Layers, swapping **Layers 5** and **6** in the **Layer Stack**. Each situation is different. Feel free to work with these Slides before moving on.

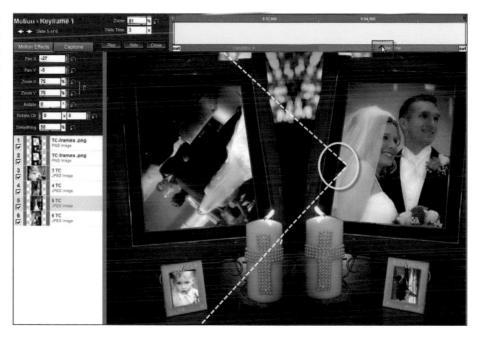

Figure 3.23

Rotation may cause one Layer to overlap another during the course of an Effect. It's always wise to carefully Preview after setting up an Effect.

A Quick Recap

We have now worked with all of the positional controls used to set up **Motion Effects**. Let's review them before seeing how **Motion Styles** refine their operation.

Motion Effects require two points of reference, the Starting Position and the Ending Position. In Gold these are the only available control points. In Producer, Keyframes let us set different Starting Positions and end points to each Layer, and add additional Keyframes to individual Layers to provide the ability to have a series of Motion Effects in a single slide, and even on a single Layer.

- The **Pan X** and **Pan Y** settings (Gold only offers a single combined **X-Y Pan** setting) control the position of a Layer horizontally and vertically within the frame. When a Layer's **Pan** setting changes between the **Starting Position** and the **Ending Position**, the center of that Layer will move across the frame between those two points.
- The Zoom X and Zoom Y settings (Gold only offers a single combined X-Y Zoom setting) control the magnification of a Layer horizontally and vertically within the frame. When a Layer's Zoom setting changes between the Starting Position and the Ending Position, the size of that Layer will increase or decrease in the frame during play.
- The Rotation Setting controls the orientation of the Layer as if it was on a turntable or potter's wheel. When a Layer's Rotation setting (expressed in degrees, 360 in all) changes between the Starting Position and the Ending Position, the Layer will rotate to the left or right in the frame during play. The Rotation Center setting lets us change the point of the center of rotation away from the default center of the Layer.

We can combine these controls to produce complex Effects with Layers that Pan, Zoom, and Rotate. It's a good idea to preview the Slide after setting up a **Motion Effect**, especially if the Slide has more than one Layer. It's possible that the motion will cause part of one Layer to cover up a lower one in ways you didn't expect. Sometimes a minor modification to one Layer is all that's needed to fix such a problem. It might require changing the Layer order or adjusting a Crop.

Tip

The **Copy Layers** window is a handy tool when you want to use **Motion Effects**, or a complex array of settings, on more than one Slide. Right-click on a Slide in the **Slide List** and choose the **Copy Layers and Captions>Copy Layers** Option from the context-sensitive menu shown on the right side of Figure 3.24. That opens the menu shown on the left side. In this example I've configured it to copy **Layers 1**, **2**, **5**, and **6**—images and all, to a new **Slide 6**. If you want use it to Copy a Layer (or Layers) to a new last Slide, you'll have to create a black Slide first, since you have to have an existing location to set as a target.

Figure 3.24 The Copy Layers menu can save considerable work by selectively placing images and Effects you want to re-use onto another Slide.

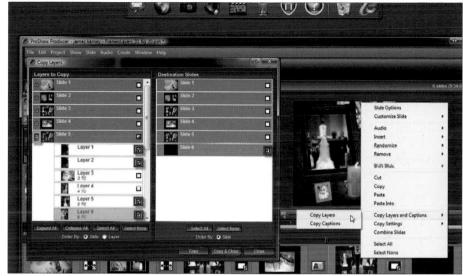

Smooth Moves: ProShow's Acceleration Styles

There are times we want our **Motion Effects** slow and smooth, and times we'd like a bit more punch. That's where ProShow's **Motion Styles** come in handy. The drop-down menus located underneath the **Starting Position** and **Ending Position** panes adjust the way the Effect is applied. Figure 3.25 shows the Producer controls (bordered in green) pasted over the ones available in Gold.

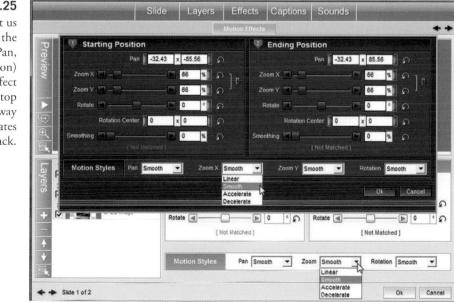

Figure 3.25 Motion Styles let us adjust the way the components (Pan, Zoom, and Rotation) of a Motion Effect start, move, and stop to fine-tune the way an Effect operates during playback. In Gold we can set individual **Motion Styles** for the way the **Pan**, **Zoom**, and **Rotation** settings operate between the **Starting** and **Ending Positions**. Producer provides **Pan**, **Zoom X**, **Zoom Y**, and **Rotation Styles** that can be set for the way a Motion Effect operates between any pair of **Keyframes**. The following list explains the way each **Motion Style** modifies an Effect setting.

Linear

Use this setting (the default) when you want a *constant rate of Motion* the entire time the Layer is moving for the Effect. The speed will not vary, and the rate is determined by the total Time the Slide is on the screen. This is like setting the cruise control while driving and letting it maintain a constant speed.

Accelerate

This Style starts slowly and *gains speed during the entire Effect*. The maximum speed is reached at the very end of the Slide. Compare this to driving while slightly increasing pressure on the gas pedal to keep the speed increasing at a set rate.

Decelerate

As the name implies, this is the opposite of accelerate. The Motion starts at full speed and *immediately begins to slow*. The braking effect is increased during playback so that the Layer is at rest just as the Slide ends.

Smooth

This is a style that *combines the other three*. It accelerates up to the midpoint of the allotted time, peaks, and then decelerates for the remainder of the time, coming to a full stop at the end.

Note

Don't confuse the **Smooth** setting with the **Smoothing** control located under the **Rotate** control. Smoothing works only in Producer, and only when you have more than one set of **Keyframes** in a Slide. It *sharpens or softens the angle of change* when a **Motion Effect** applied to a Layer *changes direction*. We are going to save working with it for the detailed discussion on **Motion Effects** with multiple **Keyframes** in Chapter 7.

The only way to become really skilled with manipulating **Layers**, crafting **Motion Effects**, and getting a sense of how **Motion Styles** modify a **Motion Effect** is by playing with the controls and using the different styles with the same **Motion Effect** and *comparing the way the Layer moves with each one*. Take a few minutes to experiment with this Show. Try adding different **Motion Effects** and applying different **Styles**. Use the **Preview** window to see how they change the way the composition works visually. Watch for any overlap in the **Layers**. The two larger Layers will be the most likely culprits. Change the design to accommodate as needed. As you work, consider how **Rotation** draws the eye to that portion of the composition. When several Layers are moving, it's easy to overdo **Motion Effects**. The entire Slide must work visually. It's much like not overdoing the number of fonts or capital letters when designing a text layout. When you are finished, close the Show. We won't be using it again.

Matchmaking, and Moving Outside the Box

ProShow's **Layer Matching** features let us *link* the settings for a Layer on one Slide to another Layer on the Slide that precedes or follows it in the Show. The two Layers make a permanent connection—one that automatically updates and maintains changes to the linked Slides. It's called the **Layer Matching** function.

Link a Layer, and the Layer's settings are forced to keep the values of the Layer either before or after it. If we change the settings for the matched-to Layer, the settings are also copied to its linked Layer. This is a handy tool for carrying an Effect across multiple slides. It's possible to use the Layer on either side as the source or target. That's because the link works both ways. (All of the Matching functions work the same in both Gold and Producer.)

It's possible to use a Layer from the Slide on either side of the slide, with one being linked as the source or target. That's because the link works both ways. Change a setting on one of the linked controls and the same setting for the matched control changes as well. (All of the matching functions work the same in both Gold and Producer.)

Just under each collection of **Adjustment** controls (**Starting** and **Ending Positions**, and **Keyframe** controls in Producer) in the **Motion Effects** window are the words "**Not Matched**." Click on either one and a dialog box opens like the one in Figure 3.26. It offers two drop-down menus that contain links for each Layer in the Slides before and after the current one.

Open the **two frames.psh** Show in either Gold or Producer. This file contains two copies of the same design, copied from the preceding Show. Both Slides have three Layers. The first has **Motion Effects** on the two images beneath the frames. The second slide does not contain any Motion Effects or matched Layers. We are going to link **Layer 3** on **Slide 1** with **Layer 3** on **Slide 2** and extend a **Motion Effect** onto **Slide 2**.

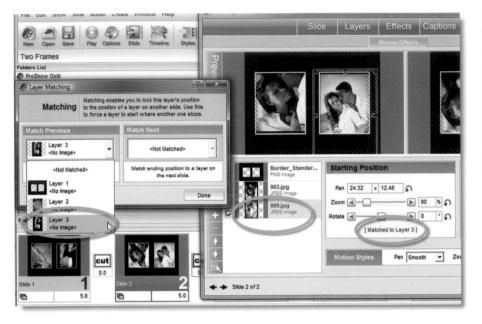

Figure 3.26

Use Layer Matching to create a permanent duplication of Layer Effects between adjacent Slides. When you change a setting on the source Layer, ProShow automatically updates the target Layer.

Tip

If the **Transition** between the Slides is set to **zero**, the next Slide becomes an extension of its predecessor in time. That opens up a world of creative possibilities, especially to Gold users, who don't have the ability to use **Keyframes** to slice time and modify the impact of Effects within a single Slide.

If both Layers being linked already contain an image, the existing files will be retained. If you change the image file on a Layer after they are linked, *both will then have the new image.* You can get around this and keep separate images on the matched Layers by un-matching them before loading the new file on the Layer, and then re-matching the Layers.

Select and open **Slide 2** in the **Motion Effects** window. Select **Layer 3** from the **Layers List** (marked with a red arrow in Figure 3.27). The current Pan settings are **-24.33** × **4.21**. That's the same value as the **Ending Position Pan** setting, confirming that there is no **Motion Effect** for this Layer.

Now click on the **[Not matched]** link below the **Rotate** slider (I've marked it with a green arrow) in the **Starting Position** column. When the **Layer Matching** dialog box opens, use the drop-down menu to enable the **link** with **Slide 1's Layer 3**. (The blue arrow marks the spot.) Click on the < **Done** > button to complete the process.

	Layer Matching				
Preview	Matching to the	e position o	a layer on another to start where anot	slide. Use this	
iew	Match Previous		Match Next		
	<not matched=""></not>	•	<not ma<="" td=""><td>itched> ~</td><td></td></not>	itched> ~	
	<not matched=""></not>			osition to a layer on ext slide.	
	<no image=""></no>			Done	
1 № Layers	Layer 3 <no image=""></no>	1g	Position		End
2 2	JPEG Image	Pall -24	.33 x 4.21	ନ	Pa
+	IN JPEG Image	Zoom 🛃 - letate 🛃 -	-0	▶ ⁸⁵ % ດ ▶ "ີດ	Zoor
+			[Not Matched	1 No	

Re-examine the **Slide 2**, **Layer 3 Starting Position Pan** setting. It's changed to -23.17×10.41 . Play the **Preview** and watch the **Layer 3** image move down as the Slide plays. The Layer moved because the setting was changed to match **Layer 3** on **Slide 1**. There is one problem. A bit of the black background shows through the because the Layer isn't properly lined up with the "picture frame" created by **Layer 1**.

Change the **Start Position** for **Slide 2, Layer 3** so that the **Pan** setting reads **-23.9** \times **-6**. That will center the **Starting Position** nicely. Now make **Slide 1** active, using the left-facing arrow in the bottom-left corner of the **Motion Effects** window. Make sure **Slide 1, Layer 3** is active in the **Layers List**. Examine the **Ending Position Pan** setting for this **Layer**. It's now **-23.9** \times **-6**. The **Layer Match** works in both directions. Change one linked Layer and they both change, no matter which one you choose.

Experiment with the settings; try linking Layer 2 on one Slide to Layer 3 on the other. This will force more movement on the target Layer, because the two Layers started on opposite sides of the frame. When you are done, close the Show. We won't be using it again.

Putting It All Together

We are going to watch and manipulate one more short Show to review skills in this chapter and look more closely at some design elements. In the Folder for Chapter 3 (which you have copied from the companion CD-ROM to your hard drive, right?) is a file named <All Together.psh>. It was created using Gold, so you can open it using either Gold or Producer. (Don't worry about the version warning message if you are using Producer. The Show will load properly.) I've also included a self-running version of the show, **All Together.exe**, in the Chapter 3 folder. It combines all the design elements and tools we have worked with so far. You can use this file for an overview or review if you wish.

Once **All Together.psh** is loaded, run the **Preview** in **Full-Screen** mode. Then continue reading. This Show has the steps in the Exercise already completed, so you can either follow along as I go through the steps, or if you wish you can move the files needed to create this Slide from the Images subfolder in the Chapter 3 folder into a new Show and practice "from scratch." I'll detail the steps; feel free to follow along and make a copy of the design. Gold will work fine to do that.

Two Slides, Two Backgrounds, Eight Layers, and a Disappearing Act

The basic way the Show uses Layers and Motion should be obvious. All the Layers are using a simple path to pass in front of the background. To the casual observer, that's about it. Let's look closer. There are some tricks of the trade to discover.

Matching Motion Speed between Layers

Let's summarize how **Slide 1** uses **Motion Effects**. It begins with only the Background visible, and then two pictures drop on either side of the frame as a third rises from the bottom. They all pass through the center at exactly the same time. Then all three pictures exit the viewing area.

Matching timing between Layers isn't hard to set if you follow a few basic principles. Remember that all movement in a slide is *limited to the amount of time the slide is visible* during play. All we need to do to get all three pictures to travel at exactly the same rate is to *have them cover the same distance using the same Motion Styles*. If the sizes of the images or the length of the **Motion Path** differed, then there would be some variance, but they are the same size.

The design process for this Effect isn't as difficult as it might look. Start by opening **Slide Options** into the **Slide>Background** window and choose the **Override show background for this slide** Option (circled in green in Figure 3.28). Add the background file < **blur dot bkg.jpg** >. Then enable the **Colorize** control and set the color to a gray with **RBG values** of **56**, **56**, and **56**.

Next, change to the **Motion Effects>Precision Preview** window, and adjust the **Preview Zoom**, circled in green in Figure 3.29, to about **80** percent. Add the three pictures (**TC-S21**, **TC-S52**, and **TC-S55**), and adjust them to fit side-by-side in the frame. The easy way is to place all three images alongside each other, as shown in Figure 3.29, and use the mouse to size them. I've shifted to Producer, because

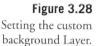

Figure 3.29 All three images pass vertically through the center of the frame at exactly the same time. At the Starting and Ending Positions in play, none are visible on the screen. The design starts with sizing the images to match this point in play.

it offers a larger **Preview** and the **Keyframe Timeline**. Gold will work fine too. We'll move them into the proper **Starting Positions** shortly.

Now it's time to set the **Motion Effects**. We'll stay in the **Precision Preview** window. Make sure that the **Preview Display** menu has **Show Inactive Layers** enabled. These three images all start and end outside the **Safe Zone** (The portion of the frame seen during play). Set the **Preview Zoom** at the top of the window to about **35** percent (*not* the **Zoom** control that changes the size of a Layer). That provides the view we need to easily place the Layers. We'll set the **Pan** for all three **Layers** at the beginning of the Slide first, then the end using the mouse. Producer will do the rest. In Producer, click on the **Starting Keyframe Marker** on the left side of the **Keyframe Timeline**. In Gold, click on the **Starting Position** thumbnail above the **Preview** pane to make it active. Now use the mouse to set the image Layers as seen in Figure 3.30. The Preview area is dark outside the Safe Zone. I've outlined the **Background Layer** in white, and each of the other images in a contrasting color, to make the locations easier to see. If you are using Producer, consider turning on the **Grid** to aid in positioning the Layers.

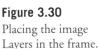

It's also possible to set the **Pan** numbers with the coordinate system we used earlier in the chapter. Starting with all three images placed as in Figure 3.29, move one of the two images that starts above the frame to the desired beginning location. Note that Layer's **Pan** coordinates and adjust the other pictures accordingly. The other picture that starts above will keep its current **X** value and will be given the same **Y** coordinate as the picture you just moved. That will bring it up to the same level, without moving it to the left or right.

The picture that starts below the frame is given the negative value of the same number for the **Y** coordinate. Setting the **Ending Point** is even easier; **Copy** the setting to the end of the Slide, and then reverse the **Y** values by adding or removing a **minus sign**. See Figure 3.31.

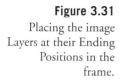

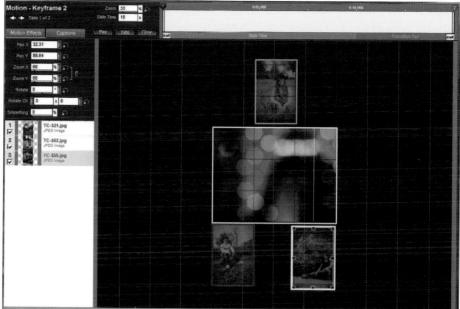

Preview the finished Slide and gauge the Effect. I used the mouse to place the Layers and took the screen shots without making the minor adjustments needed to bring the images into perfect alignment. If the Slide lasted longer, or a more precise timing was needed, a bit of tweaking might have been called for. It all depends on the design requirements and the amount of time available. Close the **Precision Preview** window, and make **Slide 2** active with the right-facing **arrow** at the bottom left of the window.

Who Says We Have to Start at the Beginning or the Middle?

Slide 2 starts with only the background visible, and then adds five pictures that slide into the middle of the frame, slowing into a pleasing collage as the frame begins the following Transition. Watch this slide in **Full-Screen Preview**, and you'll notice that the pictures don't all move at the same rate. They do all slow to a stop at the same point during playback. That's because the Slide has run out of Time, and the Effect ends. Once again, the designer has let ProShow do most of the work. Follow along and see how easy it is to make a moving collage. I won't give quite the full level of detail in the instructions this time, since the tools should be familiar by now.

Let's take care of a couple of details before working with the moving Layers. The Slide starts with the **Open Vertical Soft Edge Transition**. We can add it now. It's

located at the top of **column 6** in the **Transitions** menu. Next, we need to add the **Background**. The file is named **Floral_01.jpg**.

Now for the fun part: adding and arranging the pictures. Choose five or six pictures from the Chapter 3\Images folder; don't worry about using the same ones as in the original example. You can add them by selecting them with the mouse and then dragging them right onto the Slide in the Slide List while holding Control Key. Now double-click on the Slide to open the Slide Options window and select the Effects>Motion Effects tabs. Notice how the pictures aren't visible in the **Starting Position Preview**? The designer got them into their proper positions by working backwards. That's what we are going to do now.

Let's open the **Precision Preview** window and set the **Preview Zoom** to about 95 percent. Then make **Keyframe 2** active. Now arrange the images to form an interesting montage. **Resize**, **Crop**, **reorder Layers**, and **Rotate** as desired. The final design for the original **Slide 2** is shown in Figure 3.32.

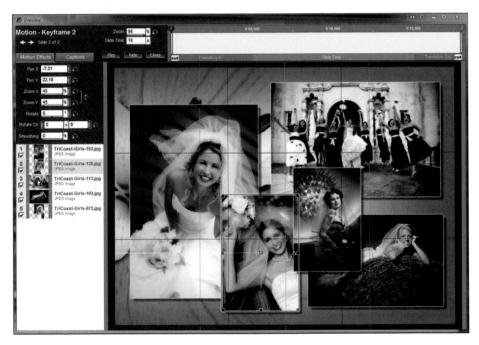

Figure 3.32

Sometimes it is easier to design the final appearance of a Slide and then add Motion Effects to set the start of the Slide. That's easy to do in the Motion Effects Precision Preview window, as seen in this example.

Once you are done making the desired adjustments to the ending of the Slide, open the Copy menu and choose the < **Copy Start to End (All Layers)** > Option. This makes sure that any accidental differences between the **Starting Position** and the **Ending Position** are neutralized. Now we have the Layers in their proper **Ending Positions**, but without any Motion.

It's time to craft the **Motion Effects**. Select the **Starting Keyframe** (in Producer) or the **Starting Position Thumbnail** (in Gold). Change the **Preview Zoom** to about **39** percent. Then re-arrange the design so that the pictures are positioned the way you want them at the beginning of the Slide.

Keep in mind that with only two **Keyframes**, all the images will start and end at exactly the same time. If one Layer travels twice as far as another Layer during play, then it will move twice as fast. Consider the way you want each image to move to that **Ending Position** and its speed relative to the other pictures, and choose the stacking order by considering how one picture might hide another as they travel inward.

Select one Layer at a time and use the mouse to drag the pictures off the page to the appropriate **Starting Position**. If you want the picture to travel faster than average, move it farther outside the frame. For a slower Effect, keep it shorter. Remember that the speed depends on the total length of the **Motion Effect** and the Time the Slide is visible. Figure 3.33 shows the **Precision Preview** at the beginning of the Slide's play with the image Layers outlined in color. This background is bright enough so that it is not outlined, to make it easier to see the other Layers' positions.

When I'm setting up a **Motion Effect**, I choose a Layer that has an average time, place it first, and use that as a reference. If a Layer needs to move faster, it should get placed farther out than that. If the speed is to double, it needs to be twice as far away. If a Layer should move a third slower, then it needs to move in by a third.

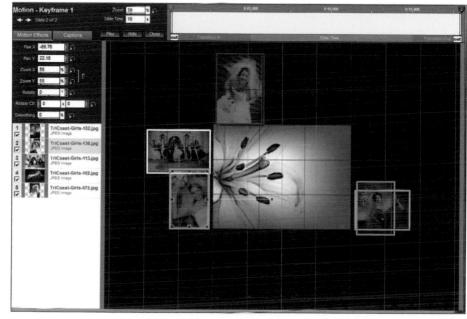

Note that the travel is based from the center of the Layer at the start of travel to the center of the Layer at the end. Don't gauge the distance to the center of the frame unless the Layer will end there.

As I work, I use the Timeline to see how the elements fit together. Then, when all the Layers are set, I **Preview** the results in **Full-Screen** mode in real time. This gives me a good idea of the pace of the **Motion Effect**. To tweak, go back to **Slide Options** or **Preview**.

Have fun and experiment a bit with the design. Add some **Rotation**, use different **Motion Styles**, and vary the Slide playback Time. We have only begun working with **Motion**. When we take the basic concepts of **Layers** and **Motion**, and our understanding of how the design elements work together, then add **Keyframes** and combine them with **Adjustment Effects**, mastering ProShow's more advanced tools will become that much easier.

Up Next

Movies are better with a sound track, and ProShow productions are no exception. Adding audio clips is easy, and ProShow provides tools that let us enhance our sound with Effects like multiple track cross-fades and custom-tailored volume levels.

4

Adding and Editing Soundtracks

It's hard to imagine sitting through a movie without a soundtrack. Audio is a powerful component of any professional visual production, pacing the images as they are presented to the viewer and evoking an emotional response. ProShow provides exceptional tools for incorporating audio clips and quickly and precisely controlling their relationship to the visual elements of a Show. We can add multiple soundtracks to a Show. In fact, we can even have several tracks playing at the same time, or attach a sound clip to a single Slide. Using ProShow's advanced audio tools, it's easy to blend audio effects to produce smooth Transitions, and even precisely play portions of a track with a specific Slide for enhancement and dramatic effect.

Just as it does with images, ProShow only "borrows" the data from audio source files. So when you edit them inside the Show, your originals are never modified.

Note

Of course, just as with images, you can use an external editor to modify an image, sound, or video file; in those cases, of course, the originals *will* be permanently changed. If you want to preserve the source content unchanged when you use an external editor, first be sure to make a backup copy of the original file.

Working with Audio Files

You can import audio files into the body of your Show and run them at full length, trim them to a partial segment, or limit them to a specific Slide. To add audio, your Show must have at least one Slide. We'll start with an existing Show, see how to add content, and get familiar with interactive Controls (the fun stuff). Then we'll build a new Show and add audio content.

We'll start our discussion with how to add and remove soundtracks for Shows. First, move the entire **Chapter 4** directory onto your hard drive from the accompanying CD. Next, start ProShow, either Producer or Gold; then click < **File>Open** > and load the **Working With Soundtracks** show located in the Chapter 4 directory.

Note

Don't worry if a warning appears concerning the file type if you are using Producer; I created this Show in Gold, so you can use either program.

Once the Show is loaded, click on the < **Music** > icon on the far right of the Tool Bar. When the **Show Options>Music>Show Soundtrack** window appears, click on the < + > sign as shown in Figure 4.1, then click < **Add Sound File** > and then navigate to the **Larry_Allen_Shenandoah.mp3** file located in the Chapter 4 folder. Select the file and click < **Open** >. When the file appears in the **Soundtrack** pane, click the **Done** button at the bottom right of the window to add the clip to the Show and return to the Work Area.

Adding, Removing, Positioning, and Previewing Audio Files

ProShow lets you add sound clips (MP3 and WAV formats, and you can rip tracks from a music CD) to a Show in other ways. We could have also navigated to the folder containing the desired file and dragged it to the **Audio Waveform** pane, located just below the Slide List or the Timeline. You can see the green **Waveform** for the track we just added in Figure 4.1.

Right-clicking on the **Waveform** below the Slide List or the Timeline brings up a submenu; click < **Manage Soundtracks** > and the **Show Options>Music> Show Soundtrack** window will open, as in Figure 4.1. You can import both traditional audio files and Photodex Media Source music from this submenu.

Figure 4.1 The Slide Options> Music window offers tools for adding, deleting, and editing soundtracks.

titled Pro	Save Play Options Side Timeline Styles Layers	Effects Captions Music Create Output	des (4:47.76),
	Show	Captions Music	
÷Q.		how Soundtrack	
coast-Senio	Master Volume	Larry_Allen_Brown_Shenandoah.mp3	
	Volume 🗐 ——— 🕞 100 %	our	A
2	Defaults For Other Sounds	Click the + to add	
-	Volume 3 (b) 100 %		
oast-Senio	Fade in (1) 8	a soundtrack	
100	Fade Out		
125	Soundtrack During Other Sounds		Sec. 19
oast-Senio	Volume 3 8 50 %		522
7	Fade In (0.1 s)	Track Name Larry Allen Brown Shenandoah.mp3	
34	Fade Out 1 0.1 s	Track Name Larry_Allen_Brown_Shenandoah.mp3 Track Type MP3 Audio	
	Soundtrack Tools	Track Length 4:10.54	0 550
List (Pres	Save Music From CD Import music from an audio CD into your show	Volume	al labor
	Record Slide Timing Interactive timing tool. Just tap while you	Fade In	engelow/
	Isten to set timing. Surge Slide to Audio. Adjust slide and transition times to match	Fade Out	50
	Sync Slide to Audio Adjust slide and transition times to match the total audio length.	Offset 0 s from previous track	
Sector	L	Con racing con racing	

Note

Media Source content are collections of Show components, like Themes, backgrounds, and in some cases audio files, available from Photodex. Check the product section of their website (www.photodex.com) for more information and pricing.

The vertical column at the left edge of the **Show Soundtrack** pane includes the **Add Track** button, (a + sign), and a **Remove Track** button (the - sign). Soundtracks within a Show play in the order they are displayed in the **Track** pane of the Show Soundtrack window. Use the **Up** and **Down** arrow buttons to change the order of clips in the stack. At the bottom of the column is a **Right Arrow**; pressing it opens an **Audio Preview** applet that plays the selected clip, as seen in Figure 4.2.

You can delete soundtracks by right-clicking on the **Waveform** and choosing < **Remove Soundtrack** > from the submenu. The **Waveform** is handy for quickly sceing just how the audio tracks match up with the Slides. Although it will be visible beyond the last Slide in your Show, *the audio will not continue to play* past that point. An exact fit requires synchronizing the Slides to the soundtrack—and having a reasonable amount of audio for the number of Slides in the Show.

Figure 4.2 The Controls for adding deleting, sequencing, and previewing audio clips in a Show.

Once loaded, any audio clips appear as **Audio Waveforms** in the **Audio View List** (located directly under the **Slide List**), or in the **Audio Timeline View** (under the **Timeline** pane) and will play when we Preview the Show in Proshow. If you add more than one soundtrack to the list, they appear in order they are added under the Slides in alternating colors. That makes it easy to see how long clips will last and when a new one will begin. The Waveform also provides a visual clue as to when the intensity of the sound rises and falls.

Using Simple Audio Synchronizing Tools

ProShow's designers have included a set of simple commands for quickly adjusting a Show's Slides and sound. The length of a Show is a determining factor in how audio can be used in a production—no Slides playing, no sounds. A soundtrack plays until either it or the last Slide in the Show reaches the end of its allotted time—whichever comes first.

ProShow Gold and Producer offer identical options for automatically synchronizing ("*syncing*") a soundtrack to a Show or a group of Slides. You can access them off the **Menu Bar** via the **Audio** menu (seen in Figure 4.3). Directly above the **Folders List** pane and the **Preview** pane is the **Show Summary** pane, which lists the name of the current Show and its statistics. This Show runs for two minutes and forty-two seconds (2:42). The soundtrack is over four minutes long: 4:10.52. At the 2:42 mark, the music will stop when the Show does.

Manage Soundtrack	F6
Sync Slides to Audio	Ctrl+T
Save Music from CD	
Record Slide Timing	
Quick Sync - Entire Show	Ctrl+Q
Quick Sync - Selected Slides	Ctrl+Shift+Q
Quick Sync - Selected Slides to Track	Alt+Q

Figure 4.3

The ProShow Audio Menu offers several options for quickly linking Slides to a Show's Soundtrack(s). Our Show has 27 Slides, each with a three-second play time, bordered by a threesecond Transition. Press the < **Control+Q** > combination (That's the **Quick-Sync-Entire Show** shortcut). Now all the Slides in the Show are set to play for 6.495 seconds and the Transitions all last for 2.783 seconds. Our Show is 4:10.54 minutes long—exactly the same as our soundtrack. Use the < **Control-Z** > keyboard shortcut to undo the sync.

Now use the < Quick Sync- Selected Slides > feature to match up our soundtrack to Slides 1, 4, and 5. Use the Control key and mouse to select the three Slides, and then use the keyboard shortcut: < Ctrl+Shift+Q >, You will see a dialog box like the one in Figure 4.4. It reports the amount of time that will be added to the Show (in this case 88.5 seconds) and the new total length of the Show (250.5 seconds long). Click < Yes >. Now two of the three Slides are 17.757 seconds long, one is 17.758, and the three Transitions following the Slides are 17.756 seconds long. Press < Ctrl+Z > to undo the action.

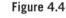

Auto-syncing selected Slides to a soundtrack will change the length of the Show.

44		23					1 K.	J. 4612.		
	Audio/S	Slide Synchronization		X	0.00 5					
Slide Liet (Press (Tab) for Timeline)	1	This function is about to in this show. The 3 sele- proportionately to add 8	cted slides will have	e their timing changed	150	200 250 300	350 40	0 450 500	550 600	550
Side 1		Pressing 'Yes' below will will be exactly 250.5 sec Are you sure this is wha	conds long.	nt. The resulting show	3.0	Side 4	4	Side 5	5	
3.0	Concernances	3.0		3.0	"[3.0		3.0	
Comparison (Comparison) Comparison C			alara dalam dan			<u> </u>		elle schemblen einen		
JPEG Image - C:Working With Sou	ndtracks\ir	nage\TriCoast-Seniors-001.	ipg (108K bytes, 1	1024 × 883, 1613 aalara)				1 selected (108K bytes) 27 o	f 28

You can still auto-sync to selected Slides if there is more than one soundtrack in a Show by using the **Quick Sync-Selected Slides to Track** option. First select the desired Slides, then choose the option, and the **Synch Slides to Track** dialog box will let you choose the desired audio clip.

A Closer Look at Soundtracks

We need to define a few terms and look more closely at the ProShow interface audio tools before starting to manually tweak soundtracks. Undo any changes you've made to the Show, other than adding the soundtrack, and return to the **Work Area**. Now press the < **Tab** > key. The **Slide List View** pane at the bottom of the window will change to the **Timeline View** pane. Pressing the **Tab** key toggles the display between the two Views. The **Audio Waveform** pane provides an interactive mode for adjusting soundtracks. We'll come back to the **Slide List** shortly. Let's explore ProShow's ability to control audio characteristics when playing an individual track. Double-click on the green soundtrack in the **Audio Waveform** pane to reopen the **Slide Options>Music>Show Soundtrack** window. Figure 4.5 shows part of the **Soundtrack** pane of the **Show Soundtrack** window, showing the clip's properties (length, file format, and filename), and Controls for the currently-selected track, laid on top of the **Preview** pane.

	Volume		-0-		100	%		
	Fade In			🕨	0	8		
	Fade Out			🕨	0	8		
	Offset	0	s from p	revious track				
	Timing	Edit Fac	les and Timi	ng			600 650	700
					,		Juliu	1
					l	Don	¥ 0:40.00	0
							r i i i i i i i i i i i i i i i i i i i	
				AB			Ŀ	A
nonement			neromenene kekotula terseti				1	-

Figure 4.5

The basic Track Controls and a portion of the Audio Timeline with a soundtrack Waveform visible in ProShow Gold.

We can see the title of the clip, its length, and audio format **Controls** in the **Track** pane. Right now the **Controls** in that section are set to their defaults. The **Volume** for playback is set at 100 percent. Adjusting this level will change how loudly *this* clip plays in relation to the *overall* soundtrack volume setting for the entire Show. *Fades* are audio effects that blend a Soundtrack as it enters or leaves a Show, using a gradual shift in volume. **Fade In** raises the volume from zero to 100 percent as the clip begins; **Fade Out** softens the volume until the track is no longer audible. An **Offset** delays the start of an audio track until the specified amount of time has passed following the end of the preceding Slide.

Going Interactive: Advanced Sound Controls

ProShow provides an elegant user interface with simple shortcuts for those who like easy solutions to common tasks. The ability to sync a show to the soundtrack with a single command is an example. But fine-tuning a soundtrack and obtaining polished professional results requires hands-on editing. ProShow's welldesigned and precise Controls should satisfy the more demanding users. Even novice audio engineers can make quick work of tasks like crossfades and matching a precise point in a soundtrack to a Slide. One of the neatest tools (available in both Gold and Producer) has an unlikely name—**Edit Fades and Timing**.

Mastering the Audio Trimmer

The quickest way to master the **Edit Fades and Timing** window is to use it on a soundtrack. Feel free to experiment as I explain how the editor works. To access the editor, also known as the **Audio Trimmer**, right-click on the soundtrack's **Waveform** in the **Audio Timeline View**, and choose < **Edit Fades and Timing** >. This will open the window seen in Figure 4.6. (It can also be accessed by clicking the **Edit Fades and Timing** button located in the **Show Options** window when the **Music** tab is active.) The values in your data boxes will be different, since I've added labels and adjusted mine to highlight some features.

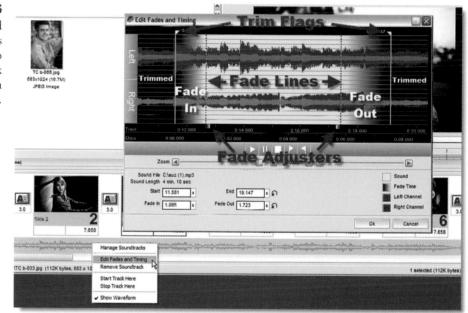

Let's start with a few introductions. The majority of the dialog is taken up by the interactive **Waveform**, showing both the left (blue) and right (red) channels. You can expand and compress the **Waveform** to show more or less detail either by dragging the **Zoom** slider or rolling your mouse wheel. Use the left mouse button on the **Position** slider to adjust the position of the **Waveform** to the section you want to work on when it won't all fit in the window.

Move the box on the **Zoom** slider to the left and the time interval will compress, move it to the right and the interval will expand. Expanding the interval makes it easier to adjust very fine increments interactively. The drawback is that you can't see the entire soundtrack in the editor. Move the **Position Slider** to the left and the track will move left; move it to the right and the track will advance to the right.

Figure 4.6

The Edit Fades and Timing dialog offers the tools needed to trim and tweak soundtracks for a Show. Figure 4.6a shows a track **Zoomed** in with the entire track visible on top, and the same track **Zoomed** out almost to maximum magnification and moved almost all the way to the right on the bottom. I've boxed the slider controls in green. These images were both made in Producer, so the color scene of the window is different—the controls are exactly the same.

Figure 4.6a

The Zoom control Zoomed in (top) and Zoomed out (bottom.) The lower example has the Position control adjusted so that the right-most section of the magnified track is visible for editing.

Notice the two Flags (I've labeled them **Trim Flags** in Figure 4.6), that rise just above the top left and right corners of the left (blue) Waveform? These mark the audible beginning and end of the clip. Black background areas have been trimmed out of the Show, and those portions of the clip will not be played. (The actual clip file is not cut.)

You can adjust a Trim Flag's position (and with it the way the clip will play) with your mouse. If you hold the mouse cursor over *either* the triangle-shaped top of the flag *or* the gray box at the bottom of the flag, the pointer changes into a hand with a finger pointing up. Place it over the flag's vertical line and it becomes a pair of parallel lines. Use either the hand or the lines to drag the flag to the desired position. You can also enter the numbers for the desired times in the appropriate boxes.

The clip shown will start playing 11.581 seconds into the track, and will stop playing at the 19.147 mark. The **Fade Time** uses yellow-and-black to show the **Fade In** and **Fade Out** of the **Waveform**; the volume will rise from zero to 100 percent as the track progresses in, and drop to zero as it exits.

The first three buttons below the **Audio Waveform** are the familiar **Play**, **Pause**, and **Stop** buttons. The last two are the **Start Playback** and **End Playback** buttons. They let you set the first and last points precisely by pressing them as the clip is played in the window.

Below the sliders is the name of the selected audio clip, including the complete path to the file and the full, unedited running time. The data entry boxes below the buttons can be used to set fade timings numerically. Most users never need these, since it is so easy to edit with the mouse.

Scaling and Positioning the Waveform

Expanding the **Waveform** makes it easier to work precisely with longer soundtracks and see the shifts in tempo and volume. Move the **Zoom** Slider to the right to increase size and to the left to decrease it. (If you have a mouse with a wheel, you can use it to adjust the magnification.) Hold down your left mouse button and the pointer becomes a hand you can use to scroll to a desired segment.

Setting the Start and End Points

Often we want to use only part of an audio file. The clip may start with silence we want to omit, or the section we want is in the middle of the track. Interactively setting the exact **Start** and **End** points is easy with the Audio Trimmer. You should already have the audio clip loaded. The first step in editing is to listen to the track and note where you want the clip to begin in the show. Press the **Edit Fades and Timing** dialog < **Play** > button to listen to the track.

A vertical bar, with equal triangles at both ends, will start moving once the track begins playing. This is the **Current Location Marker**. In Figure 4.7 the playback is paused and so the bar can be moved with the mouse to any point on the Waveform. This can be handy when trying to locate a specific portion of a track for editing purposes.

When the clip is at your desired starting point, press the < **Start Playback** > button. (Labeled **Start Here** in Figure 4.7) The **Trim Flag** (the line with the triangular Flag on the top pointing to the right) will automatically move to and mark that location as the starting point. Let the track play until it reaches your desired ending location, then click on the < **End Playback** > button. The Flag with the triangle pointing to the left will adjust to mark the end point. To set the edits, press the < **OK** > button. Now only the portions inside the Flags will be used as the soundtrack in your Show. If you don't like the result, redo the adjustment or click the < **Cancel** > button.

Figure 4.7

Shifting from the Slide List View to the Timeline View in ProShow provides access to advanced interactive audio editing tools. You can also manually set the **Start** and **End** points. Place the mouse pointer over the appropriate **Flag** and drag it to the desired location. As you move the Flags, the numbers in the white **Start** and **End** boxes will scroll. It is also possible to enter numbers, but most users find it easier to make these edits by listening to the audio and clicking the buttons.

Adjusting Fade In and Fade Out Intervals

We usually don't want a soundtrack to start or end at full volume, but rather have the sound levels fade in or fade out. This is especially useful when one clip follows another. Dropping the volume on the earlier track and simultaneously raising it on the new one is called a *crossfade*. The **Audio Trimmer** offers an easy way to "see" and adjust this type of effect.

The background's transition from solid black to solid yellow in Figure 4.8 denotes a **Fade In**. Notice the position of the **Start Flag**. The gradient is shifting from black on the left to yellow on the right, signaling a **Fade In** effect. The portion of the track with the black background is not played in the Show. See how the sound-track background goes from black to solid yellow as it moves to the right?

As you work with the line, the cursor will change to a pair of vertical bars with arrows pointing out, as seen in the figure. That line, and the gray **Fade In** box just below it, mark the end of the Fade In section.

To set the Fade, simply drag either the box or the line with the mouse. The transparent Tooltip displays as the adjustment is made. Just as with the **Start** and **End** points of the track, you can manually enter Fades into the appropriate box. Adjusting and previewing effects inside the **Audio Trimmer** *doesn't change the settings within the Show until you click* < **OK** >. For now, click the < **Cancel** > button to retain the current settings and exit the window.

Figure 4.8

Dragging the Fade Line with the mouse lets you quickly adjust the time settings for a Fade In or Fade Out.

Editing Soundtracks Using the Timeline

The **Edit Fades and Timing** dialog is a neat tool, but it works with only one audio file at a time. Creating really professional *crossfades* (the precise overlapping of soundtracks' Fades and their Volumes for effect) requires the ability to place one track over another while simultaneously controlling the fading of each in and out. The **Timeline** view in both ProShow Gold and Producer allows direct editing of **Waveforms**. Let's explore. Close the current Show. (Don't worry about saving the changes.) Open the ProShow file named < **working with two sound-tracks.psh** >.

Note

Be sure that you are using a copy that you have moved to your hard drive, not the copy still on the book's CD. ProShow files must be on a read/write device to work properly.

Note

This is essentially the same Show as above, with two exact copies of the same soundtrack one after another, and a longer Show runtime, made to sync exactly with the total audio length.

Make sure ProShow is in **Audio Timeline View**. The easiest way to tell is by simply pressing the < **Tab** > key twice; large Slides and a small Waveform indicate **Slide List View**, and vice-versa. An alternate method is by clicking the < **Slide List/Timeline** > button, located on the **Toolbar**, which toggles the View back and forth. (Be sure to close any other open ProShow windows first.) Repeat the process when you want to toggle back to the Slide List View.

In Audio Timeline View, the Timing Points for the Slides and Transitions aren't visible. (You can still get that information by holding the mouse over a Slide or Transition.) The Slide thumbnails are smaller, and the Audio Waveform is larger. Holding the mouse cursor over the Waveform and scrolling the wheel will expand or compress the Waveform, just as in the Audio Trimmer. You can also use the Plus and Minus buttons (shown in the lower-right corner of Figure 4.9) to Zoom In and Zoom Out. They appear when you hold the cursor in the Audio Waveform pane. (You must be in Audio Timeline View to use these Controls; they will not appear in Slide List View.)

1	0:10.000	0:20,000	0:30,000	0:40,000
	10.	A		AB
HUZ (1).mp				
euz (1) ms	an a stick, b, blos, Miss	Mushing and	والمرور والمراجع والمراجع	A Land Broker
suz (1) ms Fillerica				
euz (1) ms Filder 4 y bidder 4 d	1997) 1999 - State State State (1997) 1999 - State State (1997) 1999 - State State (1997)	a and a second	Hold CTRL to edit fa	

The file name of the **Waveform** appears in the upper-left corner of its pane, as well as in the tooltip seen in the center. The mouse cursor will look like a hand; use it to drag the combined Waveform and Slide thumbnails left or right to the desired portion of the Show.

The **Timeline** view of the **Waveform** makes it easy see how the volume of the audio clip relates to a specific point in the show (either a Slide or a Transition). When the sound is peaking, the Waveform "spikes" as the intensity increases. The height of the Waveform indicates relative volume.

The border color around a Slide (blue when a **Slide** and **Transition** are selected) matches the time on the Timeline during which the item will be visible in the Show. The colors may vary if you are using Producer or have changed the program's default color scheme.

Adjusting Offsets, Fades, and Volume Using the Timeline Tools

We can use the **Timeline** to adjust **Waveforms** right inside the main ProShow window using the mouse and the **Control** key. We can also set cross-fades when we have multiple soundtracks in a show—something we can't do with the Audio Trimmer. Use the scroll-bar under the **Timeline** and center the Show to about 4:11 minutes in. The top Timeline in Figure 4.10 shows how my Timeline looked at this point.

Note

The **Control Key** set ups a special *drag mode* with your left mouse button. The most effective way to work is by placing your mouse over a portion of the desired soundtrack and then hold the **Control Key** and perform the drag operation. If the desired clip is under another track, find a section that is not covered or move the other track first. Then choose the right "handle" (which may be the clip's waveform, a line, or a little box) and drag it to reshape the waveform. The following paragraphs explain the various techniques. It takes a little practice to gain proficiency.

Figure 4.9

Holding the cursor over the Audio Waveform pane makes the Zoom buttons and the Audio Waveform file name visible. Dragging the Waveform or using the Scroll Bar left or right lets you quickly navigate to the desired part of the Show.

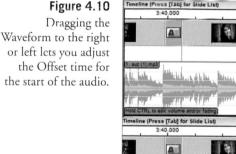

Timeline (Press [Tab] for Slide List)			
3:40.000	4:00,000	¥ 4:20.000	1 1 1
	A		
the same (1) mp3	Mana and an and a second	Plan and the second	Lathardan La La Maria
Hold CTRL to edit volume and/or fading)	ALCONT OF THE OWNER	Alles and have been party	Insparse of a first faiture
Timeline (Press [Tab] for Slide List)			
3:40.000	4:00,000	4:20.000	L
	AL.		
**************************************	Miner I.		Marine and Mary Mar
ad it is a start of the second	ANNI ANNI	Offset Time: -0:08.200	"hoursering to the un
<		DB	

We'll start by shifting the **Offset** of the second (blue) audio track to its left, so that it rides over the end of the first (green) track. (*Offset* specifies the number of seconds from the end of the previous track to the beginning of the current track. A positive number will create a gap of silence between tracks; a negative number will create an overlapping condition.)

We are going to set up an overlap and adjust the volume of both tracks in that segment so that the end track fades out as the new track fades in.

Hold your mouse pointer, which at first will look like a hand, in the blue Waveform under the third Slide (**Slide 14**), then press and hold the < **Control** > key. The cursor will change into an arrow (It isn't visible in the screenshot because of screen-capture limitations.) Now drag the **Waveform** slightly to the left until the Offset time (noted in the Tooltip) is about **8** seconds. The bottom timeline in Figure 4.10 shows about how your Timeline should look after the adjustment, minus the hand-shaped pointer.

As you drag, the Tooltip box will display the **Offset time**, and the full time of the clip will show below it. Move the Offset to the left and the clip will begin to play sooner in the Show. Moving it to the right forces it to start play later.

Notice the vertical line with the square shape in the middle at the very left edge of the second clip's Waveform? This is the starting point of the audio clip. It has been placed inside the ending portion of the first clip. If two clips inhabit the same time-space, they will both play, shown by the mixed colors in the Waveform. See Figure 4.10. Experiment a bit with the Offset, and also vary the magnification of the Waveform, to see how shifting the view helps when placing Offsets and navigating in the Show. Then place the Waveform back into the original position. You can do that by either adjusting it with the mouse or using the Undo command (**<Control+Z**>).

The yellow box around the waveform takes on a triangle shape when the handles are dragged to the right (See the section circled in red in Figure 4.11?) This section is the **Fade-In**. The triangle in Figure 4.12 is longer than the one in Figure 4.11. It is the same Waveform, but it has been "stretched" to make the **Fade-In** time longer.

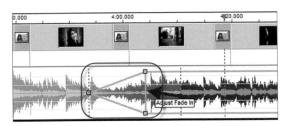

Figure 4.11 You can adjust the Fade In by adjusting the vertical yellow line to lengthen or shorten the fade effect Triangle. The longer the Triangle, the longer the Fade In time will last.

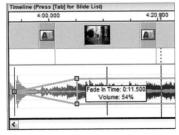

Figure 4.12 Using the mouse and the Waveform to lower the volume of a soundtrack.

Here's how to do it using the interactive Waveform. Hold your mouse directly over the vertical yellow bar (the one pointed to by the red arrow in Figure 4.11). The cursor will change into a set of parallel vertical lines. Once the cursor changes, use it to drag the lines to the right or left. As you move it left, you shorten the fade-in time. Moving it to the right increases the time.

By now, you might have guessed that the height of the Waveform denotes the relative volume of the audio clip. In Figure 4.11 the outline of the beginning of the second track has been stretched into a triangle. Try it. Hold the mouse over the end of the clip towards the top of the Timeline so it is over the **Control Box** and hold the **Control** key. Drag the square at the top yellow box that appears to the right. The triangle indicates the clip's volume at that point in play; narrower is lower, wider is louder.

Here is a quick summary of the Interactive Adjustment Controls and how they operate.

- (1) Pressing the **Control** key puts a Yellow **Control** box around an *associated* Waveform; holding the key down enables interactive **Control**s.
- (2) At the very start or end of an audio clip, an unedited Control box will look like a vertical yellow line with three square Handles at the top, middle, and bottom.

- (3) The top and bottom square handles, when, and *only* when, the cursor is *exactly centered* in either, become Adjust Fade / Volume Controls, as shown by their Tooltip. Dragging either the top or bottom box in, will set up a fade, and the end of the clip will become a triangle.
- (4) The center handle, when the mouse is in its *exact center*, becomes an Adjust Audio Start Time (or End Time) Control, as shown by a Tooltip.
- (5) Adjusting the boxes so that the box becomes narrow reduces the maximum volume of the entire clip.

Right now both of my tracks are still set to play at full volume. Usually it's better to have the opening track fade out as the new track begins, and let the new track begin softly, then rise to its full volume. We may also want to cut out any quiet space at the end of a track to enhance a smooth Transition. It's easy with the Timeline's interactive tools.

You can also adjust the overall volume of the clip by narrowing the yellow **Control** box vertically. Hold the **< Control >** key down, and place your mouse over the horizontal line above or below the main portion of the Waveform (not in the **Fade In** section). The cursor will appear as a pair of horizontal lines once in place. You drag the line down to lower the volume and raise it to increase the volume. Figure 4.12 shows the Waveform adjusted to a Volume level of 54 percent.

As you adjust the level, the Tooltip will track the current volume and show the percentage. See how the box gets smaller? Keep in mind that your Fade-in and Fade-out levels will be reduced as well. Once you feel comfortable using the **Controls**, use the **<Revert to Backup** > command in the File menu to restore the original settings before moving to the next part of the Chapter.

Creating a Crossfade Effect with the Timeline

Now for my favorite use of the interactive Audio Waveform: setting up a crossfade. It's done by setting matching Fades at the end of the first clip and the beginning of the second.

Note

Now revert to the original show (**working with two soundtracks.psh**) or reload it without saving. That way we will have a clean copy for the next exercise. This is important because ProShow saves settings into Saved files—*and* carries them forward into the next Show, where some of them may cause confusion.

Press the < **Tab** > key if needed to see the Timeline. Using the mouse, drag the Timeline **Waveform** to the right until the starting and ending points of the two tracks are visible. (The cursor will have the hand shape. *Don't* hold down the **Control** key, just the left mouse button while dragging.) The exact point is 4:10.54 seconds into the Show, but all you need is to be able to see and select the place where the two tracks meet. If the point in the show is not visible, use the Scroll Bar below the Waveform to adjust the position so you can work at that point.

Now, holding the < **Control** > key, place the mouse over the end of the first clip and, using the handle at either the top or bottom of the box, adjust the shape into a triangle like the one in the top of Figure 4.13. This sets up the **Fade Out** Effect for the ending of the first clip. Use the same technique to adjust the **Fade In** Effect at the beginning of the second clip. Then release the **Control** key, hold it over the second clip (but not at the **Control** box), and drag it to the left so that it lies on top of the **Fade Out** portion of the first clip. The result should look like the example on the bottom of Figure 4.13.

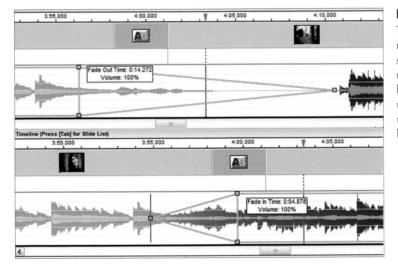

Figure 4.13

The Timeline with the Fade Out being set for the first clip on top, and the crossfade being set by dragging the second clip over the first on the bottom.

Now you can < **Preview** > the result and tweak as needed. The goal is a smooth Transition that matches the pace of the Show and fits with the Slides being seen during the Fades. Figure 4.14 shows portions of the Audio Trimmer for the two clips (the first on the left, the second on the right) after the edits. I've pasted the two views here so you can contrast the way the Trimmer shows the effect compared to the Timeline display. You don't need to open the Trimmer. It's possible to achieve the same results with the Audio Trimmer, but you have to work on one clip at a time—and you can't **Preview** the entire effect there. You have to be in the main window **Work Area**.

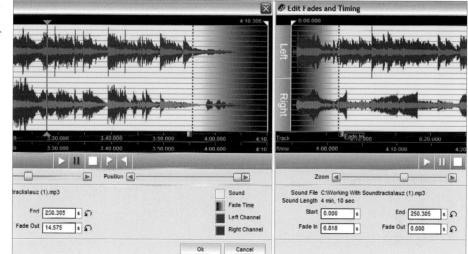

As you drag the Waveform, ProShow will provide a Tooltip noting the amount of Offset time. This will be a negative value, since you are moving to the left. Once you have placed the Offset, drag the **Timeline pointer** to a place before the Fade, about 2 minutes 50 seconds into the Show. Then **< Preview >** to see and hear the result.

Crossfades are used to produce an audio transition so that the shift from one clip to another is easy on the listener's ear. If you want a fast shift in tempo, consider a short crossfade, or none at all. If the change is from a fast or loud track to a softer and/or slow piece of music, consider lowering the volume on the first clip and blending into the new track.

Of course, you can also precisely position a Slide or Transition and set how long it appears in the Show in relation to the soundtrack. The tool of choice for that task, especially for fast tunes, is next on our list. Before proceeding, use the **< Revert to Backup >** command again in the **File** menu to restore the original version of the Show.

Recording Slide Timings—Precise Transition and Soundtrack Synchs

If you need a really precise control to synchronize places in a soundtrack with specific slides—and even Transitions—the **Record Slide Timing** window is the tool of choice. It lets you listen to the soundtrack and hold a specific point in the show until the desired point in the music is reached. Press a key, and the Transition from the current slide is linked to that point in the clip. Keep in mind that this is an advanced program feature, one that most users will not need to use. The easiest way to gain a real understanding is by practicing with an example.

Figure 4.14 The crossfades seen in two screen captures of the Audio Trimmer. Double-click on the Waveform. When the **Show Options>Music>Show Soundtrack** window opens, click on the **< Record Slide Timing >** button in the **Soundtrack Tools** pane on the left side. A window like the one in Figure 4.15 will appear. Mine has already been set to Slide 17. Yours should open with Slide 1 enlarged and will not have the blue marks in the line under the thumbnails and above the row of keys. The time in your window will be set to 00.00.00.

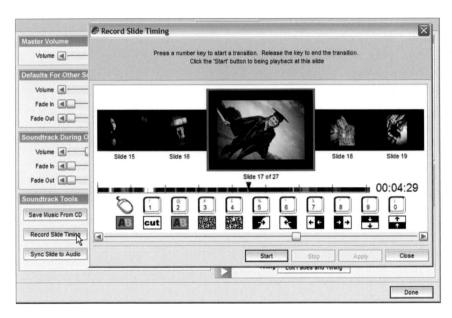

Figure 4.15

Use the Record Slide Timing window to precisely match Slide or Transition times to a soundtrack.

The basic concept of this tool is simple. As you preview the Show, the current Slide will be centered and enlarged in the **Preview**. Press and hold down a button to set the **Start** and **End** times for the desired Transition to use with that Slide. The **Preview** and **Controls** are different from the ones used in the **Slide List** or **Audio Timeline** views, so a short anatomy lesson is in order.

The series of blue marks along the bar (the black line running above the Transition Icons) note the existing **Transition** points. Use your mouse pointer to drag the scroll bar control above the buttons from left to right and all of them will appear. (There was a display artifact in ProShow at the time this chapter was written that made part of the black line turn white, but the blue markers were still visible.) The wider the mark, the longer the time the Transition effect takes to complete. The time between the blue marks denotes the time the corresponding Slide is visible. The time listed to the right of the line is the current time in the Show at the location of the black pointer (just to the right of the last blue marker in Figure 4.15). The marker moves as the show is played. You can move to any point in the show by moving the slider. The large Slide in the middle of the window is the currently active slide, the one that appears just after the last Transition you placed.

To place and set a **Transition**'s time, press and hold the associated key or mouse button just below the related Icon. Click on an existing < **Transition** > icon, and the < **Transitions Chooser** > window will open. Selecting a new **Transition** replaces the current Icon in that position.

Move the slider just below the Slides to quickly move through the Show to find a specific location. The **Start** button activates the **Control**s at the current location in the Show, and the **Stop** button halts the action. No changes are made unless the **Apply** button is used, and the **Close** button closes the window.

The Record Slide Timing Window in Action

Using the **Record Slide Timing** window effectively takes practice. It really isn't designed as a primary timing interface; the **Slide List View** is the best tool for that task. Instead, consider using **Record Slide Timing** when you want to exactly place the beginning and end of one or more **Transitions** or Slides to match exact locations in a soundtrack.

To do this, use the **Position** slider (under the Slide Icons) to locate the desired place in the Show. As the point shifts, the larger Slide in the center of the window will change, and the blue markers and time display will advance. When you have enlarged the Slide *preceding* the desired **Transition** point, press the < **Start** > button. When the soundtrack starts playing the requested audio, hold down the desired **Transition** for the length of time the effect should last.

As the **Preview** progresses, a blue mark will appear in the timeline. This indicates that the Transition time is being recorded. Hold the key down for the amount of time you want the Transition to run (or the place in the soundtrack). When the sound or time is at the point where you want the Transition to close, release the button and set the accumulated time. The next Slide will advance and be displayed in the larger, center position. If you let the Show run, the time setting for the current Slide will increase until you place the start of the next Transition. Pressing the **< Stop >** button holds the current settings.

Tip

Using the **Record Slide Timing** window takes practice. I find it easiest to use for specific edits and make a list of the planned changes before opening the window and using the tools. After setting a Transition, I go back to the **Slide List View**, check the Slide times that come after each edited Transition, and make any tweaks. Often the next Slide's time is not exactly what I wanted. Then I **Preview** that portion of the Show as a final check.

Before proceeding, use the < **Revert to Backup** > command again in the **File** menu to restore the original version of the Show.

Menu-Based Volume, Fade, and Offset Controls

The program's interactive audio editing tools are very powerful, but if you want to manually set numerical values for a Show's soundtrack, ProShow is happy to oblige. The **Show Options>Music>Show Soundtrack** window has several **Volume** Controls. The **Master Volume** slider adjusts the overall volume of the audio for the entire Show. It will raise or lower the audio levels of all sounds at all points of the Show.

Let's say you want to have a voiceover describing a set of instructions playing at enough volume to be heard over the regular soundtrack that is running during that portion of the Show. ProShow provides volume Controls for balancing the relative values of multiple sounds. We can set all the values from the array of Controls in the **Show Options>Music>Show Soundtrack** window. Their panes are shown in Figure 4.16.

Figure 4.16

The Show Soundtrack window provides all the Controls needed to adjust the relative audio volumes when more than one clip is being used in a Show at the same time.

The **Defaults for Other Sounds** volume Control lets you adjust the levels of Slide sounds while a specific audio clip is playing. The **Soundtrack During Other Sounds** slider adjusts the relative volume of the primary soundtrack for the show that is being played at the same time as a sound clip intended for a specific Slide or Slides. The values in the **Fade Out** and **Fade In** boxes located below the Volume slider set the amount of time, in seconds, that a clip takes to rise to full volume or fade to silence.

Adding Audio Tracks from a CD

ProShow has a window that lets you save and use CD audio tracks. To access it, open the **Show Options/Show Soundtrack** window and click on the **Save Music From CD** button in the lower left-hand corner. The **Save Audio Track** window,

shown in Figure 4.17, will appear after a reminder about the need to observe the laws concerning the use of copyrighted materials. You should load the source CD into the drive before opening the window.

	Show Captions Music	
	Show Soundtrack	
Master Volume	Ø Save Audio Track	
Defaults For Other Sound	Source CD Drive D: HL-DT-ST DVDRAM GMA-4082N Track Info C Retrieve artist / track info from the	
Volume I Fade In III Fade Out III	Available Audio Tracks 1. [3:40] Audio Track #1 2. [2:36] Audio Track #2 3. [4:26] Audio Track #3	
Soundtrack During Othe Volume Fade In Fade Out	4, [5:33] Audio Track #4 5, [2:41] Audio Track #5 6, [3:04] Audio Track #5 7, [4:47] Audio Track #6 7, [4:47] Audio Track #7 8, [1:59] Audio Track #8 9, [3:28] Audio Track #9 10, [3:24] Audio Track #10 11, [2:02] Audio Track #11	
Soundtrack Tools	12. [3:42] Audio Track #12 Track Options	
Save Music From SQ Imp shc Record Silde Timing linte liste	Import IV Add Imported track(s) to the show soundtrack Format 0000	100 % 0 s 10 s
Sync Slide to Audio Adj		Cancel previous track

Adding a track is straightforward. Navigate to the desired drive, folder, and file using the drop-down menu at the top of the window, if it is not already visible. If you want to retrieve artist information from the Internet, check the **< Retrieve Info >** box below the file location. Highlight the desired file. (If you are not adding the track to the Show, uncheck the Add to Soundtrack box.) Click the **< Save Track >** button, and ProShow will do the rest.

Adding Soundtracks and Voiceovers to Individual Slides

So far, we have been working with sound that is added to the Show **Soundtrack**. We can also add a clip that is directly linked to one Slide. This is especially useful for adding voiceovers to a demonstration or training slideshow. We'll add a short clip to the second Slide in our Show and explore the options and Controls ProShow offers when adding clips to single Slides.

You can use either Gold or Producer for this session. Make sure the **Slide List View** is showing, not the **Audio** Timeline. Double click on the second Slide in the show to open the **Slide Options** window then select the **Sounds** tab. The **Sounds>Sound Effects** window will open. In the top portion of the **Sound** pane located under the Preview, click on the < **Browse** > button, then **Add Sound File** (See Figure 4.18) and navigate to the Chapter folder that you copied to your hard drive. Select the **au2.ogg** file. This is a short audio file. Click the < **Open** > button, then < **OK** >.

Slide Lay	ers Ef	fects	Captions	Sounds		
	Soun	d Effects				-
Fade In Contract During This Sound Volume Contract During This Sound	8 96 8	ā	und Type Ogg V Length 0:10.0	9 cord Voice-Over s from p intinue playback ck Slide Time to :	revious side of sound after	_

Figure 4.18

The Sounds section of the Slide Options> Sounds>Sound Effects window provides the Controls needed to attach and edit sound clips in individual Slides.

The main soundtrack is now overlaid with the voiceover. The red-colored **Waveform** under the Slide is the new file, placed "on top of" the green Show **Soundtrack**. That was easy enough. But often a sound clip requires some editing to get the desired effect. For that we can use the **Edit Fades and Timing** window. To do so, click on the button located in the bottom right portion of the **Slide Options>Show Soundtrack** window with that same #2 Slide selected.

When tweaking sounds for an individual Slide, we have to consider the way the clip works with the Slide, the neighboring Transitions, and any other active sounds. ProShow makes all that easy by placing all the necessary tools in the **Sound Effects** window. The **Override Soundtrack During This Sound** sliders (See Figure 4.19) let you adjust the main audio **Fade** and **Volume** levels *while only that particular Slide* is being shown. Be sure to check the < **Off /On** > box at the top of the pane. You can <**Preview** > the effect right from the **Sound Effects** window, or return to the **Work Area**. Either way, be prepared to make several volume and placement tweaks to get the effect you want.

Figure 4.19
The same sound
editing tools that arc
available for Show
soundtracks, like the
Edit Fades and
Timing window, can
be used with tracks
linked to a single
Slide.

Finner 4 10

ON Custom Slide	e Sound Set	tings		
Volume			100	8
Fade In 🔳 🗌 –			0.1	8
Fade Out			0.1	8
	have Defaulte 1			100
Default [Edit St	now Defaults]			
ON Override Sou		ing This So		14
ON Override Sou		ing This So	50	1%
Override Sou		ing This So D		% S S

It's tempting to trim an embedded track so that the audio starts right at the beginning of the Slide, but will that give the viewer time to see the full Slide and relate to what is being said? You may want to add an appropriate **Offset**. Each track should be trimmed to suit the specific situation. If you want the Slide to display for exactly the amount of time the clip plays, click on the < **Sync Slide Time** > button located left of the **Edit Fades and Timing** button, and the job is done. Nevertheless, be sure to **Preview**!

Consider whether the Show's primary audio is distracting, and adjust the volume to work well with the dedicated clip. The **Custom Slide Sound Settings** pane lets you adjust both the Volume and Fades for the clip linked to the Slide.

It's possible to actually record a voiceover inside ProShow. In the Effects> Sounds>Sound Effects window, in the Sounds pane, click the < Record Voice-Over > button, the second option from the top, and a Record Sound box like the one in Figure 4.20 opens. Type the proper filename into the Save field, and make sure you've specified an active sound device in the Device box and that a microphone is connected and properly adjusted for volume and audio quality. Click the <Record > button at the top of the window and begin recording. The Record button will change to a Stop button. Click it when you are finished recording.

	 Marting (Planting) Marting (Planting		Record	Duration: 0:00:00.00	
		Save	cks/Untitled Pro	Show 1 - Slide 2.ogg	Browse
0%	0%	Device	Primary Sound	Capture Driver	2

Most current Windows PC come with sound capability and a microphone input. The quality of a voiceover depends on the quality of the sound card, microphone, and environment used to make the clip. The details of setting up a computer for audio production are beyond the scope of this guide. If you need more information refer to either your computer manual or an expert source.

Up Next

We've covered the basics of adding images and sound to our Shows. Now it's time to look deeper into how using Layers lets you really "weave the story" into your Shows.

5

Caption Fundamentals: More Than Just a Way with Words

Pictures may be the stars in our slide shows, but captions are an important part of the visual environment. Basic captions add explanations and details for the viewer. Well-crafted captions are design elements in their own right. ProShow Producer Captions can incorporate sophisticated motion effects and interactive options for the viewer, including active links to Web sites, email requests for more information, or viewing another Show.

That's why there are two Chapters on Captions. This one covers the fundamentals of adding a Caption to a show, and explores related tools common to both ProShow Gold and Producer. The next Chapter explores the Producer-only advanced Captions tools, special effects, and editing techniques.

Many of ProShow's text-adaptive tools look and work very much like those found in word processors. That makes them easy to learn and use. But keep in mind a Caption in ProShow is not exactly like text on a page, a wcb page, or even a graphics program. Captions can be made to move, change size, and be enhanced with special effects—things that their static, page-bound cousins can't do. ProShow's text and Caption tools are designed to do more than just put letters on a page. As a result some controls work a bit differently from how you would expect.

We begin with a Show that demonstrates effective use of Captions and good design, using the tools available in both the Gold and Producer versions of

ProShow. There are two Executable Show files in the Chapter 5 directory included on the CD.

Warning

Be sure you have copied the Chapter folder on the companion CD onto your hard disk before working with the Exercises. ProShow must be able to write to these files to operate properly, which it can't do from a read-only device. **This applies to all the Exercises in this book.**

Please double-click on the one named **Caption_Gold.exe** and view it before proceeding. This production has 16 slides, 14 of them with Captions. The letters wiggle and wag, fade in and out, scroll, explode, and exhibit some most unlettered behavior! All of these effects were created using some basic Captions settings available in both versions of ProShow. Although here there may be a higher density of text (and effects) than found in most slide shows, they are designed to show what even "simple" Captions can do.

Basic Caption Design Considerations

It's a rare slide show that focuses on its text elements and Captions rather than the images. There are some basic rules that are worth remembering (and which can be selectively, creatively—but not too frequently—bent or broken).

It's a good idea to make sure that the picture does not get lost or hidden in a forest of Captions. It you have too much text for one slide, use another slide. A really good design blends Captions and their design, including effects, with both the rest of the slide and the entire Show. We will look closer at the examples in the Shows designed for this Chapter and use them to highlight specific design principles. There are some basics that apply to all Captions.

In the days when fonts were actually carved in wood or set in hot metal, each font size of the same typeface was designed a bit differently to make them easier to read and to make the type better able to stand the stress of the printing press. Most modern computer fonts can be scaled (enlarged or reduced to the exact size needed) without changing the appearance of the letters. If you are making Captions that will be displayed very large or very small, be sure to view the Slide for readability on the target output device. Consider the amount of text, and how long it takes to read and comprehend, when planning slide length and which font to use. In traditional printing, sans serif fonts (like Ariel) are used for headlines and serif fonts (like Times New Roman) for body text. The opposite is generally true in the world of the Internet. The goal in both is readability, and then pleasing design. If a font is hard to read, the reader may stop before finishing the text. If the design is unattractive or looks unprofessional, the reader's impression of the overall worth and quality of the material will be diminished. See Figure 5.1 for an example of dramatic design complemented by a dramatic font, placed effectively.

Captions don't have to hide in corners, or stand still. ProShow provides a variety of tools that made it easy to add special effects to text

elements in a slide.

Figure 5.1

Keep the number of typefaces on a single slide (and even within a Show) to a minimum. The same is true for variations in the way Captions enter, display in, and leave a slide. It's all too easy to create a multimedia version of a "ransom note" when we get too "innovative." Limiting the number of fonts and effects makes it easier for viewers to indentify and read Captions.

Early fonts were crafted to produce books, and typographic conventions were centered on making long passages of text readable—there were no photographs back then. With slide shows, we can be a lot more creative in our use of text and add neat special effects that the craftsmen of the ancient printing guilds never imagined. Still, we share the same goal: visually pleasing readers as we strive to make sure they understand what the words mean. Launch either version of ProShow and load the **Caption_PSG.psh** Show. (Ignore any warnings about file-type issues. The Show will load and work fine in both versions of ProShow.) This version of the Show has been modified from the one you just watched. You won't see the same fonts used in the Show on the Slides. This version has been modified to use standard Windows System fonts and the font settings have been adjusted so that the standard Windows system fonts will display properly within the frame. The unmodified show file **Caption_PSG original.psh** is also on the CD if you wish to use or examine it.

Note

Producer users will see a larger collection of tools in a slightly different arrangement from those in some screenshots, but the basic Options, Icons, Menus, and controls will be the same.

Some of the examples I've used in this Chapter use custom fonts beyond the standard ones that are part of the Windows operating system. That lets me better demonstrate how text can be a primary visual element in a slide. However, it also means you won't be able to exactly reproduce it if your configuration does not have a given font. The caption will load with the default system font if the one called for in the Show is not present. The Show and ProShow's tools will work the same.

The font sizes, for most of the Captions included on the CD, have been reduced in the Show from the original values in the design. That's because the standard default fonts on most systems produced Captions that extended outside the viewable area of the frame. Different fonts will show variations, sometimes significant ones, in size on the screen.

Adding more fonts to your collection is easy and can even be free. A quick search of the Internet will produce a variety of fee-based fonts (like the Adobe Type Foundry), shareware fonts, and freeware fonts. (It's a good idea to check any software from an unknown source for malware before installing it.) Once you have obtained the font file, simply move it into the **Windows/Fonts** directory to make it available in ProShow and other programs on your PC that use the common system font library. I've included one font on the CD, a script font file (**CHOPS_.TFF**). It will add the Chopin Script for use with the Exercises in this Chapter, and we'll install it shortly.

A Special Type of Layer, with Its Own Special Effects

All ProShow Captions share some common elements.

- They all use fonts present on the designer's Windows-based computer.
- They are all placed into the slide using the either the Slide Options or Show Options window.
- They all reside on a special **Captions Layer** that sits in front of all the other layers of a ProShow slide as they are viewed in the frame. That's the top-most position, above the **Layers stack** that contains images and videos that we add to a slide.

Those similarities should not blind you to the need to make a Caption unique and well-suited to its Slide and Show. The pictures in this Show are a collection of high school senior portraits taken by TriCoast photographers Mike Fulton and Cody Clinton. The Show was specifically designed to show various examples of Captions matched for the target audience: high school seniors and their parents. The typefaces and way the Captions work with the design are important parts of giving the Show an appropriate sense of style.

The title slide (**Slide 1**) is designed with those attributes in mind. Figure 5.1 shows it slightly less than halfway through its screen time. The letters are all in motion,

Figure 5.1a

Who says Captions are just words? They are also part of the Show's design. This example uses motion, varied intensity, and a decorative font to help set the mood and attract the eye. just about to swirl into the words **graduation wishes**. The font is definitely more decorative and suited to a poster than the kind you would find in a book report or a newspaper. *Decorative font* is actually a technical term. It indicates that the letters are designed more for headlines than for large bodies of text. It would be a challenge to typeset several pages of a book with all those stars buried within the text. The unusual shapes that make the letters a bit harder to read also make them more likely to be noticed. That's why you frequently see decorative type on advertisements and billboards.

The type is moving over an out-of-focus background. The words are the primary element in this design. When designing a title slide, choose a picture the way that magazine editors and greeting card designers do when planning a layout. Look for an image that offers uncluttered space for your text so that the words don't get lost in the picture. In this case a designer used a Gaussian Blur effect to make part of the image indistinct, and the grassy area provided plenty of room for the title copy.

Blending Text and Motion in the Design

ProShow takes Caption capability far beyond most business presentation slideshows. Captions add color, movement, and decorative elements to the slides. Before working with the tools, let's look closer at several slides and see how **Caption** and **Text Effects** can be combined with images to enhance the overall design.

Use the **Preview** controls to "scrub" **Slide 4**. See how the Layer with the girl enlarges as the Caption appears to flow in to the right (Figure 5.2)? At the point captured in the Figure, the second *i* in the word *beginning* is just about full size, as the next letter, *n*, is fading into view and is just over half size. Creating the movement of the picture was easy. All the designer did was adjust the size and location of the picture **Layer's** ending point with the mouse.

Setting up the Caption's *apparent* movement was simple too. Scrub the Timeline and you'll see that the position of the Caption does not change. The text flows into the frame from one side and grows in size, but does not change its location. The effect is created using a Text Effect. Just like image Transitions, ProShow comes with an extensive library of these predefined effects designed for use with Captions. They are all available via drop-down menus. There are three types; one for how the Caption comes in (**Fly In**), one for how the full Caption displays (**Normal**), and a third for how the Caption leaves (**Fly Out**). In **Slide 4** the Caption slowly grows (using the **Grow Right Fly-In** effect), then sits still (the **Normal** value is set to **None**), and then fades out (using the **Fade Out Fly-Out** effect) as the Slide's ending Transition begins. **Text Effects** are set via the Menus located in left-hand column of the **Captions/Captions Settings** window. (See Figure 5.2a.)

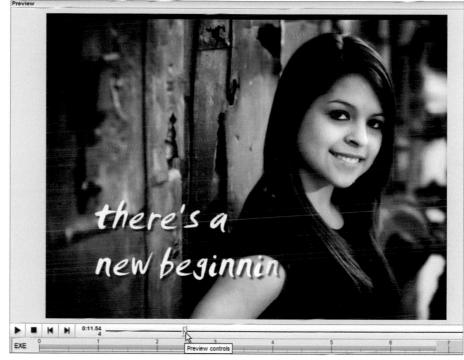

Figure 5.2

Two simple motion effects combine in Slide 4. The picture of the girl grows larger as it moves toward the viewer, while the Caption flows in from the left side of the Slide.

			and a second	-
Fly In	Grow Right	•	Browse	0
Normal	-None-	•	Browse	5
Fly Out	Fade Out	-	Browse	0

Now consider Slide 6, seen in Figure 5.3. This time the picture swirls toward the viewer in a circular motion. The picture becomes larger as the Caption becomes smaller and fades from view. This combination increases the perception of movement. The first **Text Effect** fades the words in from left to right, and the final one reduces the size and the opacity of the letters as they exit the frame.

There is a major difference between the layout of **Slide** 7 (see Figure 5.4) and the earlier Slides. Here the picture has been cropped and placed to provide an open area for the Caption over a black background. Both the picture and the text drop in from the top of the frame, and as the Slide plays, the text moves in a wavelike motion. Notice how the shorter lines of text are arranged to bring the visual center of the motion closer to the girl.

All of these Slides make effective use of Captions within their design. ProShow did most of the work. Caption placement is just as easy as adjusting an image layer. Their motion was even simpler to accomplish thanks to ProShow's built-in tools.

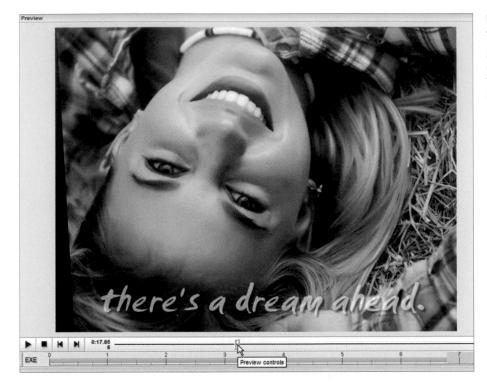

Figure 5.3

The slide's transition plus the Fly-In Effect are used to draw the viewer's eye as the Slide opens.

The happy times you've had so far,

Figure 5.4 In Slide 7 both the image and the Caption slide in from the top.

To get the most from the examples, review the complete Show before moving on to the next part of the Chapter. Consider how the images, text, and the Motion Effects all interact. As you examine each Slide, notice how the picture's composition, open space in the slide, Caption position, and Text Effects are combined in the design.

Good design requires planning where to place text in relation to all the other elements of a slide. It's important to actually view the slide in real time and make sure that the text is not only readable but also docs not distract from other ele ments. Readability in a Caption is more complex than on a page. In both cases the letters must be big enough to see easily, and they need to be displayed in a color that contrasts well against the background. In a Caption, especially one that moves, the lettrs must also be clear enough—and visible long enough—to be read and understood by your audience.

ProShow's Common Caption Toolkit and a Bit of Typography

The basic tools for creating and working with Captions are the same in both Gold and Producer. Let's **Open** a new **Show** and name it **Global.psh**. (I've included the same show containing the Slides, but minus most of the Captions, for readers who don't need practice working with slide creation.) **Add a blank slide** using the < **ALT-I** > keyboard shortcut. Next, **Select** the first slide position in the **Slide List** and then press < **Control-F9** >. That's the shortcut that opens the **Slide Options>Captions/Captions Settings** window.

The top portion of the window has the familiar **Preview** pane and its controls. Below that are two blank areas in the **Captions** pane, used to enter and arrange the slide's Captions. The **Text Field** is on top, just below the **Preview** pane. This is where we enter and edit the actual letters that make up a Caption. Click on the **Add (+)** button on the left side of the **Captions** pane. Now click your cursor inside the **Text Field** box in the Captions pane. That activates it for entering and editing the text of the currently selected item in the **Captions List** below it. Type < **Caption 1** >. Your window should look similar to the one in Figure 5.5, but the size and font may be different.

Selecting and Sizing Fonts

First in the **Caption Format** pane is a **Font** drop-down menu. This contains a complete list of all the fonts currently installed on your system that are known to Windows. (Special fonts designed to be used within programs that are not properly registered with Windows will not show up on this list.) Use the menu to set **Caption 1** in < **Arial Black** >.

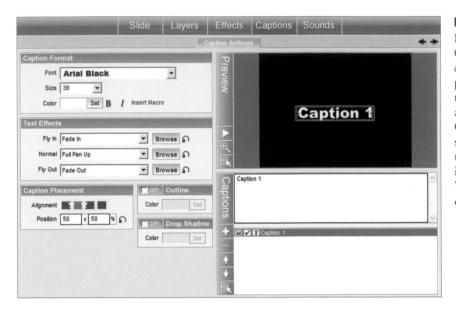

Figure 5.5

ProShow Gold's Caption window contains all the primary tools needed to define, place, and add Effects to Captions. The font selection is limited to those already installed in the computer's Windows/Fonts directory.

Note

This is done directly under the **Captions** pane in Producer. There are a few other differences in tool locations and menu options as well.

Immediately below the **Font** box is the **Size** box. Use the drop-down menu, enter a number directly into the box, or size your Caption using the mouse to enlarge the bounding box, as with a picture layer. Values are set in points. One point is 1/72 of an inch. The print in most newspapers and books is 10 to 12 points. Set the **Size** to < **36** > points.

Now let's add a second Caption. Click on the **Add < + >** button (Plus sign again) and type **Global Caption** in the **Text Field** box. Click the **Icon** at the left end of the **Global Caption**'s entry in the **List**. It looks like a miniature TV screen. It toggles any selected Caption between **Global** and **Local**, that is, appearing on all Slides in the Show, or just that particular Slide. Now set the **Size** drop-down menu as above to **36** points.

Make sure the **Global Caption** Caption is selected in the **Captions List**. That makes it the active Caption. Return to the **Font** menu and choose **Times New Roman**. (You can quickly move to a section of the **Font** list menu by typing the first letter of the font's name when the menu is open.) The size should remain **36** points.

We'll use a menu shortcut to add another Caption to the slide. Right-click on < Caption 1 > in the Captions List. A menu like the one in Figure 5.6 will appear. (I've already added the new Caption in the screenshot.) Choose the Duplicate Caption option. Change the new Caption's text to read < Caption 3 > in the Captions List box, and then adjust the font to Wingdings and make sure the size is set to 36 points. Drag the Captions in the Preview area so they look like the example in Figure 5.6. (I've circled in green the hand-cursor that will appear as you adjust a Caption's position.)

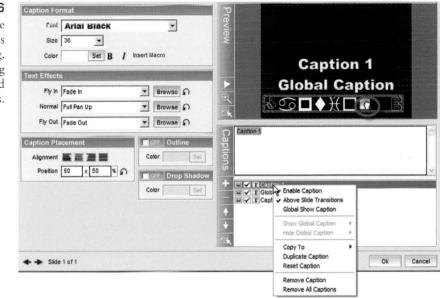

Figure 5.6

The context-sensitive Captions menu is handy for duplicating, copying, adjusting Global settings, and removing Captions.

All Fonts Are Not Created Equal

It's easy to see that our three example **Captions** don't look quite same, even though they are the same size and two of them even contain the same word followed by a single number. That's because each is set in a different font, and one of those fonts (Wingdings) is a symbol font that replaces the regular letters and numbers with special characters so that they can be typed into a document using a regular keyboard. Fonts set to the same size may not *look* the same size, and that requires a bit of typographical explaining.

Type is sized in points according to an arcane formula that is more than 400 years old. One *point* is 1/72 of an inch. Since the letters in a single font vary in size, type-setters decided to use the capital M as a reference point. That is the one letter in the set that is scaled to 72 points. (I told you it was arcane.) In a 36-point head-line, a capital M will be half an inch tall. The other letters in the font might vary in size. We don't have to worry about the details, just how they apply to our Shows.

That's a good thing, since font size in a ProShow Caption is even more variable than it is on paper. A 72-point Caption displayed on a handheld MP3 player will be a lot smaller than one projected onto billboard-sized screen. Consider a very ornate font shown very small; the fancy swirls may degrade and make it hard to tell an e from an o or a p from a q. The effective point size is relative to the viewing device and the typeface used. As designers, we need to consider readability of text. With that in mind, let's quickly review a few facts about fonts.

A *type family* is a collection of *typefaces* that are similar in appearance and design. A *typeface* is a specific type style, irrespective of size and weight. A *font* is the complete set of letters, numbers, punctuation marks, and symbols available in one size and typeface.

Classes and Styles of Type

There are two basic classes of type: serif and sans serif. *Serif* is the word for the little flourishes on letters that add to the character (and readability) of a font. Times Roman and New Century Schoolbook are familiar examples of serif type. *Sans serif* means the font is designed with minimal ornamentation. Common examples of sans serif type include Helvetica and Switzerland. Most of the words we read are set in variations of these familiar families. See the examples below.

These two major classes are broken down further into categories by intended use: *Text* (used for general reading material as in textbooks and body text), *Display* (advertising, signs, and headlines), *Decorative* (invitations, posters, and seasonal and specialty items), and *Symbol*.

Symbol fonts often don't have a full set of alphabetical letters, but rather offer an extended collection of special characters like business, mathematical, scientific, or musical symbols. These are usually type elements that are not found on traditional keyboards, including items like the copyright symbol and square root notations. **Wingdings** are a type of symbol font that includes items like heart shapes and astrological signs. Most common fonts offer a collection of common symbols, and ProShow offers an easy way to add them that we will work with later in the Chapter. The following list shows examples of well-known members of the different font families.

Serif Font Examples: Times Roman, Garamond, and New Century Schoolbook.

Sans Serif Font Examples: Helvetica Bold, Arial, and Lucinda Sans.

Decorative Font Examples: American Text, Brush Serip, and Old English Text.

Setting Bold and Italic Styles

Font Styles refers to specific variations of the basic way a typeface looks. Not all fonts have all styles available. Body, **BOLD**, *italic*, and *BOLD italic* are the most common. Some typefaces come with several variations of the basic style, with names like Light and Narrow.

ProShow provides an easy way to set bold and italic styles. The **B** and **I** Icons, located to the right of the **Color** box in the **Caption Format** pane of the window, toggle a selected Caption's text to bold and/or italic, respectively. The results vary with the Caption's original font. We could go into a study of the true nature of bold and italic, but a demonstration is much more practical.

Double-click in the **< Preview >** pane to open the slide in the **Precision Preview** window. Below the **Font** box, click on the **< B >** Icon with each Caption selected in turn, and notice the relative change in size. I've made duplicates of all three Captions. The original is on the top, and the Bold version right below it. See Figure 5.7.

As you can see, only the middle Caption looks much or any different when set to **Bold**. Fonts that are already formed in Bold, like the Arial Black used with Caption 1, aren't affected by the style change. The same is true for most symbol fonts and many decorative fonts. Standard body text fonts, like Times Roman and plain Arial, will look thicker and expand horizontally when made Bold.

Figure 5.7

Using the Bold command produces different results with different fonts. Those that are already Bold, or that don't really have a Bold style, will change very little or not at all. Standard text fonts will usually look thicker, and the line of text will become longer. You may need to allow for that factor, if a Caption needs to fit into a specific space in a Slide. Notice that making the Caption Bold didn't make the letters taller, just longer. They are still set as 36 point, and the height of the capital *M* stays the same. Select each Caption in turn and click on the < **Bold** > Icon to toggle the font back to its normal state. Then close the **Precision Preview** and **Captions>Captions Settings** windows to return to the **Work Area**.

Adding Another Slide and Caption

It's time to add another slide to our Show to experiment with and review the skills used. If necessary, use the **Folder List** to navigate to the Chapter 5 Folder on your hard drive, and click in turn on the three image files to load them into the **File List** pane. Drag the file of the young man at the water's edge named **TC b-033** into the second position on the **Slide List**. When you release the mouse, it will become the new **Slide 2**.

Now hold down the **Control** key and drag the file with his close-up portrait (**TC b-066.jpg**) onto **Slide 2** on top of the first file. We now have two **Layers**.

Set the **Transition between Slides 1 and 2** to **Cross Fade (Blend) Linear**. That's the one with the **AB** side by side whose Icon appears raised next to the **Cut** transition in the top row on the lower-right corner of the **Choose Transition** window.

Open the **Slide Options** >**Effects**>**Motion Effects** pane. Use Figure 5.8 as a visual reference for the placement of the two **Layers** at the starting and ending positions. Using the mouse is fine, or you can enter the values as follows. Start with **Layer** 1 selected (the Figure shows **Layer 2**).

Layer 1 Starting Position has a **Zoom** value set to at 83 and the **Rotate** set to -30. The **Pan** values are 32 x 41. **Ending Position Zoom** is set to 113 and a **Rotate** value of 32. The **Pan** is 20 x 18.

Layer 2 Starting Position has a Zoom value of 120 the **Rotate** set to 25. The **Pan** is at 27 x -69. It ends with the **Zoom** at 153, the **Rotate** value set to -15. The **Pan** is at -5 x 51.

I usually preview motion effects by scrubbing the **Slide List** or (in Producer) the **Keyframe Timeline** before adding any Captions. That lets me see how the effect works visually and identify areas in the image that should not be obscured by the Caption, or that might present a major distraction when trying to read the Caption during the Show. Grass-green slides won't do well over a picture of a well-maintained golf course, and red may not be the ideal color for a caption with a fire truck behind it.

Figure 5.8 Which comes first, the pictures or the words? This time it's the images, but the choice often depends on the relative importance of each and which approach better helps the Slide's creator see and work with the relationship between them.

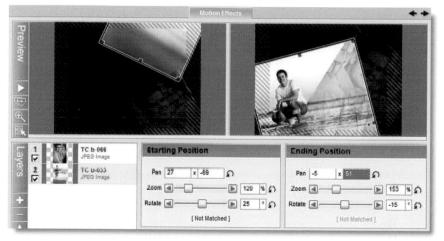

Make sure **Slide 2** is selected. Click on the **Captions** tab to open **Slide Options** >**Caption Settings**. Add a **Caption** with the words **So Dream Your Dreams**. Place a carriage return between the words *Dream* and *Your*. Use the *Script* font that is included in the Chapter 5 folder or a similar script font.

Note

If you don't have a script-style font on your computer, copy the **CHOPS_.TTF** font file to the **Windows/Fonts** directory on your primary hard drive. You could also install the font using the Fonts utility found in the Windows Control Panel.

Set the size as 30 points. Notice if the **Bold** Icon is active. Try turning it on and off. If yours is a old font like this, it won't make a difference in the appearance of the letters.

Use the mouse to move the **Caption** to the location shown in Figure 5.9. Exactly matching the location in the screenshot isn't critical. Just as with picture Layers, we can adjust the **Position**, **Scale**, and **Rotation** of a Caption using either the mouse or by entering numbers into the appropriate data box.

Click on the < Set > button and the use the Caption Format Color Wheel to match the example in Figure 5.9. (I've enlarged the Color Wheel to make it easier to see the details.) The Hex values for the three boxes are 245, 194, and 31. The Outline and Drop Shadow panes are active in the screenshot so they can be formally introduced. You have to click the check box in their upper left-hand corners to enable them. Then their Set Color buttons are used just like the one for Caption Format color. You can see them in Figure 5.10.

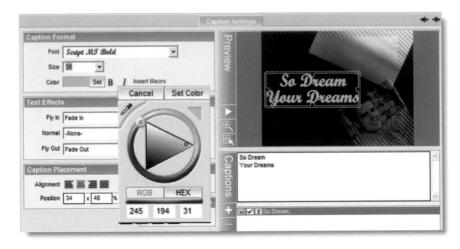

Figure 5.9

The new slide with its Caption in color, and an Outline and Drop Shadow defined.

The primary use of an **Outline** is to help separate an object, like a **Caption**, from the objects behind it. Set the **Outline** for the **Caption** to < **white** >, as it is in the screenshot. Enable and disable it and move it over the darker and lighter areas of the two pictures a few times and watch what happens to the letters. They look a little larger and lighter with the outline active. Now set the **Outline** color to < **black** >. The visual relationship between the Caption and the pictures will be different. **Drop Shadows** are an alternate way to provide visual separation between objects, often with a more three-dimensional look.

Choosing a Caption's color, and deciding on the use of **Outlines** and **Drop Shadows**, can be very subjective. A lot depends on the size and font of a Caption and the objects underneath it during its time on display. With the right combinations of **Drop Shadow** and **Outline**, you can place white on white and make it readable—sometimes. The nature of the underlying layer, the relative contrast between them, and Motion and Text Effects all are factors that can often be judged accurately only during Previews, and sometimes (rarely, thankfully), during fullsized playback.

For our current Caption, let's turn both the **Outline** and **Drop Shadow** off.

Making Captions Move Using Text Effects

The **Motion Effects** we watched in this Chapter's opening Show made use of very complicated special effects. Those effects required lots of planning. Fortunately, they are already built into ProShow's toolkit. There are more than 100 **Text Effects** in the collection, and they can be applied to any Caption with the click of a mouse.

There are three types. **Fly In** text effects control how a Caption enters the frame; **Fly Out** text effects determine how the letters disappear at the end of the slide and **Normal** controls text behavior in between **Fly In** and **Fly Out**. See Figure 5.10.

	iption Settings
Caption Format Font Scupt .M.S Bed Size B Color Set B / Insert Macro Toxt Effects Fly In Fade In Normal -None- Fly Out Fade Out Fade Out Fade Out Fade Right Alignment Fade Right Alignment Fade Right Fade Tail Fade Ta	Provo Settings

Text Effects have descriptive names indicating the style and direction of the motion applied. For example, the **Zoom In Fly In** effect makes the Caption grow from small to full size, while Captions given the **Fade-Down Fly Out** effect will become transparent as they scroll down and out of the frame.

The major **Fly In** categories include Elastic, Pan, Fade, Grow, Spin, Spring, and Zoom. **Normal** categories include Pan, Grow, Galactic Scroll (this one looks like the opening credits in the *Star Wars* movies), Shrink, Pulse, Rotate, Strobe, Slide, Spin, Warp, and Wave. The major **Fly Out** effects categories are Elastic, Explode, Fade, Pan, Shrink, Spin, and Zoom.

X

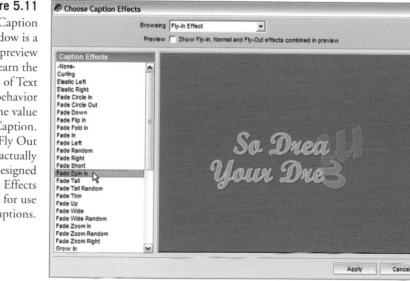

Figure 5.11 The Choose Caption Effects window is a handy way to preview and learn the variations of Text Effects' behavior while setting the value for a new Caption. Fly In and Fly Out effects are actually specially designed Motion Effects developed for use with Captions. The three drop-down menus in the **Caption Settings>Text Effects** pane let you assign any of the Text Effects, but we are going to use an alternate approach right now. Clicking on any of the **< Browse >** buttons, located right of each of the three **Text Effects** boxes, opens the **Choose Caption Effects** dialog (shown in Figure 5.11). This dialog provides the best way to gain a quick working knowledge of **Text Effects**—and to sample them—and to Preview the different major styles.

Make sure **Slide 2** is selected and open the < **Choose Caption Effects** > dialog now. At the top is a drop-down menu to select which of the main three types you want to modify or observe. The drop-down list on the left-hand side of the window displays all of the available effects. On the right-hand side, the **Preview** window plays a continuous example of the selected effect(s). The screenshot shows a jumble of letters matching the curling **Fly In** effect that was Previewing as it was captured.

In the center of the top pane is a **Preview** check box. When it is enabled, from one to all three of the currently-selected **Text Effects** for the slide are continuously displayed below in the **Preview** pane. When the box is unchecked, only the one **Text Effect** selected above it is **Previewed**. Check the box now. When all of the **Text Effects** for the active slide are set to **None** (as is probably the case with your Show), the **Preview** area in the **Choose Caption Effects** dialog shows just a blank, solid-gray background while the Caption blinks continuously.

Let's change that by adding some effects to our Caption. Pick < Fly In Effect > from the drop-down menu, then < Elastic Right > from the list of available Text Effects. Next, change the drop-down menu to < Normal Effect >, and choose < Shrink Slowly >. Change the effect to < Fly Out Effect > <Elastic Right >.

The only way to control the speed of **Text Effects** is by adjusting both the running times for the Slide and the **Transitions** on either side of it. The longer a slide is displayed, the slower the speed of its **Text Effects**. The shorter the time, the faster the effect.

As we work, the **Preview** changes to show the current settings. If you are curious about the different styles, experiment with different combinations. Using the **Caption Effects** window is an easy way to quickly become familiar with Text Effects, and how to combine them into pleasing combinations. Take some time to experiment. Vary the Slide Times and notice how longer and shorter values modify the visual impact of the effects. The right combination for a given slide will vary, based on the overall design, the images used, the font, and the mood or message intended for the viewer.

After I introduce the rest of the common Caption tools, we'll look at some more examples from the Slide. For now, close the dialog box

Alignment and Anchor Points

The same X-Y coordinate system we use for graphic Layers works for Captions, too. The first value sets the X-axis and the second value the Y-axis. That location is called the Caption's Anchor point. When a slide has only a single Caption, critical positioning usually isn't necessary. But when several Captions share space in the frame, and when you're working with Caption >Motion Effects in Producer, planning and precision become more important. Those require more understanding about how Anchor Points and Alignment work.

Tip

Sometimes new Captions that may be placed outside the **Preview** area arc in the **Slide List** or **Slide Options** window. In that case, open the **Precision Preview** window and **Zoom Out** to locate and position them.

Refer to Figure 5.13. Notice the four **Icons** to right of the word **Alignment** in the first row in the **Caption Placement** pane in the **Caption Settings** window. They look like the text alignment Icons found in word processors; they work a little differently in ProShow, however. Traditionally, "Alignment" is the way a line of text is set in relation to the "page." In ProShow, **Alignment** determines how multiple lines of text are positioned inside a Caption's bounding box—and exactly how the bounding box is positioned over its **Anchor Point**.

If you change the **Alignment** setting for a Caption, it may move. That's because the **Anchor Point** of a Caption is relative to the **Alignment** setting. (Don't worry about the technical details.) Figure 5.12 shows examples of each of the four **Alignment** styles with their **X-axes** lined up with the vertical center of the slide. They are in same order from top to bottom as they are arranged in the Captions window and in the following list.

Left Alignment places the Caption so that the left side of the bounding box is vertically centered at the current position for the Caption, and the text inside the Caption's bounding box is shifted so that each line of text is aligned against the left side of the bounding box.

Center Alignment places the Caption so that the center of the bounding box is centered at the current position for the Caption, and the text inside the Caption's bounding box is shifted so that each line of text is centered within the bounding box.

Right Alignment places the Caption so that the right side of the bounding box is vertically centered at the current position for the Caption, and the text

inside the Caption's bounding box is shifted so that each line of text is aligned against the right side of the bounding box.

Fill Alignment places the Caption so that the left side of the bounding box is vertically centered at the current position for the Caption, and the text inside the Caption's bounding box is shifted so that each line of text is against the left side of the bounding box. (In some versions of ProShow Gold, the tool tip that displays for Fill Alignment uses the term Fill Justification.)

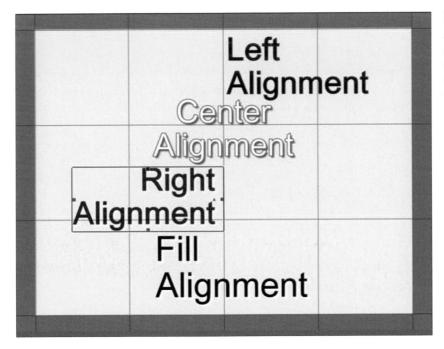

Figure 5.12 A Caption's Alignment setting determines where the text is placed inside the bounding box.

ProShow automatically positions the **Anchor Point** of the first Caption added to a slide directly in the middle of the frame. If you add additional Captions to a slide before the first one is moved, ProShow will put the new arrivals directly below the preceding ones and provide some vertical space between them based on the size of the font being used.

When you're placing a single simple Caption, it's easy enough to adjust position and alignment by eye so that the result is visually pleasing. When more precision is needed, having a firm understanding of Caption placement is essential. ProShow offers some really valuable tools that let us generate Global Captions and pull information from the files placed in the Show's slides. We'll make use of the program's placement features (and gain some practical experience) as we add **Macros** to our next slide. Now click < **OK** > to save the adjustments and return to the **Work Area**.

"Automatic" Captions: the Power of Macros

ProShow Captions can be enhanced with **Macros** (abbreviated alphanumeric instructions). Macros let us quickly add symbols and special characters to a Caption. They can be used to automatically create Captions that show the filename of the picture in a slide, the complete path to its location, exposure data, and the date and time it was taken. And they can be set to add that data to a single slide, or to every slide in the Show.

To see them in action, we need a new Slide and we need to create a caption to use them with. Add the slide by dragging the file named < **TC c-003** > (located in the Chapter folder) into the Show. Make the Slide duration **6 seconds**. Now open the < **Captions>Caption Settings** > window with that Slide selected. Add a Caption to the Slide that says **Working with Macros**. Place a carriage return after the word **with** so that the word **Macros** is on a line by itself.

Set the font to **Arial**. (If you click on the drop-down menu and press the letter *a* on your keyboard, the list will move to that part of the alphabet.) Make the size for the new Caption **30**, and set the style to **Bold**. Make the Caption color **white**, and set the **Alignment** to **Center**. Leave the **Outline** and **Drop Shadow** fields disabled. Your slide and its Caption should look like the example in Figure 5.13.

Note

ProShow will remember the settings we just applied and use them as the default for any new Captions until we change them.

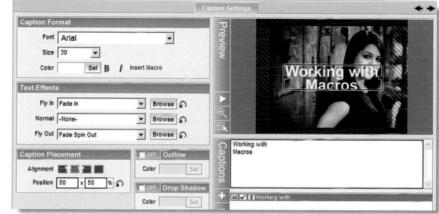

Figure 5.13 The first Caption predictably appears in the exact center of the slide, thanks to ProShow's default placement configuration.

Inserting Special Characters into a Slide with Macros

Click on the < **Plus** > sign to add a new Caption. Now click on the < **Insert Macro** > command (noted with a red arrow). The **Insert Macro** dialog will open, as in the foreground of Figure 5.14. Use the top drop-down menu to choose < **Symbol Macros** >. There are a number of very useful symbols in most fonts that are not displayed on a standard computer keyboard. For example, the copyright symbol (©) is commonly used in slide shows to warn viewers that the content is owned and protected. It is part of almost every standard font.

Note

Speaking of copyrights—keep in mind that these files are actually copyrighted by the photographers that own them, and they are just on loan to you specifically for use with these exercises and not for any other use.

Producer users: Note that the Insert Macro link is located below the Caption List.

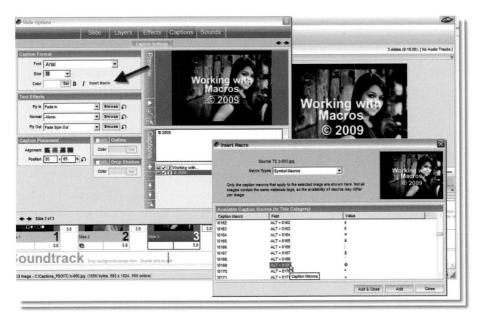

Figure 5.14

Special characters can be inserted into a Caption using the Insert Macro window, or by typing in the appropriate Alt-[number] combination. There are three ways to enter these characters into a Caption. Use the method that is most convenient for you.

- The Insert Macro dialog contains all the current font's symbols, along with their Macros and the actual symbols. (Most character numbers are the same for all common text fonts; symbol fonts may vary.) You can click to select the desired item, and then choose the < Add> or the < Add & Close > button to place the symbol into the Caption. The symbol will appear immediately on the slide.
- Secondly, each of the symbols is assigned a number in the font table. If you know the number, you can place the cursor where you want the symbol to appear in the Text Field, hold down the < Alt > key, and type the number. I just entered the copyright symbol by typing < Alt 0169 >. The symbol will actually appear in the box at that location and in the Caption in all ProShow Preview panes.
- Thirdly, you can also enter a symbol (or any other Macro value) by typing \macro code in the desired location in the Caption text in the Text Field.

Note

Some fonts may not contain the character or symbol you wish. In that case, trying to insert it as a macro will not work.

Let's use the second method right now. Add a space and then hold down the **Alt** key and type **0169**. The © symbol appears. Now add a space and the number **2009**.

There is an obvious issue with the location of the new Caption. It's overlapping the bottom line of the first one. ProShow makes an allowance as it inserts additional Captions into a slide. The first Caption placed on a slide is always placed with its anchor point in the exact center of the frame (**Position 50x50**). If you add a second Caption, it will be placed a set number of points below the first one based on the size of the currently-used font. Let's say the point size is 15 points. The second Caption will be offset by an interval of 15 points, to **Position 50x65**. The next Caption added will appear at 50x80, the next at 50x95, and so on.

If the first Caption has only one line of text, the default space between the existing and new Caption that ProShow automatically provides will have been enough. When we add multiline Captions, some manual adjustment will be required. We'll wait until all of the Captions for this slide are in place to correct the Caption positions. **EXIF metadata** macros read **metadata** information from the file on the currentlyselected Layer and place it in the Caption. The available data will vary, based on what was captured with the image file as it was created and modified. This is one set of macros that is much easier to define using the **Insert Macro** dialog than typing it out. The syntax is a bit longer than for other types of macros.

Predefined macros use a shorthand code to identify the file information to be placed in the Caption. They also draw the information from the file for the currently-selected Layer. Click on the **Plus Sign** to the right of the **Captions List** to add a new blank Caption to the List, and then click on the < **Insert Macro** > button. Select the **Predefined macros** Option from the **Macro Types** drop-down menu. Insert the macro that displays just the name of the file from the available macros, as shown in Figure 5.15. The mouse cursor is pointing at the macro to use. This Caption should appear at position **50x80**.

Be sure to click on either the left or center columns. They will insert that Macro code. Clicking on the right column will enter the data for that specific item and repeat it on every slide. Click on the < Add & Close > button when you are finished.

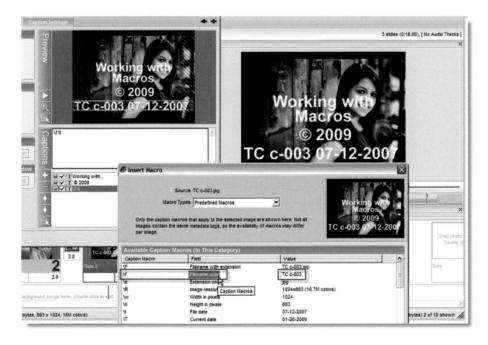

Figure 5.15

ProShow macros can insert information from an image's EXIF metadata and a file's attributes (like the filename and size). This example displays the date and time the picture was taken.

Show Captions, Globalization, and the Art of Invisibility

So far, we have been placing Captions on individual slides using **Slide Options;** the **Show Options/Captions** window offers the ability to turn a Macro into a database command that can be used to place slide-specific information in every slide in a Show. Macros wouldn't save much time if we had to apply them to one slide at a time. They can also be used to exclude specific slides from such *Global* operations (i.e., those which are applied everywhere).

Close any open windows other than the main ProShow **Work Area**. Press < F5 > (or choose < Show>Captions > from the main Menu). The Show Options> Captions>Show Captions window will open. It provides similar controls to those in the Slide Options/Captions window. There are no Preview controls, and the only thing that shows in the Preview pane will be the defined Global Captions. Individual captions placed on Slides will not be seen. That's because this window sets up Global Captions, which are replicated for every Caption in the Show.

Note

There are ways to hide a **Global Caption** and change its order. More about that soon.

Adding a Global Caption

We are going to add a **Global Caption** that displays the filename and file size of the **Layer 1** image in the upper right-hand corner of the frame using predefined Macros. They are available from the same menu we just used. This time the Caption will be set to show on all slides with a **Layer 1** in the Show. We are going to enter them using the keyboard. (I didn't mention which slide to place the Captions on, since the **Captions** are **Global**—we can assign them with any Slide in the show selected. I'll use the current slide.) Keep in mind that blank slides, and any that only contain Captions have no filename to display. Use one that does have a Layer 1 with an image file present.

You can add a new **Global Caption** by placing the mouse cursor in the **Text Field** located below the **Preview** (see Figure 5.16). It's better to actually click on the **Plus** sign located in the column. If you don't, the Caption may not show up in the Captions List in the Slide Options window. Click on the **Plus** sign now.

Type $< \ f >$ on the first line, add a second line by pressing the **Enter** key, and type $\ S$. The $\ f$ adds the filename, and the $\ S$ the file's size. These Macro codes will obtain and display the file information for the first content Layer on each slide. It is not possible to set up a second Caption to display information from another **Layer**.

Adjust the settings for the new Caption as follows. The font should be **Arial**, size **14** points, and the **Alignment** set to **Left**. Adjust the position to **83x16**. The Caption color is **White**. Make sure both the **Bold** and **Italic** styles are turned off. Add a **White Outline** and a **Black Drop Shadow**. Modify the text effects so that the **Fly In** field is set to **Fade In** and the **Normal** and **Fly Out** fields are set to **None**.

Close the **Show Captions** window and press < **Control-F9** >. That reopens the **Slide Options**>**Captions** window. Note the three **Icons** in front of each Caption in the **Captions List**. (See the **Captions List** section overlaid on the third slide in Figure 5.16.) The left-most Icon for top three Captions is a rectangle, representing a Caption limited to one slide. The bottom Caption has an **Icon** with three rectangles there, denoting a **Global** slide.

Clicking on an Icon toggles its state. **Global Icons** can be set to **Local** (they are then only seen on the selected slides), and vice-versa. When the **Check Mark** is visible, the Caption will be visible on the Slide (s). Click it off, and the Caption becomes invisible. The Square **T** determines if the Caption will be modified by the Slide's **Transition Effects**, or "ride above" the **Transition Effect** and remain in view the entire time. Toggle it on and off to see the effect.

All Captions Are Not Created Equal

The new Caption should now be visible in the upper right corner of the second and third slides in our Show and in the **Preview** area of the **Slide Options** window when you open a slide. As you have seen, the tools for creating and adjusting **Global Captions** and **Captions with embedded macros** are the same as the ones we use for working with standard Captions, but there are some fine points of using **Macros** and **Global Captions** that tend to confuse the uninitiated.

Figure 5.16

Global Captions are added to every Slide's Captions List in the Show. You can tell they are global by the Icon with the three squares in front of the listing. Captions that are only shown on one Slide have a single square for an Icon. With **Slide 3** selected, double-click in the **Slide Options Preview** area to open up the **Precision Preview** window. It should look like the screenshot in Figure 5.17. We now have a large Preview of the slide. All four Captions are present in the **Captions List**, but only **Captions 1** and **2** are visible—the **Preview** window can't display information that is generated by the action of a **Macro**. During the Show, **Slide 1** will not show the Macro-generated Caption because it does not contain any external file layers, and so there is no file data to display.

The Precision Preview Window gives us a larger copy of the slide, making it easier to place Captions. Some Macro data will not be shown in this window. The date, for example, has a default value in this window, and shows the real file date in the actual Show.

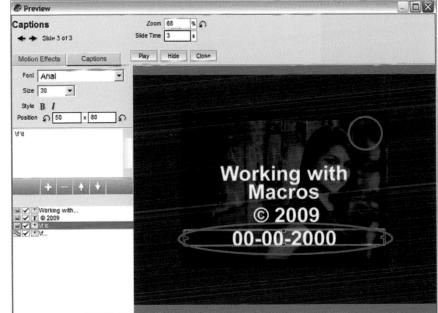

Like the file information, it is a fixed element. That's why it can be seen. The file name has been recorded as a default place-holder. Hence the **00-00-2000** Caption I circled in green. The ProShow development team was working on improving how such Captions are shown in **Precision Preview**, so your screen may look different. While we have the window open, let's move **Caption 1** (Working with **Macros**) up so that it does not encroach on the top of Caption 2. Change the **Caption 1 Position Settings** to **50x45**.

Close all windows except the main **Work Area** and slowly examine **Slide 2** by scrubbing the line using the control beneath the **Preview** pane. Watch the upper right area as the **Global Caption** with the file information is presented. The sky makes it difficult to see the information. We can use ProShow's **Drop Shadow** and **Outline** features to improve a Caption's readability. Open the **Slide Options/Captions** window and select the **Global Caption**. Set both the **Outline** and **Drop Shadow** colors to **black**. Figure 5.18 shows the result superimposed to the left of the unmodified Caption with the settings pasted underneath each.

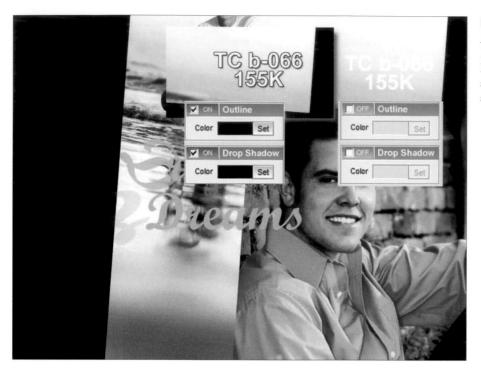

Figure 5.18

Adding Outlines and Drop Shadows can help a Caption to stand out against some backgrounds.

The contrasting outline makes the text easier to read, without blocking up the white letters. My own workflow includes at least one viewing of the entire Show that focuses on just the Captions. Are they all easy to read? Do they move as planned? Do they sit on the screen long enough to be easily read by the viewer? Depending on the images in the slides, a different combination of colors or a change in font might be in order. The proof is in the seeing.

Since this Caption is **Global**, the change applies to every other Slide in the Show. Let's adjust the Caption's position with the mouse. Shift it so that the text is just inside the safe zone. The screenshot already shows the change. Changes made to the appearance of a **Global Slide** will be seen in all the other slides in the Show that share the modified element.

Look at **Slide 1** to see how this works in practice. The only text showing on the black background is the Local Caption. The Global Caption isn't visible. Open the **Slide Options** window, double-click to see the **Precision Preview**, and check the contents of the **Captions List**. The reason we don't see a metadata Caption is that the slide contains no Layer with an image file, so there is no filename to list or file size to report (see Figure 5.19).

Figure 5.19 The Global Caption that displays filename and file size is absent from this slide because it does not contain a Layer with an image or video file that reports data to the Macro function.

A Closer Look

Now that we have worked with ProShow's primary Caption tools, let's revisit the **Captions_PSG.psh** Show and examine how Captions are used in selected slides in the Show's design. I'll provide figures as we go along. You can watch the Executable version, or load the Show file and scrub the Slide List to watch the effects as the move on the screen.

This Show uses a series of related Captions, producing a running commentary that is matched to the selected pictures. The fonts are similar to those used on professional posters and underscore the high-quality and well-styled pictures. The quick pace of the Show, the Motion Effects, and the Caption Text Effects allow the viewer to read the Caption and see the image but not dwell on them. Longer display of the Slides and Captions would change the mood of the Show.

Slides 5 and **6**, shown in Figures 5.20, are examples of how good design operates. Each Slide has a Caption that carries half of the phrase "for every memory, there's a dream ahead." The picture of the young man has a darkened tone, the portrait was taken with dramatic side lighting, and the subject has a quiet, almost pensive look. The picture and words indicate reflection, memories. The line break and Text Effects used with the Caption given a little extra emphasis to the word "memory." Although the images in both slides are presented with a circular motion effect, the slower rotation in **Slide 5** creates an appropriate lingering effect.

Slide 6 shows a young woman lying on her back looking at the camera. The motion effect quickly spins her face as the image grows in the frame. The Caption fades in across the bottom. This image is bright, and so is the girl's smile. The visual impression, combined with the text, lets the viewer imagine a pleasant day-dream of the future.

Figure 5.20

Slide 5 and Slide 6 combine to make a statement that is reinforced by the pictures and Motion Effects.

The visual flow of the Slides continues to match the words in the Captions. Slides 7, 8, and 9 all work together by using slight variations and good eye-carriage the way Motion, Text Effects, and the pictures in each work individually and together.

Slide 7 shows a young woman on the right side of the frame, and the Caption drops into the black area on the left side and wags as it reads, **The happy times you've had so far**. The Caption is aligned right to bring all the words close to the picture. Slides 8 and 9 are shown in Figure 5.21. The Captions continue to alternate in the series from side to side, and so does their alignment. The pictures carry the visual theme, with young ladies facing the center of the frame. The text effects on both Slides 8 and 9 drop in to pull the eye into the Slide.

The people you have met.

Figure 5.21

Alternating use of right and left open space and green and pink Captions, along with mirror-image poses, complete the "matched" effect of Slides 8 and 9.

The designer wove Slides 10, 11, and 12 visually into another Caption triple-play. The Caption on Slide 10 (shown on the left in Figure 5.22) enters from the left side using the **Elastic Right** Text Effect. The picture pans in from the right at the same time. All three Captions are separated by the same two-pass, door-opening **Transition**. The Caption in Slide 11 (not shown) starts a new phrase, but one that continues the overall statement of a changing time of life.

Flgure 5.22 Slides 10, 11 (not shown), and 12 combine with Transitions, Text Effects, and Layout to maintain the viewer's attention.

The subject in **Slide 12** (shown on the right side of Figure 5.22) has the same direct gaze. The Caption is displayed as a single horizontal line apart from the subject of the picture. Consider how the three Slides (and in fact in the entire Show) use eye carriage, open space in the pictures, the actual words in the Captions, and the movement of Text Effects to convey a visual theme and keep both the eye and the mind of the viewer engaged.

The final Caption in the Show is on the next-to-last Slide (shown on the right side of Figure 5.23). It opens using a slide open-corners effect that reveals the text as the preceding picture of the teenager walking (on the left half of the Figure) is divided into four sections that pull out and away to the corners of the frame. The designer uses the same decorative font that graced the Title Slide at the beginning. The Title Slide's picture included an out-of focus student in the background. The Ending Slide has the same girl, on a Slide without a Caption, in her graduation cap and gown. The balance at the beginning imparts a subtle symmetry to the overall design of the Show. In many Shows the Captions play a secondary role, and the nature of the design and the way text is used have to be adjusted accordingly. However, in this example, the text—what it says, and *how* it says it—is a major element in the design. All the other components were tuned to the words, and creative vision with Captions, Text Effects, and Transitions contributed greatly to a lively and impressive Show.

Figure 5.23

The closing statement takes center stage, as the Transition opens directly onto the center of the frame and the Caption by itself.

Up Next

The basic ProShow Caption toolkit we used in this Chapter is only the starting point when it comes to working with Text Effects in Producer. Advanced typographic control and Keyframes let us create sophisticated Motion Effects and precisely adjust the appearance of text on slides. In the next Chapter we will use Keyframes to dramatically expand our ability to fine-tune every aspect of a Caption, and also work with interactive Captions that allow user-chosen variations of a Show, and which let the designer link the Show to websites and obtain e-mail responses from viewers.

6

Getting Fancy: Advanced Caption Tools and Keyframing Basics

This is where the fun really begins. We've covered ProShow's basic tools and concepts. Now it's time to shift into the program's high-performance mode and start working with ProShow Producer's powerful Keyframing tools. Combined with Producer's advanced graphics capabilities and interactive Caption toolkit, that gives us all the tools we need to create really professional multimedia Text Effects. This Chapter serves as the foundation for working with Keyframes and ProShow's multi-layer Motion and special Effects techniques in the following Chapters. I'll review the basics of Keyframes as we work. Keyframe tools and operation were discussed in Chapters 2 and 3 in more detail and touched on in Chapter 5.

You will need Producer to follow along and work with the examples. That's because Gold lacks Producer's Keyframe editing tools and its advanced text manipulation features. The latest version can be downloaded from the Photodex website, Photodex.com, or you can use the trial version included on the CD in the back of the book. *You must copy the folder with this Chapter's Exercise files to your hard drive*. In the Chapter 6 Folder of the CD-ROM is an Executable Show file named **Chapter_06.exe**. First off, open Producer, and please watch the Show by doubleclicking on its icon. While watching, pay particular attention to how the Captions enter and leave the frame in relation to each other.

Note

In ProShow Gold all Captions (and all Layers) share the same timing as the Slide. That restriction is lifted in Producer. Keyframes and interactive control give us the power to make Captions do some amazing things.

Keyframes Defined, Captions Redefined

Standard Captions, like the ones we created in the last Chapter, may move around, but we have no real control over their predefined actions. Their time on screen is determined by the Slide's time on screen. So they all enter and exit at the same time. Gold does not allow *user-defined* Motion Effects for Captions. Those limitations are gone when we use Keyframing to control special effects. Before we can work with Keyframes, we have to understand what they are and how they work.

Keyframes are points of reference used in Producer to control an Effect. They are like the landmarks and turning instructions we use when giving travel directions to a friend: "Turn right at the gas station and go three miles to the city high school, and then turn left at the next intersection." The friend will handle the mechanics of getting between the landmarks and making the turns.

A Keyframe marks a change point in the settings for an Effect. They always work in pairs: a "from" and a "to." Let's say we want to move a Caption halfway across a frame over a period of two seconds; we also want the Caption to change in color from dark blue to light blue as it travels across the frame during those two seconds. If the frame rate during play is 30 frames per second, that's 60 frames (each with slightly different locations and colors) that have to be created.

All we have to do is set two Keyframes, the first defined with the desired starting location and color settings, and the second set to the final position and appearance. Producer generates all the frames in between and automatically makes the required adjustments to each of the intermediate images. (Each frame is a separate image in the final video file.) Change the display times or frame rate, and Producer will regenerate the appropriate number of new frames with the required settings for the effect. Since Keyframes always work in pairs, adding a new Keyframe creates a new pair with the one before and/or behind the addition. In effect, adding another design control point.

We'll start with a simple example. That makes it easier to understand how to apply them with more advanced controls in the following Chapters. Opening the Producer Show that created the example we just watched will let you follow along with the discussion. Because the show uses custom (and copyrighted) fonts, I've included three versions of the Show file. If you have installed the Chopin Script True-Type font (available in both the Chapter 6 and Chapter 5 Folders), then use **Caption_PSP chop.psh** with the Exercise. If you don't want to install that font, then use **Caption_PSP system fonts.psh**.

Figure 6.1 shows **Slide 3** in the Show, most of the way through its five-second play time. There are two Captions in Slide 3. Both use Keyframes to create precise **Motion Effects**. The first one to appear contains the word **Wedding**, replete with a gold-toned **Gradient Fill** (another Producer feature not available in other versions of ProShow) and Drop Shadow. It moves from the right side of the frame to the left and fades out and back into full opacity. The word **Gallery**, set in a script font, becomes visible from left to right as if someone were writing it with a pen, just as the **Wedding** Caption fades back into view. < **Scrub the Preview** > to see just how it plays on your screen.

Figure 6.1

Two Captions, one with a Gradient Fill and the other with a Motion Effect resembling a handdrawn word, let us know this Slide was created using ProShow Producer's advanced Caption toolkit.

If this Slide had been created without Keyframes, each Caption would have appeared—and ended—at the same time. Independent Keyframes let us control exactly what each Caption (or a Layer) will do as a Slide is displayed. Add interactivity to a Caption, and Keyframes become tools the viewer can use to control the Show and even expand its domain to the Internet and e-mail. There are four Captions in **Slide 4**, shown in Figure 6.2. Once again, the designer has used Keyframes and a script font to make the letters appear as if they are being written as the Slide plays. Hold a mouse over a Caption when the show is played or **Previewed**; and it will **"pulse,"** denoting an interactive function. In this case, the Captions link to a specific Slide in the Show; click one and the program jumps to that location and continues playing.

Figure 6.2

The four Captions on this Slide are all interactive links, allowing the viewer to jump to a different point in the Show.

Note

Interactivity is *only* enabled when the show is **Output** and viewed on a compatible device. (For example, you can't follow a website link unless there is an available Internet connection.)

The next four Slides, including **Slide 5**, shown in Figure 6.3, are the destinations linked to the Captions in **Slide 4**. These destinations could have been at any point in the Show, in another Show, on the Web, or even in a command to launch another program. We'll look more closely at Producer's interactivity options and how to use them shortly.

Figure 6.3 Scrubbing the Slide List lets us Preview and tweak settings for maximum impact. This image shows Producer's built-in Capture feature; right-click in the Work Area's Preview pane for the menu.

There are three Captions on each of these four Slides. The titles ("The Engagement," "The Formals," etc.) use the now-familiar left-to-right scroll. A Shakespeare sonnet scrolls up the right side of the Slide, and an interactive link to **Slide 4** ("**Back to Gallery**") is in the upper-right corner. That **Gallery** link, and the four titles on Slide 4 provide a user interface, allowing the viewer to easily navigate the Show at will. With only nine Slides, that isn't really necessary, but is useful for the sake of demonstration. Consider a complete set of wedding proofs with more than 300 images. Some viewers will want to watch every minute. Others will want to go right to a particular section.

ProShow makes it easy to give viewers the access they desire, or what we want them to use, with well-designed Captions. The timing of the Caption motions relative to images used in the Slide, the **Fly In** and **Fly Out** Effects, and the chosen fonts are all elements that can be used to create an overall design. Captions are more than words.

The closing Slide in this Show has five Captions. (See Figure 6.4.) The large "Contact" Caption uses an image for a fill to give it a unique appearance. Adding "Contact Us" as a separate Caption underscores the point of the Slide. Interactive links to the Web site and e-mail address make it easy for the viewer to follow up without delay or the need to manually launch a browser or c-mail program. This Slide Show quickly demonstrates Producer's advanced capabilities with words. Now let's see how they work.

Figure 6.4

The last Slide in the Show features an interactive Caption linked to a website. Clicking on it will open a web browser and load the page.

ProShow Producer's Caption Window

Select **Slide 4**, and press < **Control-F9** >. The **Slide Options>Captions>Caption Settings** window will appear, as shown in Figure 6.5. The basic Caption-related features found are the same in Producer as in Gold, so I won't detail the steps here. (The information is available in Chapter 5.) But the locations are a bit different. The Captions List, Selected Captions, and Preview tools work the same in both versions. So do the Text Effects, Caption Color, Outline, and Drop Shadow controls. Before getting into the details, let's take a quick tour of the expanded interface. It offers some new tools, as well as more than those found in ProShow Gold.

Caption Styles

Producer features include **Caption Styles**. A *Caption Style* is a collection of **Caption Settings** that can be **Saved** and applied to a new **Caption**. Almost every setting, except the actual location on the Slide, can be defined and applied with a couple of mouse clicks. Not only is this a great time-saver, but it also ensures a consistent appearance within a Show.

Setting up and applying Styles is easy. Choose a < **Caption** > on a Slide in the **Captions List** pane, and then click on the < **Styles** > button (located with the green arrow in Figure 6.6). The **Caption Styles** dialog will open. Several predefined styles are available in the left-hand column. Choose one, and all its settings will be applied to the currently active Caption.

Figure 6.5

The Captions window in Producer provides more tools than in the Gold version, including additional Placement Adjustments, Interactivity, and the option to use Texture Effects as Fills.

Slide Options						La
		Slide Lay	ers Effects	Captions Sound	S	State of the Characteristics
		Caption	n Settings Ca	pton Motion		+ ♂ -
Text Effects		CFF Outline	ס	152212121282 6		ALTER CAR
Fly in Fade Right	Browse D	Color	Preview	SUS TAN		1
Normal -None-	Browse O	CIT Drop St	nadow 🖇			
Fly Out Fade Out	Browse s	Color	54	S. 3	A A	
Caption Placement				Ete Er	Energy Sec.	tamat (
Algriment 藍 🧱 🏭				See Trees		1558
Postion 31.75 x 4			S. Statilland			7-88
Opacity		90 %	ନ କ ୍			
	Contraction of the local data	And the state of the	\$ B	200 - 24	Wedding The	S. tate
Rotate Character Rotate	<u> </u>	and the second se	See Training and the second second			SUCCESSION
		and the second se	S C 1	he Engagement		2
Character Spacing			Captions G G G			
Line spacing	Led and the second s	118 18	Succession 2			V
Use Texture on Cap	tion			Style [No Caption Style]	sty	
🕑 knage	Browse	Edd		Fort Janesterten	Size	14 💌
Crackent Edit Grad	nt.			Color Set B	Insert Macro	
Zoom 100 % () Scaling Fill Character	-		The Economia		
Caption Interactivity		STATISTICS STATISTICS		The Wedding		
Action Jump to Slide	•					
Jump to Sase			+			
Destination 5			R			
						Ok Cancel
Charles and the second second						UK Cancel

Figure 6.6

Styles are a quick way to apply Text Effects and formatting attributes to a Caption.

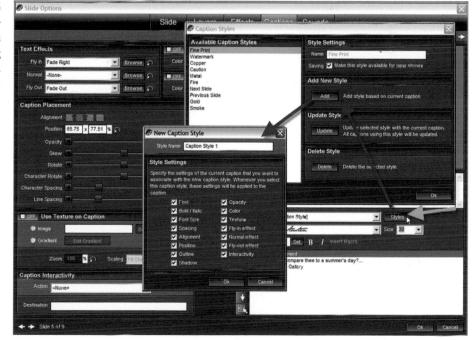

You can use the < **Add** > button (follow the red arrow) to define a new style based on the current Caption. Figure 6.6 shows the **Caption Styles** window and the **New Caption Style** dialog (blue arrow) arrayed over the Captions window. Create a new Caption if desired, name it, and check the attributes to be included, then click < **OK** > to Save it.

Caption Placement (with Style Added)

Placement controls in Producer are extensive. You can adjust Character and Line Spacing, Opacity, and Skew and Rotate both the Caption and the characters in it. Keyframes let us change the action and Motion Path for a Caption as it is being played in the Show.

Let's add a Caption to Slide 5 and experiment with the **Caption Placement** controls. Select it and open the **Caption>Caption Settings** window. **Add** a new Caption (use the **Plus** sign and type in the **Text Field** above the **Captions List**) that says **Turning Around**. In the **Captions** pane, set the font to **Arial** and the size to **30**. Click the box in the **Drop Shadow** pane to give the Caption a black Drop Shadow.

Adjust the following values in the **Caption Placement** pane: **Rotate** to **43**, **Character Rotate** to **-43**, and **Character Spacing** to **140**. Use your mouse and place the Caption so the "g" in "turning" is in the center of the Slide. Figure 6.7

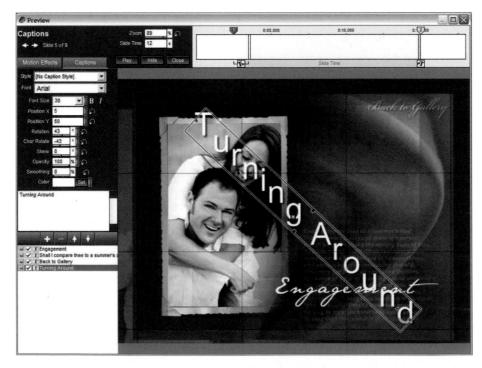

Figure 6.7

Producer's Caption Placement controls can be combined to create a wide range of special effects. shows the result in the **Precision Preview** window after applying the settings, and positioning the new Caption in the center of the Slide.

We now have a diagonal Caption. Fine-tuning Spacing, Rotation, and Skew settings provides almost total control over the letters in the Caption. Notice that the **Precision Preview** window (reached via the Magnifying Glass tab of the **Preview** pane) provides access to many, but not all, of the **Caption Placement** controls. You may have to reselect an active Caption when shifting between the **Captions** and **Precision Preview** windows.

Let's save this new **Style** for future use. Return to the **Caption Settings** window. Click the < **Styles** > button (in the **Captions** pane below the **Text Field**). When the **Caption Styles** dialog appears, then click on the < **Add** > button under the **Add New Style** pane. The **Add New Styles** dialog box opens. Name the new Style **diagonal**. It's a good idea to consider which of the available settings need to be included (and excluded) when we create and save **Caption Styles**. Generally speaking, it's best to limit the options to those needed for a specific effect or action. < **Uncheck** > all but the **Spacing**, **Alignment**, **Position**, **Shadow**, and **Opacity** options. (See Figure 6.7a.)

Once the settings are adjusted, click < **OK** > to save the **Style**. Then select our new Caption and click the < - > (**Delete**) button, removing the Caption we just made. Leave the **Slide Options>Captions>Caption Settings** window open and be sure that **Slide 5** is selected. You can check and adjust the Slide number in the bottom left corner of the window.

Using Interactive Captions

The Caption that says **Back to Gallery** in the upper right corner is an interactive element. Select it and notice the settings in the **Caption Interactivity** pane (bottom left of the **Caption Settings** window). There are two boxes in the section: **Action** and **Destination**. The **Action** setting determines what happens when the

viewer clicks on the **Interactive Caption** during playback. The **Destination** setting defines how the action works. In this instance, when a viewer clicks on **Back to Gallery**, the Show jumps to **Slide 4**.

Note

Interactivity works only when the Show is being played in ProShow Presenter. That includes Autorun, Executable files, and when the show is viewed in a web browser that has the Presenter plug-in installed.

Actions fall into several categories. Some let the user control the operation of ProShow Presenter. As the Action drop-down menu shows, Captions can be set to pause or resume playback, open another Show, jump to a specific point in the Show, and exit Presenter. They also allow the viewer to shift between Full Screen mode and a smaller display size. The Caption can launch another program and return the user to the Show when the other application is closed. An active Internet connection expands the possibilities. Action can let the viewer visit a website and send an e-mail to a specific address. These tools let the user provide feedback, request information, and even visit an online shopping cart to purchase items featured or described in the Show.

Placing Captions on Multiple Slides

It's easy to see how you might use a Caption several times in the same Show, but which you don't want to set as a **Global** Caption. (Global captions are covered in Chapter 5.) We can use the **Copy Captions** commands to handle that task easily. To add a single Caption to another Slide (or group of Slides), select the target(s) Slide(s) and open the Captions window. Then right-click on the Caption you want to Copy and use the context-sensitive menu to Copy your selected Caption to the other Slide(s) (see Figure 6.8).

There is a better way to broadcast Captions if you have several to place. Open the same context-sensitive menu and choose the < **Specify Destination** > option. The **Copy Captions** dialog shown in Figure 6.9 will appear. The left side of the window has a thumbnail of all the Slides. In front of the thumbnail is a box used to show or hide the Captions for that Slide. Figure 6.9 displays the list for this Show with Slide 5 expanded and the rest closed. Choose the Captions you want to copy to other Slides in the Show. I've placed a check mark in the listing for the **Back to Gallery** Caption.

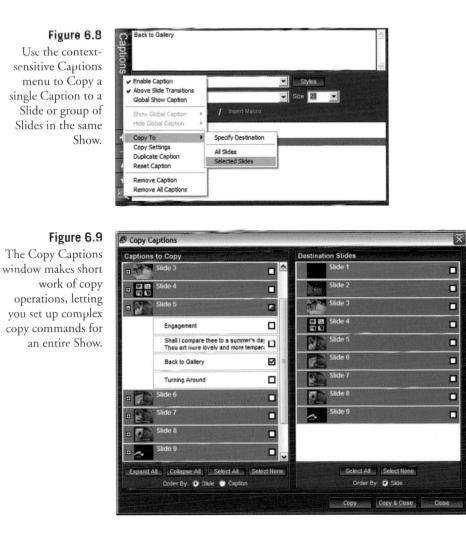

The right-hand list is used to set the target Slides where the selected Captions will be added. All that is left is to place check marks next to the slides where you want to add the Caption. At the bottom, Choose < **Copy** > if you want to add Captions and set up another **Copy** command. Choose < **Copy & Close** > when you are assigning the last set of copies. This window is a great one-stop Copy center.

The **Copy Caption** feature makes it easy to keep the spacing between lines of type consistent through a Show, as well as the individual characters, opacity, and the exact placement of a repeated Caption. Suppose we have a Caption that runs across two Slides, or that appears in several Slides. Sudden changes in position or color as a new Slide comes in, distracts the viewer. We usually don't want parts of our design to radically change from one Slide to the next. Copying lets us place a Caption on multiple Slides using the same settings.

Keyframing, Caption Motion Effects, and the Magic of Timing

We are going to turn our attention to **Caption Motion Effects** and how **Keyframes** work with them in Producer. We'll continue to use the current Show for this Exercise. If you have been experimenting, please use the **Revert To Backup** option in the **Work Area** File menu to load a clean copy of the show.

As we saw in Chapter 5, the built-in **Fly In** and **Fly Out** Text Effects do add motion to a Caption, but lack the ability to control the timing and direction of the movement beyond the predefined menu options. To produce custom **Motion Effects**, you have to be able to control the direction of movement, speed, and the time that an object travels along a path. That's where **Keyframes** come in. With them, you are able to precisely place **Control Points**; these position and adjust the attributes of any object or Effect at specific points in time and location *within* the Slide; and may also change those settings during the time the Slide is on the screen.

The easiest way to understand how they work is by using the **Keyframe** controls. Select < **Slide 8** > and open the **Slide Options>Captions>Caption Motion** window. (The keyboard shortcut is **Control-F11**.) Your window should look like the one in Figure 6.10.

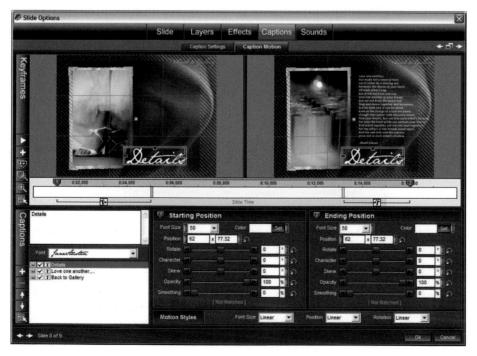

Figure 6.10

The Caption Motion window lets you control every aspect of a Caption's behavior during playback and use Keyframes to precisely adjust the timing of special Effects. This Slide has three Captions, listed in the **Captions List** in the lower left corner of the window. The first Caption (**Details**) fades into view and remains. The second (**Love one another...**) fades into view and then scrolls up the right side of the Slide. The third Caption (**Back to Gallery**) remains in view the entire time. The controls in the **Starting Position** pane are for the **Left Preview**, and show the Slide and its settings at the beginning of playback; the **Ending Position** pane and the **Right Preview** show the Slide and the settings at the end of playback for the *currently-selected* **Keyframe**.

Up until now, we've only worked with Slides and Captions that have one pair of Keyframes. That's because all **Layers** in all Slides have a *first and last Keyframe*, even in Gold. These two set the **Starting Position** and the **Ending Position** for a setting or Effect.

In Gold all layers share the same Keyframe timing. That means that both the Starting and Ending times for all Effects are identical for all the Layers in the Slide, since those two points mark the beginning and end of the Slide and we can't add any intermediate points.

Producer lets us add and adjust Keyframes, and they don't have to match the ones for other Layers in the Slide. *We can control the timing of each Layer individually*. That's critical for complex Motion Effects that make several captions behave independently from each other. Add and adjust a new Keyframe, and you have another point in time to craft and tweak the behavior of a special Effect. *Keyframes always work in pairs*, and act as *Control Points* that mark the beginning and end of a given Effect or setting. Producer creates all the intermediate frames to yield the desired results.

Some practice working with Keyframes makes the concept easier to understand. Slide 8 should be open in the Captions>Caption Motion pane. At the bottom left of the window is the Captions List, and the Text Box; and below the Left and Right Previews, in the middle, is the Keyframe Timeline. The lower portion of the window has the two Keyframe control panes for the pair. The pane on the left controls the Starting Position, and the one on the right controls the Ending Position, in reference to the currently Selected Keyframe pair; in this case it is Keyframe 1 and Keyframe 2, the only pair residing on the Active Layer, Layer 1 (Details). We can adjust the Font Size and the X-Y Position by entering numeric values into the data boxes located above the column of sliders.

The **Rotate** setting rotates the entire Caption, the **Character** setting rotates the letters inside the Caption, and the **Skew** setting tilts the letters along the Caption's baseline. **Opacity** adjusts how transparent the Caption is. **Smoothing** adjusts the level of jerkiness during a shift in the path of a Motion Effect.

Working with the Keyframe Timeline

We use the **Keyframe Timeline** to *create Keyframes and adjust their timing*. Let's examine the Keyframes on **Slide 8** and see how the Keyframe Timeline works. Figure 6.11 shows **Caption 1, Layer 1** selected. It has only two Keyframes. As mentioned before, all Layers in Producer have at least two Keyframes, a **Starting Position** and an **Ending Position**.

Note

Position here means the *position on the Keyframe Timeline*, not the position in the frame.

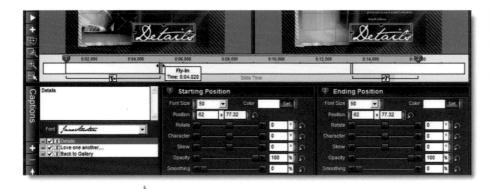

Figure 6.11

The Keyframe Timeline and Position Settings for the first Caption and Layer on Slide 8.

On the top of the bar are the two Icons, **Keyframe Markers 1** and **2**, (looking like baseball's Home Plate), each with its **Keyframe number** in the center. The area between them on the Keyframe Timeline shows the length of time that these two Keyframes control. The **Left Preview** pane shows the Slide's appearance *at that point in playback of the beginning Keyframe in the currently-selected pair*. The **Right Preview** pane shows what the Slide looks like when the playback reaches the second Keyframe of the currently-selected pair.

Along the top of the blue bar are tick marks and numbers denoting the amount of time elapsed at each point. The red boxed area to the left in Figure 6.11 is the segment of Time that is used by the Caption's beginning Transition (visible when the mouse cursor is placed over it). The ending **Transition** can be seen the same way. A light-yellow **Gradient Fill** shows how the **Transition Effects** blend in and out, and the Timeline is solid when the Slide is being shown at full intensity. Each Layer has its own Beginning and Ending Transition. The bar (the gray horizontal rectangle) marked **Slide Time** in the center of the Timeline area indicates the entire length of the time that any portion of the Slide can be seen on the screen. This is the time from the midpoint of the preceding Transition to the midpoint of the Transition that follows.

Underneath the bar are two "**Tilted-T**" Icons representing the Caption's **Fly In** and **Fly Out** Text Effects. Two vertical lines above each Icon show the points on the Timeline where the Transition Effects begin and end. I've placed my mouse cursor over the end point of the **Fly In**, and my cursor has changed into adjusting arrows (see Figure 6.11a). The tooltip shows exactly how long the Effect will last. Placing the cursor over the beginning point of the **Fly Out** provides the same type of adjustment of the **Fly Out** Text Effect. The colored space labeled **Slide Time** in Producer (not shown in the segment in Figure 6.11a) denotes the total Slide Time.

Figure 6.11a Adjusting the Fly-In portion of the Keyframe Timeline. The top screenshot shows the Text Effect reduced to almost zero. In the bottom example it's been adjusted to span the entire play time of the Caption.

Notice the column called **Keyframes** at the left edge of the **Left Preview** pane. Clicking on the **Plus** button will add a new Keyframe.

Adjusting Keyframes and Text Effects

Let's experiment and see how moving the objects on the **Keyframe Timeline** changes how the Caption works. First, Save the Show (press < **Control-S** >—the Show will play in the left Preview pane while a red marker slides along, indicating the progress of the Save) so you can revert to the current version when you finish. **Preview** the Slide, by clicking the <**Preview Slide** > arrow button (top one on the left border of the window), so you'll know how it played before the Adjustment. Now place your cursor over **Keyframe Marker 1** so that a tooltip showing its allotted Time appears next to the cursor. Now drag the **Keyframe** to the right until the position is similar to the one in Figure 6.12. Don't worry about the exact Time interval; just be sure that it is about the same distance inside the Slide Time, and the Time shown in the tooltip is about **4.5** seconds.

Note

When positioning Keyframe Markers, the exact timing may vary after placement because the program will tweak the settings to render an effect.

The **Preview** is changing as you move the **Keyframe**. Adjust the Icon so the result is similar to the one in Figure 6.12. Now Play the **Preview**. The Slide still starts at the same point, but the word **Details** starts fading in much later. That's because we shifted its location on the Timeline. The **Text Effects** still work the same, but their entry point is delayed.

Now place the mouse cursor over the **Fly In** so that you can see the red box and the **adjusting arrows**. Drag the right edge of the box to the left until the time is reduced to **zero**, as shown in Figure 6.13. The tooltip will change. Note that the **Fly In** Effect will not appear. The right side of the Figure shows the **Fly In** and the red box as I began dragging the box, the red dashed arrow shows the direction to drag, and the area under **Keyframe Marker 1** on the left, shows the way the **Timeline** will look with the time properly adjusted.

0:04.00	0:86.000		0:08.000	0:10.000	
++	Fly-In Time: 0:00.000	-	a	Fly-In	
F.	Time: 0:00.000	F		Time: 0:04.490	

Now **Preview** the Slide again. The Caption no longer fades in—the word **Details** appears all at once. The Slide plays for the same amount of time and fades out normally.

Note

The changes we are making apply *only* to the *selected Caption* and *only* to the section of the time for that Caption that we manipulated.

Now place the cursor on < **Keyframe Marker 1** > and drag it all the way to the far left of the **Keyframe Timeline**. That brings it into the area of the Transition Effect between **Slides 7** and **8**. Close the **Caption Motion** window and **Preview** the Show from the start of **Slide 7**. The word **Details** now appears as **Slide 7** Transitions, and stays at full Opacity until the point where the **Fly Out** makes it fade.

Figure 6.12

Moving a Keyframe is simply a matter of drag and drop. As the Keyframe is moved, the appearance of the Slide in the Preview area will change.

Figure 6.13

Reducing the Fly In time to zero by dragging the arrows prevents the appearance of the Effect—without removing it. Open the **File** menu and choose the < **Revert to Backup** > command to restore the Show to its original condition. If you have more than one version available, choose the one with the original file name. Click on the **Open** button to reload the Show. Select **Slide 8** and open the **Captions/Caption Motion** window. It's time to see what happens when an object has more than two **Keyframes**.

Working with Multiple Keyframes

Select **Caption 2**. This is the block of text (**Love one anothcr...**) that scrolls up the right-hand side of the Slide. Notice that it has three **Keyframes**. Remember no matter how many Keyframes an object has (or how few, two being the minimum), they always work in pairs. *Only two Keyframes are active at a given time*, whether in editing or when the Slide is played. The **Keyframe 1** (Starting **Position**) controls adjust the starting point of the first Keyframe in the pair. The **Keyframe 2** (Ending Position) controls on the right adjust the ending point for the second Keyframe in the pair. Producer uses the two sets of Keyframe settings to determine what the intermediate frames will look like.

When the Timeline reaches the ending point of the pair (the second Keyframe) one of two things happens. If there is no further Keyframe, that finishes any Keyframe Effects for that Layer. If there is another Keyframe in the Slide, the *former second Keyframe* now becomes the *first Keyframe* of the new current pair—the **Starting Position** of a new Time sequence, and the next following Keyframe becomes the **Ending Position** of this segment. The very first Keyframe is still the *technical* Starting Point of the Slide, and the very last Keyframe is the Ending Point of the Slide.

See how the left Keyframe pane in Figure 6.14 is labeled **Keyframe 1 (Starting Position)** and the right one is labeled **Keyframe 2**? Let's examine the Effects set for each Position and see what these two Keyframes are doing in the design.

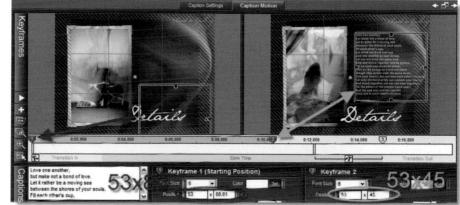

Figure 6.14

This Caption (the block of text) has three Keyframes. Each pair of Keyframes allows you to create a new set of Effects within the Slide. I've added colored arrows that point to Keyframes 1 and 2 and their related Caption Movement. Hold your mouse over the **Fly In** Icon on **Keyframe 1**. It is set to **None**. Now examine the **Fly Out** Icon. It is set to **Fade Out**. **Keyframe 1** is all the way at the left edge of the Timeline for Slide 8. So the Effect begins at the midpoint of the preceding Transition.

How is the design doing this? There is no **Fly In** Text Effect, yet the **Keyframe 1** pane shows that the **Opacity** is set to **Zero** so that the text is invisible as the Slide starts, and **Keyframe 2** gradually reaches **100%**. *That's* what is producing the Fade-In effect, the **Opacity** settings, *not* the Caption's **Text Effect**. The **Position** settings cause the block of text to scroll up as the time advances. Each shift in position is the result of a frame that was produced based on the settings of the current Keyframe pair.

Click on the space between **Keyframes 2** and **3** and the segment and those **Keyframe Markers** will turn blue. The **Preview** panes will now show how the Slide will look at these points in the Show. This Keyframe pair is designed to produce a block of time when the text is opaque, and then let the **Fly Out** fade the text until it is invisible, ending just *before* the next Transition begins. Figure 6.15 shows the Preview above the Keyframe Timeline, just at the point where the following Transition begins. The red **Keyframe Timeline Marker** indicates the point on the Timeline when I made the screenshot. (I've circled it in green.) Notice that the text (i.e., the second Caption) has disappeared at this point during the playback in the Preview pane on the left.

Figure 6.15

The second set of Keyframes (2 and 3) holds the text in position and then uses the Fly Out text effect to let the Caption completely disappear before the start of the following Transition.

Playing the Show into the next Slide (9) reveals why the Caption was completely removed before the start of the next Transition. The next Slide has a black back-ground, and the designer wanted to have only pictures visible as it came into view. Allowing the Caption to play during the Transition would have interfered with that effect.

Adding and Adjusting Keyframes

We can add Keyframes to any object on any Layer or Caption in a Slide. (Remember that the basics of Keyframe manipulation are the same for both Layers and Captions.) A Keyframe is added each time you click on the **Plus** button in the column called **Keyframes** at the left edge of the **Left Preview** pane. An easier way is to use your mouse. Let's do that now. With **Keyframes 2** and **3** selected, place the cursor midway between them and double-click. (Be sure you are on the **Keyframe Timeline** and **not** the Preview pane; clicking there opens the **Precision Preview** window.)

Voilà! Now we have four **Keyframes**. The new one is **3**, and the old **3** is now **4** and designated as the **Ending Position**. The settings for the new Keyframe are the ones the program had already calculated to produce the effect for that object's appearance *at that precise moment in the Show*. (Producer automatically generates the intermediate frames, so the new Keyframe is pulled from that array, and fixed as a point on the Keyframe Timeline.)

With **Keyframes 3** and 4 selected, adjust the **Skew** setting for **Keyframe 3** to -360. Leave all the other settings the same. Double-click on the left **Preview** pane to open the Slide in the **Precision Preview** window. Select **Caption 2** and click the < **Play** > button at the top of the window. Figure 6.16 shows the change in

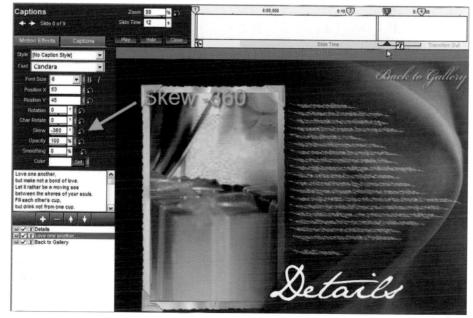

Figure 6.16

The effects of a single setting in a single Keyframe can be quite dramatic. Here just shifting the Skew setting makes the Caption (text block) twist like it was caught in a windstorm. **Precision Preview** as the new **Skew** setting takes hold. Notice how the **Keyframe Marker** position is inside the text effect area. Keyframes can be placed anywhere on the Keyframe Timeline.

We can make a wide range of Keyframe and Caption adjustments in the Precision Preview window, but there are some differences in the way it works compared with the **Caption Motion** window and the **Motion Effects** window. Look at the **Keyframe Markers**. In the **Precision Preview** window, only **Keyframe 3** has turned blue, and there is no shading in the space between the active Keyframes. That's because we can only adjust one Keyframe at a time. If you want to add, remove, or adjust the time for a Keyframe in the **Precision Preview** window, right-click on its **Keyframe Marker** and choose the appropriate option from the context-sensitive menu.

Now look at the colored bars at the right end of each Setting box. All but the one for **Skew** is **green**. Its box is **blue**-colored. A **green** box indicates that the setting is in **Auto** mode. That means that Producer is calculating the settings between the Keyframe before and after this one, and that the current value is the result. **Blue** boxes appear when we set values for a Keyframe and override the generated values.

So, when you want to create an Effect, determine where you want the action to peak. Place a Keyframe there and make your Adjustments. Producer will make the needed adjustments to the surrounding Keyframes and generate the intermediate frames to produce the desired result. You can then tweak the effect by adjusting either the settings, or the locations, of the Keyframes.

Keyframes Move More Than Words

Our discussion of Keyframes has been focused on Captions. Keyframes work the same way on any Layer in Producer and they do just one thing, one very important thing—no matter if their target object (the aspect of the Show they control) is a Caption, an image, or an Adjustment Effect. **Keyframes** control the *timing* of an action: when it occurs, and for how long. The **Effect** settings define *what* the action is, and the *intensity* of the Effect.

We are going to use **Captions** and **Adjustment Effects** tools with **Keyframes** to make a simple yet sophisticated final Title Slide for the current Show. Our new Slide will scroll three Captions into the frame, one at a time from left to right. The result will look as if someone was writing them with a pen over a picture of gift boxes. Close the **Precision Preview** and the **Slide Options** windows to return to the **Work Area**.

Adding New Slides

Add three blank Slides after **Slide 9**, new Slides numbered **10**, **11**, and **12**. The Show already has a **Slide 9**—it is the black-and-white "**Contact Us**" Slide. Then hold down the **Control** key and drag the **Tricoast-Details-012.jpg** file (an image of gift boxes and lit candles) onto the new **Slide 11**. This image will serve as the background for the Slide, which will also have three white Captions.

Set the Time for **Slides 10** and **12** to **zero**, and the Time for **Slide 11** to **8** seconds. Set the Transition Times as follows; before **Slide 10** to **0.5** second, between **Slides 10** and **11** to **2.5** seconds, between **Slides 11** and **12** to **1** second, and after **Slide 12** to **zero**. See Figure 6.17 for an annotated example. I've noted the Slide Times in red and the Transitions in green. I've worked ahead, so you can see the final design. The finished **Slide 11** is visible in the Figure.

Figure 6.17 The new Slides in the Slide Timeline with the Time settings overlaid in green.

The blank Slides on either side of the final title **Slide** add a smooth black backdrop that is independent of the title Slide. I usually add one at the end of a Show and trail just a little of the soundtrack into its playing time. It's a way to control the end of a Show, rather than have it end abruptly.

Setting Adjustment Effects

Select the new Slide 11 and press < Control-F8 >. This shortcut opens the Slide Options>Effects>Adjustment Effects window. An *Adjustment Effect* modifies the way an object appears on screen (such as its brightness, contrast, or Opacity). The Adjustment Effects tools, including its Keyframe Timeline and Keyframe controls, work just like the Caption Motion window. This Slide has only one image Layer, so that is already selected for our Adjustments. We are going to make several Adjustments, shown in Figure 6.18. (Your Preview pane will look different. I've pasted in the Preview that shows how the Adjustment Effects will look at the point of the second Keyframe.)

Leave the **Starting Position Opacity** at **100** percent and set the **Ending Position Opacity** at **32** percent. Shift the **Ending Position Contrast** to **-25** percent. Now use the mouse to drag **Keyframe 2** in until the tooltip reads about **10.6** (the image is labeled 10.5) seconds. The number may vary slightly after it is set, as the program fine-times all the effects.

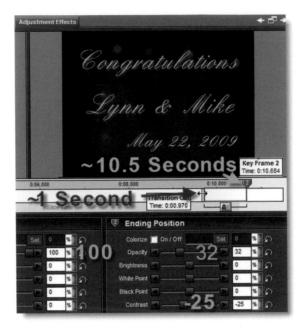

Figure 6.18

Keyframes are used to change settings as a Slide is played. Here we'll use Opacity and the Layer's Transition to fade the image to black before the start of the Slide's ending Transition.

Note

If your Timeline doesn't allow that amount of time, make sure you have already made the proper time settings for the Slide in the **Work Area Slide Timeline**. You can't adjust Time beyond the available amount.

Now place the cursor over the left end of the ending **Transition Out** (the doublebar on the Timeline) for the Layer and drag it to the left, so the tooltip shows about **1** second. Make sure the **Transition Out** for the Layer is a **Crossfade** (**Blend**). If not, open the **Choose Transition** window and make the modification as shown in Figure 6.19.

Adding and Adjusting the Captions

Click on the **Captions>Caption Settings** tabs and add three Captions to the Slide. I've used a script font and adjusted the sizes to fit the design. Feel free to use any font you like and adjust the size as needed. The first Caption reads "**Congratulations**" (without the quotes, of course) and is set to **42** points. The second Caption says "**Lynn & Mike**" and is set to **42** points also. The third is the date—"**May 22, 2009**"—set in **30**-point type. Adjust the placement and size of the Captions to match the example in Figure 6.20. We want the top Caption near (but not touching) the upper left corner of the safe area. The name of the couple

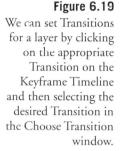

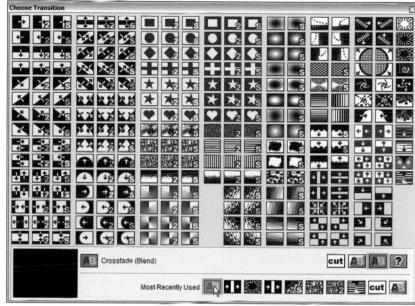

is in the middle of the Slide and starts a little to the right of the left side of the first Caption. The date is below and to the right of the middle Caption, mostly over the tablecloth.

Now we are going to add a **Drop Shadow** to all three Captions. The image in the background contains a wide range of tones, and it can be hard to make out the white letters over the brighter portions of the picture. Select each Caption in turn and enable the **Drop Shadow** Option. Then click the **Set Color** button and experiment with the **Color Wheel** to pick a color that offers a clean shadow that adds to the Caption's readability. I found that the top Caption required a lighter color and the bottom one a darker color to contrast with the portions of the picture underneath.

Using the Multi-Layer Keyframe Editor

Once the Captions are in position, we can adjust the Keyframes to produce the desired effect. In Producer 3.x we had to select and adjust each Layer's Keyframes individually. Now we can use the **Multi-Layer Keyframe Editor** to examine and tweak all the Keyframe settings for a Slide at the same time. In the **Effects>Motion Effects** window, click on the icon circled in red in Figure 6.21 and the **Editor** will open. (The Editor in the Figure is open on top of the **Motion Effects** window.) The left side of the Editor has a **Preview** pane, and the right side a column of all the **Keyframe Timelines** for the Slide. The screenshot shows the Slide after editing, so yours will look different.

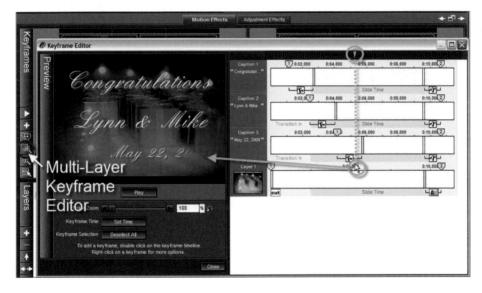

The Multi-Layer Keyframe Editor open over the Motion Effects window.

See the two green circles I've drawn? The top one outlines the **Timeline Pointer**. The lower one is my mouse cursor. We can scrub any Layer's Timeline and the Preview will show that playback point. I've added a vertical green line showing how you can use the Editor to scrub the line and see how the Keyframes work in relation to each other. That's how we are going to manipulate this Slide to create an effect that looks like each Caption being written on the Slide in turn.

So the top Caption fades in, then the second and finally the third, using a Leftto-Right Fade-In Transition. We'll obtain that result with the Multi-Layer Keyframe Editor by staggering the first Keyframes of each of the Captions so they look like the example shown in Figure 6.22. I've drawn a red box around them. Notice that the Ending Transition intervals for all three are the same. We'll also set the second Keyframe of all three Slides so that they exit at the same time. I've drawn a green box around them. Let's start with the first Keyframes.

Caption 1 Congratulati"	0:02.000	0:04.000	0:06.000	0:08.000	0:10.00
Caption 2 Lynn & Mike **	0:02.0	0:04.000	Slide Tim 0:06.000	B 0:08.000	0:10.00[2]
Caption 3 May 22, 2009 "	cansition in Co.02.000	E	Slide Tim 0:06.000	e 0:08.000	0:10.00d
	ransition In	L FC			Key frame 2 Time: 0:10. 30

The three Captions are shown in the **Multi-Layer Keyframe Editor** in the same order they appear on the Slide. The one that says **Congratulations** is at the top. Use your mouse to arrange the first Keyframe and its Transition as shown in Figures 6.23a and 6.23b. The values: **Keyframe 1** set to **0.01.150** seconds, the **Fly In** set to **Fade Right** for **0.01.520** seconds.

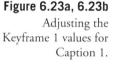

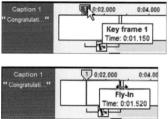

Now position **Keyframe 1** and the entering Transitions for **Captions 2** and **3** so that they are adjusted as shown in Figure 6.24. Scrub the Keyframe Timeline as you work to see the Effect. In the Figure I've combined two Adjustments into a single image showing you how it works. The timing does not have to be exact, just be sure to arrange the timing so that each **Adjustment Effects**-modified **Caption** "writes" onto the Slide so it looks like a person is actually adding the letters with a pen.

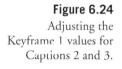

Now we want to line up all of the ending (second) Keyframes to perfectly matched points in time. The **Multi-Layer Keyframe Editor** makes that task easy. Click on any **Keyframe 2** and a vertical line will appear.

In Figure 6.25 I've clicked on **Keyframe 2** of **Caption 2.** All you have to do is set one Keyframe to the right time, then choose the other Keyframes and line up the vertical line with the middle of the "master" Keyframe's marker. Then adjust the ending Transition for all the Captions to match the example shown for the third Caption in Figure 6.25. (Once again I've combined two screenshots in one image.) Don't worry about making all the adjustments exactly the same. Make use of the **Multi-Layer Keyframe Editor** to tune the settings visually.

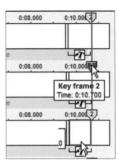

Figure 6.25

Using the Multi-Layer Keyframe Editor to align the ending time of Effects for all three Layers.

Click the < **Play** > button to see the result. Adjust the **Keyframes** and **Transitions** as needed to get the Effect of a line starting to appear as the preceding one becomes completely visible. The exact time will vary depending on the typeface and the length of the Caption. **Keyframe Timing** is part art, part science. The slideshow is a visual experience, and so the way the viewer sees an effect is the true test. Once you have obtained a pleasing Effect, click on the <**Apply**> button in the lower left corner of the **Multi-Layer Keyframe Editor** and return to the **Effects**>**Motion Effects** window.

Figure 6.26 shows the final result of the Slide as the last Caption reaches its halfway point during playback. Shifting the **Starting Position**, adjusting the playback time for the Slide, adjusting the **Font Size**, and even using the **Smoothing** function to reduce jerkiness, are all variables you can use to tweak the Captions. The **Opacity** amount and timing offer additional tools for fine-tuning the effect. Take some time to experiment with the settings, and for adjusting Keyframe Timing.

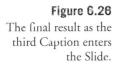

Up Next

Keyframes, one of the most powerful tools Producer offers, are on the agenda for the next three Chapters. Combined with the various settings and special effects, they offer incredible creative possibilities. This Chapter was only an introduction to their use. Now we turn to Advanced Motion Effects that you can combine with Keyframes to produce stunning professional effects.

Advanced Motion Effects Using Keyframes

Keyframes add a new dimension to ProShow's Motion Effects. We can make multiple Layers dance across the frame independently of each other, each with its own timing. They can enter and exit at will, and each Layer can have its own Transitions, adding to the creative special-effects possibilities.

This is a Producer-only chapter because it is the only edition of the program that supports Keyframes. Before working on the following Exercises, you should already know how to use the Keyframe Timeline and understand the basics of how to manipulate Layers and apply basic Motion Effects.

Note

There is some overview material on Keyframes in Chapters 1 and 2; Chapter 6, and to some extent Chapter 5, will give you refreshers or teach the fundamentals.

All of the files needed for the Exercises in this Chapter are located in the Chapter 7 folder on the companion CD. Please be sure to copy them onto a local hard drive before using them. ProShow needs access to files in a directory with read/write permissions enabled.

A Traffic Control Lesson

Keyframes are powerful and fun once you get to know them. As with any highperformance technology worthy of those adjectives, it's best to understand how it works—and how to control it—before doing anything serious. Trying to track the effects of several Keyframes with several Layers going in multiple directions can be confusing to the uninitiated. Once you understand the basic concepts and controls, creating fancy Motion Effects is much easier. So, before we start making multiple Layers do all sorts of fancy movements, a test drive is in order. We are going to make a single Layer move its center so that the Motion follows a square path.

Power up Producer, and then create a new **Slide 1** by dragging the file named **TC-2.jpg** from the Chapter 7 folder, which should be on your hard drive by now.

Give the Slide a **10**-second play **Time** and a three-second **Transition**. Now press < **Control-F7** >, the key combination that opens the **Effects>Motion Effects** window. Your screen won't look quite like the one in Figure 7.1. That's because I've already added a new **Keyframe** and made some adjustments for the demonstration.

Right-click on a **Preview** pane, and then enable the **Show Motion Path** Option on the context-sensitive menu, (highlighted in the Figure and indicated by the red arrow). The screenshot shows the other Options I keep checked as well. Then < **double-click** > on the top area on the **Keyframe Timeline**, about where the mouse cursor is, identified by the green arrow in Figure 7.1.

Now right-click on the new **Keyframe 2 Marker**, and set the time to **2** seconds using the dialog box method. As you can see in the screenshot, Producer may adjust the time slightly. That's OK. Make sure the first and second **Keyframes** are

Figure 7.1

The Motion Effects menu open, while setting the Show Motion Path option. selected by clicking in between them on the **Keyframe Timeline**. The space between them will now be a darker shade than the space between **Keyframes 2** and **3**. That denotes the Active **Keyframe Pair**.

Remember that Producer automatically generates video frames between a **Keyframe Pair** to produce special Effects. We've added a **Keyframe**, and now it is time to tell the program what we want it to do. We want the first **Keyframe Pair** to move the center of the image to the right.

In the **Keyframe 2** control pane (the right-hand one), change the **Pan** value for the **X-axis** of **Keyframe 2** to **25** (in the left **Pan** value box). This adjustment moves the image one-quarter of the way across the screen to the right during the interval controlled by **Keyframes 1** and **2**. I have already changed it in Figure 7.2.

Figure 7.2 The Motion Effects window with the second and third Keyframes selected.

The **Motion Path** tells the story. See the green square with a red border in the center of the **Keyframe 1 Preview** pane (left side in the Figure)? That symbol, the **Current Keyframe Marker**, *notes the position of the center of the Layer on the screen when the Keyframe time is reached during Play*. The green square <u>without</u> the red border notes the other Keyframe in the currently-selected pair. The right-hand **Preview** shows the **Motion Path** with the second **Keyframe** marked as current.

Now click between the second and third **Keyframes** on the **Keyframe Timeline**. You should see **Keyframe 2** listed above the left side's controls and **Keyframe 3** (**Ending Position**) noted above the right side's controls. Figure 7.3 shows the **Preview** with overlays that outline the **Layer's** position for all three **Keyframes**.

Keyframe 1's position is outlined in yellow in the left **Preview** pane, and the **Layer** is centered in the frame. The second **Keyframe** shifts the position to the right, and is outlined in red in the left **Preview**. **Keyframe 3** has its original values of **0** for **X** (**Horizontal**) and **0 for Y** (**Vertical**). Play the **Slide** and you will see that the image moves to the right and back to the center.

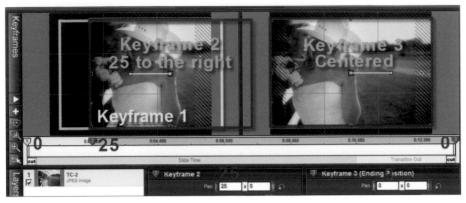

Figure 7.3 The Motion Effects window with the second and third Keyframes selected.

From now on, when giving **Keyframe** position settings, I'll usually note the **Pan** values as "number x number." For example, **0x0** is the current value for **Keyframe 3** and **25x0** is the value for **Keyframe 2**. Select **Keyframe 3** and adjust the **Pan** values to **25x25**. That setting pushes the center of the **Layer** directly down from its current position. Figure 7.4 shows the **Motion Effects** window after making the adjustment.

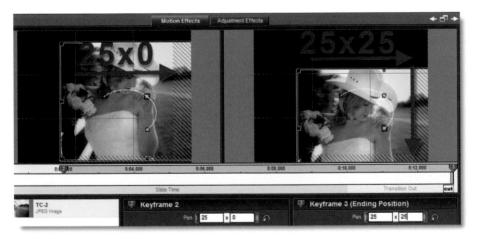

The **Preview** areas now have a **Motion Path** with three squares on the screen. The **Current Keyframe Marker** marks the center of the **Layer** at that point in play. In the left-hand **Preview**, it notes the starting point for the currently selected pair; and in the right **Preview**, it notes the ending point. That's because the Active **Keyframe** is different in each window. The other green **Marker**, the one without the border, notes the location of the center of the **Layer** when the other **Keyframe Marker** is reached during play. Red **Markers** note the center position of the **Layer** for any defined **Keyframes** that are not currently selected.

Figure 7.4a is a close-up of the **Preview** for **Keyframe 3**, showing the center of the **Layer** with the **Motion Path**. I've labeled each of the three **Motion Path** points with its number. The labels are formatted like the **Keyframe** they represent. **Keyframe 1** is red, because it is unselected. **Keyframe 2** is green, meaning that its point is the other matching Keyframe of the pair. **Keyframe 3** is green with a red border, denoting the fact that it is the **Current Keyframe** shown in the **Preview** pane.

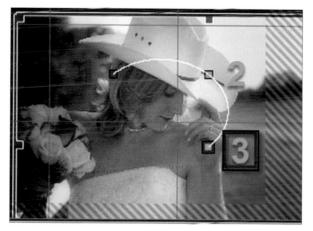

Figure 7.4a A close-up of the Preview for Keyframe 3, with labels for the Motion Path nodes.

Play the **Preview** to see the current **Keyframe** settings in action. It will take a few moments for the playback to begin. That's because ProShow has to gather resources and render all of the images to produce the video stream. For a 10-second Slide at a rate of 30 frames per second, that's 300 images at the working resolution. That means it also has to calculate how each frame will look based on the desired **Motion Effects**. Any **Captions**, **Soundtracks**, or **Adjustment Effects** add to the workload and have to be calculated for each frame.

The Smoothing Effect

Did you notice that when we added the **Pan** effect to the third **Kcyframe**, the shape of the **Motion Path** changed from a straight line to a curved one? That's because ProShow has applied a **Smoothing** effect to even out the visual appearance of the **Motion Effect**. A sharp turn in a **Motion Path** can look jerky during playback, as the picture quickly changes direction.

Consider how it feels when you are in a car during a turn. If the angle of change is sharp, the shift in direction feels more pronounced. A more curved path results in a gentler turn. The same is true in **Motion Effects**. The default **Smoothing** setting is **50** percent, and produces a medium curve in the **Motion Path**. A value of **100** will generate an even larger curve. A value of **zero** produces a straight line

and a fast break in the line of travel. Figure 7.5 shows the **Motion Path** with all three **Keyframes** set to **zero Smoothing** on the left, and the **Smoothing** slider control on the right. It is located near the bottom of the **Keyframe** control column. (It is not the same as the **Motion Styles** at the bottom of the stack.)

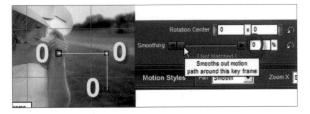

A higher **Smoothing** setting also avoids the visual appearance of a pause or slowing of motion when a very sharp change in direction (over 90 degrees) occurs. Adjust all the **Keyframes** to a **Smoothing** setting of **zero**. Then play the **Preview** and watch how the image moves as it makes the sharp turn.

Adjust the **Smoothing** settings for all three **Keyframes** to **100** percent. Play the **Preview** again and observe the change. Finally, set the first **Keyframe 1** to zero, the second to **50** percent, and the third to **100** percent. The path will look like the example in Figure 7.6. There is no hard-and-fast rule for applying this setting. The "best" value varies based on the image, the **Motion Path**, the nature of the Effect, and the desired result. Take some time to experiment with settings as we work with different **Layers** and **Keyframes** in this Chapter to get a better appreciation of how it can improve your results.

Figure 7.5

The shape of the Motion Path line shifts depending on the amount of Smoothing applied to each Keyframe. Lower values produce straighter lines.

Figure 7.6

The Smoothing setting changes the shape of the Motion Path, and how a Layer behaves as it moves along the path.

Getting Things in Proper Order

Before we start really playing with **Keyframes**, it's important to understand a few quirks in their behavior. Let's add another Slide to our Show. It's easier to demonstrate with a fresh example. Return to the **Work Area**. Drag the image **TC-4.jpg** into the **Slide 2** position on the **Slide List**.

Press the **Control-F7** combination to open the **Motion Effects** window. Rightclick at the 8-second point on the **Keyframe Timeline** and choose < **Insert** > to add a new **Keyframe**. Click between **Keyframes 1** and **2** to select them. Now in the **Keyframe 2 Preview**, drag the **Layer** straight down (the cursor will change into a hand symbol) until the **Y-axis** has a value of about **25** (the exact amount isn't critical, but make sure the **Motion Path** is a vertical line). Your **Motion Effects** window should look like the example in Figure 7.7. I've added the **Pan** values for **Keyframes 1** and **2** in green, and circled the mouse cursor.

Figure 7.7 The new Slide 2 Pan settings ready for Preview in the Motion Effects window.

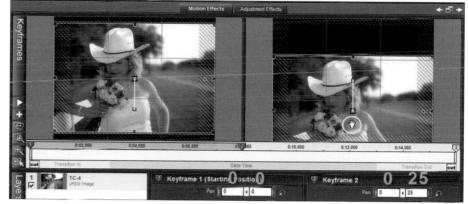

Now click the < **Play** > button and see the results. The **Layer** moves down as expected. Did you expect it to move back up? Understanding why it did and how to control such "unexpected" behavior is a critical skill for anyone wanting to create fancy **Motion Effects**.

The reason is simple. We added our new **Keyframe** in the middle of the **Keyframe Timeline**. The program had already calculated the position for the ending point (that is now **Keyframe 3**). Select **Keyframes 2** and **3** and you can see the reason. When we moved the middle **Keyframe**, the program calculated the new position for **Keyframe 2** but left **Keyframe 3** with the original settings that were assigned when the **Slide** was first created. The settings and **Motion Path** are shown in Figure 7.8.

Figure 7.8 The settings for Keyframe 3 are the same as the settings for Keyframe 1 because they were set when the Layer was added to the Slide.

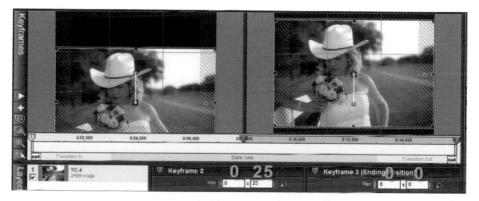

Make sure that Keyframes 2 and 3 are selected. Click on the Copy Motion Effects menu icon. It's identified by the red arrow in Figure 7.9 and located on the column on the left side of the Preview pane. Choose the < Copy Start to End > Option that is highlighted in the Figure. Keyframe 3 now has the same Pan values as Keyframe 2; 0x25.

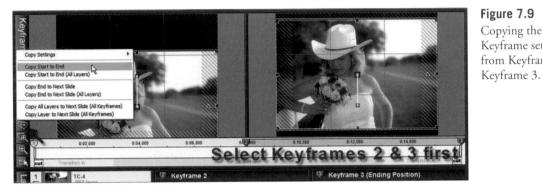

Figure 7.9 Copying the Keyframe settings from Keyframe 2 to

This is a very handy menu item when working with Keyframes—as long as you understand how it works. "Start" is the start of the first one of the active Keyframe Pair. In this case, that is Keyframe 2. "End" is the end of the Slide. So all of the settings for Keyframe 2 are now applied to Keyframe 3 and to any Keyframes that follow this Slide. We'll play with this concept some more in a minute.

Run the Preview again. Now the Layer travels down and then stays in place until the end of the Slide. Make sure Keyframes 2 and 3 are selected. Now look at the Motion Path, shown in Figure 7.10. They are the same in both windows! What happened to the second green dot, the one without the border that denotes the other active part of the current Keyframe Pair?

Figure 7.10

The Motion Path looks a bit different when no Motion occurs during a Keyframe segment. The second green dot is hidden under the Current Keyframe Marker.

The second green dot is hidden under the Current Keyframe Marker. The red dot is the marker for Keyframe 1. We will see both Keyframe Markers for a given pair only once the Layer moves during the pair's active playback period.

Simple Keyframe Effects: There and Back Again

Let's exit the current **Show** and create a new one to practice what we've just covered. In your new **Show**, drag **TC-2.jpg** into the **Slide 1** position on the **Slide List**. Set the **Slide Time** to **10** seconds and the **Transition** to **zero**. We want just 10 seconds on the **Keyframe Timeline** and all 10 included in the **Slide Time**.

Adjusting Keyframe Timing and Position

Press the < **Control-F7** > combination to open the **Motion Effects** window. Now right-click and choose < **Insert** > on the **Keyframe Timeline** four times to add four **Keyframes**, at approximately 2-second intervals, to make a total of **6**. (Two were created when the **Layer** was added.) Right-click on **Keyframes 2**, **3**, **4**, and **5** in turn and choose **Set Time** from the context-sensitive menu. Set the **Time** for **Keyframe 2** at **2** seconds, **Keyframe 3** at **4** seconds, **Keyframe 4** at **6** seconds, and **Keyframe 5** at **8** seconds (as shown in Figure 7.11). **Keyframe 1** is already set to **zero**. **Keyframe 6** is set to **10** seconds since it is the last **Keyframe** and automatically matches the end time for the **Slide**.

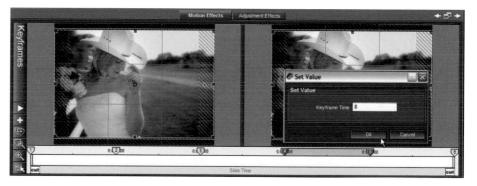

Figure 7.11 Using the Set Value dialog box is the quickest way to set exact times for a series of Keyframes.

Click between **Keyframes 1** and **2** on the **Keyframe Timeline** to select that pair. Leave **Keyframe 1**'s **Pan** at **0x0**, Adjust the **Pan** for **Keyframe 2** to **25x0**. (That is, the left side entry box to **25** and the right to **zero**.) That's just what we did in the very first **Slide** in this Chapter. As you enter the numbers, the **Layer** will move to the right. Click between **Keyframes 2** and **3** and adjust both the **X and Y Pan values** for **Keyframe 3** to **25** (**25x25**).

Now click between **Keyframes 3** and 4. Look at the **Motion Path** and the values for **Keyframe 4**. The program has already entered values for the remaining **Keyframes**, and the resulting **Motion Path** has a somewhat rounded triangular shape, as shown in Figure 7.12. The Pan settings for **Keyframe 6** are **0x0**. Of course, that is because the settings for **Keyframe 6** were set by Producer when you first dropped the image onto the **Slide List** and that **Keyframe** was the original ending point.

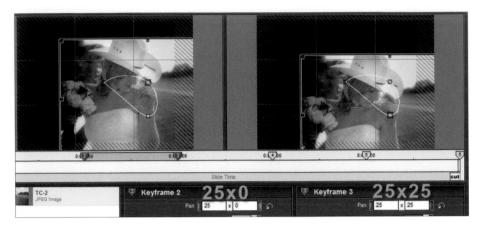

Figure 7.12

The rounded triangleshaped Motion Path at this point in our design is due to the way Producer automatically adjusts later Keyframes when a user modifies one earlier in the sequence.

If you plan for a design to end at the same point, the current **Motion Path** is just part of the process, as long as you properly line up the intermediate **Keyframes**. Since that's our current plan, the existing settings will work fine.

Sometimes the **Motion Path** can hide one marker behind another. If you can't see the **Current Keyframe Marker** for **Keyframe 4** in the **Keyframe 4 Preview**, it may be behind the **Marker** for the end point. The green markers will be in the same location on the **Motion Path** if the starting and ending **Pan** settings are the same. Try clicking on that location and the **Current Keyframe Marker** will become visible. Only the **Current Keyframe Marker** will move when you drag in either **Preview**. That's because you are moving the active **Layer**, not the **Marker**. The **Marker** just shows how you are changing the **Layer's** position.

Just as when we worked with simple **Motion Effects** without **Keyframes**, it's sometimes easier to start at the end of an Effect and work forward. That's how we are going to make our next adjustment. Make sure that **Keyframes 3** and **4** are selected. Drag the **Current Keyframe Marker** in the **Keyframe 4 Preview** pane so that it is positioned under **Keyframe 1** and to the left of **Keyframe 3** to form a square **Motion Path**, as shown in Figure 7.13. If you are dragging the **Marker**, the numbers don't have to be precise: **±3** is good enough for this Exercise. You can adjust the **Pan** settings for **Keyframe 4** to read **0x25** by entering the numbers if you prefer.

Producer has calculated the **Pan** value for the last **Keyframe** pair to return the **Layer** to the original position and close the square. That's because we added **Keyframes** inside the original pair on the **Keyframe Timeline**. If we had started by moving the original **Keyframe** to the **2**-second point on the line and then added **6** new **Keyframes** at 2-second intervals, we would have had to adjust the **Pan** settings for **Keyframes 5** and **6** to complete the square **Motion Path**. The values are **0x12.5** for **Keyframe 5** and **0x0** for **Keyframe 6**. You can check it by selecting that **Pair** and examining the **Pan** values.

Figure 7.13 Kcyframe adjustments can be made in either Preview pane when working with Motion Effects. When you drag the Layer in the left-hand Preview, only the first Keyframe in the Pair settings will be modified. In the right-hand Preview, only the second Keyframe in the pair will be changed.

Tip

Your window may look somewhat different as you work. Both the **Motion Path** display and the exact values for a **Keyframe** are dynamic during the design process. As you move a **Keyframe**, ProShow adjusts the values for other parts of the Effect, and the **Motion Path** and values for the related **Keyframes** are updated. Producer may generate slightly different final position numbers for intermediate **Keyframes** because it applies a **Smoothing** factor to the Slide. Don't be surprised if the numbers change a bit.

Once all the elements are in place, both the **Preview** and the **Effect** should be the same. The trick is to work in an orderly fashion and have a plan in mind for the **Effect**. Always keep an eye on the **Motion Path** as you work and **Preview** an **Effect** when you are finished setting values. If you set the wrong value, the entire **Motion Path** can be changed. If that happens, locate the problem **Keyframe** and correct the setting. That will be a lot easier than trying to redesign the effect.

Zooming In for a Closer Look

So far, we have only used **Keyframes** to control a **Layer's Pan values** and create **Motion Effects**. Now we are going to combine the **Pan** and **Zoom** controls to enlarge the picture and center the girl's face in the frame as it moves. This is a fairly simple **Keyframing** operation, but there is a trick to making sure that the adjustment does not alter the preceding **Keyframes**. It's easy to understand with the help of a practical example.

Producer's default **Keyframe** controls automatically calculate intermediate frames so that an effect smoothly occurs throughout the entire time a **Slide** is on the screen. Without intervention, that would make the **Layer** enlarge slightly throughout the entire **Motion Path**. To see what I mean, change both the **X-axis** and **Y-axis Zoom** values for **Keyframe 6** to read **180** each. Select the control and either rotate the mouse wheel to enlarge (it can also reduce) the **Zoom** settings or enter the values into the appropriate data boxes. (See Figure 7.14.) Now Play the **Preview**. The image slowly enlarges during the entire time the **Slide** is shown.

Figure 7.14

Setting the X and Y Zoom values for Keyframe 6 to 180 causes Producer to auto-adjust the preceding Keyframes' Zoom values as well.

Locking and Manually Setting Keyframes

Here we only want to have the Effect take place during the period controlled by the last **Keyframe** pair. So **Keyframes 1-5** need to stay at **100**, and **Keyframe 6** should be set to the final **Zoom** value. If we wanted the **Zoom** to occur during the time controlled by the first **Keyframe** pair, then the settings for **Keyframes 2-6** would have to be fixed.

To limit a special Effect, like the **Zoom** we are discussing, to a single **Keyframe Pair** (or any specific portion of a Slide's **play time**), we must stop ProShow from automatically adjusting the **Keyframes** that are not part of the Effect. Producer provides a set of toggle switches for each **Keyframe** setting that lets us choose either the program's default **Auto**(matic) calculation mode or **Custom** (manual) calculation set by the user. Figure 7.15 shows a labeled screenshot of toggles.

Figure 7.15

Keyframe Toggle switches let us set individual Keyframe modes to either Auto or Custom (manual) modes. There are also toggles to link or unlink the X-Y Zoom settings. **Toggle switches** are colored boxes located next to the value entry box they control. The first and last **Keyframes** for a **Layer** are always colored **gray**, since they have a fixed value based on the values for the beginning and end of play. **Green** denotes an automatically-calculated value, and **blue** a custom setting. Behind the **Zoom X** and **Zoom Y** controls are a pair of buttons, which I've circled in red, that show if the controls are *linked* (to have identical values) or *unlinked* (to allow individual settings). Click inside **Keyframe 5's Zoom X** box and enter **100**. The toggle button will change to **blue**, showing manual mode. Set the **Zoom Y** value to **100** as well. Now play the **Preview**. The **Zoom** effect is now limited to the last **Keyframe**.

Working with Precision Preview

Double-click on either **Preview** of the **Slide** to open the **Precision Preview** window. This is a handy interface for fine-tuning **Layer** placement and adjusting individual **Keyframes**. There are some differences in the way the **Keyframe Timeline** works in this window compared to the controls in the various **Slide Options** windows.

Look at the top of the **Keyframe Timeline** in Figure 7.16. The mouse pointer is selecting **Keyframe 6**, but there is no darkened area between it and the paired **Keyframe**. That's because *we can adjust only one Keyframe at a time in Precision Preview.*

The **Precision Preview** window is fine-tuned for working with individual **Keyframes**, and to closely examine the actions of special Effects. Just to the left of the **Keyframe Timeline** at the top of the window is a **Zoom** control. It is used to adjust the *area seen in the Preview*, *not* the size of the **Layer** in the **Slide**. Small settings are great for adjusting **Layers** when their locations (and/or **Motion Paths**) are outside the normal field of view.

Make sure **Keyframe 6** is active, and then adjust the image and the **Motion Path** so that it looks like the example in Figure 7.16. Click the < **Play** > button and examine the effect. Take a few minutes to experiment. Enable the **auto** function for the **Kcyframe 5 Zoom**. See how that alters the entire **Motion Path**. Reset it, and then unlink the **Zoom X-** and **Y-axes**. (Click on the **Link/Unlink** tool circled in green in Figure 7.16.) Increase just the **X-axis** value (to about 360 or so) and play the **Slide** again. Now the image grows, but the image is distorted due to the disjointed **Zoom** settings.

The screenshot of a portion of the Preview with the X-Axis Zoom set to **360**, and the Y-Axis Zoom still at **180** is shown in Figure 7.16a. It's easy to see why we will usually leave the X-Y Axis linked. Now switch the settings. Return the X-Axis to 180 and boost the Y-Axis to 360. The face is now tall and drawn. Return the settings to 180x180 and **re-link** the tool before continuing with the Exercise.

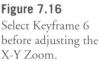

Experimenting with Rotation and Precision Preview

Figure 7.17 is a composite screenshot. I've pasted sections (as you can tell from the multiple mouse pointers) into one image. It was created as I adjusted the **Rotate** and **Rotate CTR** (Center) controls to experiment with our **Slide**. Select **Keyframe 5**, and adjust the **Rotate Center** value to **25x25** (X and Y coordinates just as with **Pan** settings). Now play the **Preview**. Nothing happens. That's because

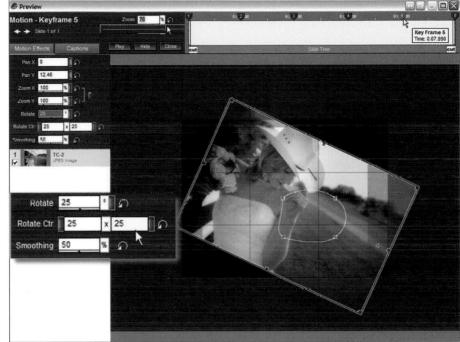

Figure 7.17

The Rotate control influences the amount of Center Rotation set in the Rotate Ctr value box, which sets the central point of the Rotation for the Layer.

> the amount of **Center Rotation** is based on the amount of **Rotation** that is set in the box located right above the **Rotate CTR** box. Now set the **Rotate** value to **25** for **Keyframe 5** and **Preview** the **Slide** again. Now the **Layer** spins as it moves along the **Motion Path.**

> The **Rotate CTR** command modifies where on the **Layer** the **Rotation** occurs. It's a bit like pinning a picture to a bulletin board and spinning it around. The point where the pic is placed determines how the picture rotates. The **Rotate CTR** location settings work just like the **X-Y Pan** values. An **X-axis** setting of **25** will move the center of rotation right one-quarter of the way across the frame, and a -**25** the same distance to the left.

> Experiment with and become comfortable with the controls we have used so far. You can also add a soundtrack to the **Slide** and view its **Waveform** in the **Precision Preview**. The audio clip will be displayed in the center of the **Keyframe Timeline**. That view can be handy for tweaking a precise point in the **Motion Path** to a peak or valley in the soundtrack.

Motion Keyframing with Multiple Layers

In the Chapter 7 folder on the CD-ROM is the **MotionKeyframing.psh** Producer file. Copy the entire folder to your hard drive (if you haven't already done so) and load the **Show**. Use the **Preview** to see it in motion. There is only one **Slide** in this **Show**, with two image **Layers** and a plain black **Background**. The two pictures cross over each other, and then one **Zooms** while the other shrinks and **Rotates**. As they do, one image appears to grow darker to make a new **Background** for the one that is now smaller and rotated.

Once the **Preview** is finished, open the **Show's** single **Slide** in the **Effects>Motion Effects** window. Make sure **Layer 1** is selected. The images are the same two pictures we've been using in this Chapter. We have already worked with all the tools used to create this **Show**. Now we are going to apply **Keyframe-controlled Motion Effects** to multiple **Layers** in the same **Slide**.

Managing the Preview Area

Some designers create complex Shows lasting several minutes with only a few Slides, and sometimes, even just one. That requires being able to see and manipulate the objects, and *establishing relationships between Layers* over their Play time. That can be tricky when there are six or seven images on a **Slide**, all stacked on top of each other and visible during only part of the playback time. Customizing the **Preview** pane and making full use of the **Motion Path** (along with a little practice) and the **Multi-Layer Keyframe Editor** makes that job a lot easier.

Right-click in the **Preview** pane, and open the context-sensitive menu. We've already used this menu. While working with multiple **Layers**, you quickly learn to rely on its Options to reduce clutter and highlight what's important. Figure 7.18 shows **Slide 1** with **Layer 1** and **Keyframes 1** and **2** selected.

Adjust the context-sensitive menu so that the **Show Composition Lines**, **Show Safe Zone**, and **Darken Inactive Layers** options are enabled. We also want to have the Options **Activate Layer With Mouse Click**, **Show Layer Outlines**, **Show Motion Path**, and **Show Grid** checked, as shown in Figure 7.18. (Note that **Darken Inactive Layers** and **Show Inactive Layers** are alternating settings; you have to click on one to turn the other off.)

Figure 7.18

Adjusting the custom settings for the Preview pane makes it much easier to work with Motion Effects in Slides with Multiple Layers. Darkening the **Inactive Layers** makes it easier to see the selected **Layer**. To **Hide Inactive Layers** lets you see and work on a Layer that is "underneath" other Layers during playback. To **Show Inactive Layers** makes it easier to position two **Layers** in relation to each other. Keep these Options in mind as you work, and use the settings that best meet the needs of the moment. I find the current settings to be the ones I use the most.

Can you interpret what the **Motion Path** and the **Preview** are telling you about the way this **Keyframe** operates and how the Layers move in the Slide? Both **Layers** 1 and 2 start with the **Layers** in the **Slide** sitting out of view, and then move into the frame, finally pausing side by side. So why don't we see a starting point in the **Starting Position Preview** for **Layer 1**? Only the **Ending Position** of the first **Keyframe** and two red **Keyframe Markers** are visible. (The **Preview** for the **Ending Position** does show the **Current Keyframe Marker** for **Keyframe 2**.)

The reason is simple. The **Preview** pane *shows only the Markers inside the viewable area*. The **Current Keyframe Marker** for **Keyframe 1** would be *outside* the zone and so not visible in the frame. So will most of both image **Layers**, since the view in the **Motion Effects** window extends only slightly beyond the area that will be visible in the **Slide** as it is played.

Double-click on the **Preview** pane and open the **Precision Preview** window. The same situation with the **Motion Path** display applies here, too. Only the Markers inside the active rendering area will be shown at full magnification. Figure 7.19

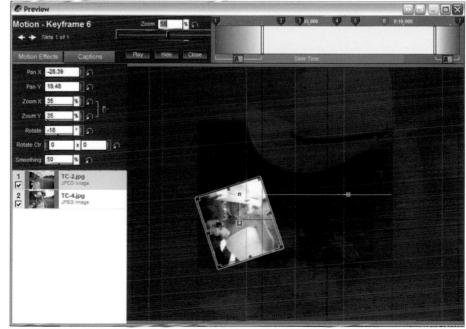

Figure 7.19 Adjusting Options in the Precision Preview window with the imaging area Zoomed out to show a wideangle point of view. shows the **Precision Preview** window with **Keyframe 6** active and the **Preview Zoom** reduced to show a large area outside the **Show's** viewable frame area.

See how the viewing area is much larger? The **Zoom** control (located in the upper portion of the window to the left of the **Keyframe Timeline**) lets us change the magnification to widen or narrow the work area. Here I have used the slider to set the zoom to **58** percent, bringing both **Layers** well inside the window. When you are finished, Close the **Precision Preview** and the **Slide Options** windows and return to the **Work Area**.

Multilayer Motion Effects Workflow

The key to developing **Keyframe** skills is being able to visualize effects and order them in sequence over time, and then matching to those segments, the mix of Motion and/or Adjustment Effect settings needed to control the Slide's appearance. There are no hard-and-fast workflow rules for designing **Motion Effects**. It is a *creative process* rather than a mechanical procedure.

For simple Effects, an "interactively intuitive" approach often works well: moving and adjusting **Layers**, tweaking Effects and Settings until things "look right." More complex **Motion Effects**, which demand precise placement, often require using a numbers-based approach. It's often helpful to draw a simple storyboard sketch, before actually importing your files into the **Slide** when creating complex **Motion Effects** with multiple **Layers**.

In this example, the process begins by importing and sizing the images, then setting the **Keyframes**, and then adjusting the position of **Layers** for each **Keyframe Pair** to produce the **Motion Effect**. As the process unfolds, more **Keyframes** are added and **Motion Effects** values are set.

The **Slide** we are about to create (or rather, duplicate) is a basic design. There are two **Layers** that move across each other in the frame, and then **Zoom** during the ending **Transition**. Both **Layers** have seven **Keyframes** with exactly the same timing.

Note

Remember that the **MotionKeyframing** Show in the Chapter folder already contains the finished slide. It can always be used if you would like to examine the final product, or you want to verify a setting.

Placing and Adjusting the Images

The foundation of a Slide is its images. It's a good idea to Crop and Size images before applying **Motion Effects**, and see first how they "work together" visually within the frame.

The **Layer order** is important when working with complex designs. The lower the number, the higher in the stack. So a **Layer's number** must be lower than any other Layer if it must pass "on top" in the frame during Play. If you need to have an image pass both behind and in front of another image, then you'll need to place copies of that picture on *two separate* Layers. In this **Slide**, we want the picture of the girl touching her hat to pass in front of the one where she is smelling the bouquet.

Drag the image of the girl looking at the bouquet (TC-4) into Slide 2 position on the Slide Timeline. Then select the one of the girl touching her hat (TC-2), hold down the Control Key, and drag it on top of Slide 2 and release the mouse. That should make TC-2 Layer 1 in the new Slide and TC-4 Layer 2. The Layers stack from the bottom to the top of the Layers List as they are added to the Slide. The last Layer added will be Layer 1.

Set the **Slide's** duration to **10** seconds, and adjust the preceding and following **Transitions** on the **Slide Timeline** to **zero**. That way we'll have a full ten-second interval available on the **Keyframe Timeline** as we design our effects.

Open the Layers>Layer Settings window and make sure that the one where she is touching her hat, TC-2, is Layer 1. In the Layer Settings pane, set the Scaling to Fill Frame for *both* Layers. Figure 7.20 shows how your screen should look at this point with Layer 1 selected. I've circled the Fill Frame area for reference.

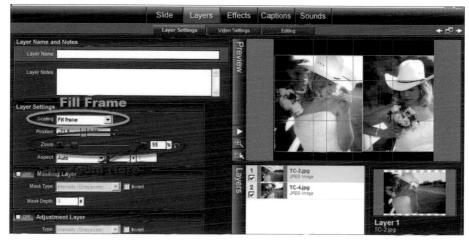

Once the images are imported, we want to be sure the pictures work with the design. We want the images to fit side by side in the safe zone, have an Outline, and be cropped so that the girl's face takes up more of the area. We'll do that using the controls in the Layers>Editing tabs of the Slide Options window. Open it, enable the Outline box, and make sure the color is white. Check the Crop box in the Editing Tools pane in the left column. We could use the mouse to crop the images, but typing in values is more accurate. A precise crop ensures that your results will look the same as the example, so let's enter the values manually.

Click the button, and when the **Crop** window opens, adjust **Layer 1's** image (**TC-2**) using the following settings: Left to 4, Right to 633, Top to 0, and Bottom to 683. Now the Size boxes in the lower right-hand corner of the window should read 629 x 683. The results should match those shown in Figure 7.21. (Remember that **Producer** never makes any modifications to the source images.) Click the **OK** button to set the **Crop**.

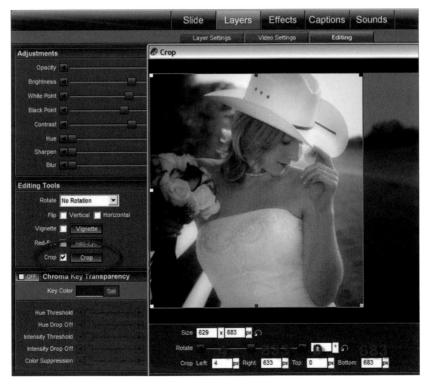

Stay in the **Edit** window, make Active **Layer 2**, and repeat setting an **Outline** and the **Cropping** process. The same goal applies. You want the images to be basically the same size and have similar aspect ratios. That way they will look balanced in the Slide when they are side by side.

Use the example in Figure 7.22 as a model and enter the following values: Left to 63, Right to 640, Top to 0, and Bottom to 683. Now the Size box above the Rotate slider should read 577 x 683. Click < OK > when you're finished.

Figure 7.22 Layer 2 being Cropped.

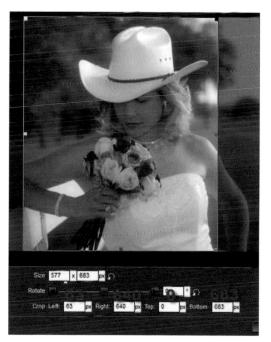

Our last step in sizing is to use the **Effects>Motion Effects Zoom** control to adjust the images to properly fill the frame. Return to **Effects>Motion Effects**. Use a **Zoom** of **55x55** (both **X** and **Y Axis**) for **Layer 1** and a **Zoom** of **50** for **Layer 2**. That's to adjust visually for the variations in the cropped size of the images. In the < **Copy Motion Effects >** menu, choose < **Copy Start to End >** to make sure that the **Zoom** values are constant throughout the entire play time. The red arrow drawn in Figure 7.23 points to the Icon used to open the menu, and the mouse pointer is selecting the Option in the open menu.

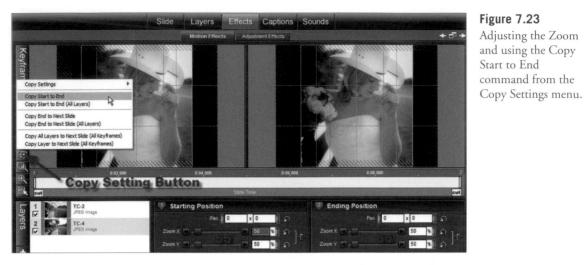

Figure 7.23 Adjusting the Zoom and using the Copy Start to End command from the

Setting the First Layer's Keyframes

The next step is to create the timing sequences for our Motion Effect-seven Keyframes per Layer. (They only require a few settings, most stay the same.) Since both Layers will have the same number of Keyframes and basic timing, we can set Layer 1 and then export those settings to Layer 2. Be sure Layer 1 is active, and right-click on the < Keyframe 2 Marker >. Set the Time to 3.5 seconds. See Figure 7.24. Once the adjustment is made, the active area will appear compressed. It will expand as we add the additional Keyframes. This segment is the portion of the design where the two pictures fade into view and will incorporate the beginning Transition.

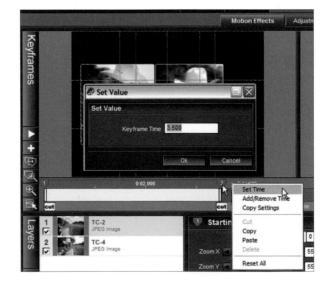

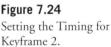

Remember that the Time settings for a **Keyframe Marker** determine where on the **Timeline** the **Keyframe** will appear. We could also use the mouse to drag the **Marker**. I often use the **Set Time** command when an Effect has been planned with precise intervals, and I use the mouse when experimenting with Options. Be aware that Producer may alter the times slightly when calculating an Effect.

Now double-click on the top of the **Keyframe Timeline** to the right of **Keyframe 2** and add a third **Keyframe**. Set its **Time** to **4.5** seconds. This will become a **1**-second segment where the two **Layers** will be side-by-side. Use the **Copy Start to End** command to set all three **Keyframes** to the same **values**.

Adjusting the Layer 1 Transitions

Click on Layer 1's Before and After Transitions in turn to open the Choose Transitions window. Set both to the Crossfade (Blend) style. Right-click on the Keyframe Timeline in the beginning Transition area and use the context-sensitive menu and dialog box to set the Time to 2.5 seconds. Repeat the process to adjust the ending Transition to 1.25 seconds. (Figure 7.25 is a composite screenshot of the selection menu and timing box for reference.)

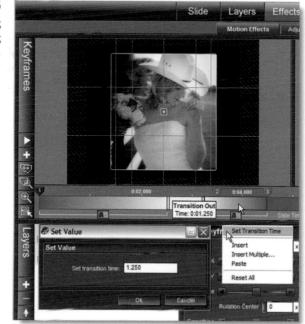

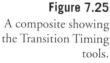

Adding the Remaining Keyframes

Double-click on the **Keyframe Timeline** behind **Keyframe 3** and add a new **Keyframe** (Number 4). Set its Time at **6.5** seconds. (Right-click on the **Keyframe Marker** and choose < **Set Time** >.) The segment controlled by **Keyframes 3** and **4** is where the pictures will cross over each other and switch positions. Notice that the ending **Transition** has moved to the end of the new **Keyframe**, and that its Time has stayed the same.

Using the same technique, click behind **Keyframe 4** to add three more **Keyframes**. They will automatically be numbered **5**, **6**, and **7**. As you add each one, adjust their times as follows. Set **Keyframe 5** at **7.5** seconds. The **Keyframe 4-5 Pair** will become the **1**-second interval, where the images will sit side-by-side after the cross-over.

Set the Time for **Keyframe 6** at **9** seconds. The interval between **Keyframes 5** and **6** is when the two **Layers** begin to part company. **Layer 1** will rotate as it becomes smaller and moves to the left side of the frame as **Layer 2** will grow larger in the background. Our final **Keyframe**, Number **7**, occurs at the very end of the Slide, the **10**-second mark.

Creating Layer 2 Keyframes

We want to make **Layer 2's Keyframe** numbers and Timing match the settings for **Layer 1**. Producer has a **Copy Settings Between Layer Keyframes** command which can handle the job. The drawback is that there must already be a matching **Keyframe** in the target **Layer**, and that it only copies one **Keyframe** at a time. It's quicker to make a copy of **Layer 1** with the **Keyframes** in place, and then use the **Copy Settings** menu to replace the image.

Right-click on **Layer 1** (circled in green in Figure 7.26) to open the contextsensitive **Layers** menu. Choose **Duplicate Layer** (also circled in green). You should now have three **Layers**: two **Layers** with the girl holding the brim of her hat, and one with her looking at the bouquet. **1** and **2** are identical **Layers**. They have identical **Keyframes**, **Time**, images, and Adjustments. Click on the < **Copy Settings** > Icon (end of red arrow in Figure 7.26), open the **Copy Settings** flyout menu, and then choose the **Between Layers** Option (circled in red).

The **Copy Settings** window should open. It can copy virtually any attribute of one Layer to another or from one Slide to another (depending on which selection you chose in the **Copy Settings** menu). Since we used the **Between Layers** command, we now see the **Source Layer** box in the left column and the **Destination Layers** column on the right. I've outlined the areas with the selections we need in

Figure 7.27. You'll need to scroll down to see the **Cropping** section of the settings. (It's pasted on the screenshot from a separate capture.) The other scttings we want should be visible when the window opens.

Here are the step-by-step instructions for setting up the **Copy** command. Choose < **Slide 2, Layer 3** > as the **Source Layer** by clicking on its radio button. If you can't see the Layers, click on the **plus sign** to the left of the Slide's thumbnail. Now click on **Slide 2, Layer 2** in the right column to mark it as the **Destination Layer**.

In the **Settings to Copy** list enable the following, by clicking to place a check mark in its box: **Image File**, **Zoom**; and between is a list of settings with check boxes. Choose the attributes you wish to **Copy** from the menu in the center column. We'll need **Enable Layer**, **Image Type**, **Image File**, and **Zoom**. Scroll down in the menu and in the **Cropping** options choose **Enable** and **Cropping Region**.

Then double-check the destination **Slide** and **Layer** in the right column. Click on the **Copy & Close** button. ProShow will make the desired modifications.

Layers 1 and 2 should now have identical Keyframes and Transitions, with different images. The thumbnail and label for Layer 2 may still have the old thumbnail and image name. Open the Layers>Layer Settings window and choose Layer 3 in the Layers List located in the lower right-hand area. Right-click on Layer 3 and choose the Remove Layer Option to delete it.

If your **Layer 2** thumbnail and **Layer** name don't match, edit the setting in the **Layer Name** dialog box in the upper left section of the **Layers>Layer Settings** window to change it to read **TC-4**. When you choose < **OK** > the name and thumbnail should be correct. I've pasted the **Layer Name** box over a screenshot of the screen with the naming problem and circled the names in red before the correction in Figure 7.28 as a reference.

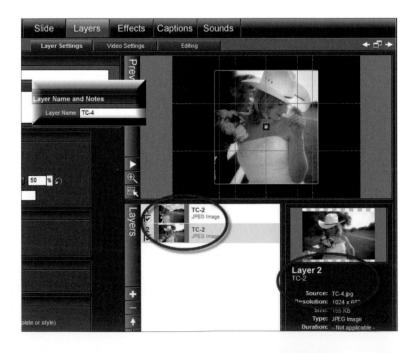

Right now the only real difference between these two **Layers** should be the picture that each contains, and the slight variation in their **Zoom** factors. If you want to check that, open the **Multi-Layer Keyframe Editor** and examine them. It's a handy way to be sure that the **Copy** command produces the desired result.

Setting the First Three Keyframes

Now it's time to set the **Motion Effects** values. We could use the mouse, but let's use precise numbers. Open the **Precision Preview** window (double-click on the **Preview** pane in any **Slide Options** window).

Click on the **Motion Effects** tab in upper left-corner of the window. Make sure that **Layer 1** is selected. Right-click in the **Preview** to open the context-sensitive mcnu. Adjust its settings to enable **Show Inactive Layers**, **Show Layer Outline**, and **Show Motion Path**. Set the **Preview Zoom**, located just left of the **Keyframe Timeline**, to **70** percent. Be sure the **Motion Effects** tab at the top of the column of **Keyframe** setting boxes is Active.

The **Precision Preview** offers controls for only one **Keyframe** at a time, and shows the matching **Preview** for that point when it plays. Select **Layer 1** by clicking on it in the **Layer List** on the left of the window. Select **Keyframe 1** by clicking on its **Marker** (it will turn **blue**) and adjust the **Pan X** value to **28**. (**Pan Y** should be at **zero**.) That will place the center of the **Layer 1** image to the right side of the frame.

Make sure the **Zoom X** is set at **55**, and the **Smoothing** at **50**. Now select **Keyframes 2** and **3** on **Layer 1** and use the same settings. All the other **Keyframe values** for these three **Keyframes** should be left at **zero**.

Figure 7.29 shows the **Precision Preview** for **Layer 1** with **Keyframe 1** selected. Your window will look a bit different, because I've already set the values for **Layer 2**. The three **Keyframes** have the same values because the **Layer** stays in the same place during that portion of play. You can tell that by watching the **Motion Path Markers** as you shift between the Keyframes. The current **Keyframe** remains in the same place.

Select Layer 2, Keyframe 1 and adjust the Pan X value to -28. Repeat the process for Keyframes 2 and 3 to -28. That will place the center of the Layer 2 image on the left side of the frame because of the minus value. The Layer 2 image is also stationary during these segments.

Make sure the **Zoom X** and **Smoothing** are set at **50**. Now select **Keyframes 2** and **3** on **Layer 2** and use the same settings. All the other Keyframe values for these three **Keyframes** should be left at **zero**. Figure 7.30 shows the **Precision Preview** with **Layer 2** and **Keyframe 3** selected, and all the values are set.

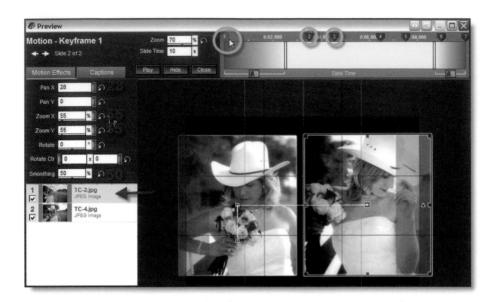

The settings for the first three Keyframes on Layer 1.

@ Preview (DI D Motion - Keyframe 3 Zoom 70 18 0 Slide Time 10 8 + + Slide 2 of 2 Key Frame 3 Time: 0:04.520 Piay Hide Close A * 0 % 2 x 0 16 \$ 5 C-2.jpg C-4.jpg

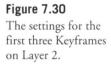

Swapping Positions: Keyframes 3, 4, and 5

The segment controlled by the **Keyframe 3-4 Pair** is when the two **Layers** trade places. They stay in place again during the space between **Keyframes 4** and **5**. We only have to make identical minor changes to each **Layer** for **Keyframes 4** and **5** to produce the effect. Add a minus sign to the **Pan X** value for **Layer 1** so it reads **-28**. For **Layer 2** remove the minus sign to make it read **28**. Make the same

changes to both Keyframe 4 and Keyframe 5. As long as the proper settings are entered, it does not matter which Layer you change first.

Swapping the minus sign swaps the center of each Layer in the frame. Producer creates a set of intermediate images that move the pictures across each other, and the Layer order in the List determines which Layer is on top during the Effect. Since all the settings stay the same during the Keyframe 4-5 Pair, the Slide stays the same during that portion of Play. Figure 7.31 shows the settings in Layer 1 in the screenshot, with the ones for Layer 2 pasted below.

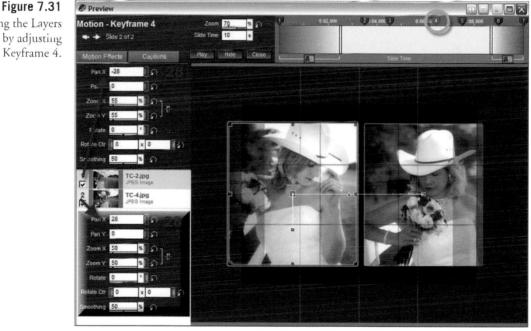

Adding a Little Spin: Adjusting Keyframes 5, 6, and 7

We're almost finished. It's time to add the Rotation movement to Layer 1, enlarge Layer 2, and then fix the Layers' position so they don't move at all during the ending Transition. Let's close the Precision Preview and make the final adjustments in the Effects>Motion Effects window. That way we can work with Keyframe pairs. I've changed the Preview Options to Darken Inactive Layers (using the context-sensitive menu) so it's easier to see the Active Layer.

Select Layer 1 and click between Keyframes 5 and 6 to make that the Active Pair. (They are circled in green in Figure 7.32.) We need to make the Keyframe 5 settings Custom, rather than Automatic. You can either click the tabs next to the data boxes, or enter the values. Make sure the Pan is -28x0, the Zoom values are both 55, and the Rotate is at zero. Now enter the following values for Keyframe 6: the Pan is -28x20, the Zoom values are both at 35, and the Rotate is -18.

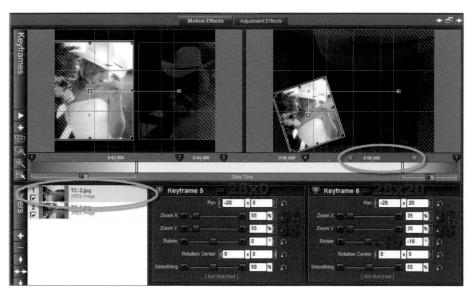

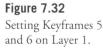

Next we need to set **Layer 2** so the image grows and shifts position to fill the background as **Layer 1** shrinks and rotates. Make sure **Layer 2** is active. Select **Keyframes 5** and **6**. Again convert the **Keyframe 5** settings to **Custom** values with **Pan** at **28x0**, and both **Zooms** at **50**. Set **Keyframe 6** to a **Pan** of **9.5x19** and the **Zooms** both to **155**. Now your window should look like the example in Figure 7.33.

The final adjustment is to set the **Keyframe** 7 settings the same as **Keyframe** 6; a **Pan** of **9.5x19** and the **Zooms** both to **155**. That's it; all the **Motion Adjustments** have been made. Now Play the **Show**. The two **Slides** move the same way.

There is a visual difference between the two **Slides**. Did you notice how **Slide 1** has some **Adjustment Effects** in place that darken **Layer 2** at the end of the **Slide**? We'll be covering **Adjustment Effects** in the next Chapter, so this example is just a teaser. Click on the **Adjustment Effects** tab above the **Preview** area and make **Slide 1** Active. Select **Layer 2** and the **Keyframe 6-7 Pair**. Your screen should look like Figure 7.34.

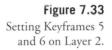

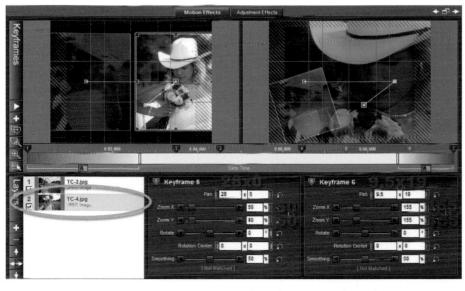

Figure 7.34 Setting Kcyframes 6 and 7 on Layer 2.

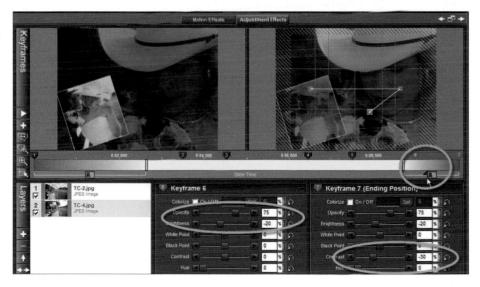

I've reduced the **Layer's Opacity**, **Brightness**, and **Contrast** during the final segment. That makes **Layer 2** stand out in the design and emphasizes the **Motion Effect**. It's obvious in the left **Preview**, which was captured as I scrubbed the **Keyframe Timeline** about one-third of the way through the **Keyframe 6-7 Pair**.

Use the Keyframe Timeline to Preview the Slide by "scrubbing" below it with your mouse.

Note

By now, the basic procedures for manipulating the **Motion Path** and working with **Keyframes** should be familiar. *It takes practice and experimentation to really master the skills.*

If you are still getting used to interpreting **Motion Path** markers, take some time now to click through the **Keyframe Pairs** and *watch* and *see* how the **Current Marker** moves and watch the way the **Motion Path** reveals how the Effect progresses during the segment. The **Motion Path** is both *vitally necessary*, and a *powerful aid*, in understanding and crafting Effects.

Designing Complex Motion Effects: The Real Deal

Now that you've been formally introduced to Producer's **Keyframing** and **Motion Effects** tools and practiced using them to build a multilayered design, let's examine a more complex **Show** that uses multiple **Layers** and multiple **Motion Paths**. The goal in this portion of the Chapter is to learn to "see" motion and develop a better sense of how to create **Motion Effects** using Producer. *Developing this skill is the key to mastering the advanced features of the program and being able to create professional-quality Shows, with the least amount of effort.*

If necessary, move the **Show** named **realdeal.psh** in the Chapter 7 folder to your hard drive. (*Be sure* to copy it from the companion CD-ROM before loading it, so you can follow along in Producer.) This **Show** contains just one **Slide** with **9 Layers** and lasts **20** seconds. Figure 7.35 shows the Slide just as all of the Layers become visible. This is the first time the Layers are arranged in a collage during the Slide.

Eight images enter the **Slide** like cards quickly dealt onto a playing table. They form a random collage and then separate. The backdrop for these images is a picture of a blackjack table complete with cards and chips. The **Layer** with the table is so dark it is not visible as the **Slide** begins. During playback, it grows lighter and fades back to almost black with a dark circle effect as the **Slide** enters its ending **Transition**. It was designed specifically for this Chapter so we could delve deeper into using **Motion Keyframing**. The images are provided by TriCoast photographers Mike Fulton and Cody Clinton strictly for use within this Exercise.

Figure 7.35 The Real Deal Slide with all nine Layers visible.

We won't re-create this Slide step by step, but you have everything you need to study and experiment with the design. The actual show is in the Chapter folder, named **The Real Deal.psh**. Before we get into the discussion, **Preview** the **Show**. Watch how the different elements interact. Can you determine the **Motion Path**? How would you plan this **Show** yourself?

A Quick Shuffle, and Laying Down the Cards

Whether you're designing or analyzing a **Motion sequence**, breaking it down into segments is a useful technique. It's a bit like giving directions. There are landmarks and turns. Once you have described the segments, it's a lot easier to determine the Motions required, and then set up the **Keyframes** and **Timing**.

There are three primary elements to any motion: **direction**, **duration**, and **speed**. In other words, the way it moves (including any turns); how long and how far it moves; and how fast it moves. Showing all the **Layers** and then selecting **Keyframe Pairs** in the **Effects>Motion Effects** window is a good way to see the relationships between the elements of a **Slide** at each point in the playback. Turning off all but one **Layer** makes it much easier to track the actions of a single component. We can also use the **Multi-Layer Keyframe Editor** to examine the relationships between **Layers**, and how they work within the **Show**. Figure 7.36 shows the **Editor** with the **Preview** as I scrubbed the **Timeline** about five seconds into play.

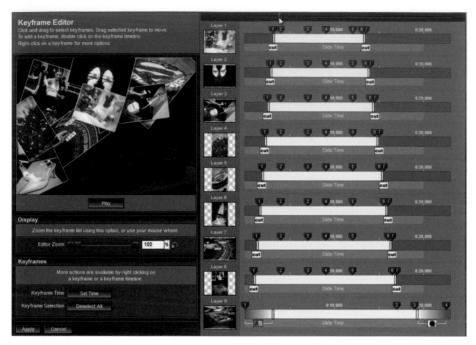

Examining the Table Background

Take a closer look at the **Slide** and you'll see that the table in the back of the design has been added as **Layer 9**, rather than defined as a **Custom Background Layer**. If it were a simple background, the designer could not use **Keyframes** or apply **Transitions** to it. In the **Motion Effects** window, select **Layer 9**.

The blackjack table does not move during the Slide, so there are no **Motion Effects**. Figure 7.37 shows the **Slide** just after the midpoint of the beginning transition for **Layer 9** (the **Keyframe Timeline pointer** is circled in green). The table looks very dark—darker than the **Crossfade Transition** would make it. This makes the bright colors in the other images more dramatic, and then the increasing color draws the viewer's eyes to the cards and chips on the table. Toward the end of play, a **Circle-Out Two-Pass Transition** (circled in red) was used to create the growing dark circle over the table. (You can scrub the **Keyframe Timeline** to see just how the table blooms into color and then fades.)

The darkening effect was generated by adjusting the **Black Point** of the **Layer** with an **Adjustment Effect**. We'll work with those in the next Chapter. They use the same **Keyframe Timeline** and controls as **Motion Effects**, so they can be easily combined with motion.

We can tell that the **Layer** is free of any **Motion Effects** by the way the entire **Motion Path** is covered by the **Current Keyframe Marker** in the right-hand **Preview** pane.

Figure 7.37 The blackjack table, Layer 9, uses four Keyframes to create its darkened background effect.

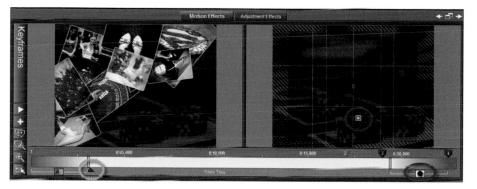

The Staggered Entry Transformed into a Second Collage

This Slide's **Motion Effects** begin with **Layers 1** through **8**, entering one at a time in a pile, and then moving to form orderly rows and columns. **Open the Multi-Layer Keyframe Editor** and let's examine the **Markers**. Figure 7.38 shows the **Editor** with **Layer 3's Keyframe 3 Marker** selected. I've drawn a red box around **Keyframes 1** and **2** and a green one around **Keyframes 3** and **4** (the Figure does not show all the **Layers**).

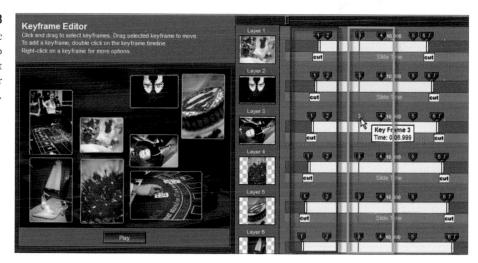

Notice how the entry time for the first **Keyframe Pair** (1 and 2) is staggered, and how the interval between the two **Markers** widens as it moves down the **Layer List**? That timing interval is what produces the delayed arrival of the **Layers**. The only **Layer** present at the very beginning of the Slide is the bottom one, **Layer 9**.

Keyframcs 3 and **4** (outlined in green) are all timed at exactly the same point. This is the common point on the **Timeline** where **Layers 1** through **8** are in place

Figure 7.38 The first Keyframe

Marker is staggered to have each of the first eight Layers appear one at a time. to form the second collage over **Layer 9**. It's possible the designer started with this Layout, and then arranged each **Layer's** position for the other **Keyframes** in the Slide.

It's possible to add **Keyframes** before a point on the **Timeline**, and use it to manipulate the path earlier in the **Layer's** playback.

The second collage is the central point in the design. All of the images are stationary and visible in the frame. Close the **Multi-Layer Keyframe Editor** and select **Layer** 7 (the blackjack dealer's hand) in the **Effects>Motion Effects** window, then double-click on the **Preview** to open the **Precision Preview** window. Set the **Preview** Options to **Hide Inactive Layers** and **Show Motion Path**. Scrub the **Keyframe Timeline** backward and forward from the **Keyframe 3 Marker** to gain a sense of how the **Motion Effect** is constructed and how each **Keyframe** works in the design. Figure 7.39 shows the window with **Keyframe 3** Active and the **Keyframe** numbers labeled in **white**.

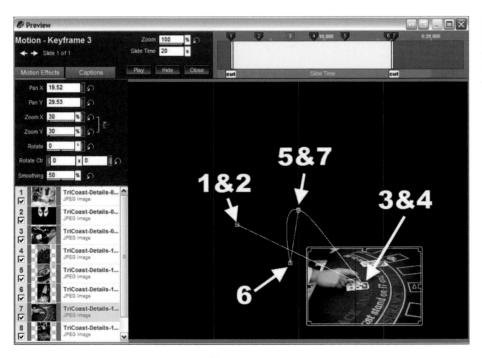

Keyframe 3 Active with the Keyframe numbers labeled in white.

The **Motion Path** is basically an "open triangle" shape. The **Layer** begins by appearing at the lower left **Keyframe Marker**, **Rotated** about **45** degrees from the ending position in the Figure in the lower-right corner of the viewing area. Let's look at each **Keyframe Pair** in detail.

Keyframes 1 and 2

The first **Keyframe** is offset from the beginning of the Slide to delay the picture's entry and has a **Cut Transition**. This explains how the Layer pops into view after **Layer 8** (the image with the women playing craps) is already visible. During this **Keyframe Pair**, the **Layer** stays still.

Keyframes 2 and 3

This is the segment when Layer 7 Rotates and moves from the original position near the center of the viewing area, to its resting point in the lower right-hand quadrant of the Slide. We can see the Motion Path and confirm our analysis by checking the Pan and Rotate settings. The Layer stays the same size, as we can see from the constant value for the Zoom settings.

Keyframes 3 and 4

This is a **Keyframe Pair** where all the **Layers** sit still with no special Effects of any kind. We can verify this by checking the settings, but it's just as obvious when scrubbing the **Keyframe Timeline**. If you examine the other **Layers** you'll find a similar design (except for **Layer 9**, which is stationary). Each enters with a **Cut Transition**, and is slightly offset from the entrance time of the others.

Keyframes 5 and 6

Here is the segment when the **Layer** moves to the center of the frame and grows to fill it. The movement is masked by **Layer 8**, until that **Layer** disappears as its **Cut Transition** occurs.

Keyframes 6 and 7

What goes up must come down. The **Layer** rapidly shrinks and vanishes as its **Transition** is reached. That opens the frame so the next **Layer** can be seen in its turn. As it moves, the **Zoom** setting drops from **178** percent (the program allows **Zoom** factors up to **500** percent) down to **zero**. The exact percentage of beginning **Zoom** varies for each **Layer**. That's because the source image size is different and so requires more or less magnification to fill the **Slide**. They all drop to **zero** to disappear.

The Beginning Is Not Always the Best Place to Start

It's easy to see how starting work from the second collage makes setting up the design simpler than working in order from the first **Kcyframe** to the last. Just as we adjusted the entry of the Captions in Chapter 6 with slight adjustments to the starting point of **Keyframe 1** in the **Timeline**, this design staggers the beginning of each **Layer** here.

Take the time to compare the intervals of the same **Keyframe** in different **Layers**. What does the shift tell you about how the **Timing** and **Settings** alter the way the **Layer** moves?

Note

As we begin working with both **Keyframes** and **Motion**, *the controls are not very intuitive*; and *slight mistakes can be very confusing*. Looking at designs that work, and figuring out how they do their magic, is a shortcut to the day when understanding becomes skill.

One of the nice things about this Show's design as a learning tool, is that several **Layers** use slightly different **Motion Paths** and **Timing** with almost identical effects. Comparing the variations is a good way to learn how different settings produce different—or similar—visual results.

Play the **Slide** again and watch the end of each **Layer**. Are they the same? Try adjusting the duration of the **Keyframe 6 and 7 Pair** for some, but not others. What difference does it make? How much difference does it take to be noticeable? Try the same experiment with the sections of the **Motion Path** and see how it looks. The key to mastering **Keyframes** and **Motion** is playbacks and comparisons.

Up Next

Now that you have a good grasp of **Keyframing**, it's time to apply these skills to **Adjustment Effects**. These tools let us transform the appearance of a **Layer** during the course of playback. Alone or combined with **Motion Effects**, they offer astounding creative tools.

8

Adjustment Effects and Advanced Editing

There's more to working with ProShow Producer's Keyframes than just Motion Effects and Captions. Adjustment Effects and advanced editing tools let us control (and change) how a Layer looks—as a Slide is played. They can make images change color, fade, grow in intensity, and become transparent. We can combine Keyframes with Adjustment Effects to control the timing of an Effect within a Layer. And multiple tools can be combined in the same Keyframe pair for even more control. This Chapter assumes that you already know the basics of working with Keyframes and the Keyframe Timeline. If not, you might want to review Chapters 2, 6, and 7 before continuing.

Adjustment Effects Controls

We'll work with three shows in Producer, since the effects all require Keyframes. The required files are in the Chapter 8 folder on the CD-ROM. Please be sure to save it to your hard drive *before* working with Exercises. Let's start by opening the Show file **adjustment 01.psh**. Once it's running, select **Slide 1** and press < **Control + F8** >. That launches the **Adjustment Effects** window.

Note

All images used in these three Shows were taken by TriCoast photographers Mike Fulton and Cody Clinton. As with all the other images supplied on the companion CD, they are provided only for use with these projects. The respective owners retain the copyright and reserve all other use.

Your **Preview** won't look quite the same as the one in the screenshot. The **Timeline** has been slightly advanced in Figure 8.1. I moved it for purposes of discussion, and have noted the location of the pointer with a red circle. Most of the controls should be familiar now. The **Layers** and **Keyframes** tools are the ones we have used in preceding Chapters. So are the two Preview areas.

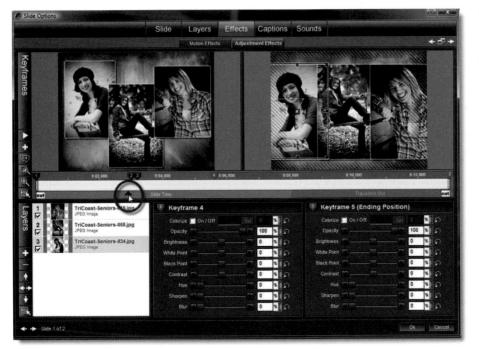

Figure 8.1

Slide 1 open in the Slide Options window with the Effects>Adjustment Effects tab selected. The lower right section of the window offers two matching sets of imageadjustment controls, hence the name **Adjustment Effects**. They adjust the appearance of the **Layers** in a **Slide**. The left-side set manipulates the first **Keyframe** in the currently-selected pair, the right the second **Keyframe** in the set. Modifying a setting only changes the appearance of a file *within ProShow*, and only for the active Keyframe segment. The source file is not actually modified.

I won't present here a detailed discussion of Keyframing, which we covered in Chapters 2, 6, and 7. Here is what each control does.

Opacity. This Slider specifies how opaque or transparent the current Layer appears. A value of zero makes it disappear, while a setting of 100 shows it at full opacity. This is a handy tool for fading a Layer in or out.

Brightness. Moving the Slider lightens or darkens the appearance of the selected Layer. Increase the value to lighten the object and decrease it to darken.

White Point and Black Point. The possible tones in an image range from total black to total white. In between are the middle tones. Adjusting the white point changes the point at which the tones are forced to appear white, hence the name. Changing the black point does the same thing from the other end of the tonal range. These two controls set the lightest and the darkest point in the image.

Contrast. This slider adjusts the overall difference between the light and dark areas of the image. A bright, sunny day has higher contrast than an overcast day.

Hue. Hue is the dominance or wavelength of a color. Adjusting this control changes the shades of the colors within an image.

Sharpen. This control allows you to make edges in the large areas of an image more clearly defined, increasing how well-focused the objects look. Oversharpening will make objects look posterized.

Colorize. This control produces a toned-image effect by adding an overall selected color. Shifting the color to gray produces a black-and-white effect that can be adjusted with the Slider settings.

Use your mouse to scrub the **Keyframe Timeline** for **Slide 1**. The Slide has three Layers and a Background. The three Layers begin as black and white and then move into the center of the screen and blossom into color. About four seconds into play, the Slide should look like the one in Figure 8.2.

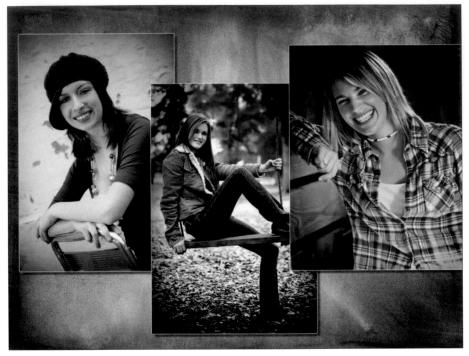

Figure 8.2 The first Slide, about four seconds into its playback.

Working with the Colorize Controls

The Colorize controls are simple to use and powerful in their effect. They are used to vary both the color of a Layer and its intensity. We can easily generate a wide range of special effects by combining various Colorize settings with Keyframes. You can set the Keyframes long to produce slow Transitions where the Layer shifts gently from one color to another. Or, place several Keyframes close together with dramatically different settings, and you get what looks like the Layer being bathed in flashing colored lights.

The Oz Effect: Black and White to Color

This first Slide uses Colorize with Keyframes to shift quickly from black and white to color, like the gray Kansas landscape gave way to bright color in the movie *The Wizard of Oz.* The movie used two different kinds of film to produce its magic. In ProShow, it's done using the Colorize controls. They are enabled by checking its box (circled in red in Figure 8.3). The image has regained most of its color by the four-second mark. Click < **Layer 2** > to follow it through the Slide's Keyframes, see how the effect was produced, and learn more about the control and how the window operates.

Figure 8.3 The first Keyframe pair for Slide 1 shows the Colorize settings, including the Set Color values.

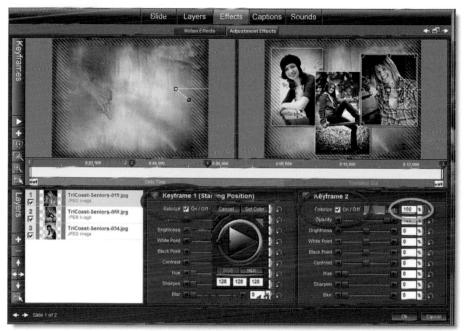

The first Keyframe pair opens with just the background visible. Then the three pictures enter the frame in black and white and pause in a triangular arrangement, as shown in Figure 8.3.

I've opened the **Set Color** control for the first Keyframe. The basic interface should already be familiar from the preceding Chapters. The numeric values in the three boxes at the bottom of the control are all set to 128—producing a medium grayscale result in the image. The **Colorize** value (circled in green for Keyframe 2 in Figure 8.3) determines how strongly the Effect modifies the colorization. (There is a matching control hidden under the **Set Color** control for **Keyframe 1**.) Both controls are set to **100%**, so the controls are fully active.

Without making any other change to the Slide, toggle the first **Colorize** box off and on for the active Layer. What happens? Do the same for the second **Colorize** box. As we tour the various controls, modify them to see what effect changing the values has on the current Layer. Then revert to the original settings and rejoin the discussion. The variations possible with **Adjustment Effects** are incredible, and the best way to learn them is by experimenting.

The basic Adjustment Effects controls have all been introduced. The examples in this Chapter reveal how to use them to create interesting effects. We won't be doing a lot of directed step-by-steps. Instead, we'll examine the examples to see how the effects were created and consider additional experiments to extend your skills.

The interval between **Keyframes 2** and **3** has exactly the same **Adjustment Effects** settings as the first pair. Its sole purpose is to halt all Layer movement, and it only lasts for a fraction of a second, as you can see in Figure 8.4.

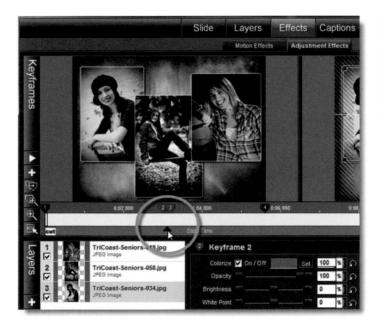

Figure 8.4

The second Keyframe pair for Slide 1. This segment halts all Layer motion, maintaining the same Adjustment Effect.

When you combine Motion Effects and Adjustment Effects in the same Slide, <u>keep in mind that both Effects use the same Keyframes</u>. You can actually use the **Preview Areas** to change a **Motion Effect** in the **Adjustment Effects** window. If you drag a **Layer**, the position (and hence the **Motion Path**) will change.

That also means that if you add a new Keyframe in either the Adjustment Effects or Motion Effects window, it will be active in the other window the next time it is opened. Consider this situation: you want a Slide to change from one color to another during the course of a six-second playback, *and* you want it to have a **Motion Path** with two segments—so you need three **Keyframes**. The color effect calls for only one Keyframe pair.

If there are three Keyframes on the Timeline when you create the color effect, it will have to be designed in two segments. That's because the program calculates the intermediate frames from one of a Keyframe pair to the next. If you set up the color adjustment first (when there are only two Keyframes), then the program will calculate the entire run and save you the extra work. Then you shift to the **Motion Effects** window, add the third **Keyframe**, and adjust the **Motion Path**.

Tip

When possible, create the type of Effects with the fewest number of Keyframes first; then shift to the other window and add those Keyframes and settings. In this case, the best approach is to create the Adjustment Effects first and then add a Keyframe to control the pause in movement.

The third pair of Keyframes demonstrates the easy way to eliminate a Colorization: use a Keyframe that exists just to turn it off. **Keyframe 3** has the same Colorize settings as **Keyframes 1** and **2**. The **Colorize** check box has been disabled in the **Keyframe 4** box. That automatically changes the value to zero and neutralizes the effect.

Now scrub the **Keyframe Timeline** from the beginning of the Slide to the **Keyframe 4** marker. Watch how the **Layers** shift into color as they move between **Keyframes 3** and **4**, as shown in Figure 8.5 (the point in the playback is highlighted with a dashed green line). The Transition is smooth; the program is rendering the frames with a constant reduction in the Colorize effect, so that it is removed just as the three Layers reach their side-by-side position along the **Motion Path**.

Obtaining the perfect timing was easy. All that was required was to be sure that the arrivals of all the Layers at that point along the **Motion Path** were linked to the same Keyframe that was assigned to the zero point for the Adjustment Effect.

Figure 8.5 The shift into color occurs between Keyframes 3 and 4.

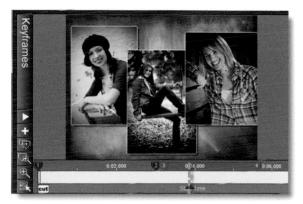

The **Preview** in Figure 8.6 shows the Slide during the following Transition. Notice how Keyframe 5 is placed all the way at the end of that portion of playback. That's part of the reason we see the beginning of the next Slide appearing in the middle of the screen as the first Slide ends.

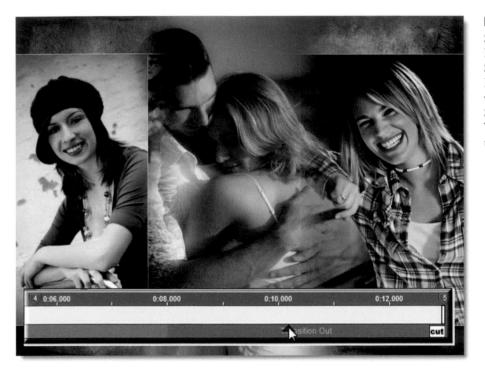

Figure 8.6

Scrubbing the Preview shows how Slide 1's final pair of Keyframes' playtime works with following Slide and the Transition between them.

The first **Keyframes** for **Slide 2's Layers** are placed at the start of the same **Transition**. The **Opening Transitions** for these Layers in both Slides are **Cuts**. Cuts are designed to totally reveal the images as soon as that point in the Keyframe Timeline is reached—without any Fades or other special Effects. The **Slide Timeline Transition** between **Slides 1** and **2** is a doors-open–soft-edge effect that lasts for five seconds. <u>Remember that a Layer's Transition is an independent effect from the Transitions placed between Slides</u>. We can mix and match, as done here, to produce combination Transition effects.

Select < Layer 1 > on Slide 1 in the Adjustment Effects window. Move Keyframe 5 to the left for that Layer so it is just at the end of the Slide Time and the part of the Transition time on the Keyframe Timeline (I've pasted it over the Preview of the Slide in Figure 8.6a). Now scrub the Keyframe Timeline and watch how Layer 1 disappears from view just before the next Slide starts to grow in the center of the frame. The red box drawn over the Slide in Figure 8.6a shows where Layer 1 was before we moved the Keyframe at that point in play.

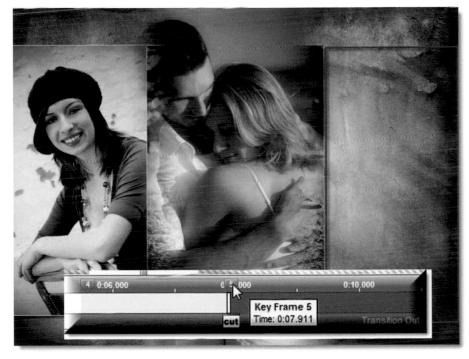

Figure 8.6a Scrubbing the Preview after moving the Keyframe, and Layer 1 vanishes as the Layer Transition is reached.

Slide 2 has three Layers, plus a picture of a beach scene used as a background. It opens to reveal a black-and-white image of a couple hugging on the edge of the surf. Scrub the Slide, beginning at the far left of the **Keyframe Timeline** in the **Adjustment Effects** window, with **Layer 3** selected. The door-opening effect during the very first part of the Slide is caused by the preceding Transition. Just past that, the doors seem to shut and reopen very quickly. Now the image is in color. Examine the **Keyframe** positions for the **3 Layers** in **Slide 2**; they all are placed *after* the door effect. The action inside the Slide's actual play time is when the picture of the couple shrinks and moves to the center of the frame, revealing the background, and then the frame fades to black.

Let's see what happens if we also move **Keyframe 1** for **Slide 2**'s **Layer 3**, the picture of the couple, from its position during the beginning of the Slide's **Transition** (at the far left of that Slide's **Keyframe Timeline**) to the point where the **Slide Time** begins. Figure 8.6b shows the result, with Before and After examples of the Keyframe placement. Move the **Layer 3**, **Keyframe 1** marker to the right so it lines up with the left side of the Slide Time section. That's where the vertical dashed green line is drawn. The top Timeline shows the Before, and the bottom is the After setting.

This example underscores how **Keyframes** are used to control WHEN things happen on the screen, and how **Effects** control WHAT happens on screen. Gaining

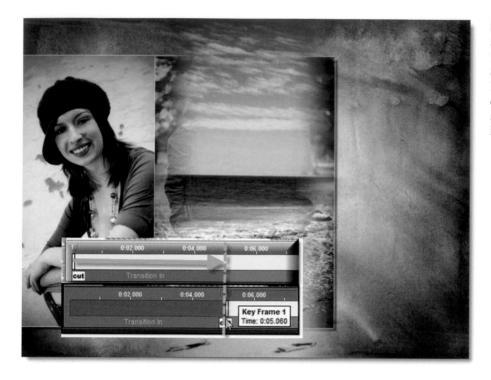

Figure 8.6b Scrubbing the

Preview after moving Slide 2's Layer 3 Keyframe 1. Now the couple's picture is missing as this point in play is reached.

<u>a real understanding of those two simple facts is the key to really mastering</u> <u>ProShow Producer</u>. Adjust the **Layer 3**, **Keyframe 1** back to its original position at the very left edge of the Keyframe Timeline (or reload the original Show) once you have finished with this experiment. We are going to delve into Slide 2's design a bit deeper.

Combining Adjustment Effects with Layer and Motion Techniques

There is some sleight-of-hand at work in **Slide 2**, a combination of **Adjustment Effects** and **Motion Effects**. There are two **solid-fill Layers** in this **Slide**. Their matching **Motion Effects** make them appear to work like a camera's shutter curtains, closing and then opening in front of the picture of the couple in **Layer 3**. At the beginning of playback the solid Layers close on a colorized picture of a couple at the beach, during the first Keyframe pair. Figure 8.7 shows the Slide as the "curtains" then open during the Time controlled by **Keyframes 2** and **3**.

The only difference in the settings for **Layers 1** and **2** are the **Motion Paths**. One enters and exits to the left, the other **Layer** performs a mirror-image movement to the right. The **Timing** and **Layer** properties are identical. Just as we saw in the

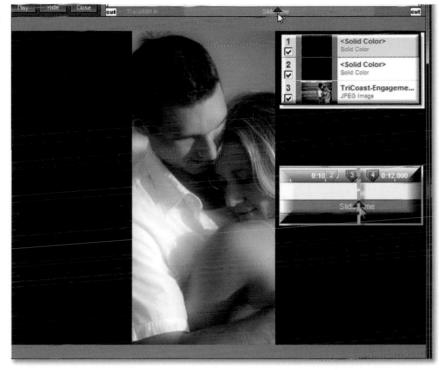

Figure 8.7 Slide 2 makes use of two solid black Layers, timed with a Colorization Adjustment to Layer 3, a picture, to create a compound effect.

Exercises in the last Chapter, **Copying Keyframe Settings** from one Layer to another makes it easy to map precise timing like this, without having to painstakingly set timing values individually.

The fast shift from black and white to color is managed with a Colorize effect lasting only a half-second as the shutter effect ends. The **Preview** in Figure 8.8 shows the Slide just before playback reaches **Keyframe 2** for **Layer 3**. We can see how the black-and-white version was produced using a **Colorize** Effect applied to **Layer 3**. It is at **100** pcrcent for **Keyframe 2** and disabled for **Keyframe 3**.

The Motion Effect makes the Layer Zoom to fill the frame until it reaches the beginning of Keyframe 2. The Layer does not move between Keyframes 2 and 3. This Keyframe pair exists to provide the Timing for the shift into color. Figure 8.8 shows the Slide just before it reaches Keyframe 3 on Layer 3. I've pasted the Keyframe Timeline and the Colorize settings for Keyframes 2 and 3 over the image. Keyframe 2 is reduced to grayscale via a 100 percent Colorize setting. Keyframe 3 is set to full color—the Colorization value is at zero. The shift into color is generated automatically as play progresses. At the midpoint for this pair, the color saturation is at 50 percent.

Figure 8.8 The Adjustment Effects window showing Slide 2, with Keyframes 2 and 3 selected.

If you want to experiment with the Effect, move **Layer 3**'s **Keyframe 3**, placing it midway between **Keyframes 2** and **4**. That adds about two seconds to the segment. Now run the **Preview**. The color flows more slowly into the couple, but the timing of the doors does not change and the effect is altered.

Reverse the timing. Return **Keyframe 3** to original position, and move **Keyframe 2** to the start of the **Slide Time**. That will advance it about **6** seconds, to the end of the preceding **Transition**. Now the image slowly gains color before the shutters cross the frame. Restore the **Keyframes** to their original positions and see how the shutter effect is produced.

Opacity: It's Not Just an Adjustment Control

Real mastery of Producer's power comes as you learn to combine the program's tools to gain total control over every aspect of a Slide and its Layers' appearance with fraction-of-a-second precision. That requires thinking creatively. See if you can figure out how the designer produced the transparent effects in our second Show. Open **Adjustments 02.psh** (in the Chapter 8 folder) and run the Show as a full-screen Preview before (in **Slide List** View) examining the Slides to see their components or Effects settings.

The **Slide 1** in this Show starts out very dark, with muted colors. Then the picture brightens and a speckled pattern plays across the image. It stays bright for only a couple of seconds as the next Slide enters to cover it up once more. Figure 8.9 shows the **Slide** as the Effect begins to clear. It looks like the results of an opening **Transition**, but there isn't one. This is the first Slide in the Show. There isn't a Transition applied to the Layer that contains the picture of the woman at all. Select it and press < **Control-F8** >. Sclect each **Layer** in turn. The **Adjustment Effects>Opacity** settings for all three **Layers** are set to **100** percent. So how was the effect generated?

Figure 8.9 The first Slide, five and a half seconds into its eight-second play.

The **Transition Effect** was created by the positioning of the *exiting* **Transitions** for **Layers 1** and **2**. The image is on **Layer 3**, so **Layers 1** and **2** (both Solid Black Fills) hid the picture while they were in view. The best way to examine the design is with the **Multi-Layer Keyframe Editor**. Click on its < **Icon** >, circled in green in Figure 8.10. I've enlarged the Editor and put part of it over the **Adjustment Effects** window to make it easier to see.

All three **Layers** begin with a **Cut**-style **Transition**. As **Layer 2**'s **Ending Transition** occurs (a **Big Dots** pattern with a soft edge), it begins to reveal **Layer 3** from the lower right to the upper left. Then **Layer 1**'s **Ending Transition** occurs, moving from upper right to lower left. When it finishes, we can see **Layer 3** fully exposed. That accounts for the pattern over the picture, but not the level of Opacity.

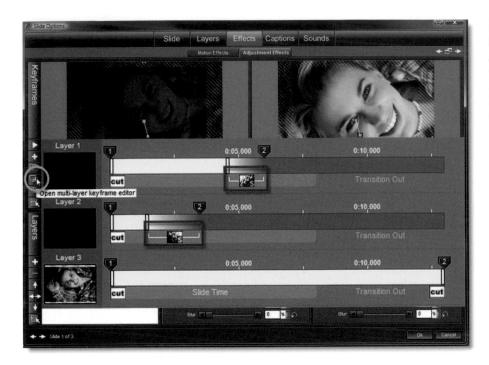

Figure 8.10 Slide 1 open in the Adjustment Effects window, with part of Multi-Layer Keyframe Editor pasted on top of the Slide.

Scrub the **Keyframe Timeline** and watch how the action in the **Preview** matches the information the Timeline provides. We can see that **Layer 3** is present from the very beginning of the Show and runs right through the Slide's ending Transition. Close the **Multi-Layer Keyframe Editor** and select each **Layer** in turn. You'll see that all three are free of any **Adjustment Effects**.

If there are no **Adjustment Effects** applied to any Layer on this Slide, how were the changes made, from almost dark, to not so dark, to bright? We know that the two solid-black Layers are involved. That is obvious from their **Transitions**. But what caused the change in Opacity, and why wasn't it done using the **Adjustment Effects** window? Why could we see the woman at all when the Slide began, if it was covered with two **Solid Fills**?

There is another place in the Slide Options toolset that allows the user to change a Layer's Opacity. Open the **Slide Options>Layers>Editing window**. Select **Layer 1**, as shown in Figure 8.11. I've added the **Opacity** settings for each **Layer** in red letters.

Layer 1's Opacity is set to 55 percent. The Before and After Editing Previews (boxed in red in Figure 8.11) show how the Layer has become semi-transparent. Layer 2 has an Opacity setting of 30 percent. So why wasn't the Opacity modified in the Adjustment Effects window? Because *the Layer needed to be active at that Opacity setting throughout the entire Keyframe*, and the Edit window was the easiest way to get the desired result.

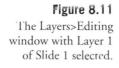

You can get the same effect by setting both the **Starting** and **Ending Position**> **Opacity** to the same number. That's a little more work. The same is true for any of the other common tools found in both the **Editing** and **Adjustment Effects** windows. Feel free to experiment with the settings, then click on the < **Cancel** > button and return to the Producer **Work Area**.

Smooth Moves: Creating a Composition with Opacity and Transitions

Let's turn our attention to **Slide 2**. It has three **Layers**, all photographs. **Layer 1** is a flower, **Layer 2** is a mirrored disco ball, and **Layer 3** shows a couple dancing at their wedding reception. All three images were black and white before being imported into the Show, rather than Colorized in ProShow.

Open **Slide 2** in the **Effects>Adjustment Effects** window. Use the **Preview's** context-sensitive menu to **Hide Inactive Layers** (right-click in the pane to open it). Let's examine the composition a bit closer before looking at the technical aspects. This Slide, shown in Figure 8.12, is an excellent example of how to combine the composition of an image with ProShow's Effects to create mood and a visual statement.

The primary image is the one with the couple dancing. The other two are simple details of the event. The photographer placed the couple in sharp focus on the right side of the frame. That side is much brighter than the left, and the audience in the background is slightly out of focus. This composition sets the stage for the design.

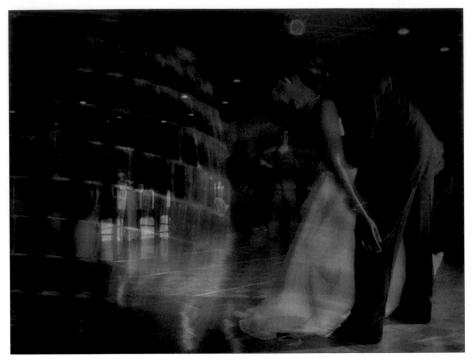

Figure 8.12 Slide 2 in the Show uses a combination of Timing and Effects to blend three Layers into a romantic composition.

Open the **Multi-Layer Keyframe Editor** and use your mouse to scrub the **Keyframe Timeline**. Pay attention to the way the different elements and the brightness of the scene work during the Preview. The beginning of the Slide has the disco ball on the left. The couple moves slightly as the Slide plays, but remains on the right side of the frame. At the midpoint in the playback, the disco ball disappears and the couple looks to be bathed in a moving spotlight. From that point on, the flower blends into the left side of the scene from the middle to the left and then the image fades into the next Slide.

Figure 8.13 shows the Editor just about at the midpoint of the Slide. (The dashed green line notes the point of the playback when the screenshot was captured.) **Layer 3** (the couple) is the central element of the composition. It has a short **Motion Path** with a little **Zoom and Cut Transition** at either end. It's visible for the complete length of the Timeline, from the start of the preceding Transition to the end of the following Transition. There are no **Adjustment Effects** applied to this **Layer**.

Layer 3's slight motion enhances the visual effect of the couple dancing. Scrub the Slide Time portion of the Keyframe Timeline. Can you see how the spotlight effect was created? It relies on the ending Transitions of the Slide's other two Layers and their placement on the Keyframe Timeline.

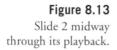

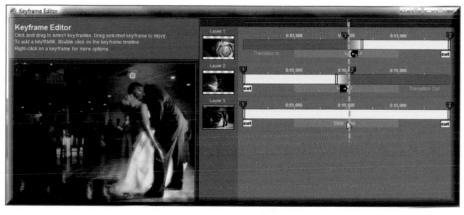

Let's look at **Layer 2**, the disco ball. It enters the frame with the couple at the very beginning of the starting Transition. Figure 8.14 shows the **Adjustment Effects** window with **Layer 2** selected. **Layer 2** has an **Opacity** setting of **100** percent, applied in the **Editing** window, so it lasts the entire time the image is visible on the screen. This **Layer** has a very short **Motion Path**, which pulls the ball away from the couple toward the upper-left corner of the frame. This movement adds just a hint of rotation and makes the highlights on the dance floor, on the **Layer** below, look like they are glittering with light reflected from the mirrors.

The ending **Transition** for **Layer 2** is a circular wipe, left to right. The last part of the Layer to dissolve is the right side, reducing the amount of time that the couple will be darkened by the **Layer 2** empty area, to the right of the ball. The total Transition time is **1.3** seconds.

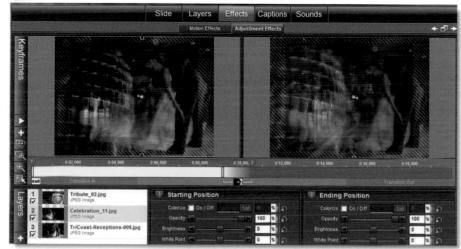

Figure 8.14 Layer 2 in the Adjustment Effects window, just as the disco ball begins its ending Transition. Now select Layer 1, containing the flower image. It has an **Opacity** setting of **50** percent, defined in the Layers>Editing window. The image has been flipped horizontally as well. Originally, the flower was on the right side of the Layer. Figure 8.15 shows the Slide as Layer 1's Keyframe 1 is reached. I've pasted in the Keyframe Timeline and the Before Editing and the After Editing Previews. This Layer stays in the same position during the entire play of the Slide.

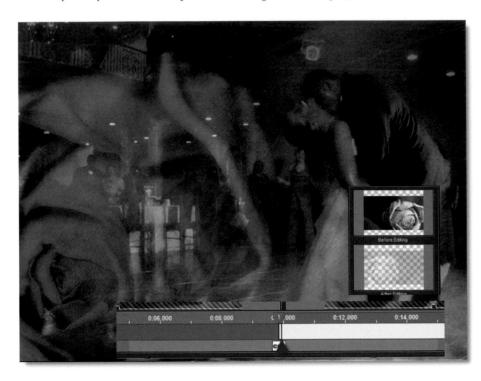

Figure 8.15

The flower (Layer 1) as it enters into view. The Keyframe Timeline pointer is hidden under the Transition Icon.

The combination of **Keyframe** timing and alternating visual flow creates the spotlight effect. The spotlight was already present in the source image. When the upper two Layers are both off-screen, **Layer 3** is unobstructed. The rest of the time, **Layer 3** is darkened by the semitransparent **Layers** above it, so the brightly lit area is muted.

Before moving on, experiment with the **Transition Timing** of these Layers to see how it modifies the way the spotlight effect works. This is a good example of how subtle designs can use very simple (but not always obvious) settings to accomplish their results. It didn't require shifting white points, or adding multiple versions of the image after retouching it in a program like Photoshop. It was simply the creative use of **Keyframes** and **Transitions**.

Creating an Overlay with Opacity

Select **Slide 3**, which uses a variation of the technique we just examined, to create the interesting effect shown in Figure 8.16. The topmost Layer (**Layer 1**) is a picture with a graduation cap with its tassel position on the right side of the frame. Its **Layers>Editing** window **Opacity** is set to **50** percent. The **Layer** is visible, but partially transparent, the entire time the Slide is on the screen—from the start of the Slide's opening Transition to the close of the ending Transition. The Transitions are both **Cuts**. It does not have any other **Adjustment Effects** or **Motion Effects**. The result is *a Layer that acts like a semi-transparent overlay*.

Figure 8.16 The third Slide in the Show as the Transition phase ends.

The lower two **Layers** on this Slide are both Senior portraits, each with a young woman positioned on the left side of the frame. They are both set to **100** percent **Opacity**. Figure 8.16 shows **Layer 2** visible under **Layer 1**. The **A/B Fade-In Transition** before this Slide lets the image of the girl come into view as the play begins. The only adjustment is a slight **Zoom**. There are no **Adjustment Effects** applied to **Layer 2**.

The second **Layer** ends with a **Wipe Transition** that runs from the lower-right corner to the upper-left corner of the frame. Its complete Opacity hides **Layer 3** until its ending **Transition** occurs. Then the lower image takes over the left side of the frame as the Transition runs its course. You can see how it works by scrubbing the **Keyframe Timeline**. Figure 8.17 shows the Slide during the **Layer 2** ending **Transition**, with the **Multi-Layer Keyframe Editor** super-imposed over it.

The last portion of the design shows the cap and tassel still in place and the **Layer 3** picture in the position that just held **Layer 2**. This Layer remains on the screen until the end of the Show and exits with the **Crossfade Transition** that follows the Slide.

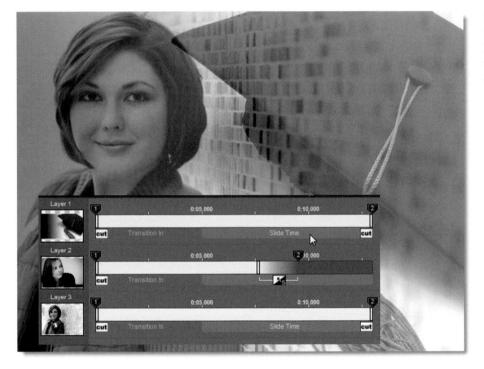

Figure 8.17

Layer 2 exiting as Layer 3 comes into view, the changing Senior portrait.

The **Keyframe Timeline** for **Layer 3** shows how it is present during the entire duration of the Slide. It is visible under **Layer 1** because of the relative **Opacity** settings. To learn more about using transparency, experiment before moving on to the next Show. Open the **Editing** window and modify the **Opacity** values for both **Layers 1** and **2**. Now adjust the duration and timing of the ending **Transition** for **Layer 2**.

We've come to the end of our experiments with this show. Feel free to explore the design, and then close the show and move on to the next topic.

Hue Adjustments: Playing with Color on the Move

Open the **adjustments 03.psh** file and play the Show. The three Slides in this Chapter's final Show focus on using color as an Effect. **Slide 1** in the collection is a collage consisting of several duplicate images that shuffle like cards, move into a diagonal set of three variations with changing colors, and then expand and merge as this Slide dissolves into the next one. This Slide offers the opportunity to see the results of blending several controls at once, and also how to manage multi-Layer **Motion Paths**. Figure 8.18 shows the Slide with all four Layers on-screen, each containing the same image. We'll tour several Producer windows, to discover what Effects the designer used to create this Slide.

Figure 8.18

The first Slide, just as all three images have extended and changed color.

Setting Up the Layers

Double-click on **Slide 1** and then open the **Layers>Editing** window. The first step in creating a Slide like this one is to assemble and prepare the **Layers** for the **Motion Effects** and **Adjustment Effects**. The **Editing** tab controls the BASE SETTINGS for a **Layer**. Remember that ProShow only borrows a file for use in a Layer. You can load several copies of the same file, and give each one a different

appearance by applying different settings in the **Layers>Editing** window. This window determines the basic (think: default) settings for how a Layer looks in the Slide. **Adjustment Effects** are modifications that can be applied at the **Keyframe** Level in addition to the **Editing** settings.

Note

Figure 8.19 shows the same four **Layers**, each with the same image file. I've adjusted the **Editing** settings for each. I've not modified the **Adjustment** or **Motion Effects** in any way. The result is available in the Chapter 8 folder both as a Show (**four layers.psh**) and an Executable (**four layers.exe**). It demonstrates how the **Editing** settings serve as a baseline for **Adjustment Effects**.

Figure 8.19 The first Slide, just as all three images have

color.

extended and changed

There are four **Layers** in this Slide, but only two different image files. Both are variations on the same picture. **Layers 1**, **2**, and **3** are the same image as **Layer 4**, but slightly Cropped: you can tell by looking at the Layer information displayed next to the listing and in the **Layers List** below the **Preview** area. (I'll explain the reason for the Crop shortly.)

The basic settings for all four **Layers** are the same in this window. **Layers 1**, **2**, and **3** have both the **Drop Shadow** and **Outline** tools enabled. These enhancements

hclp separate them from **Layer 4** and add depth to the composition. Try replacing the **Drop Shadow** with a contrasting color and see what difference that makes to the look and feel of the Slide. (Be sure to revert to the original settings before moving on.) (See Figure 8.20.)

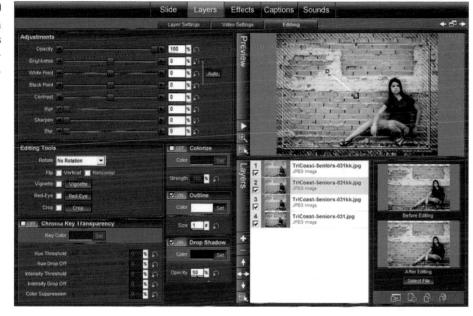

the Slide Options window's Layers> Editing mode.

Layer 4 does not have either a **Drop Shadow** or an **Outline**. Remember, when designing a Slidc, that the image Layers are like the ingredients of a recipe. Just as with cooking, some ingredients need special preparation before being added to the mix. The basic sepia tone is one example. It was set in an external image editor (like Photoshop) before the file was imported.

While we can add multiple copies of the same file into a Slide by repeatedly dragging one of them while holding the Control key, it's quicker to **Duplicate** when there are common modifications to be made. In this case, the **Drop Shadow** and **Outline** can be added in the **Editing** window and then the **Layer** duplicated using the **Copy** menu (its Icon is at bottom left of the **Layers** pane), or using the **Layers** submenu (marked with the red arrow in Figure 8.20a).

Now click the **Layers>Layer Settings** tab (Figure 8.21) and examine the image dimensions. **Layer 4** is larger than the rest. It is sized to an area of **1024x683** pixels, and cropped to cover the background area of the Slide. This Layer has also been **Zoom**ed slightly, to **115** percent. That ensures it covers the entire frame. If it were 100 percent, you would still be able to see the top and bottom edges of the Background. **Layers 1**, **2**, and **3** are **821x587** pixels with a **90** percent **Zoom**.

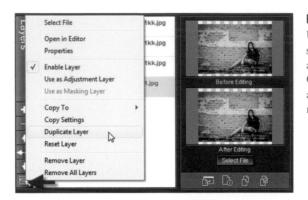

The Crop allows the smaller versions to sit inside the area covered by **Layer 4** and make them look like one picture with a section set off in a frame. Run the **Preview** again, and watch how this framed section appears to shrink and replicate. The larger copy sits directly underneath the smaller versions during the entire play time.

Motion and Adjustment Effects: An Intricate Dance, with Some Sleight of Hand

Now it's time to see how the **Keyframing** is configured. A bit challenging; but this sophisticated effect isn't too difficult with a bit of planning. To the casual observer it looks like one Layer gets Duplicated and moves to the upper-left corner. Then

Figure 8.20a

Using the Layers submenu to Duplicate a Layer lets us quickly Copy settings, as well as the image file reference.

Figure 8.21 Slide 1's Layer 4 selected in the Slide Options >Layers>Editing window.

Copies are made, which slide diagonally down the frame, changing colors as they go. The reality is a bit different and easier to create. A look at the **Keyframe** structure and **Motion Path** tells the tale. The most complicated part of the design is the movement of the **Layers**. Shift to the **Effects>Motion Effects** window and choose **Layer 4**. Here we see the larger version of the picture filling the frame (shown in Figure 8.22).

Figure 8.22 Layer 4 serves as the backdrop for the moving Layers in Slide 1.

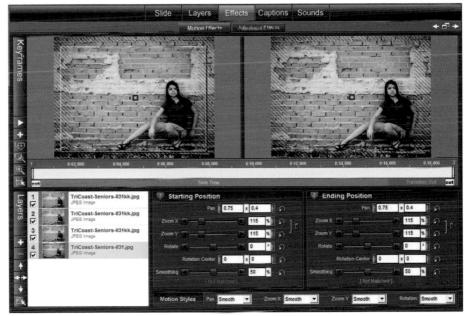

There is only the default Keyframe pair (two **Keyframes**) associated with this **Layer**. This Layer is the base of the design. It just forms a static backdrop during the entire playback, as we can tell by the **Motion Path** and the fact that the **Position** settings are the same for both **Keyframes**. The designer sized this **Layer** to fit the space before placing the smaller **Layers** on top and adding their **Motion Effects**.

A Closer Look at Layer 1

Open up the **Multi-Layer Keyframe Editor** so we can see the way the Layers interact during play. It's open in Figure 8.23, and the Icon used to access it is circled in red. I've superimposed the **Preview** for **Layer 1** from the **Slide Options** window so you can see its **Motion Path**. As you can see in Figure 8.23, **Layer 1** has eight **Keyframes**. **Layer 2** has six **Keyframes**, **Layer 3** has four, and **Layer 4** just two. What does this tell you about how the Slide's design was set up?

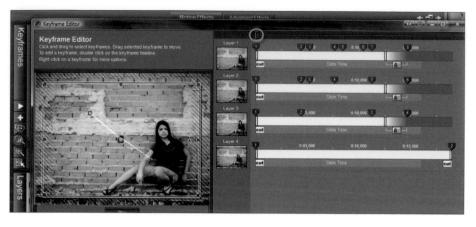

Figure 8.23 Layer 1 is the cornerstone of the design and contains the most Keyframes. They encompass the entire Motion Path.

Layer 1 is actually the only Layer that travels the entire Motion Path. Scrub the Keyframe Timeline (circled in green in Figure 8.23) and watch Layer 1 move. The image shrinks into the upper-left corner. It changes color and moves to the center, leaving behind a Copy in the new color. It moves down to the lower right, repeating the process of changing color and leaving a Copy. Then all three copies enlarge and blend back into Layer 4.

Return to the **Slide Options** window and use your mouse to select each of **Layer** 1's Keyframe pairs and examine both the **Adjustment Effects** and **Motion Effects** windows. During the four seconds of the first pair, the **Zoom** changes from **90** percent to **55** percent and the **Pan** shifts from **-0.7 x 1.25** to **-18.45 x 18.92**. The next pair lasts one second, and the only change is a shift in hue from **0** to **17**.

The third pair is used to move the Layer to the center of the frame in just over two seconds. Another second or so of rest (I used **0.8** second) during the fourth pair (**Keyframes 4** and **5**) brings another change in hue. The fifth pair (**Keyframes 5** and **6**) move the Layer to the lower corner of the frame (shown in Figure 8.24). That is followed by another color change between **Keyframes 6** and **7**.

The final **Keyframe** pair is when the hue is restored to the original settings. That lets the color of the image blend to match **Layer 4**. The **Zoom** and **Pan** settings are adjusted to enlarge the image and make it appear to fade into the larger picture.

Some sleight of hand and the use of Motion make this Slide easier to create. The moving **Layers** do not have to line up precisely with **Layer 4** at the start and end. Look closely and you can see that the designer used the lines of the brick wall with the **Drop Shadow** and **Outline**, and a little experimentation with the **Zoom** and **Preview**, to create the illusion of a perfect fit.

Figure 8.24 Layer 1 in the Effects>Motion Effects pane, with Keyframes 5 and 6 selected.

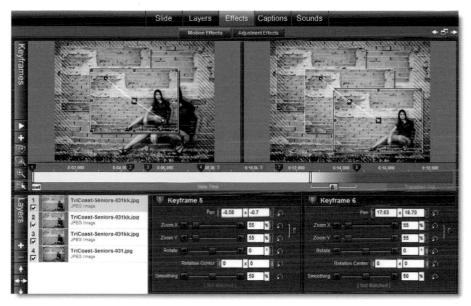

Cloning the Effects and Adjusting the Keyframe Timeline

Select Layer 2 and compare the Keyframe Timeline with that for Layer 1. While Layer 2 has fewer Keyframes, they are arranged with the same timing and functions. The designer Duplicated Layer 1 to make a template, replaced the image, and then adjusted the settings.

Let's look a little closer. The basic structure is the same until the last **Keyframe** pair, **Keyframes 5** and **6**. (See Figure 8.25.) This Layer starts full frame and shrinks into the upper-left corner of the Slide. Then it changes hues and moves to the center of the Slide. I've hidden the other Layers in Figure 8.25 so the actions of **Layer 2** are easier to see. The timing and settings are the same as those for **Layer 1**. This frame is hidden until **Layer 1** moves to the lower-right corner, leaving **Layer 2** exposed in the center of the frame.

In short, the Layer 1 Keyframes that move it to the lower-right corner were removed, so that Layer 2 stops in the center position, and then grows larger at the same time as Layer 1. The final Keyframe pair's Pan and Zoom settings had to be aligned to the timing of the last pair for Layer 1.

Now select **Layer 3**. We can see that the same technique was used here. This **Layer** is a Copy of the first portion of **Layer 1**. It simply shrinks and travels to the upperleft corner of the frame. Then it waits for the other **Layers** to move into position and then joins in the final enlargement and **Fade Out** at the end of play. See Figure 8.26. I've hidden **Layers 1** and **3**, leaving **Layers 3** and **4** visible.

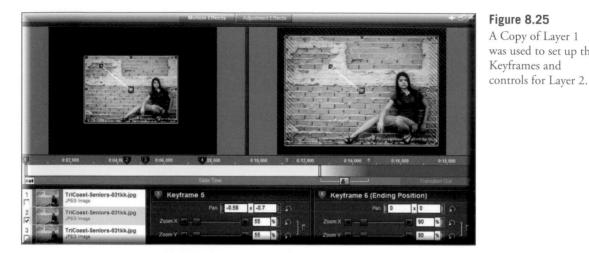

Figure 8.25 A Copy of Layer 1 was used to set up the Kevframes and

	Holder Erfe	
đ	Side Tane	Transferr Out
TriCoast-Seniors-031kk ing	Keyframe 3	Keyframe 4 (Ending Position)
TriCoast-Seniors-031kk.jpg JPEG Image TriCoast-Seniors-031kk.jpg	Pan -18.45 x -18.92	Pen 0 x 0
TriCoast-Seniors-031kk.jpg JPE0 Image TriCoast-Seniors-031kk.jpg JPE0 Image	- Refinance s	
TriCoast-Seniors-031kk.jpg JPEG Image TriCoast-Seniors-031kk.jpg	Par -18.45 x -18.92	

Figure 8.26

Layer 3 has also been copied from Layer 1 and then adjusted to map a shorter Motion Path.

The Slides in these Shows are excellent examples of how to combine Effects and use efficient workflow. The techniques we are using to discover how Slides were built can be used with all of the Shows on the companion CD-ROM, and the Slide Styles provided with ProShow.

Note

Keep in mind that Slides that use features found only in Producer can't be used in the Gold version of the software.

Variations on a Theme

This Show's **Slide 2** employs a thematic design that works well when deployed in digital picture frames or trade show display panels. (See Figure 8.27.) The bottom **Layer** is a generic detail picture composed within the frame as a setting with open space for placing pictures. Above it, images are displayed using a combination of **Motion Effects**, **Layer**, **Transition**, and **Hue** adjustments to attract the eye and add interest. Right now there are only two other **Layers**, but you could add more to extend this Slide into a Show in its own right.

Figure 8.27 Slide 2 in the Show after Layer 3 becomes fully exposed.

We aren't going to examine this Slide in detail, but rather, focus on the elements just mentioned and see how they work within this design. **Preview** the Slide, and then open the **Adjustment Effects** window. Select **Layer 1**. This Layer has six **Keyframes**. It opens with a **Cut** and ends with a **Close Vertical** Transition. (See Figure 8.28.) Right-click in the Preview pane and set the context-sensitive menu Option to **Hide Inactive Layers**. Now scrub the **Keyframe Timeline** and pay close attention as the closing **Transition** occurs. You can use the **Keyframe Timeline** in the **Adjustments Effects** pane or open the **Multi-Layer Keyframe Editor** to examine the **Keyframes**.

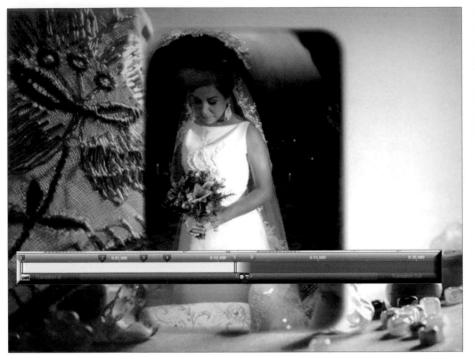

Figure 8.28 Layer 1 being replaced by Layer 2 using the Close Vertical Transition (the Keyframe Timeline is superimposed on the frame capture).

The direct placement and cropping of **Layer 1** (the three-quarter-length bridal pose) and **Layer 2** (fitting the earring) over each other creates an activity zone inside the frame—a frame within a frame. **Layer 3** is static throughout the Slide. The **Vertical Transition** adds to the effect in the way it reveals the Layer underneath.

In this Slide **Layer 3** is not the primary focus; it is a backdrop. So we are free to move and zoom in on an object as desired. Scrub the **Keyframe Timeline** again and pay attention to the **Motion Path** of **Layers 1** and **2**. Both **Layers** cover the entire frame and change position when they are at their smallest.

Each Layer's relationship to the other elements of a design determines how a Layer can be positioned and moved. First, there is the visual composition of the frame area itself. Remember how the flower and disco ball were used in the Slide with the dancing couple? They had to be placed in the left half of the frame to avoid covering the bride and groom. Even though they constituted the "background," they were the primary focus of interest.

Change the active Layer to Layer 2, and change the menu setting to Darken Inactive Layers. Select each Keyframe Pair in order. Layer 2 actually sits under Layer 1 through the first part of the Slide. Mimicking the path and sitting below the top Layer made an easy way to keep Layer 2 out of sight and properly positioned for the **Transition** point. As long as the lower **Layer** was either the same size or slightly smaller, there were no problems with it being on the screen before its proper entrance.

Examine the **Keyframe Pairs** again (use either the **Keyframe Timeline** or the **Multi-Layer Keyframe Editor**). Observe how—and when—this design adds emphasis using a shift in the image's hue. Examine the shift that happens in **Keyframes 4** to **5** during a short interval without motion. (See Figure 8.29.)

Figure 8.29 Layer 2 uses a line to add another element of contrast to the composition.

> Experiment with alternate settings to get a sense of visual flow and impact. Alter the white and black points as well as the hue. There are no precise rules, and different images may look better with different combinations. The nature of the background, the preceding and following **Layers** and **Slides**, the desired effect, and personal taste, can all be factors in choosing the final combination.

A Horse of a Different Color

Digital photography makes it easy to experiment with various processing options for an image. Producer makes it simple to display these variations, assemble proofs for a client, create a sample collection, or just design something for artistic pleasure. The final Slide in this Show offers an example of how this can be done, and combines several techniques we have been using in this Chapter and the preceding one. We'll use it to expand on our discussion and do a quick review.

Play Slide 3, and then open it in the Motion>Motion Effects window. In the preceding Slide 2, the bottom Layer was an integral part of the design. This Slide uses an image as a designated background Layer. It is simply an attractive backdrop pattern that is covered during much of the playback. There are also two Layers that both contain the same image file. See Figure 8.30.

Figure 8.30 The final Slide in the Show uses hue and two Layers with alternating Motion Paths to create a shuffle effect.

Figure 8.31 shows the Slide with **Layer 1** selected. Change to **Layer 2** and the Keyframes don't change; only the direction of the **Motion Path** changes. Just as with the Slide of the bride in the cowboy hat in Chapter 7, this design is a natural for creating one **Layer**, setting the **Keyframes**, Duplicating it, and then changing the assigned image file. With the Chapter 7 Slide, all we had to do then was to reassign the **Motion Path** to the new **Layer**.

There is still additional work to do here. The images change hue three times each. You could do it to one Layer before the Duplication and then adjust the hue for the second, or you could set both together during another design step. Figure 8.31 Layer 1 of Slide 3, showing the Motion Path with Keyframes 3 and 4 selected. The screenshot is a composite image to allow showing more detail in the Keyframe Timeline.

This is a matter of personal preference. I tend to do both at the same time. It's easier to judge which colors work best side by side that way (see Figure 8.32). If onc is already set, it tends to limit the options or require changing both sides to complement each other.

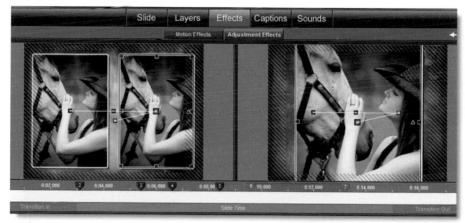

Figure 8.32 Layer 2 in the Adjustment Effects window with Keyframes 6 and 7 selected.

That brings up another issue. Any changes in the **Adjustment Effects** controls alter the way the image looks on the screen. In some cases the new look may clash with the other **Layers** in a **Slide**. It may be possible to tweak the design and keep the new look. Sometimes it requires paring or altering the design.

Producer offers an extensive array of design tools, multimedia effects, and image controls. The interface offers a very flexible workflow and the ability to change and extend a Show at any time. It lets us use the same Show file to generate a wide variety of Output formats. When working on the design, we have to keep the final goal for each project in mind.

Up Next

We have covered most, but not all, of the design tools in ProShow. The next Chapter explores some of the program's most advanced Layer controls: Masking, Vignetting, and Chroma Key. These tools offer powerful ways to add depth to a Slide and link the way Layers relate visually to each other.

9

Advanced Layer Techniques: Masks, Vignettes, and Chroma Key

Get ready—in this Chapter we'll combine what we've already covered, with Producer's Advanced Layer tools (**Masking**, **Vignetting**, and **Chroma Key**) to generate incredible effects.

Masking lets you use one Layer to hide ("mask") or reveal portions of selected Layers beneath it. We can use it to isolate, highlight, and spotlight portions of a Layer in very creative and subtle ways.

Vignetting controls the shape and Transparency of a Layer's edges, giving you the tools to frame and blend one Layer with another.

Chroma Key makes one color in a Layer transparent. Best of all, you can pair these tools with **Motion** and **Adjustment Effects** and **Keyframing**.

The best way to master these advanced topics is to follow along with the lesson files in Producer. I'll explain how the Slides work, but won't give step-by-step instructions. By now, I assume you are familiar with the Producer user interface and know how to use the necessary controls to duplicate the design. I will point out any innovative or unusual design techniques. Keep in mind also that you always <u>have the actual settings</u> for each effect in the sample Show itself.

Note

This Chapter's shows require ProShow Producer. Before working on the following Exercises, you should already be familiar with the material presented earlier in the book, and have already copied the Chapter 9 folder from the CD-ROM to your hard drive.

All images used in these Shows were taken by TriCoast photographers Mike Fulton and Cody Clinton. As with all the other images supplied on the companion CD, they are provided only for use with these projects. The respective owners retain the copyright and reserve all other use.

The material assumes a reasonable knowledge of Motion and Adjustment Effects, Keyframing, and the ProShow user interface. Also, be aware that many of the Slides shown here use complex effects, and they may take longer to render Previews than those in the preceding Chapters, if your computer is configured with minimal memory, or your hard drive is close to full capacity. (That won't, however, slow down Previews you do by scrubbing the Slide List or Keyframe Timelines.)

Let's start with a quick example of Masking and Motion. Run the automaticallyexecuting Show file **Jump for Joy.exe**, which started in the Chapter 9 folder on the CD-ROM and now is on your hard drive. It uses a single image, albeit a very active one, of a groom and groomsmen jumping in the air. Figure 9.1 shows a segment of the show.

We'll look closely at how it was created momentarily. For now, as you watch the Show, notice how the vertical slit in the center works as the Slide plays. Visually, black covers either side of the frame and the areas above and below the image, leaving the center section free. In reality, the center is covered by a black Layer! It is defined in Producer as a Mask—so we can see through it!

Masking is a very sophisticated technology, and can be a bit confusing at first. Solid fills become transparent, for example. We'll take things steps by step, with plenty of examples. Before you go into your first hands-on session, let's look at how **Producer** uses the **Mask** in this example. Open the **Jump for Joy Show** in Producer and then open the **Layers>Layer Settings** pane.

This Slide has three Layers: a solid-black one on top and two copies of the same picture of the groom's party. There is also a solid-black background. Figure 9.2 shows the **Layers>Layer Settings** window for the **Show** with **Layer 1** selected. Notice that in the **Masking Layer** pane the **ON** box is checked. The actual Layer is the gray area in the center that I've outlined in green in the Figure as well.

Figure 9.1

This zany portrait of a groom and groomsmen by TriCoast Photography, really comes to life with a bit of Masking magic and Motion Effects in Producer.

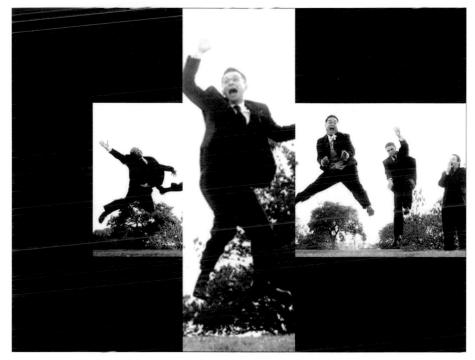

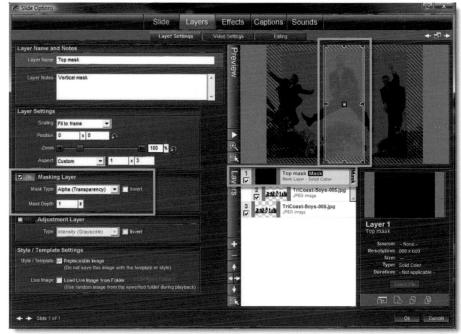

In the **Masking Layer** pane (boxed in green in Figure 9.2), the **Mask Depth** is **1**, which means that the Mask is applied to the first Layer *below* it. If the number were **3**, then the Mask would control the first three Layers below it. Any deeper Layers would not be affected by the Mask.

The **Mask Type** determines the Mask's behaviors. This one is set to **Alpha** (**Transparency**). The black Layer is really a transparent Mask. In any Layers controlled by the Mask, the portion of the frame where the Mask is placed will appear transparent, and the rest of the frame will not. The color of the Mask makes no difference when it is a transparent Mask (also called an *Alpha channel* Mask).

Grayscale (also called *Intensity*) is the other type of Masking. When a Layer is used as a Grayscale Mask, the dark areas of the image hide the Layers below, and the light areas are shown. We'll work with this type of Mask later in the Chapter.

Examine the **Layers List**. See how **Layer 1** is designated a **Mask** (the black label with the word "Mask" in the Layer's first line)? **Layer 2** is indented, indicating that **Layer 1** is masking it. The **Mask** bar on the far right of the **List** also shows which Layers the Mask affects. The Mask determines what portion of the Layers underneath is seen in the show.

The Alpha Channel and a Spotlight on Masking

One of the most common (and easiest to master) Masking effects is the moving spotlight. We'll use it to introduce the basics of both **Transparency Masking** and Producer's **Vignetting** controls. They complement each other, and the combination makes it easy to see exactly how **Alpha Channel Masking** (**Transparency Masking**) works.

Creating a Simple Transparency Mask

Open the Show file **Mask1.psh** in Producer. This show has one **Slide** with a single image **Layer**, underneath a **Transparency Mask**, and a solid black background. As the Show plays, the Mask's **Motion Path** creates a spotlight that focuses on the bridesmaids' flowers, and then enlarges to reveal the entire picture.

Open the **Effects>Motion Effects** window and select **Layer 1**. The **Preview** pane in Figure 9.3 shows the Slide in the window with the line being scrubbed at a point between **Keyframes 5** and **6**. You can see its **Motion Path** in the right **Preview** pane on the right side; the area of black inside the Layer's outline in the right pane is the background, not the **Layer 1 Mask**. It is the area defined inside

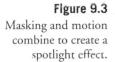

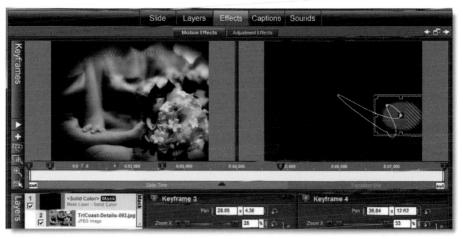

the Layer outline. If your Layer does not have the outline, enable it using the context-sensitive menu. Right-click in the **Preview** pane to get the menu, and enable **Hide Inactive Layers**, **Show Motion Path**, and **Show Layer Outlines**. It really helps when working with solid Masks.

Let's add another Slide to this Show and create a similar effect. That's the quickest way to learn basic Masking. **Cancel** the open window and return to the **Work Area.** Drag the image file **TC-G113.jpg** to the **Slide 2** position on the **Slide List** and drop it. Adjust the **Transitions** before and after this Slide to **0.0** seconds.

Open the **Slide Options** window by double-clicking on the new **Slide** and choose the **Layers>Layer Settings** tab. Left-click on the < + > sign (circled in green in Figure 9.4) and choose < **Add Solid Color** >. The **Create Solid Color** window will open. In the **Color** pane, click < **Set** > and use the mouse to drag the round button to the blue part of the **Color Wheel**. Then click the mouse in a blue part of the Triangle, and then click the < **Set Color** > button to make the new **Layer** a dark blue. (The button is indicated by a green arrow in Figure 9.4.) Figure 9.4 shows my screen just as I finished this step. Click < **OK** >.

The **Preview** pane should show a solid-blue fill, our new **Layer 1**. The picture of the jumping bridal party is now **Layer 2**, covered by the new **Layer 1**. If your Layers are not in this order, please adjust them. Click to enable the **Masking Layer** pane's check box (indicated by the red arrow in Figure 9.4a). Right-click in the **Preview** pane and cnable **Show Inactive Layers**; you'll now be able to see **Layer 2** grayed out underneath the Mask.

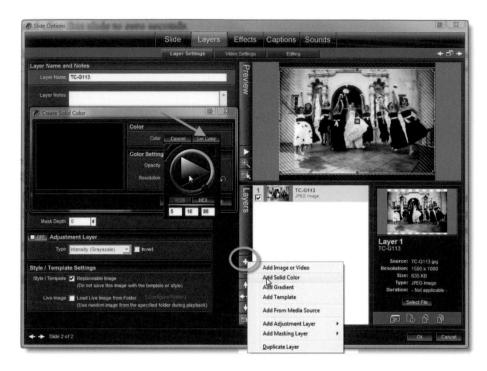

Figure 9.4

Setting up the color for the new Layer 1, to be converted into a Mask.

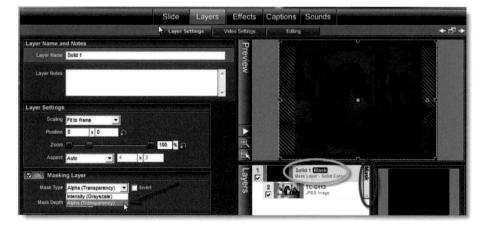

Figure 9.4a The new Mask configuration in place.

Look at the Layers List. Layer 1 is designated as a Mask (note the Mask label circled in green in Figure 9.4a), and Layer 2 has been indented in the List. The right edge of the List has a Mask bar that also denotes which Layers are in the Mask's stack (circled in red in Figure 9.4a). The Left Arrow at the left edge of the Layers pane undoes the indent and removes the Layer from the Mask's stack. Use the Mask Type drop-down menu in the Masking Layer pane to set the Mask to Alpha (Transparency) mode. It's pointed out in Figure 9.4a with a red arrow.

Figure 9.4b shows the **Slide** with some extras **Layers** we are not going to create. It's designed to illustrate the basics of working with Masks. The two Horizontal **Arrows** side by side at the left of the **Layers** pane are used to shift a **Layer's** position; the one pointing right indents it under the **Mask**, and the Left one outsets it to the left margin and moves it out from under the Mask. The **Up** and **Down Arrows** above and below them move a selected **Layer** up or down in the **Layers List**.

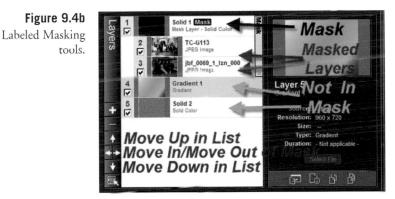

A **Masking Layer** can Mask more than one **Layer**. As you can see in the Figure, the bar on the right side of the **List** extends down to border the **Mask** and the two **Layers** underneath. It does not include **Layers 4** and **5**. They are not part of the stack, and are not controlled by the Mask.

We set the **Mask** to dark blue to illustrate another fact about Masks. *The color of the Mask has no bearing on how the Slide looks.* A **Transparency Mask** does one thing—it blocks portions of any **Layer** beneath it (that are indented and made part of its stack) from being seen. This is *not* the same thing as placing a transparent **Layer** that is not a **Mask** on top of other **Layers**, even though the results may look similar in some cases. Masks offer a lot more control.

Change to the Effects>Motion Effects window and set Layer 1 Starting Position Zoom to 50 percent. Do the same for Ending Position. Scrub the Keyframe Timeline to the middle of the Slide's play Time. Figure 9.5 shows how your window should look. There is no Motion Effect; we simply used the Zoom control to set the size of the Mask in the frame. The black area that borders the group is the Slide's black background. The Mask opens the Effects > Motion Effects pane. Adjust the X-Y Zoom for Layer 1 to 50 percent in both the Starting and Ending Position Keyframes. Now scrub the Keyframe Timeline. The Mask hides all but the portion of the underlying Layer that it covers. (See Figure 9.5.) That is what we'll use to create our spotlight effect.

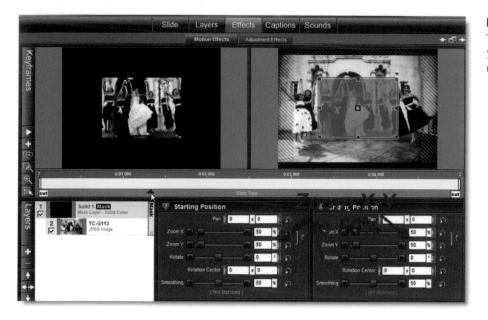

Figure 9.5

The Mask, zoomed to 50 percent midway through playback.

Combining Transparent Masks with Vignettes

Right now our Mask is a sharp-edged rectangle that doesn't look much like a spotlight. Let's make the shape round and feather the edges before we add a **Motion Path.** That's easy with Producer's **Vignette** controls. Open the **Layers>Editing** pane with **Layer 1** selected. Check the **Vignette** box, then the button, in the **Editing Tools** pane. A dialog box like the one in Figure 9.6 will open. For the **Shape** option (follow the red arrow drawn in the Figure), choose an **Ellipse**, and set the **Type** (green arrow) to **Transparent**.

This type of **Vignette** has two controls. The **Vignette Size** setting (white arrow) adjusts how big the soft edges of the **Layer** are, and the **Border Size** (yellow arrow) sets the diameter of the **Ellipse**. Set both to **zero**, and the result is an oval shape with sharp edges. Change both to **50** percent, and you get a mid-sized oval with a soft, feathered border. Play with both controls to get a good idea of how they operate, and then set the **Vignette Size** to **75** and the **Border Size** to **25**.

Now the **Mask** produces more of a spotlight effect. It's time to make it move and light up the ladies. Combine the Mask with **Motion Effects** and we have the desired result. The design calls for nine **Keyframes** and a twisted **Motion Path**. I've created a second version of the show to save you the process of manually adding the **Keyframes** and adjusting their settings.

Close this Show and open the **Mask1 with both Slides.psh** Producer file and double-click on **Slide 2** in the **Slide List** to open the **Slide Options** window. Double-click again to open to the **Precision Preview** window. Choose the **Motion**

Effects tab and make sure **Layer 1** is active. Your window should now resemble Figure 9.7. (I've trimmed the empty section of the window in the screenshot, and added arrows that point between a **Keyframe Marker** and its point on the **Motion Path** in the Preview.)

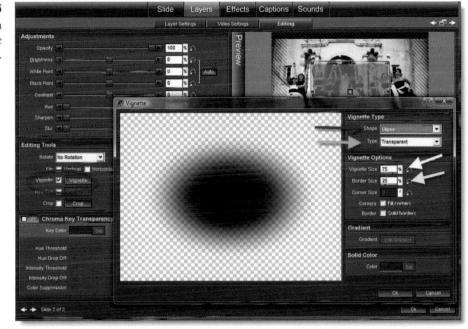

Figure 9.6

Designing a transparent ellipse Vignette for Layer 1.

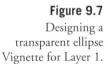

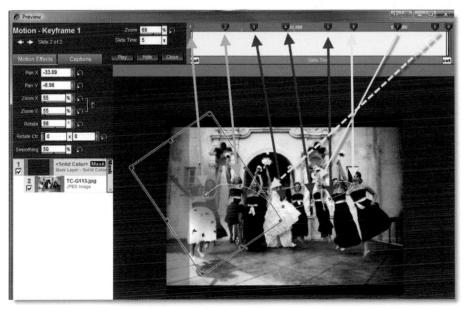

The Slide's nine **Keyframes** enable a **Motion Path** that moves the spotlight (our **Mask**) from the junior bridesmaid on the far left across to the woman next to her (green arrows) then drops down and moves to the far right (red arrows), and then comes back up and to the bride (yellow arrows) and **zooms** out with a bit of rotation in the last **Keyframe Pair** (dashed yellow arrow).

If you want to duplicate the example, the easiest way to define a **Motion Path** from beginning to end is to set the first pair of **Keyframes**, then adjust their time interval and the **Motion Path** location. Then add the additional **Keyframes** one at a time and use the **Copy Start to End** command to match the values before adjusting the new **Keyframe**. (The command is off the **Copy Settings** menu, below the **Plus** sign on the left edge of the **Keyframes** pane in the **Motion Effects** window.) I use this method for almost all my **Keyframe** work. Refer to the Slide if you want to examine the actual numerical values for the settings.

Figure 9.8 shows the Slide as the **Keyframe Timeline** is scrubbed between **Keyframes 7** and **8**. I've added a red arrow to mark the point on the line and the **Motion Path**.

Figure 9.8 Scrubbing the Keyframe Timeline with the finished Motion Path, shown in the Precision Preview pane.

Isolating Portions of the Frame with Transparent Masks

Static Masks (those without **Motion Effects**) are used to set off a portion of the frame during play. Of course, they Mask only the **Layers** nested underneath them. **Layers** above are not affected, and neither are those below that are not part of the Mask's stack. Static Masks can be modified using **Editing** and **Adjustment Effects** to control what and how they modify in the **Layers** they cover.

Let's look more closely at the Slide with the groom's party and see how it works. Open the **Mask2.psh** file in Producer, and then open the **Slide** in the **Slide Options** window with the **Layers>Layer Settings** window active. Select **Layer 1**. Your window should look like the one shown in Figure 9.9.

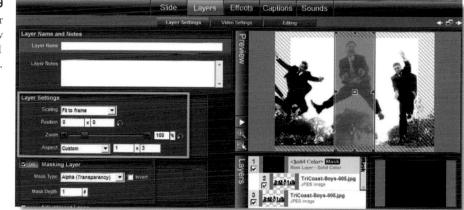

This Slide has three **Layers**: the **Mask**, a nested image in the Mask's stack, and a copy of the same image that is not Masked. Let's look at how the **Layer** is configured. It's a **solid-color Fill** set in the **Masking Layer** pane (boxed in red) as an **Alpha (Transparency) Mask**. The **Scaling** field in the **Layer Settings** pane (boxed in green) is set so the **Layer** fits within the frame. So why does it appear as a narrow vertical rectangle? Notice the **Aspect** ratio (also in the **Layer Settings** section): **Custom**, with a value of **1 x 3**. Change it to **3 x 3**, and the rectangle becomes a square. If you try it, change it back before you proceed.

Since Layer 1 is an Alpha channel Mask, only the portions of Layers in the Mask's stack will show. In this case, Layer 2 is affected, but Layer 3 is not. This is another example of how ProShow does not actually modify an external file; rather, it just "borrows" the data and renders it in a video stream.

Figure 9.9

The Layers>Layer Settings window open, with Layer 1 selected. Click the check box in the **Masking Layer** pane that says **Invert** and scrub the **Timeline**. Now the **Mask** produces a black vertical section in the center of the frame. The rest of the picture, which was hidden before, is now visible. **Uncheck** the box to return to the original setting.

Double-click on the **Preview** to open the **Precision Preview** and select the **Motion Effects** tab. The **Mask Layer** has only one **Keyframe** pair, running from the beginning of the **Show** to the end of the following **Transition**. (There is no **Transition** before the Slide.) That means that the Mask is present on the screen for the entire playback. You can see it in the **Preview** Area. It is the transparent, gray, vertical panel in the center of the frame.

Select Layer 2 in the Layer List at the left side of the Precision Preview window. Now you can see the Mask in place with part of the underlying Layer and its Motion Path visible (see Figure 9.10). The black on either side is the underlying Background. To prove that, switch to the Slide Options>Slide>Background window and change the selected color. The areas on the sides will then show that color. Then Cancel it.

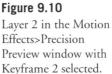

Open the **Multi-Layer Keyframe Editor**. Run the **Preview** and watch how fast the segments change. Now examine the **Keyframe Timeline** for **Layer 2**. See how **Keyframes 2** to **14** have sets, with one **Keyframe** sitting on top of another? Then the interval for the final **Keyframe** Pair increases to allow the underlying **Layer** to slide into the frame and **Zoom** toward the viewer. This design really fits the mood of the subjects and their zany poses. The first part of the playback, with its fast shifts in the **Masked** region, matches the acrobatics of the groom and his friends. The viewer is drawn into the action, but it doesn't give the full picture.

Then the entire image scrolls in from the right. The viewer can focus on the way the men are all in the air at the same time. Can you figure out what happened to make the **Masked** area and **Layer 2** disappear to the left as **Layer 3** passed bencalli it? It's the same reason that the color of the Mask makes no difference. Understanding the way it works will help you understand how **Masks** and the **Layers** they control operate.

Figure 9.11 shows the playback in the **Multi-Layer Keyframe Editor** just as the **Masked** area starts to close. A red dashed line has been added to mark the point in play being scrubbed. The green box in the **Preview** shows the mark as it narrows. The vertical rectangle that makes up the Mask will continue to make the underlying **Layer** visually narrow and then disappear. The Mask isn't there as an object in the Slide. It is simply a regional effect defined by the shape of the Mask that limits what is seen of the underlying Layers. That's how a Mask differs from a transparent file used as a frame.

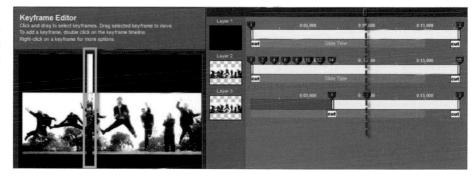

Layer 3 entering the Slide as the Mask begins to narrow and disappear.

> Layer 2 is moving to the left at this point in the Slide. As the right side of the picture reaches the right side of the Mask, more of the background is revealed. That's what makes the Mask "disappear." Layer 3 first slides behind Layer 2, unaffected by the Mask. The part of Layer 2 that you can see hides that portion of Layer 3.

> Compare the **Keyframes** for **Layers 2** and **3**. (**Layer 3** is shown in the **Precision Preview** window in Figure 9.12.) As **Layer 3** starts to move into the right side of the frame, **Layer 1** stops moving back and forth and pans to the left in its exit pass. The difference in **Zoom** means that **Layer 3** travels faster and so passes partially beneath **Layer 2** before it can fully leave the frame. Finally, **Layer 3 Zooms** during the segment controlled by **Keyframes 2** and **3**.

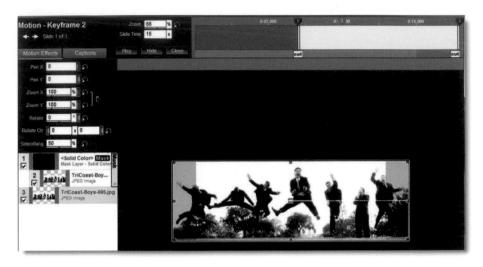

Figure 9.12 Layer 3 enters the frame as Layer 2 scrolls off to the left.

These examples give a good introduction into the realm of **Transparency Masks**: how to use them in your productions and how to combine them with **Motion Effects**. Keep in mind that you can have multiple **Layers** and that a **Mask** has control only over the **Layers** in its stack. Lower **Layers** that are not in the stack are not **Masked**. You'll see more of how that affects the view of a Slide next, when we use **Intensity Masking**. Close the current **Show**.

Intensity Masking: White Reveals while Black Conceals

Intensity Masking (also called **Grayscale Masking**) is based on the **Grayscale Intensity** of the **Masking Layer**. The basic rule is, "white reveals while black conceals." If you choose the **Invert** Option, white will conceal while black will reveal. Portions of a **Mask** that are not pure black or white will pass through the Mask's **Layer** stack based on density. A **50** percent gray will be **50** percent transparent. We can use images, **Gradient Fills**, and even video clips as **Masks**. Of course, we have to choose the **Mask** carefully to create the desired effect.

Slide 1: a Simple Stencil

Launch Producer and open the **Mask3.psh** Show file. This **Show** has two Slides that make use of **Intensity Masks**. **Slide 1** isn't designed to be a showstopper. I created it to demonstrate the basic principles of **Grayscale Masking** using a **Gradient Layer**. The other **Slide** is designed to show what you can accomplish with this style of **Masking** and a little imagination.

Select Slide 1 and press the < Control + F4 > keys. The Slide Options> Layers>Layer Settings window should appear, as seen in Figure 9.13. This Slide has four Layers. Layer 1 is a Gradient created in ProShow and designated as a Grayscale Mask. Layer 2 is an Adobe Photoshop file with black letters and a Transparent Background. Layer 3 is a solid color generated in ProShow, and Layer 4 is a JPEG-textured background that comes with Producer. Layers 2 and 3 are masked by Layer 1.

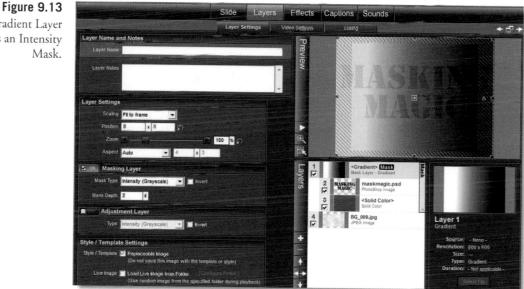

A Gradient Layer used as an Intensity Mask.

> Layer 1 is a linear Gradient fill divided into three zones. It is pure white on the left side and pure black on the right side and has a middle that compresses the rest of the Grayscale. As a result, the Mask will show the left side of the Layers beneath, hide the right side, and provide a graduated **Opacity** in the middle.

> The first step in setting up an Intensity Mask is to left-click on the < Add New Layer > (Plus sign), and choose the Add Gradient option. (I've pasted the menu into Figure 9.14.) This opens the new Layer for fine-tuning in the Create Gradient dialog box. You can see the one I used to generate Layer 1 in Figure 9.14. Right-click on an existing Layer in the Layers List and choose Open in Editor to edit or examine it. If you want to practice with this window before moving on with the discussion, add a new Layer and experiment. (Just don't forget to delete it before continuing with the Exercise.)

> Notice the five markers on the Colors bar, to the right of the Create Gradient Preview pane in the center section of the window. They look a lot like Keyframe Markers. The Plus and Minus buttons on the right of the bar are used to add and remove markers as needed to get the desired effect.

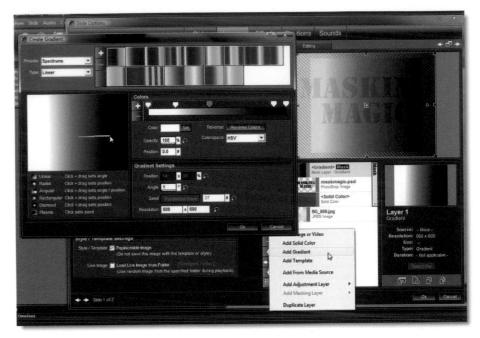

In this case, I adjusted the two **markers** on the left to create the pure white zone. The two on the far right control the width of the black region. By adjusting the **Grayscale** density, you control the effect of the **Layer** as a **Mask**. See the line with the mouse cursor at its right end in the **Preview**? Placing the mouse pointer on the **Preview** and dragging lets you adjust the angle of the **Gradient Fill**. This window offers an interactive and intuitive way to create a complex **Gradient Mask** with very little work.

Underneath the **Preview** are six icons showing the types of **Gradient** styles available. Set the desired **Type** using the drop-down menu above the **Preview**. You can see the complete design, and the result of the **Mask**, in Figure 9.15. Most of the words in the **PostScript** file ("Masking Magic"), and the red **Layer** underneath, are visible, but both begin to fade as you move from left to right because of the **Mask**—near the letter **s** in the word **Masking** and the letter **a** in **Magic**. Most of the letter **g** in **Masking** is not visible at all. The pattern of **Layer** 4 starts to become visible near the middle of the Slide and is the only thing you can see in the frame on the far right.

Close the **Create Gradient** dialog box and double-click in the **Preview** area to open the **Precision Preview** window. Choose the **Motion Effects** tab and select **Slide 1**, **Layer 2**. Now scrub the **Keyframe Timeline** as shown in Figure 9.16. Just after the **4.2**-second point, everything but **Layer 4** vanishes! You can see that the ending position for this Layer is all the way at the end of the following

Figure 9.15 The appearance of the complete Slide just before the end of Layer 1's display time.

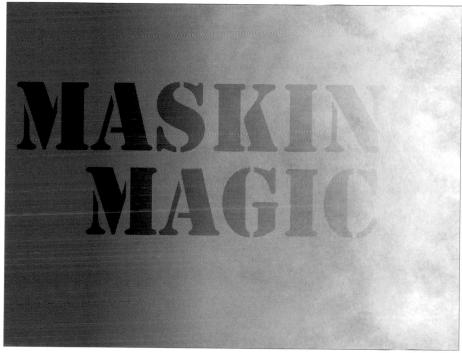

Figure 9.16

Layer 2 vanishes from the Slide midway through playback, even though its ending Keyframe has not been reached, due to the timing of the Mask in Layer 1.

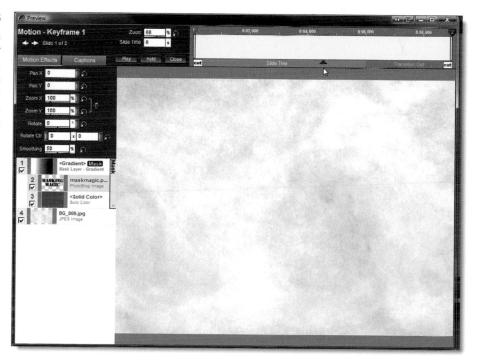

Transition. Shouldn't you be able to see **Layer 2**? **Layer 3** also extends to the end of the following Transition, and it is gone as well.

Select Layer 1. It has only two **Keyframes**, and the second one is placed at the precise time that the lower Layers vanish during playback. That's why only Layer 4 is visible. To gain a better understanding of how this works and what kind of control you can achieve, take some time and add different ending **Transitions** to Layers 1, 2, and 3. Modify the **Type** and **Angle** of the **Gradient** for Layer 1.

Then add some motion. Make **Layer 1** rotate. That will change the placement of the light and dark areas within the frame and so change what is visible at any given time. What happens if you add **Motion Effects** to the **Layers** in the **Mask's** stack?

Try variations in the **Adjustment Effects** settings for **Layers 1**, **2**, and **3**. Then **Invert** the **Mask** in **Layers>Layer Settings**. This type of exploration not only shows more about how **Intensity Masks** are controlled and about their effects on other **Layers**; it also tends to spark new ideas for special effects and creative slide design. When you're ready to continue, remove **Slide 1** from the Show. Select it and choose < **Slide>Remove>Delete Selected Slide >**.

The New Slide 1: a Role Reversal

Let's look at the Layer structure and the Masking configuration for the remaining Slide in the Show. Double-click it in the Slide List and open the Layers>Layer Settings window. The Preview pane in this window defaults to the Slide's starting point on the Keyframe Timeline. Make sure Layer 1 is selected. See the square red-and-green marker noting the center of the Mask Layer in Figure 9.17? It shows that the Layer is positioned on the left side of the frame (the gray area). The image is visible as a reversed copy because the Mask is Inverted, and because the Mask is not an image—just a Mask. Your screen should look like the example in Figure 9.17. I've trimmed the screenshot to increase the size of the Figure.

There are four **Layers**. One image is used twice (**Layers 1** and **4**), another image (**Layer 2**) appears once, and **Layer 3** is a **Solid black Fill**. The Slide also contains a **Solid Black Background** that is not on this list, since it is defined separately in the **Background** window.

The black area we see to the right of the **Mask** is the portion of **Layer 3** that is not covered by the Mask. If you want to test this, use the mouse to drag the **Mask** to one side or the other. You can see **Layer 4** because the black portion of **Layer 3** on its left side is **Masked**.

Layers 1 and 4 are identical. Making Layer 4 an Inverted Intensity Mask allows Layer 4 to show through any Layer inside Layer 1's stack. You can prove this by unchecking the box in front of Layers 1 and 3 and Previewing the Slide. The black area on the left side of Layer 2 now hides Layer 4 when it slides into place (see Figure 9.18).

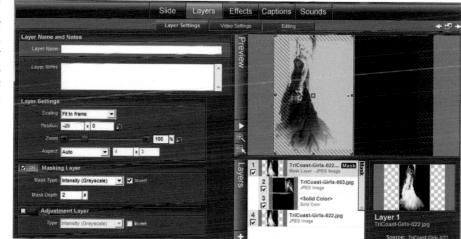

Figure 9.17

The Layers>Layer Settings window, showing the Layer and Mask assignments for the second Slide.

Figure 9.18 This screenshot shows the Slide at the peak of action, as Layer 2 nestles into place.

If you want to explore how the elements work together and expand your understanding of **Masking**, convert **Layer 3** into a **Solid White Fill**. Select the Black **Layer 3**, right-click for the submenu, and choose **Open in Editor**. The **Create Solid Color** dialog opens. Click the < **Set Color**> button in the **Color** pane, and enter **255**, **255**, and **255** into the three **RGB** value boxes at the bottom of the **Color Wheel**. See Figure 9.18a.

Figure 9.18a Using the Create Solid Color dialog to turn the Layer white.

Now run the **Preview** and see what happens. The **Masking** alters the appearance of **Layer 4** because of the shift in the underlying tones in the **Masking** stack. What happened to the dark areas of the bride, like her hair? What happened to the light areas, like the gown? Be sure to restore **Layer 3** to Solid Black before moving on.

Combining Adjustment Effects with Intensity Masking

Shift to the **Effects>Adjustment Effects** window, with **Layer 1** selected. Figure 9.19 shows the left **Preview** pane two-thirds of the way through the **Slide Time**. This is the point where **Layer 3** has completed its motion and is nestled "under" the bride on the left. I used quotation marks around the word *under* because the bride on the left is really under the **Mask** stack.

We can see that **Layer 1** has a single **Keyframe Pair**, so any **Adjustment Settings** apply to the entire play time for this **Layer**. The **Brightness** and **White Point** values have been adjusted from their default values to **80** and **40** percent, respectively. That alters the appearance of **Layer 4** in the Slide because it adjusts the **Intensity** values for the **Mask**.

Let's make some modifications to really see the effect. Shift Layer 1 Starting Position Brightness to -100 and the White Point to 100 percent. Leave the Ending Position settings the same. Scrub the Keyframe Timeline to see the change in the Slide. The bride on the left is now missing at the beginning of play, but slowly brightens to almost full Intensity. (See Figure 9.19.) That's because we changed the tonality of Layer 1's Grayscale range. The original settings changed Figure 9.19 You can fine-tune the way an Intensity Mask alters the rest of the Slide by changing the Mask's Adjustment Effects settings.

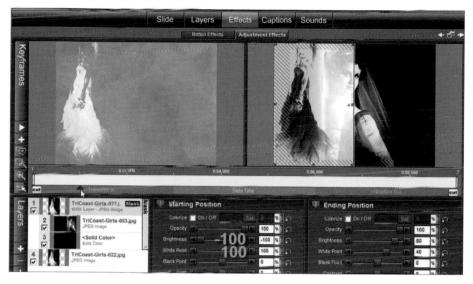

the tonal range just slightly to enhance the detail in the gown against the backdrop of **Layer 2**.

Restore the starting position's original values to **Layer 1** and select **Layer 4**. Adjust the **Black Point** to **-100** and the **Brightness** to **-22**. Repeat the **Preview**, paying attention to the way the edges of the white gown and highlights in **Layer 4** are darkened during the beginning of playback.

This Exercise shows how any variation in the **Gradient** of an **Intensity Mask** can change the way the **Slide** appears during playback. When you blend images using **Gradients**, consider making a second pass to fine-tune the settings in the **Adjustment Effects** window. You can adjust the appearance of the **non-Masking Layers** as an additional detail control. Close this **Show** without **Saving** it, or **Applying your Changes**—assuming you want to repeat the Exercise from scratch.

Alpha Channel Masks and a Selective Bit of Color

Our next **Show** uses an **Alpha Channel Mask** to create a moving band of color over a black-and-white image. Open the **Mask4.psh** file in Producer. Once the **Show** has loaded, open its single **Slide** in the **Slide Options>Layers>Layer Settings** window.

This **Slide** has three **Layers**. **Layer 1** is the **Mask**, set to **Alpha (Transparency)**. It has an aspect ratio of **6 x 1**, making it appear as a horizontal rectangle. **Layers**

2 and 3 are both the same file, TriCoast Girls-045. These are a copy of a bride in front of a desk and a wall-sized world map. Layer 2 is stacked under the Mask. (See Figure 9.20.) Notice that the Mask Layer has a vertical Motion Path. Can you figure out what it does? A hint: the Mask only covers a portion of the frame vertically, but all the way across horizontally. Preview the Slide.

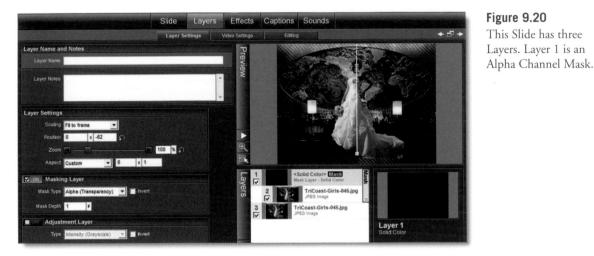

Figure 9.20 This Slide has three Lavers. Laver 1 is an

This same technique can be used to "paint" virtually any variation you create in Producer over another copy of the same image. Change to the Editing window; try Colorizing Layer 2 and play the Slide again. Now the Slide shows the contrasting color as the Mask moves over the frame.

The variation can be made to change over time through the use of **Keyframes**. Alter the color during the course of a Keyframe Pair, and the Mask will reveal the changes as they occur. You could also have additional Layers in the Mask stack and have them enter and exit the Mask's path by using the Keyframe Timeline to adjust when they become visible. That concept can be taken even further by allowing the beginning or ending Transition of a Layer to be revealed by the Mask.

Double-click the Preview pane to open the Slide in Precision Preview. Play the Slide, and you'll see how the Mask moves over the frame. Only the portion of Layer 2 under the Mask will be shown in color, as Layer 1 moves and reveals it. The rest of the frame will show the black-and-white, colorized version of Layer 3, as shown in Figure 9.21. Close this Show before we move on, without Saving it, or Applying your Changes—assuming you want to repeat the Exercise from scratch.

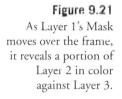

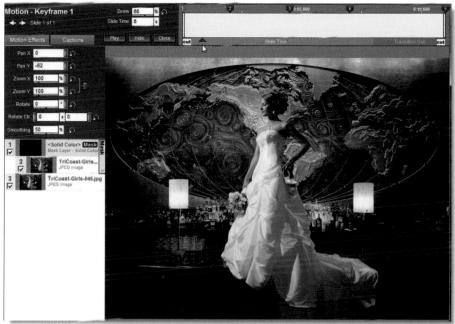

Working with Multiple Masks

It's possible to use multiple **Masks** in the same **Slide** and have a single **Mask** control several stacked **Layers**. You can combine both **Grayscale** and **Transparency Masks** in the same **Slide**, but only one **Mask** can control a single **Layer**.

Note

You can't have two Masks controlling the same Layer.

Open the Mask5.psh file and then examine the Slide in the Slide Options>Layers>Layer Settings window. There are 10 Layers in this Slide, and half of them are Transparency Masks. The other half are image files, with one Mask matched to each image Layer, as shown in Figure 9.22. The number of Layers might lead you to think that the design is complicated. It's not, as you will soon see.

Run the **Preview** for this **Slide**. The basic design is obvious. The images have no Effects at all. They sit centered in the frame without any variation in their appearance. All of the action in the **Slide** is created by the movement of the **Masks** over their respective Layers.

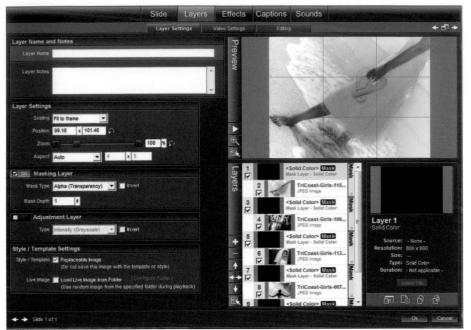

Figure 9.22 This Slide has 10 Layers; five are Transparency Masks.

The **Slide** has a black background, so as each Mask/image pair is played, the portion of the image under the **Transparent** portion of the **Mask** is shown, and the rest of the frame is filled with black. We can see the **Motion Path** for the **Layer 1 Mask** superimposed over the **Layer** it controls. During play, the **Slide** looks as if a black frame were being slid over the picture. The frame moves from the lowerright corner to the upper-left corner of the frame.

Then the image of the bride on the beach is replaced by a picture of a bride holding her bouquet. A black frame pans from the upper right to the lower left. As the other images come into view, the motions of the **Masks** become more varied.

Open the Effects>Motion Effects window and select Layer 9, the final Mask in the Slide (not the final Layer; that's Layer 10). The Preview Area in Figure 9.23 shows the Slide at the midpoint of the first Keyframe Pair for this Layer. We can see in the Keyframe Timeline that its action takes place late in the Slide. It's not surprising. Each of the other pairs has already played. The images are rendered invisible as their Mask's final Keyframe is reached. To prepare for our next bit of magic, Close this Show before we move on, without Saving it, or Applying your Changes—assuming you want to repeat the Exercise from scratch. Figure 9.23 The final Mask and its Layer being played in the Preview. The Motion Path is visible on the right side.

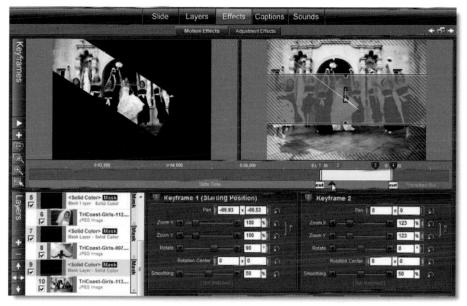

Life on the Border: Vignetting

It's easy to see how powerful **Masking** is as a tool for adding professional effects to Shows. Let's look at how **Vignetting** (a Producer-only feature) can play a role in refining how **Layers** and **Masks** are used (and appear) in a production.

Layers normally have sharply-defined edges and are either square or rectangular. **Vignetting** lets you soften edges and adjust the outer shape of a **Layer** to suit the needs of a design and produce subtle variations. There are two basic outer shapes to a **Vignetted** Layer: a **Rounded Rectangle** and an **Ellipse**. These are the starting points, and you can adjust them dramatically with the other controls.

Vignettes let us quickly create **Masks** with custom shapes and edges when they're combined with a **Solid Color** or **Gradient Layer**. We can also use **Vignettes** to produce an incredible array of borders, ranging from simple feathered edges to psychedelic rainbows.

One common use of **Vignettes** is for softening the edges of a **Layer**, allowing it to blend in smoothly with the other elements of a design. That's their primary purpose in the **Show** we are about to work with. Open the **Vignette1.psh show** file. Select its single **Slide**. Play the **Preview**, and pay close attention to the edges of the **Layers**. **Vignetting** does not produce a dramatic difference in the show, but it does improve the appearance of the **Slide**. Let's see how they work. Press the **Control + F6** key combination to launch the **Layers>Editing** pane. The top two **Layers** of the **Slide** both have **Vignetted** borders. Select each in turn and click on the **Vignette** check box in the **Editing Tools** pane. Watch the changes in the **After Editing** pane in the bottom right corner of the window. (I've boxed both the controls and the **Layers** in green in Figure 9.24.) When finished, re-enable the **Vignettes** on both **Layers** by rechecking the box.

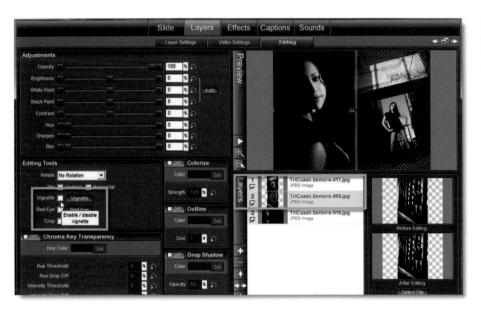

Select Layer 1 and click on the Vignette button located in the Editing Tools section of the window. I've marked the button with a green arrow. The Vignette window will open as seen in Figure 9.25. In the upper right corner of the Vignette window are the drop-down menus for setting the Shape and Type. This Layer uses a Rounded Rectangle for its Shape; the other option is an Ellipse. There are three Types. This Layer is a Transparent Type, and so the Layer's edges are softly feathered. This effect is signaled by the gray and white checkerboard effect in the Vignette Preview window. The other Type options are Solid Color and Gradient.

The best way to learn how these controls affect a **Layer** is by experimenting with them. The various combinations can be used to create complex border effects. Figure 9.26 shows my window after making some adjustments to produce a rather colorful **Gradient** border. The changes include adjusting both the **Vignette Size**, which determines how far the effect comes into the image area, and the **Border Size**, which controls the size of the edge effect. Go ahead and experiment, and then Close this **Show** before we move on, without **Saving** it, or **Applying your Changes**—assuming you want to repeat the Exercise from scratch.

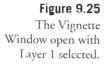

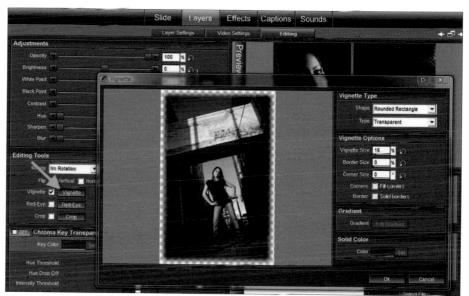

Figure 9.26 Layer 1 with a Gradient Vignette.

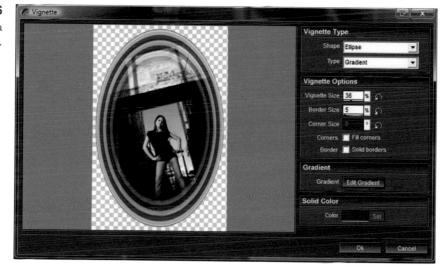

It's Not a Mask, It's a Vignette

Vignettes can be used to create some interesting effects, which can be used to blend or fade a **Layer** into a design. Our next **Show** provides a good example. Open **Vignette2.psh** and play its single **Slide** in **Full-Screen Preview**. The portrait of the young woman has edges that darken into a kind of spotlight effect as the picture **Zooms** slightly larger. At first glance, this looks like a **Slide** that has had a **Mask** applied. Press the < **Control+F6** > combination and examine the **Layers** in the **Layers>Editing** pane. No **Masks** at all. There are two copies of the same image file, each on its own **Layer**. **Layer 1** has been **Vignetted** into an oval with transparent edges, as shown in Figure 9.27. With **Layer 1** selected, click the < **Vignette** > button in the **Editing Tools** pane.

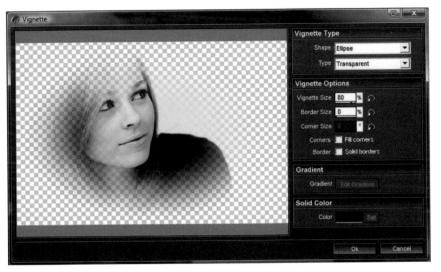

Figure 9.27 Layer 1 employs a Transparent Gradient Vignette.

The **Vignette** leaves only the woman's face without some degree of **Transparency** and reduces the outline to an oval. This is accomplished simply by setting the shape to an **Ellipse** and the **Type** to **Transparent** and adjusting the **Vignette Size** to **80** percent, as seen in the **Vignette** Window.

With these settings, the areas that are shown as **Transparent** allow **Layer 2** to show through **Layer 1** during playback. Instead of a **Mask**, we have an overlay. Shift to the **Effects>Adjustment Effects** window, open the **Multi-Layer Keyframe Editor** and examine the **Keyframe Timeline** for both **Layers**. (See Figure 9.28.) **Layer 1** has only a single pair of **Keyframes**. We can see that no **Motion Effects** are applied to this **Layer**, because no **Motion Path** is showing in the **Preview** pane. All of the **Adjustment Effects** settings for this **Layer** are still set to their default values.

At the very beginning of play, the corners of the image look bright, but they quickly become dark. Close the **Editor** and return to the **Effects**>**Adjustment Effects** window. We'll use this window to examine the settings and progression in more detail. Select Layer 2, and then select the first **Keyframe Pair** (1 and 2) on the **Keyframe Timeline**. The picture has a normal brightness with bright corners.

Make sure that the **Preview** pane is set to **Hide Inactive Layers** using the context-sensitive menu. Select the second pair of **Keyframes** (2 and 3). Your screen should look like the one shown in Figure 9.29.

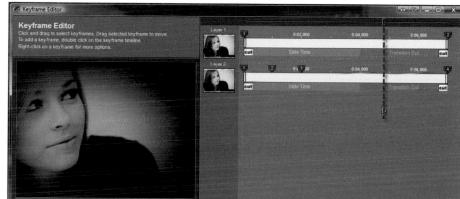

Figure 9.28

The Slide open in the Multi-Layer Keyframe Editor. A dashed red line notes the point being shown in thc Preview.

Figure 9.29 The Slide with the second pair of Keyframes (2 and 3) selected in the Adjustment Effects window.

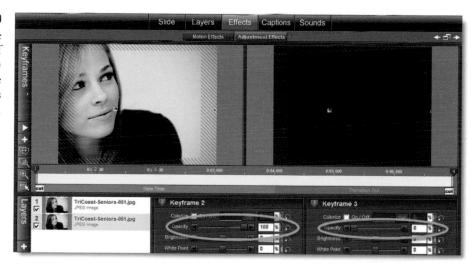

Note the **Opacity** settings for this pair of **Keyframes** (circled in green in Figure 9.29). The **Keyframe 2** is set to **100** percent, and **Keyframe 3** is set to **zero**. That accounts for the black frame in the right **Preview** pane. Enable the **Show Inactive Layers** option in the context-sensitive menu. **Layer 1** now floats on top of the black **Slide Background**, and **Layer 2** is invisible. The **Crossfade (A/B) Transition** that follows the **Slide** causes it to fade as time runs out. Close this **Show** as we move forward again.

A Final Spotlight on Vignettes and Masking

Our next show combines two **Vignetting** Effects in a single **Slide**: a **Transparent Mask** spotlight effect in one **Layer** and edge softening in the other. Open **Vignette3.psh** in Producer. Play the Slide in **Full-Screen Preview**.

There are nine **Layers** in this **Slide**. **Layer 1** is an **Alpha channel (Transparency) Mask. Layers 2** through **8** are image files, and all are included in its stack. **Layer 9** is another image file. **Layers 2** through 7 are carefully placed on the left side of the frame. They do not move or have any **Adjustments** applied during their entire time on the screen.

Layers 8 and 9 slightly Zoom. Layer 8 is on the left side of the frame, and Layer 9 on the right. Layer 1 creates a spotlight effect over the left side of the frame during the entire playback time.

Open the Layers>Editing window and select Layer 1, and you can see the Masking stack. Scroll down to make Layer 9 visible and select it. Make sure the Vignette box is checked in the Editing Tools pane, and click the < Vignette > button. See Figure 9.30.

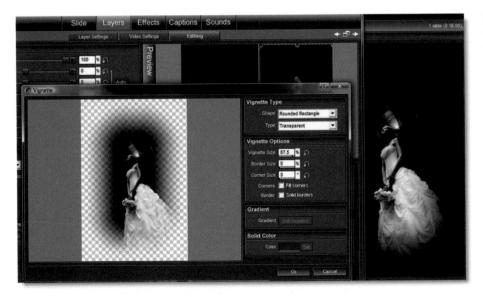

Compare the **Before** and **After Editing** panes for the appearance of **Layer 9**. Turn off the **Vignetting** and see what that does to the composition. Change to the **Effects>Motion Effects** window. Scrub the **Keyframe Timeline**. Without the **Vignette**, the overhead lighting that was obscured in the **Vignette** is a major distraction, and the left side of the picture overlaps the other **Layers** as they are shown during playback. Re-enable the **Vignette** and replay the **Slide**. Less can be more with a properly designed **Vignette**.

Now select Layer 1 in Motion Effects. It is a Mask with a Transparent Ellipse Vignette applied. This Layer has more Keyframes defined (a total of 22) than any other Layer we have seen so far. Figure 9.31 shows its Vignette window with the Keyframe Timeline included. All but the last three Keyframes are configured with Motion Effects that make the spotlight travel back and forth over the left side of the frame. The last three add a Zoom Effect that places the Transparent Layer over more of the frame.

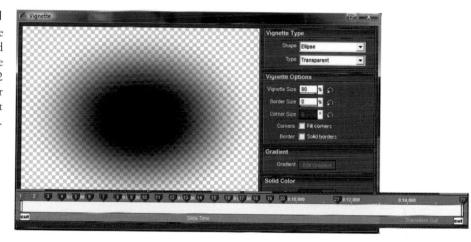

Figure 9.31 Layer 1's Vignette

Layer 1's Vignette window and Keyframe Timeline showing the 22 Keyframes defined for the Masking Spotlight Effect.

Figure 9.32 shows the appearance of Producer's main **Preview** window as the **Keyframe Timeline** is being scrubbed between **Keyframes 2** and **3**. We can see how the size of **Layer 1**'s **Vignette Transparency** softens the edge of the spotlight Effect, and **Layer 9's** allows the two images on the screen to properly blend with each other in the frame.

Take a few moments to examine how the **Keyframes** for the other **Layers** have been arranged and matched to the actions of the **Mask**. Once the basic design was figured out, assigning the **Keyframes** was not that difficult a task. The **Copy** menu's Options are very useful when creating Effects that call for a number of repetitive **Keyframe Pairs**. When you have finished experimenting, Close the **Show**.

All of the files required to duplicate this **Slide** are included in the collected **Show** files. For more practice with both **Masking** and **Vignettes**, try duplicating the basic design with a different arrangement. One way to gain experience would be to place a different image on the left and rebuild the spotlight effect. Experiment with various borders and work them into a new design.

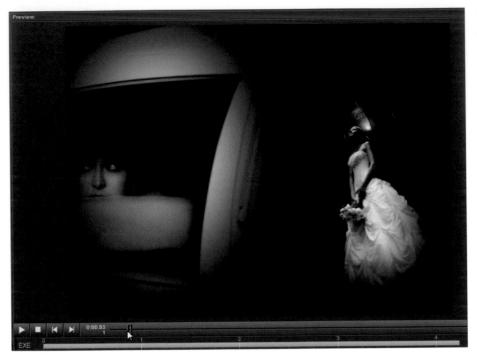

Figure 9.32

As Layer 1's Mask moves over the frame, it reveals a portion of a Masked Layer over Layer 9.

Chroma Key: More Than Just a Green Screen

Chroma Key is a popular video and motion picture technique that most of us see every day. A portion of a set is painted in a special blue or green color. That color, the **Chroma Key Color**, is then made into a **Transparency Mask**, and a second scene is dropped behind it as a second **Layer**. It places the daily weather map behind the reporter, and lets computer-generated graphics and actors inhabit the same on-screen reality in movies.

Producer lets you define any color on a **Layer** as the **Key Color** and make that color **Transparent**. That allows you to create a useful **Mask** in two ways: you can locate an existing area of an image that has a single color and define that color as the **Key Color**. Or, you can use a program like Adobe Photoshop, paint the desired portion of the image in a single color, and define that color in Producer as the **Key Color**.

We are going to use both methods (the Photoshop editing is already completed) in two **Shows** to create several drop-in effects, including a video-clip sky with moving clouds. To save time and effort, most of the design already has been completed. All we have to do now is to set up the **Chroma Key** elements. I'll point out some other interesting design elements as we work. Open the Show **chromakey_01.psh** in Producer. This Show has three **Slides**, each using a **Chroma Key** effect as part of the design. Open **Slide 1** in the **Layers> Layer Settings** window.

Layer 1 is a high school senior portrait. The young woman is posed on the left side of the image, and the majority of the frame is filled with the blue background behind her. Most of the background is a single shade, with some darker area where the material is folded. The blue color is used as the **Chroma Key Index**. The image is **colorized** in the **Adjustments Effects** window, producing the toned effect. That doesn't make any difference in the **Chroma Key** result, since Producer uses the original color values in the source file as the reference point.

In Figure 9.33, I have opened **Layer 1** in the **Precision Preview** window, whose larger size shows clearly how the original image now has room on the right for whatever will be revealed by the **Chroma Key** Layer. The original **Layer 1** has been pasted into the lower right-hand corner.

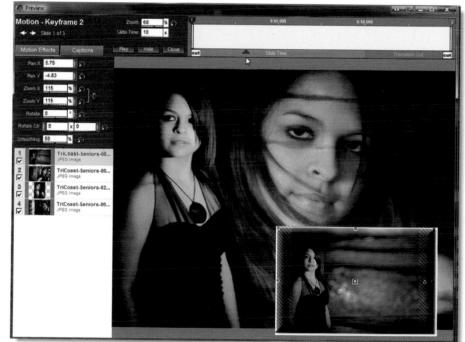

Layers 2, 3, and 4 are also senior portraits. These have all been **Vignetted** to blend easily into the composition. You can learn more about this technique by examining the settings used for each in the **Editing** window. **Timing** and **Motion Effects** were combined to bring **Layers 2**, **3**, and **4** into the right side of the frame behind the **Transparent** area during playback.

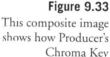

shows how Producer's Chroma Key technology makes the right side of the first Layer transparent, allowing the right side of the frame to display several images. The original Layer 1 is pasted into the Figure's lower-right corner.

Setting the Key Color Using an Existing Color

Open the Layers Editing pane (press Control+F6) and select Slide 1, Layer 1. Right now the Preview Area shows the colorized rendition of the image, and the before and after views are about identical and in color. Locate the Key Color box in the Chroma Key Transparency pane. The color that is selected here is the shade that becomes Transparent in the Layer—the Key Color. Check the box to enable the feature, and then click its < Set > button. The Color Wheel will open, as seen at the left end of the green arrow in Figure 9.34. Using the left mouse button, click the < Triangular Upper Left Corner > of the box to activate the Eyedropper, which you can use in the Preview to select a color. As you move the Eyedropper, you will observe the changing colors on the Wheel and in the inner triangle. When you see a potential color, click the mouse and then click it in the triangle to select a color.

Note

Don't be fooled by the miniature size of the Color Wheel! It is an extremely sophisticated and interactive tool, and both requires and rewards considerable practice and experimentation.

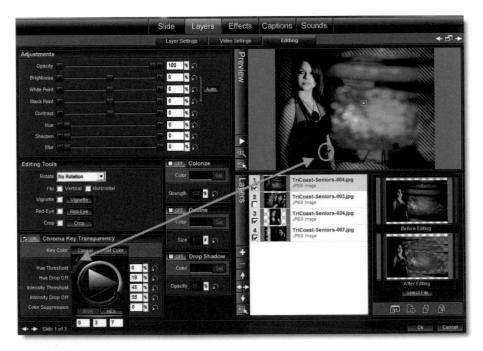

Figure 9.34

Locating the Key Color using the Set Color dialog box's Eyedropper tool. Before setting the final color, try experimenting a bit. Place the tool on a very dark, even black, portion of the image and click (like the one I used, outlined with the green circle at the right end of the arrow). Notice the result. The **Before Editing** and **After Editing Previews** (boxed in red) are handy aids in this process. Choose the **Eyedropper** again and choose a very light-blue area. Observe how that changes the result. When you choose black, all the true black is removed from the entire image. **Chroma Key** does not limit its actions to a portion of the **Layer**, but involves any area containing the **Key Color**.

There are no hard-and-fast rules for selecting **Key Color** when you're working with an existing dominant color in a **Layer**. I usually set it by using the **Eyedropper** and trying several locations. You can't always tell just how the **Transparency** will work, due to slight variations in hue. You can click around anywhere in the Producer window.

In this case, values from about **0**, **80**, **175** (as shown in Figure 9.34) to **0**, **130**, **225** will produce an acceptable result—for *this specific Layer*. These may be set in the three **RGB** value boxes at the bottom of the **Color Wheel**. It's also possible to set a **Key Color Index** by using the **Eyedropper** to get a reasonable amount of **Transparency**, and then tweaking the result by adjusting the numerical values in the **Set Color** dialog box.

Adjusting the Effect

Below the **Set Color** box are five sensitivity **Adjustments**. Each of these can be used to alter the amount of **Transparency**. (The values were already set for this example.) Let's examine how each operates on this image. The exact results will vary based on the color composition of the image. Click < **Cancel** > to close the **Color Wheel** and access the sliders and value boxes.

You can use these tools on all the other examples in this discussion, but I won't give detailed instructions or settings for the other **Chroma Key** effects. As you work through the description, move each slider to both ends of the scale. Watch how the remaining bluish tint in the mostly transparent right side of **Layer 1** changes. That should give you a good working knowledge of what each control does.

Keep in mind that the relationship between colors and their visual appearance can be complex. The "correct" settings for these controls are the ones that produce the desired results. Also, if the **Key Color** is set to pure black or white, only the **Intensity Threshold** and **Intensity Drop Off** controls will be active. The others would have no effect and so are disabled.

Hue Threshold determines the range of the selected color that will become **Transparent**. Move the slider to **100** percent, and almost all of that shade of blue in the image will be removed. Shift the level to **zero**, and there will still be notable areas of bluish tones. Once you are finished, set the value back to zero.

Hue Drop Off controls how the edges of a color area are included in the **Hue Threshold** effect. The higher the number, the less color is retained. Once you are finished, set the value back to 19.

Intensity Threshold forces very dark areas and very bright areas to become opaque. Set the value back to **45** before continuing.

Intensity Drop Off controls how much of the edges of an area are included in the **Intensity Threshold** effect. Reset the value to **55**.

Color Suppression removes the **Key Color** from the edges of the image. Reset the value to **zero** when finished.

The purpose of using **Chroma Key** in a **Layer** is to selectively reveal objects in the **Layers** beneath it. Once you have the **Key Color** set, and have adjusted the other controls, it's a good idea to examine the results in the **Slide Options>Layers>Editing** window. Set the **Preview** to **Show Inactive Layers**. With the **Chroma Key Layer** enabled, make only one other **Layer** active and see how they work together. Repeat the process for each **Layer** in the **Show** with the **Chroma Key Layer** in turn.

Try that with this **Slide**. You'll see that black and white areas in the background which did not match the **Key Color** will still be visible. Do they distract from the design? What if a band of black **Masks** the subjects' eyes? You may not have to reindex the **Key Color**: just reposition the **Layer** to show the eyes.

Employing a Traditional Green-Screen Chroma Key

There are two traditional **Chroma Key** colors in photography and video production that date back to the days of film. That's because the colors were engineered to be slightly different from the shades of blue and green generally found in clothing, room décor, and, to a lesser extent, nature. They are **Chroma Key Blue** and **Chroma Key Green**. You can buy backgrounds and paint certified to be the precise hue of each. Open Slide 2 in the Layers>Editing pane, and select Layer 1. This Slide also has a dominant color in the first Layer's background, Chroma Key Green. Right now, Chroma Key Transparency is turned on for this Layer, but the Key Color is set to black. There is also a Vignette defined for this Layer. The resulting Slide Preview has a washed-out image of a young man floating over a beach scene, the Slide's background Layer. There is a slight green cast in part of the background. Figure 9.35 shows the Vignette window over the Layers>Editing pane. The Key Color is circled in red, and there is a red box around the prospective Key Color.

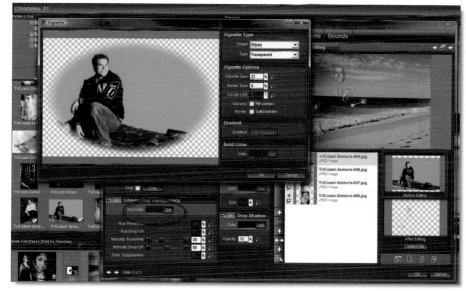

Figure 9.35 Layer 1 before adjusting the Key Color to the green, with the Vignette window open.

> Figure 9.35 shows the **Editing and Vignette** panes after I adjusted the **Chroma Key**. (The **Vignette** effect was added to help blend the **Layer** with the rest of the design.) Open the **Chroma Key Transparency** pane's **Set Color** dialog box and click the **Eyedropper** anywhere on **Layer 1's** green background in the **Before Editing Preview**.

> The result will be immediate. I've drawn a double-headed arrow between the **Eyedropper** and where I clicked on the color as a reference. See Figure 9.36.

The Layer 1 image was prepared in Photoshop. The original background did not offer a suitably solid expanse of color for indexing to a **Key Color**. So the area that was to be made transparent, was painted with a color that was <u>not present in the portion of the picture that was to remain solid</u>. For example, if you want to preserve school colors of red and white, a blue sky, and green grass, you use a color like, say, purple to paint the section of the image with the Key Color. Then import the Layer and click on the painted color to set the Key Color Index.

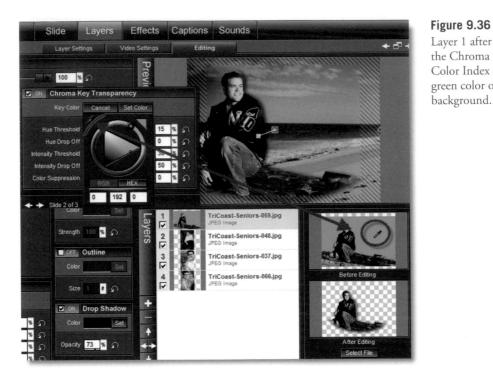

Figure 9.36 Layer 1 after adjusting the Chroma Key Color Index to the green color of its

Remember the blue area in Layer 1 in the first Slide? We could have obtained a completely Transparent area on the right side of that Slide by painting that portion of the image medium blue in Photoshop, if we wanted to eliminate the bit of existing background left when using a color already in the Layer.

Before moving on to the next Slide, take a minute to consider the other design elements. How do the Motion Effects, Crops, Vignettes, and Transitions add to the overall composition? Is there another Masking effect that could have given the same result? The best way to master slide show design, as well as the powerful tools in ProShow, is by watching examples and considering both how the design works visually and how you could produce similar results.

Fade to Black Reconsidered

The Slide 3 in this Show demonstrates how the human eye can be fooled by color, and it also shows the benefits of experimentation. Open Slide 3 in the Editing pane and select Layer 1. It is an image we have used before, of a young woman posed with her back resting against a wall. This time the picture has been rendered as a blue-toned version in an external editor. An expanse of black has been added to the left of the picture.

If you experimented with black as a **Key Color** for the first **Slide** in this **Show**, you might think that using black on this **Layer** would result in a faint, ghostly image, as all the dark colors in a dark image are removed. In fact, there is a lot of blue and a bit of green in this picture. Make sure **Layer 1** is selected. Enable **Chroma Key Transparency.** We don't need the **Eyedropper**. The color should already be set to pure black: **0**, **0**, **0**. If your default is different, adjust the **Key Color** now. Click the **Preview Menu** Icon and enable the **< Darken Inactive Layers >** Option.

The result should look like the example in Figure 9.37. (I've pasted in the **Chroma Key Transparency** box for reference.) Notice in the **After Editing** area how the black area to the left is now transparent and it looks like there's a **Vignette** around the woman. It's all due to the black around her: there is no **Vignette** defined for this **Layer**.

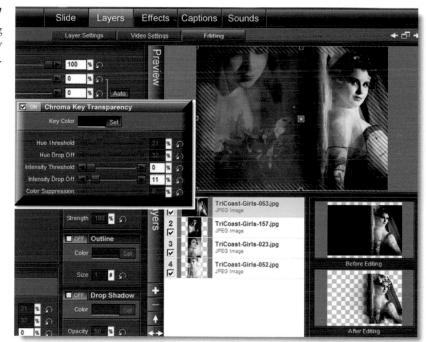

Play the **Slide** and there will be black in the background areas, generated by the Slide's **Background**. Once again, take time to explore the overall design, and to note how the different **Effects** are blended together to create the overall result. Try changing the **Key Color** for **Layer 1** to white (**255, 255, 255**) and see what kind of change that makes to the design. (You may want to check the directions back at Figure 9.18a.)

When you are finished, Close the Show.

Fast-Moving Clouds: Using Video Clips with Chroma Key

Open the file **Chromakey_02.psh**. This will take a little longer than average to open because you're loading the video clip used as the second **Layer** in the show's two **Slides**. The clip shows a sky with fast-moving clouds that appear thanks to **Chroma Key Transparency**.

Note

The video in this movie is in Apple Quicktime MOV format, which is supported by ProShow. You computer needs to have a current installation of the Quicktime driver (available free from Apple.com) for this clip to load and run properly.

The first **Layer** in both Slides is a picture of a couple sitting close together, with an open sky as part of the background. The shade of blue sky and area covered by clouds is not the same in the two images. That called for different approaches in setting up the **Chroma Key**.

Working with Video Clips in ProShow

Supported video file formats (see the Photodex Web site for a complete and current listing of file types) are imported as a **Layer** just as with an image. You just drag the video file into the **Slide List**, and the program will do the rest. Keep in mind that large video files use significant system and storage resources.

Open **Slide 1** in the **Layers>Video Settings** window and select **Layer 2**. Your screen should look like the one in Figure 9.38. As you can see in the **Layer 2** pane in the bottom right corner of the window, this **Layer** contains **clouds.mov**. This is a 13-second video clip with a screen resolution of 640x480, a 14MB file.

This clip has been imported and sized to fit in the upper three-quarters of the frame, using the familiar sizing and positioning tools that work with image file **Layers**. I've drawn a red box over the **Layer** border so it's easier to see the Layer's boundaries in Figure 9.38.

Note

Be sure to check your Layer Settings on the submenu (right-click in the **Preview** pane) and be sure that **Darken Inactive Layers** is <u>not</u> checked! Very odd appearances may result otherwise!

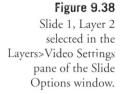

Examine the Video Clip Settings and Video Sound Settings panes shown in Figure 9.38. Sliders let us adjust the Volume of any sound during playback, and adjust the Speed at which the clip is played. If you check the Slide Time box, the Slide Time will be adjusted to match the run time of the clip. You can check the Looping box, so that a short clip repeats until the Slide has finished its full playback.

ProShow provides several dedicated tools for tuning a video clip for use in the program, in addition to the regular **Editing** and **Adjustment Effects** controls. These changes only affect the way the **Layer** looks in ProShow, in that specific **Layer**. The original source file and the appearance of the file as another **Layer**—even in the same **Show**—are not affected.

Click on the **Trim Video** button, and the **Trim Video Clip** (aka the **Video Trimmer**) window shown in Figure 9.39 opens. We are not going to make any edits; just examine the controls. This is not a full-fledged video editor, but it offers an easy way to fine-tune a clip for use in a **Slide**.

We can examine a clip, adjust the length, and set precise starting and ending points. The interface works like the **Edit Fades and Timing** window (refer to Chapter 4). In the Figure, the **start** and **end** segments have been trimmed by dragging the flag-like **Markers** in from the sides (circled in red), just as we did when working with soundtracks. The center **Preview** window shows the starting frame actually used in the **Slide**, the one on the right shows the final frame in the clip

Figure 9.39 The Video Trimmer.

that will appear in the Slide. The clip is not actually trimmed in this **Show**, so your window won't show the edits you see in the Figure. The **Hand** cursor and **line** (circled in green) appear as you drag the mouse over the **Video Timeline**. The point under the line is displayed in the larger **Preview** on the left side of the window. (I've drawn arrows between each **Marker** and the window display it controls.)

Setting Up Slide 1's Chroma Key Transparency

Close the **Trimmer** and the **Slide Options** window. Scrub the **Slide List** and **Preview Slide 1**. The sky in this **Layer** has been made transparent using the **Chroma Key** tool's **Set Color Eyedropper**. The **Layer 1** image sky is mostly blue, so **indexing** this way works very well. The way the couple is framed by the trees and the **Motion Effect** help draw the eye to them. The movement of the clouds adds impact without detracting from the man and woman as the center of attention.

Did you notice the two objects that did not completely disappear in the sky area to the left of the Capitol Dome? They are the U.S. flag and the state flag of Texas. Only the blue portions of their designs were made **Transparent**, so they are still visible; the flagpole is not. Scrub the **Slide** again and pay attention to the skylight on the left side of the building under the tree, and the windows of the dome and main portion of the building. The blue areas have been made **Transparent**. Such artifacts are common with **Chroma Key** effects. Photographers and motion picture crews have to be very careful when lighting with **Chroma Key** backgrounds and make sure that the color is not reflected onto actors, clothing, or the set in a way that would reflect enough of the index color to cause telltale fringing.

Open Slide 1 in the Layers>Editing pane and select Layer 1 (shown in Figure 9.40). You can see how effective the Chroma Key is by comparing the before and after samples. For a closer look, switch between the Show Inactive Layers and Hide Inactive Layers Options in the Preview Menu (right-click within the pane, or click the Icon at its left border, under the magnifying glass Icon).

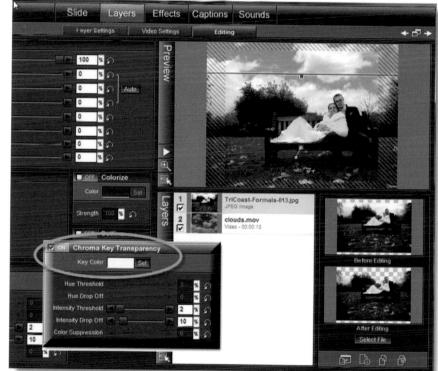

There is a very faint light-blue cast in the sky, and there is some blue visible in the girl's shirt, and the jeans both people are wearing. The **Hue Threshold** is set at **zero**. Move its slider from the current **zero** up to **51** percent. The faint blue in the sky disappears. So does most of the color in her shirt—and part of the tree above them and the top portions of the building are gone! Return the value to **zero**.

The **Hue Drop Off** is set at **10** percent. Move it down to **zero**, note the changes, and then run it up to **45**, and then **100** percent. Dropping the value quickly eliminated the **Transparency**. Raising the level to **45** percent gives just about the same result as increasing the hue threshold to **51** percent. Set the slider back to **10** percent.

The **Intensity Threshold** is at **35** percent. Drop it to **zero**, and the dark blues get very dark. Raise it to **100** percent, and the jeans become white and his shirt takes on a patterned appearance. Return this slider to **35** percent.

Move the **Intensity Drop Off** control back and forth and pay attention to the change in the color of the jeans. Move the **Color Suppression** slider back and forth and observe how the color of the woman's shirt changes.

When finished, Close Slide Options, and select Slide 2.

Slide 2: The Same Clouds, but Not the Same Sky

Slide 2 uses the same video file, and the clouds look almost the same. Doubleclick it. The first **Layer** is another couple seated on a bench. It's tempting to think the design uses the same blue-indexed **Chroma Key**. It doesn't. Open the **Editing** pane, if it's not already open. The **Key Color** has been set to pure white (shown in Figure 9.40).

Play the **Preview** and pay attention to the clouds low in the sky, on the left side of the bush. There is a portion of the sky that does not move. The sky in **Layer 1** is washed out to pure white in the upper third of the picture. The sky gets denser lower down. There is also some color in the woman's white coat, but it is not pure white. It's well worth examining other Layers closely to see how the **Chroma Key** Effects interact with different Layers.

All of the adjustments for the **Chroma Key**, except the **Intensity Threshold** and **Intensity Drop Off**, are disabled. That's because all of the others are related to the attributes of the **Key Color**. Pure white and pure black have no color values, so only the **Intensity**-related values can be modified.

Adjust the **Intensity Threshold** to **100** percent, and the **Layer** will shift in **Intensity** until it becomes white. Adjust the **Intensity Drop Off**, and you can see how the control shifts **Intensity** at the edges of the effect.

Masking, Vignettes, and Chroma Key Transparency are three tools that offer the ability to link and blend Layers and bring a three-dimensional quality to your Shows and Motion Effects.

Up Next

Producer's advanced toolkit gives you the ability to create **Show Templates** complete with all the **Effects** you might want to use. Though they initially contain empty **Layers**, you can easily populate the **Templates** with new images. Producer also can create **Live Shows** automatically, using files stored in a designated Folder. Use a camera with either a wireless or tethered connection to fill the Folder, and the software will add new **Slides** to the **Show** in real time as you send pictures to the Folder. We'll explore these fascinating features in the next Chapter.

10

Templates and Live Shows

Producer Templates let you speed up workflow by using an existing Show as the model for a new production. Combined with the Live Show feature, you can automatically generate an entire Show that adds images as they are captured in real time! Templates are Shows that have been saved with all their Slides, Soundtracks, Layers, and special Effects, but the Template files' **Layers** have been converted to "placeholders." If you repopulate the Layers with new images, you have a new Show. **Live Shows** automatically populate the Slides in a Show with content from a "Hot Folder." When you add new, supported images to the designated folder, they are automatically added to the Show.

Both features are available only in Producer, so that's the version we'll be using in this Chapter. All of the files needed for the hands-on Exercises are in the Chapter 10 Folder on the companion CD-ROM (which you should have moved to your hard drive).

Note

The content in this Chapter requires a working knowledge of the ProShow user interface, as well as the ability to work with Slides and Layers.

Working with Templates

A **Template** is a Producer **Show** that has been converted to a **Template** file. The basic process is simple and handled by the program. Open the **Show** menu and choose the **Show Templates>Save as Template** option. Producer removes all the existing files from the **Slide Layers**, leaving special placeholder-type **Layers**. You can repopulate these **Layers** by dragging new files onto the placeholders.

To save time, I've already assembled a simple Show to explore **Template** technology and demonstrate how it works. Open **show_for_template.psh** in Producer.

It has four Slides with the same basic Layout, but with different Effects applied. The color of the **Background Layer** has been set to a different hue for each one, so it will be easy to see when the Slide changes. We are going to configure this Template so that all but one of the Layers will be set to automatically load a new image each time the Slide comes into view. (You don't necessarily want to clear out all of them; most Templates have some Slides, like Captions and Credits, which you will want to keep.) We'll set the **Replaceable Layers** first, and then exempt the **Static Layers**.

Once the Show is loaded, double-click on **Slide 1** in the **Slide List** to open the **Slide Options** window and then choose the **Layers** tab. The first step in converting a Show into a **Template** is to let Producer know which **Layers** have content that needs to be removed so they can be filled with images from the **Hot Folder**, and which ones it should keep, and so properly display the original source file during playback. That's done by checking the **Replaceable Image** Option in the **Style>Template Settings** pane. See Figure 10.1.

Check the box which says **Style/Template Replaceable Image (Do not save this image with the Template or style**). The **Apply to All Occurrences?** dialog will appear. Click < **Yes** >. Then click < **OK** > to return to the Work Area. Now Open **Slide 2** in the same window and **uncheck Layer 2** as a reusable image. Do **not** choose to apply this setting to all **Layers**. We want all of the **Layers**—except **Layer 2** on **Slide 2**—to be empty in the **Template**. (See Figure 10.2.)

Tip

Setting all **Layers** as **Replaceable**, and then unchecking the box for that option for the **Layers** with content you want to keep in the Show, is usually the quickest approach when tagging **Layers** for a **Template**.

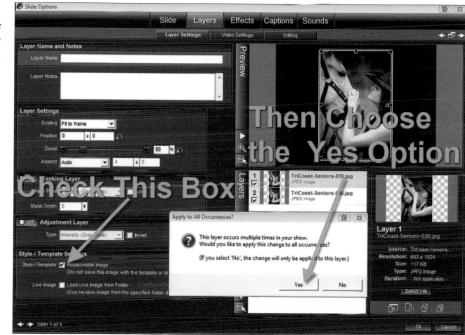

Figure 10.1 Marking the reusable Layers in the Layer Settings window.

Figure 10.2 Setting Layer 2 on Slide 2 as a Static Layer (one that does not load a new image each time it is played).

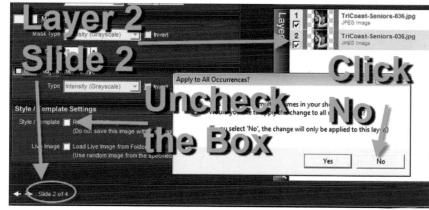

Creating and Saving Templates

Now it's time to create our **Template** file. A **Template** is not just another PSH Show file. It is a special **pst** Photodex file type that is saved in the program's Templates folder. It makes use of special file-management tools built into Producer to access and employ **Templates**. Open the **Show** menu and place your mouse cursor over the **Show Templates** Option. Now click on the **< Save as Template** > Option in the secondary menu, as shown in Figure 10.3a.

If you have not yet saved a Show when you choose this Option, a warning will appear asking you to save the file as a PSH file first. Do so with a new file name. Then name your new Template **Live Show Template**. If the file has already been saved, a dialog box will open notifying you that all Show content will be removed during the process. Click < **OK** >. The **Keep Layers Linked?** dialog appears, informing you that an image file is used in multiple places. Choose the < **No** > option as shown in Figure 10.3b. (If you click < **Yes** > by mistake, resaving the **Template**—*not the Show*—lets you choose < **No** >.)

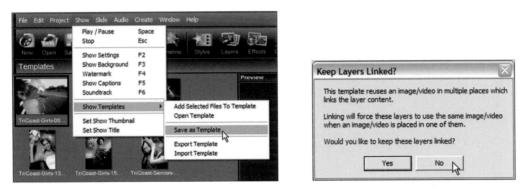

Figures 10.3a and 10.3b Saving the current Show as a Template.

This opens the **Save Show Template** window, like the one in Figure 10.4. There are already several **Templates** listed in the **Available Templates** column on the left side. There are several included with Producer and come pre-installed. The one we are saving now is new. I already have added some others to my collection of **Templates**, so my screen will be different from yours.

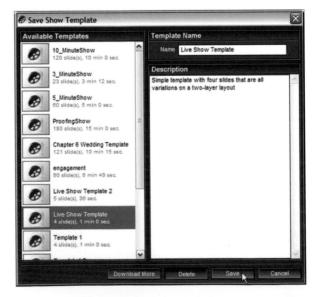

Figure 10.4 Adding a description in the Save Show Template dialog box.

Tip

You can obtain additional Templates, as well as Menus, Masks, and other ProShow goodies by clicking on the < **Download More** > button in the lower-left corner of the **Save Show Template** window.

You can give a **Template** a meaningful name and include spaces to make the title more readable. Then you can add a description with notes on its use—and any reminders about tips on customization. Add any remarks you wish, and then click < **Save** >. The new file will be created and added to the list.

A quick glance at the **Show Summary** bar, just above the **Folders List** pane, shows that the operation was a success; this **Show Summary** bar, (just below the **Main Toolbar**), now lists **Templates** where the name of the active **Show** file is usually displayed. The majority of the **Layers** in the **Slide List** are now shown as mediumgray boxes. Notice that they are no longer cropped to their former dimensions; they are now *placeholders* and will be resized to fit a new file whenever it is added.

Slide 2, shown in Figure 10.5, still has one picture visible in **Layer 2**, on the right side of the frame underneath Layer 1. That's because the check box for making it a reusable **Layer** was not enabled when we saved the **Template**.

Adding Content to Template Layers

Gray **Template Layer**s are a special type of content container. You can drag and drop a file directly onto such a **Layer**, even if another file is already there. The **Layer** will be sized to match the aspect ratio of the new arrival. Take care where you drop a file if there is more than one **Layer** on a Slide. If your dragged file is hovering over one **Layer** more than another when you drop it, the file will end up on the **Layer** with more shared real estate. That may not be the intended destination.

Open the Folder window and navigate to Chapter 10 and open < Hot Folder >.

Note

It is in the Chapter 10 folder on the companion disc. *Place it on your hard drive*, if you have not already moved it, before proceeding. ProShow requires writeable files, and the ones on a CD or DVD-ROM are read-only.

There are eight image files in the subfolder named **Hot Folder**. Some are seen as thumbnails in Figure 10.5. Drag and drop all but the one of the woman petting the horse into the open **Layers** (the ones that are grayed out) in the **Template**. **Layer 2** on **Slide 2** already has the image we preserved earlier already in place. Be sure to place the files so that the picture of the bride on the haystack is on the left side of Slide 2. Other than that, the placement doesn't really matter—other than picking images which should look good as Layers on the same Slide; remember, Producer automatically randomizes the order of Slides in a **Live Show**.

You can either drag the files from the File List, or open the Chapter 10 Folder on your hard drive in Windows Explorer. Place one image *per Layer*. That means each of the three remaining Slides will get two images each—one image for each of its two Layers.

As you place the images, a green check mark will appear in front of their thumbnails in the ProShow File List and the picture will be included in the Show. All of the **Layers** have been adjusted to show the entire image, and have inherited all **Keyframes**, **Motion**, and **Adjustment Effects** assigned to each **Layer** based on the **Template** Settings.

Tip

You can also populate a **Template** by selecting thumbnails or filenames from a list of files, and then choosing the **Add Selected Files** option in the **Show Templates** menu.

Template Planning and Workflow

Scrub the **Slide List** and **Preview** the Show. The picture of the bride lying on the haystack in **Slide 2** develops a sickly color during playback, as seen in the **Preview** shown in Figure 10.6. That's because the Slide's Adjustments were originally set to make colorized images look toned. The other **Layer** in this Slide has its original image still in place.

Figure 10.6

This bride's skin tone demonstrates why it's usually best to limit Effects in Template slides to those that will work with the images you plan to use in future Shows.

I constructed this Slide to illustrate a point: when designing slides for **Templates**, *be careful to plan Effects that will work with the files you will use in the future*. It's usually easier to add a few Effects once the new images are placed, than to rework the victims of bad settings.

Tip

Over the years, I've created a Producer Project with Shows that have my best Slides in Categories. When it's time to design a new Template, it's easy for me to build a new Show by copying the ones I want into a new Show, and then Saving the new Show as a **Template**.

Importing and Exporting Templates

A **Template** *isn't* a Show file. To have it show up in the list of available **Templates**, you have to **Export** it, and to use it on another computer, you have to **Import** it *into that copy* of Producer. Until you **Export** them, **Templates** are stored in a Temp Folder. They cannot be used until they have been properly **Imported**.

Export and **Import** are easy. Both commands are located in the **Show>Show Templates** menu. The **Export** window looks just like the **Save Show Template** window, with a different label. Select the **Template** to be **Exported**. Make any desired modifications in the **Name** and **Description** sections and click < **Export** >.

When you **Export**, a registered copy is put into the **Program Files>Photodex> ProShow>Producer** directory on your hard drive. Template files have a **.pst** extension. (They may display an Outlook icon in Windows Explorer if you have a copy of Microsoft Outlook on your computer.)

Windows Explorer will open when you choose to **Export** or **Import** a **Template**. Navigate to the Folder where you want to Save the Template (for **Export**), or that contains the desired file (for **Import**), and either **Name** and **Save** the file, or select it to **Import**. When you Import a Template it is added to the **Template List** and can be used with *that local copy* of Producer. You can save a **Template** and use it on another computer—after you **Import** it with the local copy of Producer.

Modifying and Using Templates

Editing a **Slide** in an open **Template** is almost identical to working with a regular Producer Show. You have access to all of the program tools and special effects. The only functional difference is your ability to drop a new file onto a Layer that already has a file and have the new item replace the old one.

Open Slide 2 in the Effects>Motion Effects window. Your images may vary depending on how you dropped them, but in any case each Layer behaves the same way as described. Scrub the Keyframe Timeline and watch how the Layers work together and fit within the frame. Layer 1's image is too wide, covering up too much of the other Layer during play and not fitting well in the frame. It's easy to see in the Precision Preview window shown in Figure 10.7. I've shifted to this window to make the screenshot easier to see. You can stay in the main Slide Options window if desired.

Now what you have to do to fix this Slide is **Crop** and **Size** the **Layer**. Templates are a speedy way to assemble a Show, but as with any remodeling job, paying attention to the details is important. The more complex an individual Slide is, the more tweaking it will require. Planning your content, and cropping images in advance,

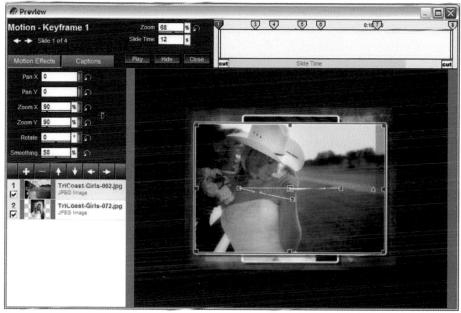

streamlines the Import process. When you have the new Show the way you want it, **Output** it and **Save** it, just as with any other Show. The original **Template** is untouched and available to use again.

Producing Live Shows

Now let's look at another way to use **Templates**. You can combine them with Producer's **Live Show** capabilities to automatically generate Shows containing all the files in a Folder—even adding new ones as they are Saved in the target location.

Live Shows are Producer's premier party trick, letting guests see almost real-time images taken during an event. They are a natural fit for occasions like wedding receptions, proms, and awards banquets. Photographers with a wireless or tethered camera can transmit images right to the Folder for automatic addition to the Show as it is running.

Setting Up a Basic Live Show

Simple **Live Shows** can consist of a single Slide and still show every image in the target folder. That's because they have special **Live Show Layers** that work like an automatic Template. We can use a Template file as the basis for a Live Show to quickly produce a complicated design. Live Shows can contain a mix of regular

Static Layers and Live Layers. Any Layer in a slide can be designated as a **Live Image Layer**. Let's create a Show with a single **Slide 1** and the same eight images we used in the **Template** Exercise.

Launch Producer. You don't have to open a new Show, since one will be created as soon as you start work. In the **Folder** pane, navigate to the **Hot Folder**. Drag the first image into the **Slide 1** position in the **Slide List**. The **Layer** must have an image in it to work as a **Live Show Layer**.

Note

If you use a **Template** file for a Live Show you must place an image in each Layer before playing the Show to avoid just seeing the gray placeholders.

Now we have to enable some settings so that the program will play the **Show** properly. As it is now, only this one image will play before the Show stops.

Open the Layers>Layer Settings window. In the Style/Template Settings pane, click the check box to enable the Live Image option. This designates the Layer as a container, similar to the way a Layer works in a Template. The content isn't fixed to Show a specific file, but you still have to tell it where to find the files to be included.

This must always be a Folder that is accessible from the host computer that will run the Show. We also have to define how the Show operates, and the sequence in which the files are displayed. Click on the **< Configure Folder >** link next to the **Live Image** box, and the **Random Image Settings** dialog will open (shown in Figure 10.8). This is where you set the Options for the **Hot Folder** that holds the image files. All the Live Show images must reside in this folder. Let's understand how Producer is "thinking" here, and then we'll return to the **Random Image Settings** dialog.

We have to tell Producer which are **Live Image Layers** and which are **Static**, just as with Templates. The program also needs to know where to get the image for Live Image Layers. Notice I didn't say *which* files, just where to find them. When a **Live Show** plays, the Slides in the Show will fill any Layer marked as a **Live Image Layer** with the next file in the designated Folder. **Live Image Layers** can draw files from any storage device that displays folders on the host PC. Here, we have one Slide with one Layer. If we make it a single-Slide, single-Layer **Live Show** and designate a folder with 300 images, the result will be a Show with 300 oneimage Slides.

Masking Layer				
Mask Type (stensty (Grayscale) : 👻 🖬 Invest	Random Image Settings Folders For Random Files ProShow Producer will select a random image from this folder for playback.			
Mask Depth				
GEF Adjustment Layer Type Miansky (Crayscale)				
Style / Template Settings	Preview Cthat failer Browse. Folder to be used when playing in the preview			
Style / Template V Replaceable Image (Do not save this image with the template or style)	Executable C:Wet folder/Vertical Browse Folder to be used when playing as an executable.			
Live Image Load Live Image from Folder [Configure Folder]	Playback Settings			
(Use random image from the specified for during playback) Configure the folder and opti	Ordor Play in random order			
for live image support	Orientation 💆 Use EXIF data for image orientation			
	holude Conty play images added in the last 300 s			
	Ok Cancel			

We also have to tell Producer where to find the files to populate the **Live Image Layers**. Any folder can be used as a **Hot Folde**r, and it can be empty when you select it. But there *must* be **JPEG** files in it at the time the Show is run for it to work. If you have not already copied the **Hot Folde**r in the CD's Chapter 10 Folder to your hard drive, do so now.

Preview or Executable?

There are two ways to run a Live Show. You can load the Show (or even just **Create** it without **Saving**) and run it using **Preview** mode. The other option is to **Output** it as an **Executable** file and play it on any Windows PC capable of running Photodex Presenter.

If you have a computer with Producer loaded, then you can use either method. To run the Show on any other Windows PC, you'll have to go the **Executable** route. Keep in mind that these Shows are actually played through Photodex Presenter.

In the **Random Image Settings** dialog, we choose the Options for our **Live Show**. For the **Preview** option, click on its **Browse** button. When Windows Explorer opens, navigate to the **Hot Folder**, select it, and then click < **OK** >. Use the same process for the **Executable** option.

You only have to set a location for the mode you actually plan to use; and these do not have to be set to the same folder. Setting both and using consistent folder names makes it easier to set up a Show file to handle both **Preview** and **Exported** and **Executable Live Shows**. You can create a special folder for a specific Show, or have one folder that you repopulate with images for each Live Show.

Note

Live Shows only work for **Executable** playback or **Preview** playback from within ProShow Producer. The program simply accesses whatever JPEG pictures are in your designated Folder; so the **Live Show** images are *not* saved in the Show.

Setting Playback Options

In the **Playback Settings** pane of the **Random Settings** dialog, use the **Order** option to choose the sequence in which the files in the **Hot Folder** will be added to the Show. **Play in random order** will add them in no set order; **Play newest files first** will select files based on the time and date the file was created; and **Play in order files are added** will display them based on the time they were added to the Hot Folder. Choose **Play in random order** for this Show.

With the **Orientation** setting enabled, Producer will check for EXIF data to determine whether a file should be displayed with Landscape or Portrait orientation for that Layer. Leave this Option unchecked.

You can use the **Include** setting to add only newer files, excluding files that were created before the cutoff point. Leave this Option unchecked. Click < **OK** > once you have all the Options set.

Creating a Loop Condition and Playing the Show in Preview Mode

Live Shows have Layers with variable content. The name of the associated file is set (and the file added to the Show) as the Slide is rendered. Right now, we have only one Slide, so our Show will be one slide long. We want the Show to play every file in the Hot Folder, and repeat the process until we tell it to stop. In effect, we are setting up an endless loop. If new files are added to the Folder, they will be added to the Show based on the conditions named in the **Order** and the **Include** settings.

Now we need to have the Slide repeat and load a new file each time it plays to get the desired result. That's easy to do in Producer by setting an **Action**. Open the **Slide**>**Slide** Settings window. In the **Action at End of Slide** pane, choose the **Jump to Slide** option and then type the number < 1 > in the **Destination** field located immediately below the **Action** field. Click < **OK** > when finished. (See Figure 10.8a.)

Run the Show as a **Preview** by clicking the main window **Play** button in the Preview pane. If it opens inside ProShow, right-click in the **Preview** pane and choose the **Full Screen** option from the context-sensitive menu. All of the images will play in random order until you press the **Escape** key to exit the **Preview**.

Creating an Executable Live Show

The **Preview** method is simple to operate and great for testing a **Live Show**, or running it under direct supervision. It also requires that you have a copy of Producer running. That means, unfortunately, that you can't share it, and that you'll need more system resources than if you were just running Photodex Presenter.

When you use an **Executable Live Show**, all you need is the **Executable** and a **Hot Folder** with the same name and drive location as the images for the Show. The **Executable** has a run-time copy of Presenter and all the proper settings for the Show.

The process is simple and the same as for creating any other **Executable** with ProShow. Select the **Executable** option from the **Create Output** menu. Enable any **Branding**, **Menu**, and other **Output** Options. (These are covered in detail in the next two Chapters.) Then click the < **Create** > button. When the rendering process is complete, the new file will be available in the location you specified during creation.

You can play **Executable Live Shows** anytime by simply making sure the **Hot Folder** is in the proper location and double-clicking on its file icon.

Creating Advanced Live Shows with Templates

Our first Live Show was a very simple production with a single slide. Live Show technology can be used to create complex productions, and **Templates** can speed the process. Still, you have to take into consideration the types of images you'll play in the Show. Live Shows play any image placed in the Hot Folder. We've already seen the need to be careful when a slide contains Adjustment Effects. Layout and Motion Effects have to be planned, too. Let's examine a more complex Show and look more closely at the fine points of Live Show design. Since this discussion involves Producer's random Live Show behavior, we can't create an exact Exercise. I'll draw on examples from the images we have been working with in this Chapter to illustrate things to consider when working with these kinds of productions.

Note

The Template file for this Live Show is included on the companion CD. You will need to **Import** it into Producer before it can be used. To do so: use Producer's **Show>Show Template>Import Template** menu and navigate to the **Live Shows Template 2** from the Chapter 10 folder on your hard drive. Select it and click < Open >. Then go to **Show Template>Open Template** and the **Load Show Template** dialog appears (see Figure 10.8b).

Select **Template 2**, and click < **Load** >. There are five slides in this **Template**. The first is a basic Title Slide. There are two slides that contain a pair of **Template Layers**, and the remaining one has only a single **Template Layer**. The final one is a Credits Slide.

Template files use **pst** as the file-name extension. If you have Microsoft Office, that extension may be linked to Outlook. Double-clicking on a Template file will then generate an error message. The file will still work properly in Producer.

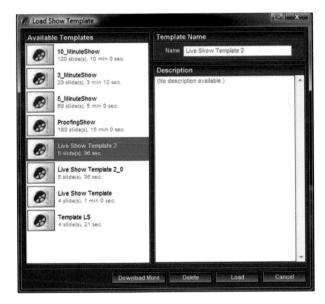

Figure 10.8b

The Load Show Template dialog, reached from Show>Show Template>Open Template.

Setting Fixed Slides and Content

The basic design workflow for a full-fledged Live Show is very much like the one for any other production. A **Template** design isn't a polished product. It is the starting point in a customization process. The Captions are generic. They have to be edited to match the needs of this specific Show. The Slides may not be in the proper order or the right quantity, and may need **Adjustments** to **Effects** or **Layout**.

Live Shows often include Slides that have Layers with *static images*—those that don't change each time the Show is played. These need to be configured with the proper files and settings. Normally, at this point in the process, I arrange the fixed content for the Show. Since we aren't actually designing a complete production, keep the existing design as is and move on to the next step.

Adjusting for Vertical and Horizontal Composition

When planning a Live Show or Template, we have to be aware of the fact that both vertical and horizontal images can be loaded into any Layer. The **Template's Slides** containing image **Layers** are the foundation of our Show. Right now, two of these Slides are designed to work best with horizontally-cropped images. Most of the pictures in the collection are vertical. That may cause problems, depending on the **Layout** and the **Fill/Fit to Frame** settings. To see what I mean, drag any vertical image into each available Layer on **Slides 2**, **3**, and **4**. Each one will produce a slightly different result because of the Layout and Layer settings. Remember that your Live Show or Template can draw from any image in the folder, so try several.

Slide 2, shown in Figure 10.9, looks fine. The title and image areas are wellproportioned and balanced. The result looks professional. Double-click on the slide in the **Slide List** and examine the **Layers>Layer Settings** window. **Layer 2**, the one with the image, is set in the **Layer Settings** pane for **Scaling** to **Fill Frame**. Try adjusting the setting and see what happens to the design's appearance.

Figure 10.9 The Layout for Slide 2 is well-suited to displaying vertical images. Open **Slide 3** in the same window (see Figure 10.10). Here the result is not as pleasing. Layer 3 (the one on the top) fills too much of the frame, and part of it is covered by Layer 2 (the one on the bottom), which is too small. Layer 2 is set to **Fit to Frame**. The smaller size was generated by Producer so that it would fit vertically in its portion of the frame. Layer 3 is larger because it has been scaled to **Fill to Frame**.

Figure 10.10

The two vertical images in Layer 3 don't fit as well as the single image in Figure 10.9 did.

Close the window and replace the vertical images with the two horizontal images. Since this is a **Template**, we can just drag an image over an existing Layer to replace the contents. Figure 10.11 shows the results of the completed revision.

The pictures aren't exactly the same size, but they fill the frame better. Open the **Layers>Layer Settings** window and set the **Scaling** option for **Layer 3** to **Fit to Frame**. That makes both Layers the same size and forces the pictures to stay fully within the safe zone. Now repopulate both Layers with vertical images. They are a bit smaller, but they fit the slide and do not overlap.

Drag one of the horizontal pictures into **Slide 2**. See how it looks too small? This is the same problem we had with the lower vertical image in **Slide 3**. Simple full-frame slides like the one in the first live Show work fine with both horizontal and vertical pictures. Slides with multiple or constrained Layers often will not.

It's a good idea to test and **Preview** Slides with a mix of horizontal and vertical images since we can designate only one folder for a working live Show. Layers and Slides that don't work well with both should be redesigned or removed before running the Show. The same is true for any **Motion** and **Adjustment Effects** used in the production.

Setting the Live Show Options and Placing the Content

Once all the Slides are tested, it's time to set (or double-check) the **Live Show** Options and arrange the content. Open **Slide 1** in the **Slide Options** window with the **Layers>Layer Settings** tab selected. Select each slide in turn and check/set each Layer. The Style/Template Settings and Live Image check boxes must both be enabled for all Live Image **Layers** in the show. They should be unchecked for the Layers that have static content. Normally we would also double-check the **Scaling** option in the **Layer Settings** pane. Since the ideal settings vary based on the specific images to be used, and since this is just a practice, we won't take the time to test the settings.

To make a Live Show that loops back through the Template, rather than stopping when the last slide is finished, we have to set the final Slide to jump back in the Show. In this example, we'll skip repeating the Title Slide. Make sure the last Slide has been set to jump back to **Slide 2**—the first Slide after the Title Slide. Open the **Slide>Slide Settings** window. In the **Action at End of Slide** pane, choose the **Jump to Slide** option and then type the number < 2 > in the **Destination** field located immediately below the **Action** field. Click < **OK** > when finished.

Close the window and return to the **Work Area**. Make sure that an image has been added to each image Layer. **Live Shows** will display only Layers that have been "primed" with an image file.

At this stage, we have what I call a "**Working Template**." Everything is loaded and ready to run. Now it's time to extend the design and add a soundtrack. Copy and load Slides with images to create a **Show** that has a bit more variety than just three slides that constantly repeat in the same order. (Normally my designs have more than three Slides. This is just an Exercise example.)

Now it's time to test the **Show**. Run it as a **Preview** and pay attention to how the Slides progress. Watch for any effects that don't work well and for images that tend to repeat too often. Correct any problems and repeat the **Preview**. Once everything is in order, **Save** the **Show**. If you are making an **Executable** version, it's ready for rendering and **Export**.

The Camera Connection

If your camera can write files directly to a computer, you can add images to a **Live Show** in real time. Advanced DSLR cameras like the Nikon D3 and D300 (shown in Figure 10.12) offer both wireless and tethered connections. A wireless adapter and a **Live Show** let a photographer work a crowd, where using a cord would be dangerous. Add a projector or big-screen TV, and your production will be a real attraction!

It's a good idea to field-test the entire process before promising a client a real-time Show at a major event. I even advise clients that we can't promise a wireless connection until the actual day. There might be interference from other electronics at the site. Even with those concerns, this is a really neat feature.

If possible, have an assistant monitoring the pictures as they are captured. The photographer might need to test a setting and produce a wonderful picture of his Show—and a guest might decide to do something untoward just as the shutter is released.

The best insurance is a trained pair of eyes and a **Holding Folder**. The images go there first to be checked, and then the ones that pass inspection are added to the **Hot Folder** for the Show. The software that works with the camera to provide remote control, usually allows you to set options for the storage location, processing of the image file, and the action the computer should take when a file is written to the target folder. (See Figure 10.13.)

Figure 10.12 The Nikon D300 with a WT-4 Wireless Transmitter attached.

Figure 10.13 Nikon Camera Control Pro software connecting a Nikon D300 for use with a live Show.

It is important to double-check the camera-control software before running a live Show that depends on transmitted pictures. I make sure that the **White Balance** adjustment renders clean whites and pleasing skin tones. Make sure that no image editors are set to open with each new file. The memory and CPU resources they use would slow down the **Live Show**.

Once the camera is connected and the software is running, take a few pictures to test the lighting conditions and the Show itself. Watch for good exposures, smooth play, and proper Layout with any Effects and Cropping. If you don't always enable the **Orientation** option for **Live Shows** (which uses EXIF data to determine each picture's proper orientation), be sure to turn it on before running or Exporting the Show.

Up Next

Adding a professional Menu interface and your own Branding increases the client's ease of use and the professional appearance of your production. The next Chapter shows how to design a user interface that does both—from the Menu design and Options, to video clips and credits that mark the Show's beginning and end.

Creating Menus and Branding Shows

It's time to turn our attention to the final product. ProShow lets us create Shows in a variety of Output formats; most make use of Menus, icons, thumbnails, and "About This Show" clips to provide information and a user interface to the viewer. ProShow provides a complete menu-authoring system, with an extensive array of customization features to polish our Shows and provide a professional visual invitation for viewers. Setting up the Menu is one of the first steps in the Output process.

Note

It's possible to create professional-looking Menus with either version of ProShow. The advanced Branding and Copy Protection features, and the ability to use Producer's Projects to include more than one Show on a disc, are available only with Producer. (See the detailed comparison of features in ProShow's versions in Appendix B.) For those reasons, we'll use Producer throughout this Chapter for the Exercises and the Chapter illustrations.

Locate the **Chapter 11** Folder on the CD-ROM. Move the Folder, with all its contents, to a hard drive on your computer. Remember that the files must be on a writeable device to work properly. The tools can be broken into two major groups: Menu Authoring and Branding. The Menu tools include features for designing Layouts and Themes; combining several Shows on one disc; and adding interactivity. Producer's Branding capability lets you personalize a production with logos, custom icons, and loading announcements. It also includes options for Copy Protection and Watermarking. We'll explore each in turn.

Adding multiple Show files to a Menu requires working in Project mode. To keep things simple, I've created a Project with two Shows in Producer to work with in these Exercises. Please launch Producer. Then off the Menu, choose < **Project>Open Project >**, and select the file named, appropriately, **Menus Project** (Menus Project.ppr). If you copied the folder to a location other than the root of your C: Drive, ProShow may report that it can't find the two Show files and ask you for their location. Both files are in the Chapter 11 Folder.

Note

There *is* no "Menus menu" in ProShow because "Menu Create" is a sub-set of the Output process. You need a Show or a Project before you need a Menu.

Designing Professional Menus and Adding Interactivity

A good-looking and well-organized user interface is part of a professional slide show. A Show's Menus are the user interface that allows the user to play and navigate the slides, choose options, and view information about the title and its author. ProShow provides an excellent set of tools for creating attractive and functional Menus, including a collection of generic menus, backgrounds, and complete Themes you can customize for your Projects. Some come with the program; others are available online from ProShow. The collections are updated and expanded periodically.

To obtain bonus content, Open < File> Download Extras> Download Extras >. (You will need an active Internet connection.) Choose the bonus content you want by clicking on the appropriate listings in the Download Content dialog box, shown in Figure 11.1. Now click the < Install Selected > button. When the process is complete, a File Loads Completed message will appear. Close the window.

The Menu Window

With the **Project** loaded, choose **Create>DVD**. (You must have a DVD burner on your computer for this option to work. If you don't have a DVD burner, choose either the Vidco CD or CD option.) The **Create DVD** window has seven tabs in a row on the top, as seen in Figure 11.2. Each one contains a different set of tools. We'll focus on the **Menu**, **Shows**, and **Branding** tabs in this Chapter. These work basically the same for all Output formats. Not all Output types support all the Menu design and customization options; nonsupported options are disabled.

Make sure the **Menu** tab is selected and that the word **Menu** shows on the left side of the **Menu** pane. I'll refer to this screen as the "Menu window" from now on. Some of the settings may vary as we work, because Producer "remembers" previous settings you or I may have made in the past. We'll limit that possibility now. Click the < **Reset** > button (circled in yellow) to restore the window defaults. The **Themes** selection column of thumbnails should be set to < **All Themes** >, as shown in Figure 11.2. If not, use the drop-down list to adjust the setting.

On the **Menu Layout** pane, (circled in green below the Preview area in the Figure) set the **Layout** box to < **Two Thumbnails Center** >. Then click the **blue** background Theme to make it active. (I've outlined it with a blue rectangle.) When designing Menus, you can use Themes to quickly change a color scheme. Actually, though, we are going to undo this step in a minute, craft a custom design of our own, and **Save** it so it can be used in the future.

Now replace the words **Main Title** with the word **Proofs** into the < **Title** > box (the data entry area is located in the area just below the **Preview** on the left side of the window). As you type, the Caption **Main Title** appears in the **Preview**.

Be sure that the **Thumbnails** check box in the **Menu Contents** pane (circled in red in the Figure) is *unchecked*. If it is enabled, the video clip will replace the chosen thumbnail.

Touring the Tools

Here's a bit more information on the tools we just used and how they work. ProShow allows users to Customize, Save, and reuse **Menus**, **Layout**s, and **Themes**. *Menus* are complete designs and can contain more than one page. They are divided into two components: a **Layout** and a **Theme**. The *Layout* details the *positions* of Show icons and any navigation objects (like Captions) on Menu pages. A *Theme* controls the options for adjusting the *appearance* of the Menu, including Colors, Caption settings, images, Music, and the pages themselves.

Each Menu page has a Background and can contain Captions (both static and interactive), Images, Video clips, and make use of Layers. You can use the same editing tools found in the main program to adjust the appearance of Layers. **Keyframes** are *not* supported, so you can't use Adjustment or Motion Effects in your menu. All of the elements in a Layout can be moved or scaled. Just as with Producer Captions, the Layers in the frame (except the Background Layer) can be

given interactive assignments, like loading a Show, jumping to a specific slide, or opening a page on a remote Website.

You can save Themes, Layouts, and Menus independently of each other within Producer. (ProShow Gold only saves entire menus.) The Menu window is where you choose either a predefined basic Menu, or load an existing Custom Menu. It can also be used to set the Menu's Title, the Menu's aspect ratio, and to enable or disable video thumbnails. Assembling a Menu with different Layouts and Themes makes it easy to quickly assemble a personalized design for a Show.

Crafting a Multiple-Show Menu

We started by loading a Project, so we could include two Shows on our DVD. If you want to Create Output that contains more than one Show, you have to Open an existing Project, or Create a new one. The Project needs to contain the Shows to be included with your Output. ProShow will prompt you to save the Project when you try to exit.

Note

If you exit ProShow without saving the Project, the additional Show information, and its related Menu options, will be lost.

New Shows are given a default title when they are first created. *Most users don't bother to change the default title before crafting a Menu.* Neither will we. It's possible to do it when tweaking Custom settings, but that can cause extra work later, because of the way Producer generates Caption text.

Setting Show Titles and Thumbnails

Now it's time to work on the details of our Layout. You may have noticed that the Shows in our Project are labeled **ProShow 1** and **ProShow 2**. These titles are the defaults for Shows added to a Project, and are not very descriptive. To change them we need to adjust the **Main Titles** settings in the **Create> DVD>Shows** Tab (or other **Create Output** windows).

Go to the **Create DVD>Shows** window and ensure that **ProShow 1** is selected in the **Included Shows** pane, and then click on the < **Set Menu Title >** button. (It's identified with a green arrow in Figure 11.3.) A dialog box will open. Change the text in the entry area to read **Beach Proofs**, and click < **OK** >. Select the second Show (**ProShow 2**) and repeat the process, changing the text to read **Seniors Proofs**. Note

Figure 11.3

Clicking the Set Menu Title button located in the Shows tab of the Create DVD window opens the Show Title dialog box. Changing the Title here also changes the Title in the main program and any other references to the Title.

Be careful *not* to click the **Create** button on the bottom right as yet!

Click the < Menu > tab; notice that the Show Titles listed within the Menu window have changed, and also within the **Project** pane in the main Producer **Work Area**. (They are outlined in green in Figure 11.3.) The filename of the Show at the top of the **Work Area** (outlined in red in the Figure) is unchanged. That's because *the Show Title is not linked to the filename*. Most **Menu Themes** use a Show's Title as a default Caption in Menus. You can also use the Menu Caption tools to change it. Here we just modified the Show Title and the Layout did the work for us.

Show Thumbnails are the images that visually identify the Show to the user in a **Layout**. They can be pulled from one slide in that Show, or be drawn from an external image file. Both of this Menu's thumbnails are drawn from Slides. Let's change the one for the second Show to an image file. I've placed one in the Chapter Folder that has been cropped to fit the planned design. (We can't crop images in the **Menu>Layers** window, so that step has to be handled outside Producer.) Click the < **Shows** > tab.

Start by clicking on the Show's Title, < Seniors Proofs > to select it in the Included Shows list (indicated by the red arrow in Figure 11.3a). Then click on the < Set Menu Thumbnail > button (green arrow). When the Set Show Thumbnail dialog box opens, choose the < Image from file > option as the Thumbnail Type (green circle) and then < Browse >, navigate to the TCS2.jpg file in the Chapter 11 folder, Select it and click < OK > to load it. It is a cropped version of the picture used in Layer 2 of the slide in the second Show. When you click < OK >, the new Thumbnail should be visible in the Create DVD window. Sometimes it takes a little time for the new settings to be refreshed.

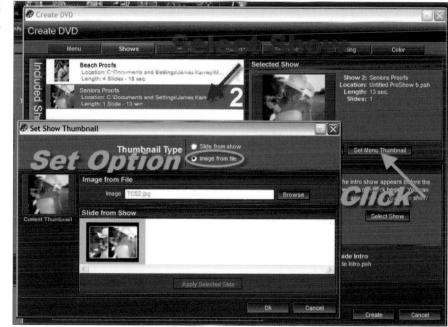

The **Plus** and **Minus** buttons at the bottom of the Create DVD window's **Included Shows** pane are used to add and remove Shows from the current Project. If you click on the Plus Sign, the Show's title will appear in the Tabbed list in the main ProShow window. The Show will be added to the Project as well as the menu.

If you decide to remove a Show while working on a Menu, just click on the Minus Sign; and the title will disappear from the Menu and the Project. Use the **up and down arrow keys** to change the order of the Shows. The principal Show you wish to feature should be first on the list. When you add a Show to the Menu window, it is automatically added to the current Project.

Note

This window also provides a pane, **Include Intro Show**, to set up a Custom **Intro Show** that plays while the Menu is being loaded. I've set a Custom Show for my Project by checking the **Include Intro Show** box. The thumbnail for that Show replaced the default Photodex intro.

We'll cover Producer's **Intro Shows** and **Branding** Options later in this Chapter. The next Chapter covers the details on **Output Options** and **Disc Burning**.

Creating a Custom Menu

Click on the **Menu** Tab to return to that window. At this point in the Menu-building process we can choose any of the Themes on the right-hand column. The Background and Caption settings would change, but we would still have our new Show titles and a new thumbnail for the second Show.

Feel free to experiment and see how different Themes change the appearance of the page. Just be sure to have the **Two Thumbnails Center Layout** option selected when you proceed with the exercise. We will be using that as the foundation of our customization process. When you are ready, click on the < **Create Custom Menu >** button in the **Menu Layout** pane. (I've added a green arrow pointing to it in Figure 11.4.) It's time to create our own theme, so don't worry about restoring the original background if you changed it while experimenting.

Figure 11.4

ProShow's pre-defined Themes can make quick work of changing a basic Layout. The Create Custom Menu options provide the tools for crafting our own designs. The **Customize Menu** window (see Figure 11.5) is where we create our own Menu designs and tailor the user interface, Themes, and Layouts. There are four Tabs at the top of the window: **General**, **Thumbnails**, **Layers**, and **Captions**. The screenshots are all from ProShow Producer. The available options will be more limited and vary in location from the screenshots if you are using ProShow Gold.

The Custom Menu—General Tab Options

You window should open with the **General** tab active. Make sure it is selected. We are going to make a couple of changes in this window. The **Navigation Settings** pane (located to the right of the **Background Color** pane, and circled in green in Figure 11.5) has two check boxes. These enable two pre-defined interactive Captions, **Loop All** and **Play All**. Be sure the one that says **Show 'Loop All'** is *unchecked*. These two navigation items are actually captions and will show up in the captions List. They will not be shown on the Menu page if the related box is unchecked. For this design, we will want the user to select a specific Show for viewing. Leaving the **Show Play All** box checked allows the viewer to choose to Play all of the Shows in the Project one after the other, one time through.

Now we are going to change the Background Image. In the **Background Image** pane, click on the < **Browse** > button, then < **Add Image File** >. Locate and select the **Theme_Film-Reel.jpg** > file, located in the Chapter folder. Click < **Open** >. Now your window should match the one in Figure 11.5a.

Beneath the **Main Title** pane is the **Background Color** pane, with **Background Color for All Pages** option and the **Custom color for this page** option. (See Figure 11.5a.) These control the appearance of the Background Layer when there is no background image set. They are *not activated*, because we have a global

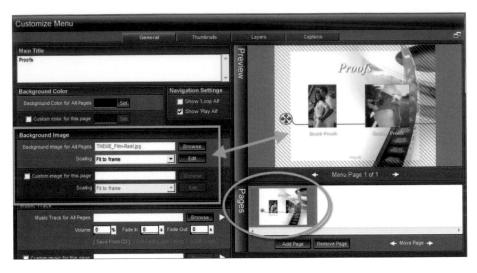

Figure 11.5a Setting up the new background image.

Background Image defined. Checking the box beside **Custom Image for this page** lets you override the Global image for the Theme and use a different image for a specific page. I've boxed the image file controls in green. The green circle shows the Page Preview. The buttons below the Page Preview are used to add and remove pages. Secondary pages can be very handy if you design a user interface for a disc with bonus content or alternate formats.

The current active Page is shown in the **Preview** pane on the upper right side of the window, and you can change the active Page using the **arrows** at the bottom of the **Preview** pane. The buttons for **Add Page**, **Remove Page**, and cycling through them are in the **Pages** pane, just below the **Preview** pane. The **Save Theme** and **Save Layout** buttons are available at the bottom left of the window, no matter which Tab is active.

Adding Menu Soundtracks

Just as with Shows, ProShow lets you apply a global **Soundtrack** to Menus, and you can assign custom clips for selected pages. We won't actually add one as part of the Exercise, but I'll detail the steps. Click on the < **Browse** > button located in the **Music Track** pane on the left. Click < **Add Sound File** > and a Windows Explorer dialog box will open, and you can navigate to the desired file and select it. Then click < **Open** >. Checking the **Custom music for this page** box overrides the global Menu **Soundtrack** setting—even if there is only one page in the Menu.

You can use ProShow's **Music>Soundtrack>Edit Fades and Timing** window to adjust Menu **Soundtracks**. There are also sliders to manage Volume and tweak **Fade out** and **Fade in** times. Feel free to include a soundtrack if you wish to practice. There are no soundtracks with this Menu. The ones shown in Figure 11.6 are just an example.

Figure 11.6 The Music Track section of the General window showing a slider open for adjustment. (You won't see the files in your window; they were added for purposes of illustration.)

Note

We've already covered all of ProShow's audio controls and features, so I won't review them here. See Chapter 4 for more information on working with audio files.

The Custom Menu–Thumbnails Tab

ProShow often offers Controls in more than one window. Our workflow was designed so that we only need a brief stop in the **Customize Menu>Thumbnails** page (Figure 11.7). We've already set several of these options, like the **Show Thumbnail** and **Show Title**. **Thumbnails** are actually image Layers, so we can use all the Layer Controls to position them and control their interactivity in the

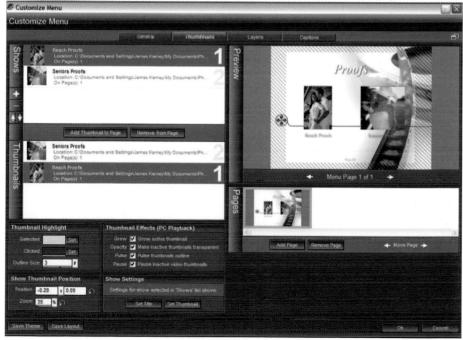

Layers window. The **Layers** tab offers finer control over positioning graphics, so we'll wait to perform that part of our design. This window also provides access to the **Set Title**, **Set Thumbnail**, **Add Page**, and **Remove Page** controls.

The only thing we need to do here is make sure the **Thumbnail Highlight** and **Thumbnail Effects** options are configured the way we want them. **Thumbnail Highlight** determines the appearance of a thumbnail's outline when it is selected or has already been used. Our white background works well with the default colors, so we really don't need to make any changes. If the underlying page color made it hard to see the outlines, then we could use these controls to set a different color scheme.

To adjust a setting in this window you have to select the **Thumbnail** you want to change, first choosing the **Show** in the list at the top-left of the window, and then the actual image in **Thumbnail** pane. (The order of the thumbnails is not the same as the order of the Shows, so it's a good idea to double-check your selection in both the Show and the Thumbnails lists.) The Thumbnails window can also be used to change the **Title** of the Show, **Show Thumbnail**, **Add Page** or **Remove Page** from the Layout, and to **Save Theme** and **Save Layout**.

Working with Menu Layers and Enabling Layer Interactivity

We can use the same interactivity features, available with Producer Captions and Layers, with **Images** and **Show Thumbnails** to provide active links and commands for menu users. For example, both a Show **Title** and **Thumbnail** can each be set to load and present a Show to the viewer

Click on the **Layers** Tab. This is where we arrange and adjust the appearance of images used in Menus. The **Layer** controls here work almost exactly like in the **Layers** window in the main program's **Slide Options** window. There are some important differences, which we will explore by example.

Note

The basics of working with ProShow Layers is found in Chapter 3 if you need a review.

The first is an expanded definition of what can be a **Layer**. All of the file types that can be used in Slides can be imported into a Menu. In addition, **Show Thumbnails** that are used in a Menu are also considered **Layers**—but they are not on an equal footing with imported images—even if they are actually the same file. Keep in mind that you can have more than one version of a file in the same slide or Menu.

Here's an example. Select < Layer 1 >, the picture of the woman wearing the cowboy hat. It now has an active selection border in the **Preview** area. (See Figure 11.8. Its List position and Preview image are indicated by red arrows.) The **Select File, Edit**, and **Properties** buttons are inactive (circled in green). Select < Layer 2 > and the buttons are still disabled. They do work, however, when you select < Layer 3 >. Layers 1 and 2 have a .psh extension in their listing. That's because they are **Show Thumbnails**. Layer 3 was imported to the Menu as a **jpeg**. If you want to edit a file using an external image editor, it has, first, to be an imported image. However, both **Thumbnails** and imported image Layers can be adjusted, using the Controls within the Layers window.

Figure 11.8

The Layers pane lets us add image files to a menu design. Layers listed with a .psh extension in the filename are actually Show Thumbnails and cannot be edited in an external editor.

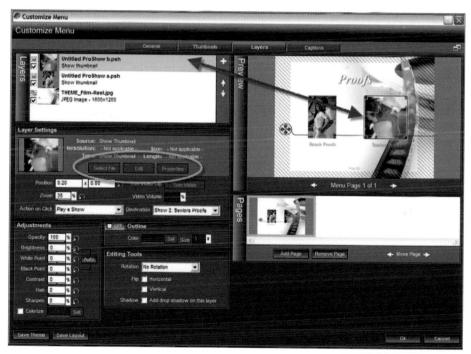

The Layer Settings pane has two drop-down Menus that are used to attach an interactive command to a Layer. These work like those for Captions. Show Thumbnails are automatically configured to begin playing their Show when clicked. The Layer Settings options are used to change the type of action and to enable/disable the action currently set. We'll leave them as is.

The other major difference from **Slide Options>Layers**, when working with Layers here in the **Customize Menu** mode, is the inability to crop an image (imported or Thumbnail), which we can do in the main program. I used Photoshop to crop the current **Layer 1** image before setting it as the **Show Thumbnail**. As this Chapter was written, that was the only option for cropping

image layers for Menus. Hopefully the Photodex design team will enable full cropping capability in a future update.

Notice that I've changed the order of the Layers; the **Woman in Hat** image is first in the **Layers** pane, but the second image on the **Menu** page. That was necessary to allow the right side of the picture with the woman to rest underneath the left side of the other image. (See how the picture of the woman is underneath the one of the couple?) Select it and use the down arrow on the right edge of the Layers List to demote it. The numbering of the Layers will change as you do. Select **Layers 1** and **2** in turn and click in the < **Zoom** > numeric box, then use the Zoom Slider to make the Layers approximately the same size as those in Figure 11.9. Use your mouse to position both Layers as seen in the example.

Figure 11.9

The Layers window is used to adjust the position and appearance of images, and to set interactive elements that work when the user clicks on an image.

Editing Layer Appearance in the Layers Window

Let's add a Drop Shadow and a white Outline to both Layers. That will help separate them from the background Layer, and each other. The **Outline** pane is circled in green in Figure 11.10. The **Drop Shadow** option is a check box located in the **Editing Tools** pane. The Outline and Drop Shadow tools work just like the ones used to add and modify the Outlines and Drop Shadows on Layers in the main program.

The **Adjustments** tools can be used on both traditional Layers and Show Thumbnails to fine-tune the appearance of images in the menu. On my screen **Layer 2** (the woman) lacks the amount of contrast seen in the one on the right. The composition will be stronger if the images have similar contrast. You can use the slider or enter values in the text boxes (circled in red in Figure 11.10) to tweak the settings. Don't let the light tones in the hat and gown turn completely white. You can adjust **Layer 1** here, even though it has a **.psh** extension.

The **Color** Control in the Outline pane is the same as in the main program. We won't use it for this Menu. Next, put a check in the box in **Editing Tools** to add a Drop Shadow to both images. This pane also has tools to **Rotate** and **Flip**

Figure 11.10 The Layers window is used to adjust the position and appearance of images, and to set interactive elements that work when the user clicks on an image.

images. We can't crop images in this window; files have to be trimmed using an image editor. This may require substituting an image file for a **Show Thumbnail**.

Working with Menu Captions

The screenshot in Figure 11.11 shows the Menu after I adjusted the Captions, with the **Customize Menu>Captions** tab still active. The main title (Proofs) is

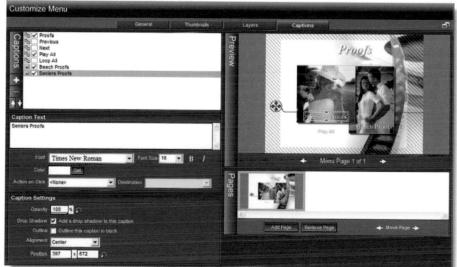

now centered over the top of the frame. The text placement tools are not as extensive as the ones in the **Caption** window in the main program, but are adequate for Menu work. I've enlarged the two Show titles, placed them over the pictures; then added drop shadows, and tweaked the text color to make them easier to see against the images.

The **Captions** pane List has seven items, and three are disabled. They are default captions that were part of the original Menu; the **Previous** and **Next** options are not needed in a one-page Menu, and not adding the **Loop All** option was a design decision. There is no performance benefit in deleting them; and it's possible they will be used in a future customization of this design, so we leave them disabled.

When adding Captions we want to ensure that the user will be able to know how to perform the desired tasks, and that the commands are easy to use. **Play All** is self-explanatory. The pictures are active links that launch the Show. You may want to add a Caption that instructs the reader to "Click on a Picture to See a Show" to make sure they understand how the menu works. Use the **Action on Click** and **Destination** drop-down menus to set the desired actions in the **Layer Settings** section in the **Customize Menu** window. These menus and the options are the same as those for adding Caption interactivity in the main Producer program. (See Figure 11.11a.)

	Reso	- Not applicable - - Not applicable -			
		- Select		Eax.	Propesties
Position	0.20	x 0.00	n Ini	m Video Clip	
Zoom	35 %	ຄ	v	ideo Volume	%

Figure 11.11a

Adding interactivity to a Layer, Show Thumbnail, or Caption in a menu works just like setting interactivity for a Caption in the main program.

There are no hard and fast answers to such decisions. Consider the location and wording of Menu captions, and how well they stand out for easy identification. Of course, a very noticeable text element may disrupt the visual attractiveness of a Menu. Professional interface designers have typical users try out Menus before they are finalized. One nice thing about ProShow Menus is, they are easy to **Save** and modify later.

Saving Menu Designs

Menus are not part of a Show or a Project. They are separate files. So, if we want to preserve any changes we make, even little ones like the Main Title or a Show Title—we must save our work before we exit the Create window. Menu files can be saved for later use with another Show, and even transferred to another computer for use by others. Be sure to manually add copies of any image files used as backgrounds to the same directory (unless they are part of ProShow's regular collection). It's a good idea to give Menus, Themes, and Layouts names that relate to their design or function.

All of the panes in the **Customize Menu** window have **Save Layout** and **Save Theme** buttons. Saving both components before changing to the next tab is a good habit to develop. Figure 11.12 shows the **Save Layout** dialog box. The top contains a text entry box used for naming the Layout. You can use spaces, and names can be long enough to be really descriptive. The list in the lower section of the box includes Thumbnail placeholders and a notice on how many Show slots (active Thumbnails) are in the design. If you want to save a revision to an existing Layout, select it first, then click on the Save button.

Figure 11.12 The Save Menu Layout dialog box.

Click the < Save Theme > button, and the Save Menu Theme dialog box appears, with three sections. The left side contains a directory of available Themes, with the background as a thumbnail. That's because Themes do not contain Layout information. The Theme Name pane has a Name text box, used to assign names to files being saved. All Themes are assigned to a Category. To create a new Category, name and < Save > it *before* you Save a new Theme that will be in it. Once a Category is created, it will be shown in the List in the Category pane. I've made a Custom Category for my own designs. The references to it are circled in red in Figure 11.13. The buttons on this window are used to Save (using a new name when saving will add a new option to the list—like Save As in the main File menu. We can also remove a Layout from the list with the Delete key.

The final step in saving a complete Menu design is to actually save the master file. Remember that a Menu loads with both a **Layout** and **Theme**. Mixing and matching saved Layouts, Themes, and Menus produces variations with the click of a mouse. Click on the disk icon in the top right-hand side of the **Create** page

Figure 11.13 The Save Menu Theme dialog box.

to save the actual Menu file. **Menus**, **Themes**, and **Layouts** can be used in any supported Output, no matter which type of file was being created when they were first saved. So you can make a custom menu for a DVD, Save it, and then use it again for a Video CD, Executable, etc.

Figure 11.14 shows the **Create Flash** window with the disk icon circled in red. I've used the **Create Flash** window to demonstrate how saved Menus, Layouts, and Themes are used. The **Folder** Icon, located next to the **Save** button, lets us re-load a saved Menu. That will be imported with all **Saved Themes** which are added to the column on the right side of the **Customize Menu/Layers** window.

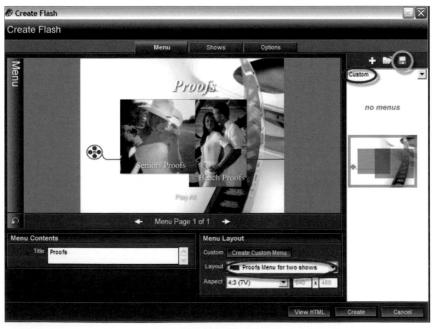

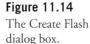

If you often create Shows and Projects for similar purposes, this offers an easy way to streamline your workflow.

I've used the **Theme** drop-down List to limit the **Theme List** to show only the items in the **Custom Category** (circled in red in Figure 11.14). In this case there is only one. If you have been following along, change the **Category** and then the **Layout** (also circled in red). Watch how the changes instantly modify the design.

Personalizing Shows with Branding

Branding is a buzzword in marketing for a good reason. It builds public awareness and fosters customer loyalty. ProShow Producer offers a variety of opportunities to Brand your Shows that provide a polished, professional look. The options vary with the type of Output, and Producer (once again) has more features than Gold. The simplest form of Branding is to place a logo and basic contact information on the Menu. It's easy to do. Just add a Layer with your logo and arrange it with appropriate Captions within the overall design.

The items used for Branding (image files and Shows) need to be prepared ahead of time. Actually adding them to an Output job (and so the final product) requires nothing more than enabling the Option and telling the program where to find the file used.

Announcing Your Work with an Intro Show

I'll use our Menu Project as an example. If you wish to follow along, choose the **Create DVD** or **Create Video CD** from the **Create** Menu and click on the **Shows** tab. They support the full range of Branding options. Different output types have different **Branding** options available, based on the features provided in the format specifications. You can tell which Options are available for a given format by the tabs that are provided at the top of the Create window. (Figure 11.15 shows the **Branding Tab** circled in green. It isn't available for Flash Output; that's why we are using the DVD for this portion of the Chapter.)

The lower-right portion of the **Create** pane (outlined with a red box in Figure 11.15) is where we set up the **Intro**. If the **Include Intro Show** box is checked, the selected **Intro Show** will play before the actual Show begins. If the Show has a Menu, the **Intro Show** will appear before the Menu does. Unless you already changed it, your screen shows the standard ProShow **Intro Show**. Its logo and color scheme let everyone know you used ProShow. Changing it provides a personal touch.

Figure 11.15 The Shows pane with a custom Intro Show selected.

Setting up an **Intro Show** is simple. Any PSH file can be used as the source. You can use any Show created in either Gold or Producer as an Intro. It is read and rendered into the final file with the rest of your Project or Show. Normally, you want it to last no more than a few seconds. My standard **Intro Show** uses one of the Theme backgrounds with an image of a projector. My logo and a copyright notice move into center of the screen during the three-second Show.

The **Intro Show** selected in Figure 11.15 is one I produced in a couple of minutes to promote this book. It's a simple one-slide Show that zooms and rotates the cover of the book as the caption fades from view. This kind of **Intro Show** is perfect for production and Output formats that don't need a Menu when you want to increase Brand awareness.

Using the Branding Tab Options

Click on the < **Branding** > tab, and a window like the one in Figure 11.16 opens. Click on an Option to enable it, and then tune settings or select a file as required. The **Show Startup Screen** and **Use Custom Icon** require identifying an image file. The **Show Progress Bar** can be configured by using the tools below the Preview area to tweak the bar and text colors and set the wording that appears over the bar. Use the mouse to position the bar over the image in the **Preview** pane.

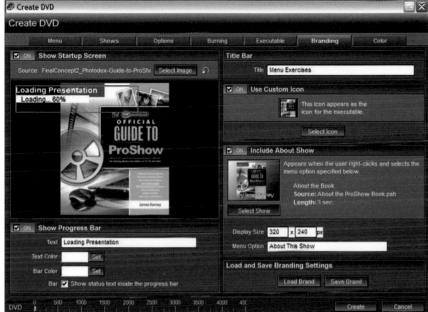

Any or all of the **Branding** tab settings can be changed and then saved for repeat use by clicking on the buttons in the lower-right portion of the pane. Producer will remember the last used settings the next time you create Output. If you want to change any of these Options, and later restore the defaults, click on the < **Save Brand** > button and name the new file **Default**. I've configured the window with custom settings based on graphics using the book's cover as a Theme.

The left side of the **Branding** window contains the **Show Startup Screen** pane; a Startup Screen is displayed while an **Autorun** or **Executable** Show is being loaded.

Note

A full discussion of Output types and formats is included in the next Chapter.

ProShow comes with a default **Startup Screen** with the Photodex logo and a **Progress** bar that extends as the Show file is loaded for playback. The logo is actually a background image, and the bar an animation on a layer in front. Click on the **Select Image** button to change the file used as the logo layer. The **Circular Arrow** on the right edge of the pane is a shortcut that resets the screen's default appearance.

One pane beneath the **Show Startup Screen** pane is the **Show Progress Bar** pane. Click on the box to toggle the bar on and off.

Just below the check box is a text box. You can change the **Loading Presentation** caption here. The check box below the text area toggles the Animation bar from a narrow strip to a wide bar. Test it to see the difference. The two color-selection tools above this area change the color of the text and bar animation.

Customizing the Startup Screen

Notice the location of the **Progress Bar** (enclosed in a red box) in Figure 11.17. The ProShow default position is in the center of the startup graphic. I've moved it to the upper-left corner, and changed the colors to show up against the background image. The **Startup Screen** is basically a *splash page*, and the program makes it easy to modify. The controls for changing the settings are circled in yellow in the Figure. I selected a JPEG of the book cover. This source file was larger than the maximum allowed size of 320x240; happily, the program automatically resized the image to fit the page. You can move the **Progress Bar** using the mouse; here I shifted it to the upper left of the design. The text remains the same as the default. If you want to restore the original Photodex bar and text, click on the counter-clockwise circle outlined in green in the screenshot.

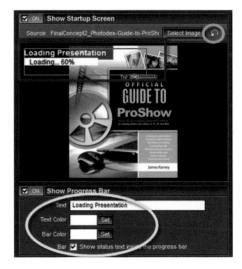

Figure 11.17 A detailed screenshot showing the Show Startup Screen controls.

Relabeling the Title Bar and Setting a Custom Icon

PC-based playback requires the Photodex Presenter viewer. A **Title Bar** pane on the top right of the **Branding** window accepts text in its **Title** box; this displays as the Show is played. This setting does not modify any other title setting for the Show or the Output.

Setting a Custom Icon

The Windows operating system displays an icon for files in folders and on the desktop. ProShow lets us set the default icon Windows will display for **Executable** and **Autorun** files. I've checked the box and replaced its default icon with a JPEG for this Show. That image will be what the user sees as the icon for this Show. If you want to use a JPEG, click the **< Select Icon** > button, then choose **< All Files** > in the **Open Icon** dialog box, whose default setting only shows the special **Icon Files** type that ProShow uses for this purpose. See Figure 11.18.

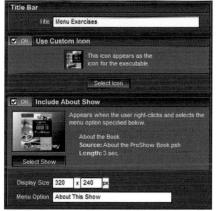

Adding a Custom "About Show"

The final **Branding** option in this window is the **Include About Show** pane. This "About Show" will play if the viewer right-clicks on the Show in Photodex Presenter and chooses it from the list in the context-sensitive Menu. To include this option, check the box and then click on the < **Select Show** > button. The **Open Show File** dialog box opens; then choose any **PSH** Show. While there are no limitations on the length of the **About Show**, it's usually a good idea to make it short and to the point.

The screen size of the **About Show** will be limited to the dimensions in the Size settings, and the text you put into the **Menu Option** box will become the link to run the **About Show**.

Setting a Disc Label and Adding Additional Content

Click on the **Burning** Tab to change windows (see Figure 11.19). We'll cover the **Output** options in the next Chapter, but I want to note two useful **Branding** options here. The **DVD Disc Label** pane (boxed in green in the Figure) lets you set the text for the label on the final disc. This is what will appear in Windows

9 Create DVD	
Create DVD	
Menu Shows Options	Burning Executable Branding Color
DVD Writer	D: HL-DT-ST DVDRAM GMA-4082N
Disc Options	DVD+R/RW Compatibility
Speed Max Disc Type DVD Media	Bitsetting will increase compatibility for DVD+R/RW discs by making them appear to DVD players as non-writable media. This requires a compatible writer, and only works for '*' media.
Multiple Copies	Efseting Detect
	Include Original Files
DVD Disc Label Disc Label Beach & Seniors Proofs DVD	Including original files will place the photos, video, and music used in your show on the disc along with the DVD video. This does not copy your show file (PSH), or include other show elements such as fonts or captions.
Treablecheeting	Include Files 🖬 Investiga ungalinat mona un ar viv
Most reported burning problems are caused by disc media.	Include Additional Content
Even major brands may experience a high failure rate. We recommend Taiyo Yuden discs.	Additional Content lets you add 'stuff of any type to your disc. The folder specified her will have its contents in placed in the root of the DVD. Any sub-folders in this folder will
Simulate 📕 Simulate (Test without actually burning)	also be included.
ISO Creation Generate disc image on the fly Also try lowering the speed (under Disc Options, above)	Folder Browse

Figure 11.19 The Disc Burning window.

folders as the label for the disc contents when the DVD (or CD or VCD) is loaded and available for play.

Setting the label with the name of the Show, or some other meaningful title, makes it easy to identify the disc without being required to open the drive to look at the label area, launch the Menu, or launch Presenter.

Another useful option is on the **Include Additional Content** pane (bottom right, circled in red in Figure 11.19). You can include any kind of "bonus" (or promotional) information. That's how the movie studios place content like Deleted scenes, Upcoming Releases, and Special Offers on movie DVDs. You might add PDF brochures, or a webpage price sheet with links, etc. to your disc. If so, consider adding a linked Caption pointing to a second page to provide ready access to the extras.

Adding a Watermark to the Slides

Copyright Protection is an issue for many ProShow users, concerned that viewers might use proprietary images captured from Slides. Producer lets you add a unique Layer on top of each slide in the Show, called a **Watermark**. It could be your logo, or a warning, or some other notice to deter unauthorized use.

To access this feature, go to the main Menu and choose **Show>Watermark**. A watermark layer most often contains an image of a logo, sometimes with a copyright notice. Figure 11.20 shows both the Watermark pane with an overlay from the main Producer Preview. The slide in the **Preview** is watermarked.

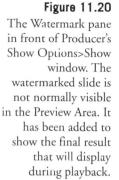

You won't see the slide in the **Watermark** window **Preview** pane, since the layer is globally applied to all the Slides in the Show. Positioning the window as shown in Figure 11.15 makes it easy to see just how the result will look. Choose a representative slide in the **Work Area Preview** pane before opening the **Show Options>Watermark** window. Use the controls to tweak the appearance of the **Watermark**. These controls work just like their **Editing** window counterparts in Producer's **Slide Options** window.

Up Next

With Designs completed and Menus ready, the only steps left in the workflow are rendering the **Output** and testing the result. The next Chapter covers the various supported file formats and actually outputting the final Show.

12

Getting the Story Out

ProShow is really two programs in one: the multimedia editing platform where we create shows, and a high-performance rendering engine that creates the final output file when we are finished with our design. The rendering engine provides a full range of Output options, from optical media to video formats that support iPods and YouTube, to high-resolution streaming Web content, and even HDTV. This Chapter is a guide to the delivery process and the options you have for getting your ProShow creation to its audience. We'll also look at the different types of files the program uses to produce a Show and how to use them to maintain your work.

The available Output formats vary slightly with the version of ProShow you use. Both Gold and Producer let you create DVDs (including Blu-ray), Video CDs, Web-ready content, and PC Executable (self-contained files that run using Photodex Presenter-only on PCs) Video Shows. Producer also supports compressed and uncompressed AVI output.

The complete Output process includes designing any Menus you need (see Chapter 11), and setting the desired Output options (which vary based on the file format), rendering the file (handled automatically by the program, and placing it on the target media (covered in this Chapter). If you want to play the Show online, the file will need a web host. That's a topic for the next Chapter, which will cover Flash, YouTube, e-mail, and web-sharing formats. Let's start our discussion with an overview of the Output process and the ProShow Output interface. Then we'll turn to choosing the proper format and, finally, the details of each major category one by one.

Show Output Basics

Rendering a Show is really a two-step conversion process. First, the rendering software "borrows" your slide Show Design and the source content. The originals are not modified. All that data is used to produce a file that complies with published standards for the desired output media. The options available, like using Menus, including certain Branding features, and adding a PC Autorun file, vary by the capabilities of the particular format.

Second, when you have a rendered file ready to go, the data is written to the target device and verified. In addition to having ProShow software, you'll need the appropriate media (like a recordable disc) and hardware (like a DVD burner) before you can generate the Output. The exact process and media depend on the target device. You can create multiple versions of the same Show for different target devices. All you have to do is choose the appropriate Output options in ProShow, and it will do the rest.

Choosing an Output Format and Understanding Common Settings Options

The **<Create Output >** Icon (the final Icon in the Toolbar) is the starting point for generating Output. It serves as a gateway, organizing the various formats into categories, and offering a short explanation of each type. Figure 12.1 shows the ProShow Producer **Create Output** window. The only difference in ProShow Gold's interface is the color scheme; the options are identical. Click on a type of target

Figure 12.1

ProShow Producer's Create Output window showing the available Output categories. ProShow Gold has a similar interface with a quite different color scheme. media, and its window opens. You can also access a specific window directly by choosing that option from < **Create Output** > on the main menu. The available option and controls in each window are customized according to the media type.

The **Create** > **Output** window lists the most common formats as icons, then organizes them by intended targets in a list on the left. Their names are active links which open the associated window. A few additional targets without icons are added. Most of the format types have a row of tabs at the top, used to call forth major aspects of the possible settings, which in turn often open submenus, which themselves possibly have associated submenus. It is very complex, truc, but with hundreds of tweaks it has to be.

Note

The key to efficient production of finished Output is to get familiar with this overall view of how ProShow "thinks" about Output, then concentrate on becoming familiar with the different formats and their options as needed. Trying to master too much at once may just confuse you!

Launch ProShow and open any Show. You must have at least one Show open and Saved before choosing any Create option. As you saw in the previous Chapter, you can add Shows to a Project during the Output creation process.

The only major difference in the actual options between the versions of ProShow is that Producer supports **Compressed** and **Uncompressed AVI Output**, and Gold does not. Both versions support any codecs you have in your system. Feel free to follow along in either program. Later in the chapter, we'll go through each Output type and its options. Right now, I'm just covering the interface basics, and the common rendering and Output tasks to explain the process.

Press the **Control** and **O** keys at the same time. This opens the **Create DVD** dialog box (see Figure 12.2). Across the top of the window is a series of tabs. Click on the Options tab and your dialog box should resemble the one in the illustration. Most of the Output windows will be similar to this, but the available options will vary based on the user-definable features for the specific format.

Some of the **Create Output** windows look very much like this one. The **Menu**, **Shows**, and **Branding** tabs should be familiar from the last Chapter. This Chapter covers the **Options**, **Executable**, and **Color** tabs and their sub-sections. We'll work with adding Shows to a web page and sharing Shows over the Internet in the next Chapter.

reate DVD	
Menu Shows Options	Burning Executable Branding Color 1 (High Quality - Safe)
Video Standard	DVD Type Information
TV System ITSC	DVD High Quality Safe - NTSC. Video: 720x480 MPEG I Framerate: 29.97/ps (8 Mbps)
Audio Type MP2	Capacity: Up to 1 hour High Quality DVDs in NTSC format may be played on computers and consumer DVD players in North America.
Anti-Flicker 🗹 Apply anti-flicker filter to video Desaturation 🗹 Desaturate images to 80 😵	This DVD format offers the least capacity, but the best picture quality. This format slightly lowers the bitrate below High Quality Maximum to accommodate DVD players that
Video Clip Output Options	do not properly support the maximum DVD bitrate.
Encoding Quality Normal Quality	

Figure 12.2

The projected file size of many formats is displayed on a bar at the bottom of the Create DVD dialog box for easy reference.

The Options Window

The **Create DVD****Options** tab settings control the quality and technical details of the **Output** format you have selected. If there are several types of a format available, choose the preferred first, ensuring you have the proper available options. The **DVD Type Information** pane offers an explanation of the format and its options. Change the **DVD Type** in the drop-down Menu above, and the options will change.

Video Standard Pane

Formats that are designed for playing on a television set will have an option for setting the video standard. In North America, the NTSC format is used. In Europe, PAL is the standard. Many formats have a quality setting that will adjust the resolution. Keep in mind that in video technology, higher quality usually results in larger file sizes.

Note

Photodex has included reference tables with international video standards and file format details. They can be accessed using Help>Contents>Reference>Table of Television Standards and also Help>Contents>Reference>Supported File Formats.

Output File Size Considerations

ProShow doesn't limit the size of a Show or the size of the files you place in a design. That's not true for Output media. The size of the target disc and hard drive, and the restrictions of the Output standard and operating system, must be considered to ensure a workable result. In general, limits are determined by Output type and available space on the Output medium.

DVD- and CD-based Shows are restricted by the amount of playing time and the capacity of the disc, set in the standard defined for each type of media. **Video CD** Suill Shows cannot exceed 99 images due to limits defined by the format. The other supported formats don't have defined size limits, but it's important to keep storage and file-loading times in mind. For example, a web-based Show has to be downloaded, and a Show intended for a hard drive or flash drive must fit into the available space.

The projected file size for many formats is readily available in a bar displayed in the main program and on the bottom of the various Output windows. (See Figure 12.2.) The limit for Executable files on some operating systems is capped at 2.1GB. This varies based on the operating system, so it's a good idea to stay within reasonable limits. Keep in mind that high-definition files can get quite large, so watch the size of the bar and trim your Show back as needed.

One way to conserve space is by limiting the Output resolution and imagequality settings when including a **PC Autorun** file in an **Output** project. This is a **PC-Executable** file that contains the Show and an embedded runtime version of Photodex **Presenter**. The result provides outstanding quality, and it can be burned to an optical disc for play on any Windows-based PC. This format supports all Branding and Menu options. We'll cover the details of setting options later in the Chapter. The resolution settings have a noticeable effect on the final file size. Click on the **< Executable >** tab. Just below the row of tabs is the check box. If it is enabled, then an **Autorun** Show will be added to the disc. It is available in many formats and is an **Output** type in its own right. (See Figure 12.3.)

Color Profiling

Now click on the **Color** tab. **Color Profiles** (see Figure 12.4) adjust the appearance of a display device (like a monitor or HDTV) to match white balance, contrast values, and standard colors as closely as possible. This tab lets you set the Show to take advantage of a **Color Profile**. While **Profiles** can improve performance and ensure accurate color rendition, use it with caution, and only if you know that the target viewing device supports color profiling and is properly calibrated. Mismatching a **Profile** can result in some very "unusual" colors.

Use Color Profiles For Video enables and disables a selected color profile when you're generating video for the PC **Executable**.

Create DVD				
reate DVD				
Menu Shows C	Options Burning	Executable	Branding	Color
P	C Autorun 🖾 Includ	le PC Autorun on Disc		
Executable Startup		Protection		
Window Size 800 x 600 px		By Days	Limit days of usage 15	days
Full Screen 📕 Start maximized		By Runs	Limit number of runs	runs
Image Size 🗾 Limit image display size 📧	30 x 600 px	Password		
Loop Show 🗾 Loop show forever (when	no menus)		Leave blank for no unlook prom	npt.)
Monitor. Default		Info URL		
Quality / Performance Settings		info Link Text	When your executable expires,	a user will sea th
Rendering 🗹 Limit rendering size	800 x 600 px		text and may click it to visit the above.	
Resizing 🔽 Manually limit images	1280 x 1024 px			
image Quality	85 %			
Audio Quality Medium Quality				
Video Quality Medium Quality				
Video Clip Resolution Medium Resolution				

🕙 Create DVD			X
Create DVD			
Menu	Shows Options	Burning Executable Brand	ing Color
Use Color Profile	es For Video		
Use Installed	Use a specific profile from this mach	nne Profile 1-Plug and Play Monitor 1 2 2008	-
Use Custom	Use another profile	Profile	Browse
Use Color Profile	e Settings for PC Playback		
Use Default	Use default color profile for the mon	itor the show is played on	
Use installed	Use a specific profile from this mach	hine Profile 1-Plag and Play Monitor 1 2 2008	+
Use Custom	Use another profile	Profile	Browse
	Change this only if you are sure the	he show will only be played on a specific dev	ice.
on i sligi	a monitor or projector with a different pro	ault will result in incorrect colors if the show is play offie than the one selected. Selecting a profile will re correction can be done during show creation inste	esult in a
DVD 0 500 1000	1500 2000 2500 3000 3	3500 4000 450	Create Cancel

Figure 12.4 The Color Profile window.

The **Color Profile Settings for PC Playback** pane has three options. **Use Default** sets the color profile for the PC Executable to the default profile of the system it is being played on. **Use Installed** selects a color profile from those installed on your computer. **Use Custom** allows you to use a color profile that may not be installed on your machine.

The **Browse** button allows you to scarch for the **Color Profile** you would like to use.

Output Formats and Files Demystified

Now that we've covered the basics of the **Output** process, let's look more closely at the file formats and then go into specific options for each. If you are already familiar with video file formats, feel free to skip this section. If it's new territory, here is a quick primer. All ProShow **Output** (except for single-slide captures of **Previews** in Producer) is video. The program renders many frames for each Slide and Transition into a proprietary ProShow **.PSH** file based on the frame rate. Each type of media has its own special format.

There is a lot of technology behind a video file format, all precisely specified usually in serious geek-speak—by an international standards association. ProShow deals with all of that. We don't have to fuss with the details, but we do need to know how the Show will be seen, on what kind of device, and how to set any desired options. You can choose an **Output** format by selecting it from the **Create** menu, using a keyboard shortcut, or click on the **Create Output** icon and then choose the desired file format. The following list highlights uses for the different **Output** options and formats. (Refer to **Create Output** Menu, Figure 12.1.)

- For Televisions: DVD is for playback on a DVD player. Blu-ray lets you burn HD DVDs—if you have a Blu-ray compatible burner.
- For the Internet: YouTube Output allows you to automatically upload your slideshow to your YouTube account with no additional steps. Flash Outputs your Show for web playback in Flash FLV format for easy integration into your web site. No Flash experience required! Web Show Outputs your Show in Photodex Presenter format and also generates the HTML code to include your web page link. Share Show creates a Presenter file and automatically uploads it to Photodex's online sharing service (http://www.photodex.com/sharing) so you can share your Shows for free.
- For Devices/Device allows you to create your Show using preconfigured profiles for many viewing devices, including cell phones, media players, and game consoles. It also includes the ability to create your own device profile.

- For Computers: PC Executable Creation makes a stand-alone slide Show that will play on any Windows PC without additional software. Autorun CD Creation creates a CD-ROM disc that runs your Show automatically when loaded into a Windows PC. It requires no additional software to replay Shows. Video File Creation lets you choose from a wide variety of video file formats, including AVI, WMV, MPEG 1 and 2, and HD Video.
- More Options: Video CD is a good option if you don't have a DVD burner or DVD media. Video CDs will play on most DVD players. Both formats let you include an optional PC Autorun Executable file for hassle-free PC playback. Screen Saver creates a screen saver of your Show that will play when your computer is idle. E-Mail Executable creates an Executable file and then e-mails it from within Producer using your preconfigured email preferences.

Supported Output File Formats and Media Types

Occasionally, you need to know the specific type of disc and file formats available to ensure device compatibility. Use only those that are certain to work with a target device. Keep in mind that while ProShow may be able to write files in a given format and to a certain type of media, your system must have the proper hardware and operating system capability to complete the task.

Tip

It's a good idea to make sure that you have the latest updates to both ProShow and your system drivers before starting an Output session, and be sure that you use high-quality optical media. Bargain media often costs more in the long run because of failed burns and poor read rates.

ProShow supports the following file and media formats:

- Video disc formats: DVD, Blu-ray DVD, VCD, SVCD, XSVCD, CVC, and MiniDVD
- Video file formats: AVI (compressed and uncompressed, Producer only), Video CD CUE/Bin Image (CUE), Windows Executable (EXE), Adobe Flash (FLV), CD/DVD Image File (ISO), QuickTime (MOV), MPEG 1 and 2 (MPG), Streaming Web Show (PX), Windows Screen Saver (SCR), Windows Media Video (WMV), High-Definition Video in 480p, 720i, 720p, 1080i, and 1080p. Producer Only: MPEG4 AVC or MPEG4 SP/ASP.

 Disc media: Recordable CD (CD-R), Rewritable recordable CD (CD-RW), Recordable DVD (DVD-R), Recordable DVD (DVD+R), Rewritable recordable DVD (DVD-RW), Rewritable recordable DVD (DVD+RW), Recordable dual layer DVD (DVD+R DL), and Recordable dual layer DVD (DVD-R DL)

Photodex Presenter Files and Plug-In

Photodex **Presenter** is a free plug-in that allows users to view streaming ProShow presentations on the Web or on a PC. It provides outstanding playback quality and performance superior to other streaming web formats, and it supports all the effects created in ProShow, including Menu and Branding features. As a bonus, the resulting file size is a lot smaller than Shows saved in traditional video formats.

You must install the plug-in before viewing **Presenter** Shows. Photodex **Presenter** is automatically installed with Producer and Gold. A runtime version is included in all **Executable** and **Autorun** Output. When users attempt to view a **Presenter**-based Show without a plug-in, they are offered the ability to connect, download, and install it automatically. Every copy of Photodex **Presenter** is digitally signed to ensure its authenticity, safety, and security.

Presenter runs in its own window, or in a web browser, in full-screen mode. It offers a variety of on-screen user controls that can be enabled during playback. I've boxed them in green in Figure 12.4a. They must be included by checking the

Figure 12.4a Presenter playing a show with the On-Screen controls enabled. The box for setting the option is inset over the window and circled in green. on/off box in the **On-Screen Controls** pane of the **Create Executable>Options** window before the show is generated. (Inset and circled in green in Figure 12.4a.) If they are enabled, the viewer can access them via the tool at the bottom when Presenter is running in window mode, or by using the right-click Menu during full-screen playback.

Pause/Play temporarily pauses or resumes playback of the Show. The current slide will display until Show playback is resumed. **Stop** ends Show playback and either returns to the Menu or to the beginning of the Show, if there is no Menu. **Previous Slide** returns to the previous slide in the Show. **Next Slide** advances to the next slide in the Show. **Sound On/Off** enables and disables sound for the Show. The **Volume Control** sets the volume level for Show sound.

Selecting Options for Different Output Formats

Each Output format works a bit differently and so offers its own set of options. In most cases, the ProShow defaults work well, but knowing how to tweak settings and match the Output specifications to take full advantage of the target player will let your viewers see the Show in its full glory.

This section gives an overview of the settings and shows the windows for each type of Output. (When one window is very similar to another, I will show only the first one in a Figure. For example, **Create DVD** and **Create Video CD** are almost identical windows, so I've used only the DVD windows.) The various **Autorun/Executable** formats are all grouped as one. Photodex is constantly updating the program's support for **Output** and new hardware **Devices**, so be sure to keep your copy up to date.

DVD/VCD/CD Production

There are a range of **DVD** and **Video CD** disc types, but all make use of the same basic options, and all support the addition of a **PC Autorun** file, **Menus**, and **Branding**. You can also include the original Show source files and add additional content.

DVD Output Options

The **Create DVD>Options** window controls the settings for video quality and defining optional disc contents. **DVD Type** specifies the quality level for the DVD. Choose from the drop-down menu (see Figure 12.5) to set the type. The panel on the right side provides information on the current selection, to help you choose the best one for your intended purpose and to ensure playback **Device** compatibility.

9 Create DVD	
Create DVD	
Menu Shows Options	Burning Executable Branding Color
DVD	HQ (High Quality - Safe)
Video Standard DVD S	10 (High Quality - Safe) SP (Standard Play) n
TV System NTSC TV System NTSC	LP (Long Play) EP (Extended Play) SLP (Super Long Play) 0 MPEG II
Audio Format	SEP (Super Extended Play) Fromerous 2000 rps (8 Mbps)
Audio Type MP2	Capacity. Up to 1 hour
DVD Output Options	High Qualty DVDs in NTSC format may be played on computers and consumer DVD players in North America.
Anti-Flicker 🔽 Apply anti-flicker filter to virten	This UVU formst offers the least capacity, but the best picture quality.
Desaturation 🔽 Desaturate images to 80 %	This format slightly lowers the bitrate below High Quality
Video Clip Output Options	Maximum to accommodate DVD players that no not properly support life maximum DVD bitrate
Encoding Quality	nn not proporty support the maximum DVD parate.
	Sheets and she was a set of the s

The **Video Standard** option drop-down lets you set the television standard to be used on the DVD, **NTSC** for North America and **PAL** for Europe. The **Audio Format** specifies audio encoding format (**PCM** or **MP2**) for the DVD.

Tip

See the Photodex Table for dozens of country standards for PAL or NTSC video. Help>Contents>Reference>Table of Television Standards.

In the **Create DVD>DVD Output Options** pane, **Anti-Flicker** enables or disables the anti-flicker filter during rendering. Anti-flicker prevents the flickering effects that you sometimes see in the DVD format. There is a small loss of sharpness, so enable this only if you really need to. **Desaturation** modifies the video by a specified percentage, keeping colors from becoming extreme, hence resulting in an unnatural-looking video. The default value usually works well. The **Video Clip Output Options** pane offers the choice of **Normal** or **High Quality** video.

DVD Disc-Burning Options

The **Create DVD>Burning** tab (see Figure 12.6) lets you control the way the files are written to the media and the operation of the drive used in the process. **DVD Writer** provides a drop-down for selecting the drive that will be used to burn the disc (if your computer has more than one available).

Figure 12.6 The DVD format Burning window.

The **Burning** window has a **Disc Options** pane with two drop-down choices. **Speed** sets the speed at which the DVD is written. The default is the maximum speed for your DVD burner. Lower speeds may improve compatibility with older DVD players. **Disc Type** specifies whether you are burning a DVD or a CD.

Just below, the **Multiple Copies** pane lets you specify the number of DVD copies to be burned during the session. Use the **DVD Disc Label** text box to set the volume label (i.e., the name on the disc) that appears when a user browses for the disc on your computer.

In the **Troubleshooting** pane, you can **Simulate** the burning process without actually burning a disc, handy for testing. This feature works only for the CD Media (MiniDVD) disc type. **ISO Creation** generates an image file for use by third-party DVD/CD-authoring programs.

In the **DVD+R/RW Compatibility** pane, **Bitsetting** specifies the bitsetting method used for the DVD. Bitsetting reconfigures **DVD+R/RW** media to make it more compatible with stand-alone DVD players. Bitsetting works only with **+R/RW** media. In addition, not all writers support bitsetting.

You can click the **Detect** button to have ProShow determine if your DVD writer supports bitsetting. Do not use bitsetting if your DVD writer does not support it. The **Include original files on DVD** pane has a check box to specify whether the original files used in your Show will be burned onto the DVD. Users can then access these files. The **Include Additional Content** pane allows you to select a folder whose contents you want on the DVD (like image files or a pdf brochure). If you check the box, the **Browse** button lets you browse for desired material.

VCD Output Options

Video CDs work like DVDs, but they are created using CD-R or CD-RW media. Figure 12.7 shows the Create Output>Create Video CD>Options window, reached from the More Options, Video CD link on the left of the Create Output window. Video CDs are less expensive to produce, provide lower quality, and offer less compatibility than DVDs. There are two types of Shows that you can create using the Video CD Output format: Video Shows and Still Shows, as shown in Figure 12.7.

Video Shows are complete productions and include Motion Effects and Transitions. They are limited in length, based on the amount of space available on your CD. They support **Video Menus**, which can have **Video Thumbnails** and background music. **Still Shows** display higher-resolution images, but do not have **Motion Effects** or **Transitions**. **Still Shows** are limited to 99 images and can contain a **Still Menu** (a solid, still image).

The **Video CD Output Options** pane for Video CD works basically the same as the one for DVDs. In the **Video CD Type** pane is the drop-down list used to set the quality for the Video CD. As you choose an option, the details of the format are explained in the **Video CD Type Information** pane. The **Video Standard** pane's **TV System** option prompts for the television standard to be used on the **Video CD**. The **Audio Format** pane specifies the audio encoding format for the **Video CD**.

The **Video CD Output Options** pane offers **Anti-Flicker**, which enables or disables the anti-flicker filter during rendering. Anti-flicker prevents the flickering effects that you sometimes see in the CD format. There is a small loss of sharpness, so enable this only if you really need it. **Desaturation** modifies the video by a specified percentage, keeping colors from becoming extreme and resulting in an unnatural-looking video. The default value usually works well. **Menu Type** enables and disables the use of **Still Menus**. Still Menus are solid, still images, while default menus are, or can be, Video menus. Some players support only Still Menus, and some support only Video Menus.

Video Clip Output Options: This pane has an **Encoding Quality** drop-down list which sets the encoding quality of video clips used in slides in your Show.

Video CD Burning Options

The **Create Video CD>CD Writer** drop-down list selects the drive used to burn the CD. In addition to the available drives on your machine, you may want to write to a **CUE/BIN** image file, which you can import into other CD-authoring programs.

In the **Disc Options pane, Speed** sets the speed at which the CD is written. The default is the maximum speed for your CD burner. Slower speeds may improve compatibility with older disc drives and players. The **Multiple Copies** pane allows several sets of the same disc.

The **Video CD Disc Label** sets the label that appears when you browse for the disc on your computer. **Simulate** enables and disables testing the burning process without wasting a disk.

The **Include Original Files** pane specifies whether the original files used in your Show will be included on the Video CD. Users can then access these files. The **Include Additional Content** pane allows you to select a folder whose contents you want on the CD. If you check the box, the **Browse** button lets you search for desired material.

Autorun CD and Executable Files

In the **Create Video CD** window **Executable** Tab, **Autoexec CD**s, **PC Autorun** files, and **PC Executable** Shows are all versions of a self-contained **Photodex Presenter** Show. They all offer full menus, high-quality output, Branding, and Color Profiles. **Autorun** CDs work very much like a **DVD** or **VCD**, but since they are actually a special form of **PC Autorun**, you can add that format's Copy

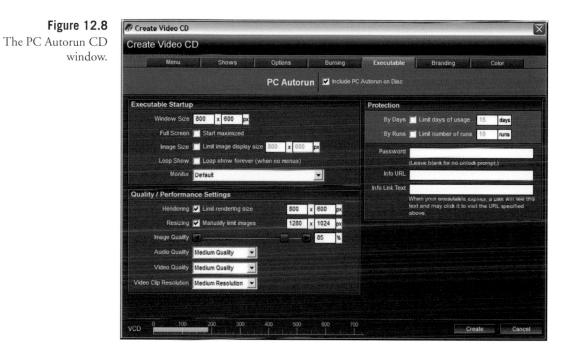

Protection to the disc itself. The other windows are the same as for VCD, so I won't detail them here. You can see them on Figure 12.8.

This **Presenter** format can be rendered as a stand-alone file, included on DVDs or CDs, and loaded on media devices that support Windows **Executable** media. Here are details of the available options. The **Executable Startup** pane's **Window Size** specifies the startup size of the **Executable. Image Size** determines the largest size at which images in the Show will be stored in the Show file. **Loop Show** enables and disables Show looping. **Monitor** specifies which monitor the Show will play on when it launches.

In the **Quality/Performance Settings** pane are several parameters. **Rendering** sets the maximum size for your Show during internal rendering. It does not affect the display size of your Show. **Resizing** specifies how your photos are resized before they're rendered. This eliminates the need to resize your images before bringing them into Producer. A smaller value yields smaller images that take up less space, but also reduce image quality.

Image Quality determines the quality setting used for image compression. **Video Clip Resolution** allows you to specify the video resolution. **Video Quality** sets the general quality level used to encode your video clips for the Show. **Audio Quality** sets the general quality level used to encode your audio for the Show.

The **Protection** pane has options to limit how long or how many times the Show can be seen, or can require an unlock key to view the Show. **By Days** limits the

usage of the **Executable** to a specified number of days. **By Runs** limits the usage of the **Executable** to a specified number of runs. **Password** allows you to specify a registration key or password that will unlock the Executable for unlimited use. **Info URL** specifies a Web site for the user to visit for more information about the Show. **Info Link Text** specifies the text that represents the link to the **Info URL**.

Screen Savers

A screen saver is a great way to share images and promote your skills. Producer allows you to create a screen saver from any Show you make so that it will be displayed anytime the computer is idle. This format does not support Menus. Since it is a simple file, there is no **Disc Burning** window. You can include multiple Shows, add **Branding**, and set a **Color Profile**.

The **Create Screensaver>Options** window is shown in Figure 12.9. It is reached from the **Screensaver** link on the **Create Output** window. In the **Quality> Performance Settings** pane, there is an **Enable Audio in Screensaver** check box, which enables and disables audio in the **Screensaver**. **Rendering** sets the maximum size for a Show during internal rendering. This does not affect the display size of the Show. **Resizing** specifies how the photos are resized before being rendered. **Image Quality** determines the quality setting used for image compression.

Create Screensaver									
eate Screensa	ver								
		Shows	Opt	tions	Bra	nding	Color		
uality / Performanc	e Settings					Protection			
Rendering	Limit rendering s	kize	800	x 600	рх	By Days	Limit days of usage	15	days
Resizing 🔽	Manually limit ime	ages	1280	x 1024	px	By Runs	Limit number of runs	10	runs
Image Quality				85	%	Password		artistic in	
Audio Quality	ledium Quality	- Er	nable audio i	n screen s	saver		(Leave blank for no unloo	k prompt)
Video Quality	ledium Quality	-				Info URL			
ideo Clip Resolution	ledium Resolution	-				Info Link Text	When your executable ex	pires, a u	ser will see t
							text and may click it to vis above		
								eate	Cance

The Create Screensaver>Options window for creating screensavers. Vidco Quality and Video Clip Resolution specify the video resolution of any video clips used in the Show. The Audio Quality slider sets the general quality level used to encode the video clips.

The **Protection** pane offers several options. **By Days** limits the usage of the Screensaver to a specified number of days. By Runs limits the usage of the Screensaver to a specified number of runs. Password allows you to specify a registration key or password to unlock the Screensaver for unlimited use. Info URL specifies a Web site for the user to visit for more information about the Show. Info Link Text specifies the text that represents the link to the Info URL.

Portable Device Output

ProShow can generate **Output** in a form that is ready to use with a wide range of multimedia devices, including iPods, cell phones, and game consoles. The program is configured with **Profiles** for many popular devices to provide **Output** with maximum quality and compatibility. You can also customize a Profile. Open the < Create Output>Device > interface. ProShow will check for an updated list of device Profiles and then present the Create Video for Device screen. Choose < Game Console>Sony>Sony Playstation 3 > and the screen shown in Figure 12.10 appears.

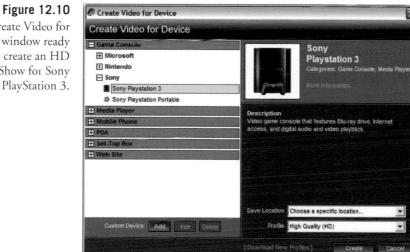

The Create Video for Device window ready to create an HD Show for Sony

Creating Video Output Using an Existing Device Profile

Generating a Show for a defined device is very simple. From the Selection list, choose the device type, then the manufacturer, and then select the appropriate device from the list. Once a device is selected, the **Save Location** drop-down menu and **Profile** drop-down menu are enabled. If a supported device is attached to the computer, it will be listed on the **Save Location** drop-down menu. If ProShow cannot detect a device attached to your system, **Save Location** will not have any options.

Note

If Photodex has added new ones, a blue **Download New Profiles** link appears at the bottom of the **Create Video for Device** screen, as in Figure 12.10. With an active web connection, ProShow will download and install any new **Profiles** automatically.

Select the **Profile** that you would like to use and click on the < **Create** > button. If you didn't specify a location in the **Save Location** menu, ProShow will ask you where you would like to save your **Output** video. Once that's complete, consult your device documentation for methods to transfer the video to your device.

Creating a Custom Device Profile

You can create your own **Profile** with the manufacturer and device name to access it again in the future. Click on the **Add** button in the **Create Video for Device** window. A dialog box like the one shown in Figure 12.11 will appear.

Enter the name of the manufacturer of your device and the model number in the **Device Information** pane. Enter the name of the new **Profile** and choose the desired format from the drop-down menu in the **Profile Settings** pane.

Now use the **Video Settings** pane to configure the Details. **Compression** is the encoding method that ProShow will use to create the video. **Resolution** is the resolution that will be used for the completed video. **Framerate** determines the frame rate that ProShow will use when rendering the video. **Aspect Ratio** specifies the default aspect ratio for the device. **Bitrate** allows you to manually determine the overall quality of the video.

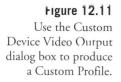

Custom Device Video Output		1000
Device Info	rmation Manufacturer Unknown Manufacturer Model Unknown Model	1
Profiles for Device New Profile	Profile Settings Profile Name New Profile	
	Format AVI	
	Video Settings Cumpression MPEG 4 SP/ASP	
	Resolution 320 x 240 px Framerate 30 fps	
	Aspect Ratio 4 x 3 Bitrate 300 kbps	
	Audio Settings Audio Format Mp3 Channels Stereo	
Profile Add Delete	Sampling Rate 44100 hz Bitrate 128 kbps	5] .
	Save	ance

The bottom pane controls the file's **Audio Settings**. **Audio Format** determines the method ProShow will use to create the audio portion of your slideshow. **Channels** specifies whether ProShow will create mono or stereo audio. **Sampling Rate** determines the playback quality of the audio in the Show. **Bitrate** determines the encoding quality of the audio in the Show.

Once you've adjusted the settings, click the < **Save** > button to register the new **Profile** and add it to the list. This type of profile will be listed under the **Custom Profiles** option, by the manufacturer and model name. Remember that many devices require very specific settings for their media files. When you're creating a **Custom Device Profile**, consult the device documentation or the manufacturer's website to make sure that the settings will function properly on the target device.

ProShow File Types and File Management

Gold and Producer create a number of different files for various uses, as well as the ProShow file itself (**.PSH**), including backup file caching and for customizing your workspace. There are four main categories. **Show Files** are the various components that make up your Show, and they can be used to recover your work in the event of a system crash. **Menu Files** save Menus, Themes, and/or Layouts created in the authoring stage of Show creation. **Output Files** relate to certain aspects of the Output functions in ProShow. **Workspace Files** consist of custom window Layout files you can use to load Custom workspace settings and configurations. The following sections detail the files by category.

Show Files

PSH File (Photodex Slide Show File) is the main file for your Show. This file contains all the settings and options ProShow needs to load, render the actual Show, and play your Show. *This file does not contain any of your Show content. ProShow simply links to your files; it does not alter or move them.* The **PSH** file is what you would save in order to save a Show—*along with a backup* of the files providing the *content* of the Show.

Note

If the **PSH** file is deleted, your Show no longer exists, but the content included in the Show remains in its original location; it is never manipulated, only copied and left in place.

The **PSH** file contains a list of all the other files used in your Show. If you move the PSH file, ProShow may not be able to link to your content properly. If you attempt to load a Show and the content cannot be found, ProShow will prompt you to locate the files in order to load the Show properly. *If you wish to back up your Show, you must back up both the PSH file and the original content used in your Show.* Off the main Menu, **File>Collect Show Files** accesses a feature to automate this process and ensure that all content is copied correctly.

Backup Show Files are created by ProShow to automatically back up your Show file each time you **Save** your Show. This allows you to revert to previous versions of your Show at any time. These backup files are stored in the same folder as your Show; they have the same name as your Show, but extensions like **.bak**, **.bk1**, and **.bk2**. Do not delete these files if you would like to revert to earlier versions while working on your Show. From the main Menu, **Edit>Preferences>Miscellaneous Preferences>Autosave & Backups** controls how many seconds before ProShow automatically backs up your Show (the default is 300 seconds, = 5 minutes), and also how many sequential Backups you wish it to store. This controls the list you see when you click **File>Revert to Backup**. Also see **Autosave Files**, on the next page.

Show Content Files (Images, Music, and Video) are the files used in your Show. When you add content to your Show, ProShow does not copy or modify the file. ProShow simply notes where the original content is saved on your computer and links to the files when they are used in the Show. If your original content moves, your Show will not be able to link to those files. The File>Collect Show Files function copies all your content into a single folder, allowing you to move your original files as desired. **PXC Files (Photodex Cache File)** are created when you load a **ProShow** slide Show. The **PXC** file is a cache file, which means that Producer can access it very quickly to load the Show you are working on. This file is generated automatically while you work on your Show, and it can be deleted at any time. You cannot load a Show or recover lost content from a PXC file.

Producer's PST Files are saved Show Templates. Off the main Menu, Producer's Show>Show Template feature lets you create and manage reusable Show Templates from any Show. When you Save a Template, it is stored as a PST file in the Templates folder in Producer's installation folder

Autosave Files are automatically created by ProShow every five minutes (default) in case of a system crash. When ProShow **Autosaves**, it places a copy of the current Show in its program folder as **autosave.psh**. This file is cleared when you **Save** the Show. Do not delete these files if you would like to revert to them in the event that your system crashes. Also see **Backup Show Files**, on the preceding page.

Temporary Files are created and removed by ProShow as you use the application. These files are stored in your Windows **Temporary folder** and will usually be named **px*.tmp** or **_px*.tmp**. ProShow will delete these files when the application no longer needs them. Do not delete these files while Producer is running.

Menu Files

MNU Files are saved **Menu Templates** for your **Shows**. With ProShow's advanced menu-authoring system, you can save completed **Menu Designs** for later use. These files can be saved in any location.

LAY Files are saved Menu Layouts. With Producer's advanced menu-authoring system, you can save Layouts that can be matched with saved Themes to create Menus. These files are saved at the Application Data>Photodex>ProShow Producer>Menu Layouts location.

THM Files are saved Menu Themes. With Producer's advanced menu-authoring system, you can save Themes that can be matched with saved Layouts to create Menus. These files are saved under Application Data/Photodex/ProShow Producer/Menu Themes.

Output Files

ISO and CUE/BIN Files are disc images used to burn DVDs and CDs. These files include all information and data necessary to write a disc. These files are created during authoring of a **DVD**, **VCD**, or **Autorun CD**. You have the option of saving these files rather than writing a disc. Most CD- and DVD-burning applications can read these files and create a final disc from that information.

PX Files (Photodex Stream Files) are ProShow **Web Shows** that are created when you choose the **Create Output>Web Show** or **Create Output>Share Show** function. The file is a compressed web stream that is copied to a web server for playback over the Internet. A **PX** file cannot be edited or used to recover lost content. To play a PX file, you must install **ProShow** or the **Presenter** web plug-in.

Temporary Video Files are created by ProShow when you select any **Output** format that requires video rendering. This file is stored in the same folder as the **PSH** file. This file contains video rendered by the application and has an **.mpg** file extension. These files allow you to create multiple copies of the Show without rerendering the video. You may delete these files at any time, but you will have to re-render the video to do so.

Show Cache Folders store video created for Output (such as DVD and VCD) in ProShow. This allows you to easily create multiple copies of the Show without rerendering the video. These files are stored in a folder created by ProShow. The folder is named using the name of your Show file, followed by **_psdata**. *Do not delete this folder unless you want to re-render the video for that Show*.

Up Next

There is one type of **Output** we haven't covered yet. Both Gold and Producer offer users a variety of ways to reach viewers via users' own websites or online **Sharing**, and to take advantage of free hosting on high-speed Photodex servers.

13

ProShow and the Web

ProShow offers powerful features for sharing content via the Internet, making our productions available to anyone with Web access. This Chapter explores how to prepare a Show for online use and make use of free hosting via the Photodex high-speed Web server, as well as the general **Output** options for hosting Shows on your own Website and third-party sites like YouTube.

Internet Hosting Basics

Most ProShow owners are familiar with surfing the Internet, so I'll skip the basics of browsers and viewing websites. Not all readers may be as knowledgeable about how to place multimedia information on the web for others to see, so a quick introduction is in order. Feel free to skip to the next section if you already know about web hosting and streaming video and audio programs.

ISPs and Bandwidth

When you surf the web, you are accessing files using a global network. The remote server holds the files and sends them on request. That requires moving the data over high-speed (broadband) trunks, even when the last bit goes over a slower dialup connection. Usually an Internet Service Provider (ISP) owns the remote computer and broadband connection.

Note

Dial-ups are not advised for uploading and distributing multimedia and streaming content. Too much time would be required, and some material may not successfully download.

The fees ISPs charge to host sites are based on the features they provide and the amount of downloaded data a site moves to its visitors each month. Websites that have only text pages and small images almost never reach the monthly limit for basic service. Sites that provide high-resolution movies to visitors often do. Owners pay accordingly. They either buy deluxe accounts with a higher limit or pay extra charges for consuming excessive bandwidth.

If you plan on hosting your own Shows, plan ahead, or limit the amount of downloads to control access. The intricacies of choosing a provider are beyond the scope of this Chapter. It's a good idea to shop around; prices, features, and the quality of service and support vary widely. Exceeding the contract limits gets expensive fast. It's a lot like running over the monthly minutes on a cell phone contract not good. If you are unfamiliar with the details of website operations, it's wise to talk to an expert before making a commitment.

Another option is sharing Shows in **Presenter PX** format for free, by opening an account on the **Sharing** section of Photodex's Website (http://www. photodex.com/sharing). There are no limits on how many Shows you can share or on their size. You can play them in full-screen mode, complete with highquality sound, and make use of all of ProShow's features, including **Menus** and **Branding**.

Figure 13.1 shows Photodex.com's welcome page for the **Sharing** section. Visitors can browse by members' names to see Shows. Members can log in here to manage their accounts directly. Shows are stored on the site in **PX** format. This is the native format for **Photodex Presenter** files. You can also use ProShow's **Email Output** feature to send a Show directly to the intended viewer. It's not the same technology as surfing, but it does let you share your work online.

If you want to host slideshow pages on a new website, look for a provider that caters to multimedia content. Vendors that specialize in Internet solutions for photographers and other visual professionals often offer Templates with pages that can easily host ProShow-generated online output. The Template approach means that you don't have to do much more than add a link, and perhaps a thumbnail image to the page, and then upload the Show file.

Keep the final Show file sizes in mind as you prepare Shows for the web. Reducing the resolution of the Show and using a compressed format can reduce the amount of data moved from your server. **Flash FLA** movies are a good choice for web output. These are low-resolution Shows viewable in any browser with a Flash-compatible browser plug-in. These are very popular and work on PC, Mac, and Unix.

I usually place a Flash Show on my web page and then have a link to the **Presenter** version in Photodex's online **Sharing** section. That approach gives me live content on my pages without my having to worry about the bandwidth load. The big

PX-format files are all handled by Photodex, and the **QuickTime** Shows can be downloaded from my site via the link.

ProShow also interfaces directly with **YouTube's** sharing application, and you can **Output** files right into a user account from the **Create** menu. This lets you post Shows without worrying about bandwidth at all. Of course, you forfeit having a Custom page and offering high-resolution content if you link directly to a **YouTube** account. It is possible to design a page that plays a YouTube Show located on a remote site via an embedded link.

Copyright Considerations

When we share Shows with others, we are *publishing* our work, and it is important to know about copyrights. If you personally produced all of the content of the Show—including images, videos, music, drawings, and designs—or have the right to use and distribute all of the content, then all is well. If you are including content from another source, you need to be aware of copyright issues. A person owns creative works just like their physical property. That is true for writing, pictures, music, and any other type of intellectual property. Before we can use images and music that we didn't create in our Shows, we must have permission. Copyright laws are also there to protect your work from being used without permission.

Some items are in the public domain. Items created before there were copyrights, or that are old enough so that the copyright has expired, can be used freely. Quotes from Shakespeare are fine—he won't complain (although the fact that an author is dead does not mean his or her work is in the public domain). The creators of some works, like the *Shenandoah* soundtrack we used in this book, have placed them in the public domain. Sometimes creators impose restrictions, such as permitting use for non-commercial purposes only.

There are also limited rights: using items only for certain purposes or for a limited time. The images in the book's exercises have been published under a limiteduse arrangement. TriCoast photographers Mike Fulton and Cody Clinton, and I, have granted use only for practice with this book—not for any other purpose.

For all other uses, you have to pay. That may be a flat fee. Sometimes the amount paid is based on how many times the item will be used or shown. There are stock agencies that offer music and images for reasonable prices. "Borrowing" creative works without permission can get very expensive. The person who does so can incur very steep penalties in court and could face criminal charges. Copyright violations are a form of theft.

Sharing Shows with a Free Photodex Account

Using Photodex's free **Sharing** utility is very simple. You can handle the entire process right in ProShow. First create the **Show**. The program will **Output** the file and place it on the server. You will be given an account to manage and can control access to your content. Let's walk through the steps, and I'll explain the process. If you don't have an account, feel free to follow along and set up a new one.

You will need a fast Internet connection and either Gold or Producer. With a Show loaded in the program, open the **Create** menu and choose the **< Share Online >** Option. (You can use any Show for account set-up, since it can be hidden from visitors or deleted at any time.) The **Share Show** window shown in Figure 13.2 will open. This is a one-stop shop. If you already have an account, all you need to do is fill in the login information, choose the folder location on the site, and set any desired viewing restrictions. When you click the **< Upload >** button, the file will be rendered and placed on the server. Click on the **< Create Account >** button (circled in green) if you don't already have an account, and you will be taken to the Photodex site.

9 Share Show	E
Share Show	
Menu Shows	Uploading Color
Sharing Service Photodex V	Veb Site
Account Information	About Sharing
Member Name Guide	Share your shows online at Photodex.com!
Password View Albums Create Account	Using ProShow Producer and Photodex.com, you can share shows online. Your shows are available for any of your friends and family
Album Selection	Yew
Album My Collection	Using Photodex.com, you can create a free account, upload your shows, and use albums to organize your shows and photos into
Show Caption Wedding Proofs	collections
Uploading Options	
Mature Content 🗾 Contains mature content	
Privacy Private - Visible only to my account	
0 2 4 6 8 10 12 14	16 18 20 Uoload Cancel

The **Create Member Account** page, partially shown in Figure 13.3, is simple and straightforward. You can also use this account to purchase Photodex products and register for training sessions. Make a note of your member name and password.

Figure 13.3						Log in Contact Us
Registering for an	PHOTODEX	P	Products Downloa	ads Store	Sharing	Support
online Sharing Account.	C	reate your free F	mber Account Photodex.com member Photodex.com gives you accor Photodex.com gives you accor	r account using the	form below.	
	60	lember Name Member Name:	Member names may include only No spaces or punctuation marks.		scores	
	Y	our Information	First Name	Last Name		
		Company:				
	Y	our Address Address				
		City:				
		State / Zip: Country:	Bizte / Province United States	Zip / Postal Code		

Photodex sends a confirmation e-mail to the address you used to register. Click on the link in that message to activate the new Account, and it's ready to use. Return to the **Create Output>Share Show** window, fill in the blanks, and click the < **Upload** > button at the bottom. The program will go through all the regular rendering steps and then will send the file over the Internet. There are no limits on the size of a shared Show, and the bandwidth is free, but think of your viewers when using this feature. If the Show is very large, either break it into segments, or reduce the image files' resolution. That will reduce both the final Show size and the viewer's wait time. ProShow will present a notice when the upload is complete. Click < **OK** >, and you can view the Show online, as shown in Figure 13.4.

Figure 13.4

An uploaded Show, being played on the Photodex website, and viewed using ProShow's Sharing feature.

The Show is attached to a web page on the Photodex site, operating from a server farm at the company headquarters in Austin, Texas. The site controls access, manages user accounts, and tracks a Show's statistics. It also provides tools for customizing information about a Show, limiting who can see it, and inviting people via e-mail to view your collection.

The screenshot in Figure 13.5 shows the Photodex.com **Edit Content** page for the Show I uploaded for this Chapter. Here you can set a caption, add a short description about the movie, limit access, and note if the subject matter is intended for mature audiences. Your collection can be arranged into separate albums that you create and control.

Figure 13.5 Customizing the options for a shared Show on Photodex's Edit Content page.

	Edit Conte	ent		
Sharing Main	You can customic	the display of th	is file using the form be	Jour and a second se
Features Spotlighted Shows Photographers Contests	These options not only	r slow you to add a desi	cription and caption, but also a	Row you to configure how your file appears in your fieg the file as for a mature audience.
Online Sharing Browse Member Edit Content	Customize			
Delete Content		Wedding Proofs		Enter a cappion for your contant.
Send invitation				
Albums My Collection				
Private	Description:			Briter o description foi your ourieri.
Ny Account				
Constant of the second	Content Access			
Share shows	Viewable:	Private Content	Checking this option will ma	ke this litem be visible only to you. Guests will not see this item in your collection.
online for free!				pl of a mature nature, pheals this box. Failure to mark mature dema may result in n
Burn shows to	Material	Stature Contant	of your content or suspensi	an of your account.
DVD + CD!	Content Location			
		My Collection +	To move this item to anothe	r album, salect a new location here.
Download free trial >				
8 mars			4pply	Changes
St. S. Patterny				
EN GOID				

Hosting Presenter Files on Other Websites

The **Create Output** Menu lets you render **PX** files without uploading them. That gives you the ability to move the files to any website, where they can be linked to a web page and made available to visitors. Load the desired Show (or Project) in ProShow. Open the **< Create>Web Show >** window. You can set up a Menu, add Shows, and set a Color Profile. Figure 13.6 shows the **Create Output>Web Show > Options** window. This lets you set a default display size, limit the maximum size, control the performance settings, as well as video and output quality, and use Copy Protection options to control access.

Raising levels on the quality settings will produce a larger file. That in turn will require more time for downloading and will increase bandwidth usage (and possibly ISP fees). Lower settings will reduce the clarity of playback, but will result in faster loading times and smoother playback. It's always a good idea to test the results before making a new Show public.

When the rendering process is complete, the new Show will just be a file on your local hard drive. It must be uploaded to the website and have a page with a **link** created. That requires adding some HTML code to the page. Don't worry if you are not a hardcore coder. ProShow will provide the code you need. Click on the < **View HTML** > button at the bottom of the **Create Web Show** window. That will open a **Web Show HTML** dialog box, as shown in Figure 13.7.

HTML Settings	URL to PX File	Enter p	ath to	px file	here	<u>.</u>	
HTML Settings	Default Size	640	x	480	рх		
HTML Output							
	Add the HTML						-
<script language="javascript" s<br=""><script> PresenterObject("Pro 20here",640,480,true); </script>	rc="http://www.	photodea	k.com	presen	ter.js">•		
<script> PresenterObject("Pro 20here",640,480,true);</th><th>rc="http://www.</th><th>photodea</th><th>k.com</th><th>presen</th><th>ter.js">•</th><th></th><th></th></tr></tbody></table></script>							

The next steps vary depending on whether you are adding a link to an existing web page, or having ProShow automatically create a Show page that you can then add to a website. If you want to let ProShow produce a simple web page that runs the Show, just place the name of the Show in the **URL to PX File** field at the top of the box and make sure the default size matches your desired resolution.

Place check marks for the options you wish to use in the three boxes in the **Web Page Options** window (refer back to Figure 13.6). Then click < **Done** >. The program will open a window so you can choose where to save the files. Both the **PX** Show file and the web page will be generated in that directory. Open the web page to view the Show and test the code. You can also view the Show by clicking on the Show file itself. Then upload both files to your website and create a link to the new page so visitors can see the new offering.

If you're placing the link onto an existing site, **Copy** and **Paste** the code shown in the **Web Show HTML** window into the desired link location on the page. This step requires a basic understanding of HTML and use of a plain text editor like **Notepad** or an HTML editor like **FrontPage**. The **PX** Show file must be uploaded to the location you used in the path statement.

Sending a Show via E-Mail

You can send an **Executable** version of a Show via e-mail from inside ProShow. This is a regular ProShow **Presenter** file that can include **Menus**, **Branding**, **Copy Protection**, and multiple **Shows**. Keep in mind that either your or your recipient's e-mail gateway may limit file sizes. The size can be controlled by reducing the targeted Display size, **Audio Quality**, and **Image Quality**, or by increasing image compression.

Note

Mac OS environments do not support Presenter.

ProShow needs to know your e-mail account information before it prepares and sends the file. Click < Edit>Preferences>Internet >, and a window like the one in Figure 13.8 will appear. Fill in the form. Some e-mail servers may require only the outgoing information, others both. It's easiest to complete the entire form at once.

The next steps are to load the Show(s); choose the < **Email** > link from the bottom of the **Create**>**Create Output** Menu; and then configure any desired output options. That process should be familiar by now, so I won't review it here. Click on the < **Send** > button once you're done adjusting all the settings. An e-mail dialog box like the one in Figure 13.9 will open.

Fill in the blanks, and your Show is ready to go by clicking the < Send > button. The recipient will be able to play it without having the regular version of **Presenter**—a runtime version is built in. Its only limitation is that it must run on a Windows-based PC.

Preferences	
Internet Pref	erences
Appearance	Web Browser
Colors External Editors Keyboard & Remotes	Web Browser C:/Program Files (x86)Internet Explorer/lexplore.exe Browse
itemet listensisepus Nayback	To configure your default web brower for use with ProShow Producer, enter the path your browser above or use the 'Browse' button to locale the application.
Show Defaults Jound Effects	Outgoing E-Mail Server (SMTP)
Startup	E-Mail Address your@email.address
	Outgoing (SMTP) Server mail.server.com
	Antulme_ outgoing account
	Password ******
	Incoming E-Mail Server (POP3)
	Incoming configurations are nece wrv if your internet service provider requires a POP3 login to send e-mail
	Incoming (POP2,
	Account Name your account
	Password **********
	2 Done

Figure 13.8 Configuring e-mail options in the Internet Preferences window.

	ail Show	
	destination@email.com	Addr Book
		Addr.Book
всс		Addr Book
From	your@email.address	
Mess	age	
Subjec	Show E-Mailed With Photodex ProShow	
		-
	Attachment Encoding Method Base54	-

Flash FLV Shows and the Web

ProShow outputs web-ready **Flash FLV** files much the same way it does the **PX Presenter** format. The program can render the file and produce the code required to place it on a website. You will need to understand a bit about HTML and use a text-based or HTML editor to craft the link to the page or Show and be able to place the actual Show file on the remote website.

You can use **Menus**, but **Branding** isn't supported with this Show format. The plus side—the results are viewable in any Flash-compatible browser. Load the Show in Producer or Gold, and then choose < **Create Output>Flash >**. A **Create Flash** window as in Figure 13.10 will appear.

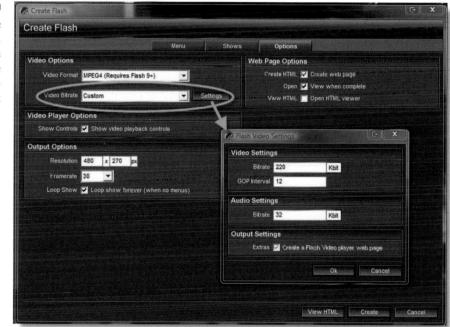

In the **Video Options** pane, the **Video Bitrate** setting should be set to match the speed of the viewer's Internet connection. The drop-down lists the common connection speeds, which will work well for most applications. If you feel compelled to tweak the values, choose < **Custom** > and click on the < **Settings** > button. A **Flash Video Settings** dialog box will open, as shown by the green arrow in Figure 13.10, which lets the user configure each element.

Figure 13.10 The Create Output>Create Flash window's Options window with the Custom Flash Video Settings dialog box open.

If you want the viewer to be able to use **Pause** and **Play** controls, check the box in the **Video Player Options** pane. The **Output Options** pane lets you configure both the **Resolution** and the **Framerate**. Remember that higher-resolution and faster framerates will increase both file size and download times. Checking the **Loop Show** box will cause the Show to repeat until the viewer leaves the web page or closes the browser window.

Checking the boxes in the **Web Page Options** pane will make the program generate code to place the Flash viewer on a page, and set all the proper options for the Show. If you choose to have the actual page made, it will be blank except for the viewer in the center, just like the Presenter web page. You can customize this page in an HTML editor, or you can add the code that appears in the **HTML Output** pane of the **Flash Show HTML** window to an existing page. Click the < **View HTML** > button at the bottom of the **Create Flash** window to see the **Flash Show HTML** window. See Figure 13.11.

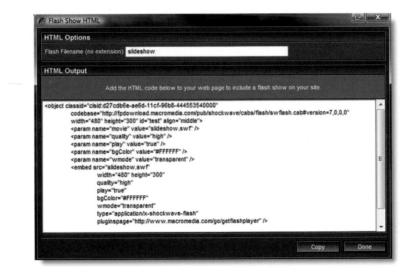

The YouTube Connection

ProShow can automatically access an existing **YouTube** account to upload and register a Show. This is a variation on the **Flash** format, limited to the options YouTube provides. The procedure is simple. Open the Show in ProShow. **Menus** and **Branding** are not supported. (You can "brand" a Show by adding a first slide that displays your information.) Choose the **< YouTube** > option from the **Create Output** menu, and the window shown in Figure 13.12 will appear. Fill in all the information and click **< Upload >**.

YouTube Upload		
Account Information	YouTube Username YouTube Password	
Video Quality		
Quality YouTube High Quality (N	ormal)	•
Video Information		
Title Wedding Collection		
Description		^
Video Categorization		
lags Wedding proofs Enter one or more tags, sei Video Category People & Blögs	persited by spaces. Tags are keywords used	to describe your video.
		Upload Cancel

Wrapping Up

It's easy to see that ProShow offers a range of web-based output solutions that meet virtually every need. The key is to choose the **Output** format that matches the quality and slideshow features you want, with the bandwidth and speed requirements that the website and your viewers require.

All of those are important to success. The goal is a Show that sizzles, without compromising speed or incurring excess bandwidth costs. Make sure to test your Show once it is on the Internet and evaluate both the visual and playback quality. Do the links work? Does the Show load in a reasonable amount of time? Are the images sharp, and do the Transitions move smoothly?

Broken links need to be edited and retested. Shows that are slow to load may need to be split into segments or use lower resolution.

Since this is the last Chapter, we are wrapping up more than just the discussion of Internet output. I hope that this book has expanded your knowledge and appreciation of ProShow—a wonderful application—and that your new understanding will lead to increased success in crafting your Shows. Enjoy the ongoing creative process and sharing your work with others.

A

Proshow Keyboard Shortcuts

Learning ProShow's keyboard shortcuts speeds up common tasks, and can be combined with context-sensitive menus for even greater productivity. Consider keeping handy a list of the combinations for your most commonly used commands, and learn the combinations as you work with ProShow.

ProShow KEYBOARD SHORTCUTS

Main Menus

File Menu	ALT+F
Edit Menu	ALT+E
Project	ALT+P
Show Menu	ALT+S
Slide Menu	ALT+L
Audio Menu	ALT+A
Create Menu	ALT+C
Window Menu	ALT+W
Help Menu	ALT+H
Create Output Menu	ALT+O

Working With Show Files

New Show	CTRL+N
Open Show	CTRL+O
Save Show	CTRL+S
Save Show As	CTRL+SHIFT+S
Close Show	CTRL+W

Working With Slides

working with	Sildes
Cut Paste	CTRL+X CTRL+V
Undo	CTRL+Z
Redo	CTRL+Y
Select All	CTRL+A
Select Inverse	CTRL+I
Select None	CTRL+ALT+A
Add Selected Files to Show	CTRL+SHIFT+A
Add All Files to Show	CTRL+ALT+SHIFT+A
Slide Options	CTRL+ENTER
Go to Slide #	CTRL+G
Shift Slide(s) Left	<
Shift Slide(s) Right	>
Delete Slide(s)	DELETE
Insert Blank Slide	ALT+I
Insert Title Slide	ALT+T
Fill Frame	ALT+0
Fit Frame	ALT+1
Fill Safe Zone	ALT+2
Fit Safe Zone	ALT+3
Stretch to Frame	ALT+4
Randomize Slide Order	CTRL+SHIFT+1
Randomize Motion	CTRL+SHIFT+2
Randomize Transitions	CTRL+SHIFT+3
Select Layer	CTRL+[#]
Nudge Position	ARROW KEYS
Nudge Zoom Level	+/-
Show Options	F2
Show Background	F3
Watermark	F4
Show Captions	F5

Working With Slides - cont.

Slide Styles	CTRL+F1
Slide Settings	CTRL+F2
Slide Background	CTRL+F3
Layer Settings	CTRL+F4
Video Settings	CTRL+F5
Editing	CTRL+F6
Motion Effects	CTRL+F7
Adjustment Effects	CTRL+F8
Captions	CTRL+F9
Caption Motion	CTRL+F11

Working With Audio

Soundtrack	F6
Sync Options	CTRL+T
Quick Sync Selected Slides	CTRL+SHIFT+Q
QuickSync to Track	ALT+Q
Quick Sync Show	CTRL+Q
Sound Effects	CTRL+F12
Adjust Soundtrack (Timeline)	CTRL+Click

Preview and Playback

SPACEBAR
ESC
ALT+ENTER
CTRL+P
CTRL+S

Executable Playback

[# OF SHOW]
HOME
ESC
ALT+ENTER
PAGE DOWN
PAGE UP
SPACEBAR
ENTER
+
-
М

User Interface

Help	F1
Toggle Slide List / Timeline	ТАВ
Lightbox	F7
Preview	F8
Favorites	F9
Project	F11
Thumbnails File List View	ALT+8
Details File List View	ALT+9
Default Panes	CTRL+ALT+SHIFT+0
Exit	ALT+X

B

Product Comparison Chart

Product	Producer	Gold
	Producer New	Gold
Price	\$249.95	\$69.95
Workflow and User Interface	Producer	Gold
Newly Designed Interface	\checkmark	~
Add Slides with Drag and Drop	\checkmark	~
Real-Time Preview	\checkmark	~
Integrated Photo Browser	\checkmark	~
Light Box View	\checkmark	~
Manual Show Control	V	
Custom Keyboard Control	V	
Built-in Audio Trimmer	V	~
Built-in Video Trimmer	\checkmark	~
Find Missing Files Utility	\checkmark	~

Workflow and User Interface (continued)	Producer	Gold
Back Up Collected Show Files	~	~
Slide Options Hot Keys	\checkmark	~
Favorites Pane	~	~
Copy Settings Feature	~	
Resizeable Slide Previews	~	~
Slide Preview Grid	~	~
Hot Folder/Live Show Support	\checkmark	
Interactive Waveform in Timeline	~	~
Timeline View	~	~
Notes	~	~
Set Name for Layer	~	~
Display Time as Seconds in Timeline	~	~
Lock Slide Timings	~	~
New Audio Sync Dialog	\checkmark	~
Show Relative Show Time in Audio Trimmer	~	~
Image/Video Options		
RAW file support	~	
Animated Gif Support	~	~
Enhanced Audio Controls for Video Clips	~	~
Adjustment Layers	~	
Modifiers	~	
Unlimited Layers Per Slide	~	~
Loop Video Clip	~	
Set Video Clip Speed	~	
Set End-of-Slide Action	~	
Gradient as Layer	~	
Solid Color as Layer	~	

Image/Video Options (continued)	Producer	Gold
Masking	~	
Opacity Settings for Photos and Videos	~	
Transparency Support for PSD, PNG, TIFF and GIF	~	V
Gradient Backgrounds	~	
Editing		
Apply Outline or Drop Shadow to Layers	~	¥
Control Drop Shadow Color and Opacity	~	
Control Layer Outline Size	~	
Chroma Key Transparency	v	
Vignettes	~	
Red-Eyc Removal	V	~
Rotate and Crop Photos	~	~
Rotate and Crop Videos	~	~
Color-Correction	~	~
Adjustment Effects Kcyframing	V	
Keyframe Editor	~	
Caption Effects and Options		
Add Multiple Captions to a Slide	~	~
Add Global Show Captions	~	~
Control Color, Font and Size of Captions	~	~
Expanded Set of 100+ Caption Motion Effects	~	~
Caption Timing Control	~	
Caption Interactivity	V	
Caption Keyframing	~	
Use Textures in Captions	~	
Use Gradients in Captions	~	

Caption Effects and Options (continued)	Producer	Gold
Caption Styles	~	
Caption Line/Character Spacing	\checkmark	
Caption Rotation	\checkmark	
Character Skew	V	
Motion Effects and Transitions		
Slide Styles	~	V
Add Motion Effects to Photos and Videos (pan, zoom and rotate)	V	~
Add Motion Effects to Photos and Videos (pan, zoom and rotate)	~	~
Over 280 Transitions	V	~
Specify Random Transition Effects Usage	~	~
Customize Transitions per Layer within a Slide	~	~
One-click Randomization of Transition Effects	~	~
Multi-layer Motion Effects	~	~
One-click Randomization of Motion Effects	V	V
Motion Effects Timing	~	~
Increased Zooming Range for Motion Effects	~	~
Motion Smoothing (for creating smooth motion paths)	~	
Motion Keyframing (advanced motion timing)	~	
Zoom X and Y Coordinates Individually	V	
Business Oriented Features		
Copy-Protect CDs	~	
Watermark Images and Videos	V	
Customizable Branding Features	V	
End-of-Slide Actions	V	
Color Profile Awareness	~	
Custom Templates	~	
Capture Frames	V	

Output Options	Producer	Gold
Burn Slide Show to Blu-ray	~	V
Burn Slide Show to CD/VCD	~	V
Burn Slide Show to DVD	~	~
Output to Streaming Web Slide Show	~	V
Free Online Sharing/Slide Show Hosting at Photodex.com	~	V
Advanced Playback Controls for Web Shows	~	V
YouTube® Uploading	~	V
Device Output	~	V
Autorun CD and EXE Output	~	V
Flash Video Output - FLV	~	V
Compressed AVI Output	~	
Uncompressed AVI Output	~	
MPEG 1 Video	~	~
MPEG 2 Video	~	~
Build Screensavers	~	~
Email Slide Shows	v	~
QuickTime Output	~	~
Windows Media Video (WMV) Output	~	~
HD Video File Output for HDTV	~	~
Custom Slide Show Menus	~	~
Save and Load Menus	~	~

Index

Note: Emphasis has been placed on basic and introductory references. Refer to these earlier citations when you need definitions and fundamental clarity. Look in the earlier chapters, and in the earlier pages of a chapter, where a concept or feature or procedure is likely to be introduced. Chapters 1, 2, and 3 provide a great deal of the basics and refer you to more advanced topics in later chapters.

A

A/B Fadc Transition, 7 About Shows, customizing, 345 acceleration, Motion Styles, 89–91 accounts, free Photodex, 374–377 actions, 166

adding

audio files, 102-104 audio tracks from CDs, 120-121 Captions, 138-140, 178-179 content to template Layers, 308 Drop Shadows, 152, 179 images, 74-79, 335 interactivity to menus, 324-327 Keyframes, 175-176, 208-211 Lavers, 59 menu soundtracks, 332–333 multiple Layers, 70-73 outlines, 152 Slides, 177 soundtracks, 7-9, 121-124 voiceovers, 121-124 watermarks, 346-347 Add to Favorites option, 44

Add Track button, 103 adjusting. See modifying Adjusting Options, 201 Adjustment Effects, 15, 33, 37, 177-179, 223-255, 315 and Keyframes, 33, 37 Intensity Masking, 276–277 Motion Effects, combining, 232 - 234windows, navigating, 223-226 Adobe Photoshop, 46-47 Adobe Premier, 46-47 **Advanced Motion Effects** Advanced sound controls, 106–120 Align command, 38 aligning anchor points, 143-144 Captions, 143-144, 164-165 images, 203-206 Keyframes, 39, 193-195 Layers, 60-61 multiple Layers, 70–73 waveforms, 109 Alignment of text blocks and Captions, 143-44

Alpha Channel Masks, 260–264 colors, 277-279 A Moving Backdrop, 16-17 anchor points, aligning, 143-144 anti-flicker filters, 359 **Appearance Preferences**, 45 Apply button, 17 applying Captions, 153-155 Colorize controls, 226-232 green-screen, 292-294 Motion Effects, 79-85 multiple Keyframes, 173-174 multiple masks, 279-281 Precision Preview window, 197–199 Templates, 304-311, 310-311 Text Effects, 163 video clips, Chroma Key, 296-301 Arial font, 137 arranging Slides, 9-10 aspect ratios, 17 Audacity, 46-47 Audio. See also soundtracks adding audio from CD, 120-121 editing with the Audio Timeline, 111 - 117files, working with, 102-106 interactive and advanced, 106-117 Menu-based controls, 120 synchronizing, 104-105, 117-119 trimming, 107-110 Voiceovers, 120-124 Audio menu, 7 Audio Timeline, 44 Audio Waveform pane, 102, 112 automatic Captions, 145–148 Autorun CDs, 362-364 axes, 68, 86 positioning, 73-74 Zoom settings, 69

В

Backgrounds colors, 331 customizing, 94 Layers, 61 Back to Gallery Caption, 167 Backup, 173 bandwidth, 371-373 Before and After Editing Previews, 236, 295 **Beginning Transitions**, 30 bitsetting, 360 black fade to, 294-295 Point, 19, 218, 225 and white, modifying, 226-232 Black Point control, 225 blending text, 130–133 Bold command, 137 bold styles, 137 borders, 57, 65, 68-9 Vignette controls, 281–283 Branding, 315, 323-325, 329-330, 341-345 Intro Shows, formatting, 341-345 Options, 346 Brightness, 19, 225 **Brightness control**, 225 Burning Disc Burning window, 346 DVDs, 359-361 Video CDs (VCDs), 361-362 buttons Add Track, 103 Apply, 17 Collect, 53 Done, 46, 92 Manage Styles, 16 Minus, 329 Play, 37 Plus, 329

Precision Preview, 14 Save List, 53 Select File, 15 Set, 19 Set Color, 179 Set Menu Title, 328

C

cameras, Live Shows, 320-322 Caption Motion window, 168 Caption Placement tools, 22 Captions, 4. 11, 13-14, .20-22, 36-41, 125-126 see also Chapters 5 and 6 adding, 138-140, 178-179 aligning, 143-144. 178-179 applying, 153–155 creating, 141-144 Copying, 166-67 designs, 126–128 formatting, 21-22 Global, 134–35,144, 149–53, 166 hiding, 148-153 interactivity, 165-166 Layers, 129-133 List, 133-35, 145, 148-52, 162, 164, 169 Local, 134, 150, 152 macros, 145-148 Menus, 337-338 modifying, 178-179 Motion, 130–133, 168–69, 176 Motion Effects, 168-178 overview, 158-162 positioning, 164-165 Styles, 162-165 tools, 133–138 viewing, 148-153 Caption Settings window, 162–167 CDs (compact discs) audio tracks, adding from, 120-121 Autorun, 362 364

Center Rotation, 199 centers Layers, 84 Rotation Center command, 86 channels, Alpha Channel Masks, 260-264, 277-279 Character setting, 169 check boxes, 61 Chouse Captions Effects window, 141 Choose Transition window, 7, 29 Chroma Key, 257, 288–296, 298–301 colors, configuring, 290-292 fade to black, 294-295 green-screen, applying, 292-294 overview, 288-289 video clips, applying, 296–301 classes, fonts, 136 Clinton, Cody, 56, 224, 375 clips sound, 102. See also audio video. See video clips cloning effects, 249 Collect button, 53 Collecting files, 50–53 Collect Show Files command, 53 Colorize controls, 19, 28–29, 225-226, 229 applying, 226–233 Color Profile Settings for PC Playback pane, 355 Color Profile window, 354 colors Alpha Channel Masks, 277–279 backgrounds, 331 Chroma Key, 290–292 Hue, editing, 243-250 Masking, 262 modifying, 18–19, 291–292 profiles, 353-355 Set Color button, 179 **Colors for Programs Preferences**, 45 Color Suppression control, 292

Color Wheel, 139-40, 290 commands Align, 38 Bold, 137 Collect Show Files, 53 Combined Layer Effects, creating, 57 Copy, 167 Copy Captions, 166 Duplicate Layer, 72 Revert to Backup, 173 Rotation Center, 86 compatibility, devices, 358 composition, see also design creating, 237-240 modifying, 317-319 compression, 351 computers, types of output formats, 356 configuring. See also formatting background images, 331 Chroma Key, 288–289, 290–292 e-mail, 380 fixed Slides and constant, 316–317 Keyframes, 246 Layers, 243-250 Live Shows, 311-314 masking, 262 operating preferences, 44-48 video, 297 connecting Internet. See Internet YouTube, 382-383 content fixed Slides, configuring, 316–317 managing, 49-50 template Layers, adding, 308 contrast, 19, 225 Contrast control, 225 **Control Boxes**, 114 Control Keys, 112 **Control Points**, 169

coordinates, 65, 67 positioning, 73-74 Copy Captions command, 166–67 Copying designs, 71–73 Layer Effects, 92 Copy Layers window, 88 copyrights, 136, 146-47, 373-374 Copy Protection, 323-324 see also Branding, and Watermarks Copy Settings menu, 206 Create Custom Menus options, 331 Create DVD Options window, 358 Create Flash dialog box, 340 Create Gradient dialog box, 272 Create Member Account page, 375 Create Output window, 350 creating. See formatting Crop function, 98, 204 cropping Layers, 204 Crossfades, 110. See also fades creating, 115-117 customizing About Shows, 345 Adjustment Effects, 177–178, 223-255 aspect ratios, 16 Backgrounds, 94 Caption Settings window, 162–167 Drop Shadows, 179 Flash FLV Shows, 381–382 icons, 345 interfaces, 42-44 Intro Shows, 342 Keyframes, 197 Lavers, 257-260 menus, 330-341 Preview display, 62–63 startup screens, 344 thumbnails, 333-341 Cut Transition, 26, 70, 221, 238, 241

D

Darken Inactive Layers, 213 darkening edges, 283-285 decorative fonts, 130, 136. See also Captions; fonts Define Grid dialog box, 63 deleting audio files, 102-104 Layers, 59 design, 2, 5-7, 11, 14-15, 22-23, 36, 40, 42, 44, 56–57, 61–63, 70-71, 76-80, 83, 85, 87, 91, 93-100, 125-33, 142, 153-55 See also formatting Captions, 126-128 Chroma Key, 288-289 copying, 71-73 menus, 324 327 menus, saving, 338-341 Motion Effects, 216-217 Transparent Ellipse Vignettes, 265 Destination setting, 166 Devices compatibility, 358 portable device output, 365–367 types of output formats, 355 dialog boxes Create Flash, 340 Create Gradient, 272 Define Grid, 63 Download Content, 324 Edit Fades and Timing, 107 Insert Macro, 146 Layer Matching, 92, 93 Load Show Template, 316 Locate Missing Files, 51 Missing File, 51 Open Show File, 345 Random Image Settings, 312 Save Menu Theme, 340 Save Show Template, 306 Set Color, 290

Sct Value, 193 Show Title, 328 Synch Slide to Track, 105 dial-up Internet connections, 371 disabling Vignette controls, 282 Disc Burning window, 346 Done button, 46, 92 Down arrow, 61, 74 Download Content dialog box, 324 drag and drop, creating Slides with, 5-6 Drop Shadows, 19, 244-245 adding, 152 customizing, 179 Duplicate Caption option, 135 Duplicate Layer command, 72 duplicating designs, 71–73 Layers, 92 **DVDs** burning, 359-361 Format Burning window, 360 output, formatting, 358-361 Type Information pane, 352 types of output formats, 355

E

edges, 264. See also Vignette controls Edit Fades and Timing dialog box, 107 editing Adjustment Effects window, 223–226 Colorize controls, 226–232 external editors, 46–47 fades, 297 hue, 243–250 Layers, 243–250, 336–337 Motion Effects, 232–234 Multi-Layer Keyframe Editor, 36–38 Opacity control, 234–237

overlays, 241-242 Precision Preview window, 38-41 soundtracks, 103, 111-112 themes, 251-253 transitions, 26-29, 237-240 workspaces, 3-4, 42-44 Editing Tools pane, 72, 204 Editors, Multi-Layer Keyframe Editor, 2, 36-37, 180-183 Effects Adjustment Effects, 177–178 Adjustment Effects window, 223-226 cloning, 249 composite, 57 Flash, Layers, 34-35 Gaussin Blur, 130 Keyframes, 193-197. See Keyframes Motion Effects, 31, 40. See also Motion Effects Rotation Effect, 86. See also rotating Smoothing, 189-190 special. See special effects spotlight, 261 viewing, 28 Vignette controls, 283–285 Emailing Shows, 379–380 enabling Layer Interactivity, 334 Ending Position, 20, 66, 70, 168-69, 263 **Ending Transitions**, 30 End points, soundtracks, 109-110 Executable files, 362-364 Executable Live Shows, 313-314, 320 Executable window, 354 EXIF metadata macros, 148 Exporting Templates, 310, 313, 320 external editors, 46-47 Evedropper, color, 290

F

Fade-In, 114 Fade Out, 120 fades, 26, 106 A/B Fade Transition, 7 to black, 294-295 controls, 120 Edit Fades and Timing dialog box, 107 editing, 297 modifying, 110, 112-115 Favorites pane, 44 feathering edges, 264 fields, text, 149 File List, 4–6, 11, 43–44 File Loads Completed message, 324 File Not Found, 51 files audio, 102-106 Collecting, 50-53 compression, 351 Executable, 362-364 managing, 367-370 menus, 369 moving, 6-7 Output, 369-370 Presenter, 357-358 PSH (Photodex Slide Show), 368 PX (Photodex Stream), 370 saving, 50-53 temporary video, 370 types, 355, 367-370 video. See video clips workspace, 44, 370 fills Captions, 163 Gradient, 26 Gradient Fills, 159 finding files, 50-53

first Slides, creating, 58-61 fixed Slides, configuring, 316–317 Flash Effect, Layers, 34-35 FLV Shows, 381-382 flipping Layers, 72 Fly In/Out Effects, 140, 161 Folders List, 4 Folders pane, 44 fonts, 128. See also Captions designing with, 135-38 installing, 159 selecting, 133-138 sizing, 133-138 formatting. See also configuring Adjustment Effects, 177–178 background images, 331 Captions, 21-22, 141-144 Caption Settings window, 162-167 Chroma Key, 288–289 Colorize controls, 226–232 compositions, 237-240 compression, 351 Control Keys, 112 crossfades, 115-117 first Slides, 58-64 Flash FLV Shows, 381-382 Intro Shows, 341-345 Keyframes, 211–212 labels, 345-347 Live Shows, 315-316 Motion Effects, 79-81 Motion Styles, 85–91, 94 multiple-Show menus, 327-341 Output, 355-356 overlays, 241–242 Random Image Settings dialog box, 312 Shows, 41-42

smoothing, 189-190 spotlight effects, 261 templates, 305-307 thumbnails, 327-330 timing, 10 titles, 327-330 Video CDs (VCDs), 361-362 framerates, 20 Frames images, 56-57 isolating, 267-270 Layers, modifying, 64 modifying, 203 Full-Screen Previews, 97–100 Fulton, Mike, 56, 224, 375 functions. See also commands Crop, 204 Layer Matching, 91–93 Smoothing, 182

G

Gaussian Blur effects, 130 GIF file extensions, 57 global Captions, 148–153 Gold version interfaces, 3–4, 38–42 limitation of Motion, 20, 168 limitation of Keyframes/Timing, 30, 169 limitations on Menus, 323, 328 Slide Options window, 13–15 Gradient Fills, 26, 159 styles, 272 Grayscale Masking, 270–274 Adjustment Effects, 276–277 green-screen, applying, 292–294

Η

handles, selecting, 112 hiding Captions, 148-153 Inactive Layers, 74-75 high-speed Internet connections. See Internet Holding Folder, 320 horizontal composition, modifying, 317-319 hosting basics, Internet, 371-373 Hot Folder, 303-304, 308, 312-315, 320 hue, modifying, 243 Hue control, 225 Hue Drop Off control, 292 Hue Threshold control, 292

I

icons, customizing, 345 images adding, 335 colors, 253. *See also* colors composition, modifying, 317–319 copyrights, 373–374 framing, 56–57 importing, 75 Layers, adding, 74–79 Layers, modifying, 243–250 positioning, 203–206 Random Image Settings dialog box, 312 Replacable Image option, 304 themes, 251–253

Importing

images, 75 templates, 310, 311, 316 Include Additional Content pane, 346 Insert Macro dialog box, 146 installing fonts, 159 Intensity Drop Off control, 292 Intensity Masking, 270–274, 276-277 **Intensity Threshold control, 292** interactivity Captions, 165-166 Inactive Layers, 201 Layers, enabling, 334 Menus, adding, 324-327, 333-334, 338 Slides, 160 interfaces customizing, 42-48 navigating, 3-4 soundtracks, 105-106 Internet copyright considerations, 373-374 Email, 379-380 Flash FLV Shows, 381-382 hosting basics, 371-373 preferences, 47-48, 380 Shows, sharing for free, 374-377 types of output formats, 355 YouTube, connecting, 382–383 Intro Shows, formatting, 341-345 isolating frames, 267-270 ISPs (Internet Service Providers), 371-373 italic styles, 137

Κ

Keyboard Preferences, 47 keyboard shortcuts, 385-386 Keyframes, 20, 31, 49, 66, 168-178, 327 adding, 175-176, 208-211 Active Keyframe Pairs, 187, 214 Advanced Motion Effects, using, aligning, 39 Captions. See Captions Colorize controls, 228 configuring, 246 effects, 193-197 formatting, 211-212 Layers, 176-178 Layers, formatting first, 206-207 locking, 196-197 managing, 186-190 manual settings, 196–197 Markers, 31, 34, 38, 170, 172, 174, 176, 194, 219 modifying, 171-176, 213-216 Motion, 199–200, 216 moving, 172 Multi-Layer Keyframe Editor, 36-42, 180-183, 218 multiple, applying, 173–174 ordering, 190-192 overview, 158-162 Pairs, 31-32, 35, 168, 221 Pairs, modifying, 33–34 paths, 194 positioning, 193-195 positioning, swapping, 212–213 Precision Preview window, 197-199 selecting, 187 Timelines, 35–38, 69–70, 169–171, 218, 225, 239-240, 242, 247-248 Timelines, modifying, 249 Timing, 193-195 Zoom settings, 195–196

L

labels, formatting, 345-347 laws, copyrights, 374 Layer Matching function, 91–93 Layers, 56 Active, 194, 205-206, 214 adding, 59 Adjustment Effects, combining Motion Effects, 232-234 Backgrounds, 61, 69, 94 Captions, 129-133 centers, 69, 84 configuring, 243-250 controls, 67 cropping, 204 customizing, 257-260 deleting, 59 Duplicate Layer command, 72 duplicating, 71, 73, 92 editing, 336-337 Flash effect, 34-35 flipping, 72 Hide Inactive Layers, 63, 237 images, adding onto Layers, 74-75 Inactive, 200-201, 211, 213-214, 220, 237 Keyframes, 176-178 Keyframes, formatting first, 206 - 207List, see next entry Live Shows, 311 Menus, 334 modifying, 63, 64 Motion, Keyframing, 199–200 Motion Matching, 94-97 Motion Effects, 63, 66-67, 71-75, 79-100 moving, 64-65 Multi-Layer Keyframe Editor, 36-42, 180-183, 216 Multilayer Motion Effects workflow, 202

multiple Lavers, 63-67,70-73, 76 numbers, 59-61 Preview, customizing for Layers, 62 - 63positioning, 59-61, 85 relationships between, 200 renaming, 210 replacing, 319 reusing, 304 Rotating, 64, 65 sizing, 64, 65 Stack, stacking, 56-57, 59-61, 71, 74, 76, 80, 87, 89 Timing, 29-38, 94-97 Inactive, 200-201, 211, 213, 214, 220 Vignette controls, 281–283 Lavers List, 29, 31, 40, 58-60, 71, 76, 81, 88, 92, 93 Layouts, 327. See also formatting letters, 169. See also Captions Light Box Slide View, 44 lighting edges, darkening, 283-285 spotlight effects, 261 limiting special effects, 197 List pane, 58 Live Shows, 303, 311-322 Adjusting for Vertical and Horizontal Composition, 317-319 cameras, 320-322 configuring, 311-314 Executable Show, 315 formatting, 315-316 Load Show Template dialog box, 316 options, 319-320 playback, 314-315 Previewing, 313-314 producing, 311-322 Templates and, 304, 315–316 Load Show Template dialog box, 316

Locate Missing Files dialog box, 51 locking Keyframes, 196–197 loop conditions, creating, 314–315

Μ

macros, Captions, 145-148 magnification ratios, 75, 80, 88. See also Zoom settings Manage Soundtracks option, 7 Manage Styles button, 16 managing content, 49-50 files, 6-7, 367-370 images on Layers, 74-79 Keyframes, 186-190 Preview pane, 200-202 Slides in Slide List, 9-10 Soundtracks, 102 Templates, 309 manual settings, Keyframes, 196-197 Markers Kevframes, 34, 171, 194. See also Keyframes viewing, 201 Masks/Masking, 49, 257, 263 Alpha Channel Masks, 260-264, 277-279 colors, 262 Intensity Masking, 270-274 multiple, applying, 279-281 Slides, 274–276 Solid, 261 Spotlight effects, 261 tools, 263 Transparency Masking, 260–264, 267, 270, 279-280 Vignette controls, 281–283 Zoom settings, 264 Matching Layer Matching function, 91–93 Motion, 94-97

Menus, 323-324 Audio, 7 Branding, 315 Captions, 135 Captions, 337-338 Copy Protection, 323-324 Copy Settings, 206 customizing, 330-341 designs, 324-327 files, 369 Interactivity, 324, 333-334, 338 Keyframes, inoperative in Menus, 326 Lavers in Menus, 326, 331, 334-337, 340 Lavouts, 324, 326-327, 331, 339-340 Motion Effects, 186 multiple-Show, formatting, 327-341 saving, 338-341 soundtracks, adding, 332-333 Themes, 324-328, 330-331, 339-340 Thumbnails, 323, 325, 326-328, 330-331, 333-336, 339 tools, 327 Transitions, 98 Menus window, 325-326 Menus and Projects, 309, 323-326, 327-331, 338, 341-342 Minus button, 329 **Miscellaneous Preferences window**, 48 Missing File dialog box, 51-53 modifying Adjustment Effects window, 223-226 Captions, 178-179 Chroma Key, green-screen colors, 292 - 294colors, 18-19, 291-292 composition, 317–319

Fade In, 114 fades, 110, 112-115 fonts, 133-138 hue, 243 images, 203-206 Kevframes, 171-176, 213-216 Keyframes and Adjustment Effects, 2 - 33Keyframe Markers, 31-34, 38, 96, 170-72, 174, 176, 187, 218-220 Kevframe Motion, 32 Keyframe Multi-Level Editor, 36-38 Kcvframe Pairs, 31, 33-34, 187-88. 192, 253, Keyframe Timeline, 35–38, 69–70, 170 - 176Keyframe Timing, 38 Layers, 63, 64 Motion, 214 Offsets, 112-115 Rotating, 65, 75 sizing, 65, 75, 95 soundtracks, 103 tempo, 109 Timelines, 249 Transitions, 7-8, 29 volume, 112–115 White Balance adjustments, 322 Zoom settings, 206 Motion Captions, 130-133 Keyframes, 199-200, 214 matching, 94-97 modifying, 214 Path, 186, 219-222 Show Motion Path option, 186 spotlight effects, 261 Starting and Ending positions in four dimensions, 66

Motion Effects, 31, 40, 79-81 Adjustment Effects, combining, 232 - 234applying, 79-81 Captions, 168-178 design, 216-217 Lavers, 83-85 menus, 186 multilayer Motion Effects workflow, 202 navigating, 81-83 overview, 87-89 rotating, 85-87 sequences, 217-222 Starting and Ending positions, 66, 85,87 user-defined, 158 Motion Path, 81-82, 84-85, 94, 186-195, 197, 199-201, 211, 216-218, 220, 228-229, 232, 238-239, 243, 247-248, 254-255 Motion Styles, 89-91 mouse Layers, manipulating with, 64–72; 73 - 80movies. See video clips moving. See also importing; motion anchor points, 143-144 Captions, 135, 164-165 files, 6–7 images, 203-206 Keyframes, 172, 193-195 Layers, 60-61, 64-65, 92 multiple Layers, 70-73 Slides, 10 templates, 310 waveforms, 109, 113 Multi-Layer Keyframe Editor, 36–42, 180-183, 236, 238, 242, 251, 269

multiLayer Motion Effects workflow, 202 multiple Keyframes, applying, 173–174 multiple Layers adding, 70–73 motion keyframing, 199–200 multiple masks, applying, 279–281 multiple-Show menus, creating, 327–341 multiple Slides, placing Captions on, 166–167 music. *See* soundtracks Music window, 103

Ν

naming Layers, 210 navigating main Work Area, 3–4, 42–44 interface Preferences and Customizations, 42–48 Motion Effects, 81–83, 87–88 Slide Options window, 13–15 tools, 326–327 Zoom settings, 67–69 negative Rotation settings, 85–87 numbers Layers, 59–61 Position Numbers, 73–74

0

Offsets controls, 120 modifying, 112–115 online. *See* Internet Opacity, 35, 49, 75, 169. 225 Opacity control, 225 editing, 234–237 overlays, 241–242 transitions, 235, 237–240 Open Show File dialog box, 345 operating preferences, 44-48 Options Add to Favorites, 44 Adjustment Effects, 177–178 Branding, 346 Caption Settings window, 162-167 Create Custom Menus, 331 Drop Shadows, 179 Duplicate Caption, 135 Internet, 380 Live Shows, 319-320 Manage Soundtracks, 7 Orientation, 322 output, 358-362 Replacable Image, 304 Show Motion Path, 186 Show Templates, 305 Specify Destination, 167 Video CDs (VCDs), 361-362 **Options window**, 352 ordering image Layers, 70-79 Keyframes, 190-192 Layers, 60-61 Orientation options, 322 Outlines, 18, 61, 244-245 adding, 152 Output, 349 Autoruns and Executables, 362-364 choosing formats, 350–355 DVDs, 358-361 formatting, 355–356 Internet. See Internet options, 358-362 overview, 350-355 Photodex Presenter, 357–358, 372, 377, 379, 381–382 ProShow Output File Types, 367-370 portable devices, 365-367

refresh rate, 79 Screen Savers, 364–365 sizing, 353 Video CDs (VCDs), 361–362 overlays, creating, 241–242

Ρ

pace, 80 pairs, Keyframes, 31-34 Pan Controls and Settings, 18-19, 67, 76 - 93panes, 58. See also windows panning, 79 Pan settings, 18–19 Pan X/Y settings, 88 paths Keyframes, 194 Motion Path, 84 Show Motion Path option, 186 personalizing Shows, 341 placeholders, 307 planning. See also managing Layers, Planning to move, 75-79 templates, 309 playback Color Profile Settings for PC Playback pane, 355 Flash FLV Shows, 381-382 Live Shows, 314–315 Play button, 11, 14, 17, 27, 37 plug-ins, Presenter, 357-358 Plus button, 329 PNG file extensions, 57 portable device output, 365-367 positioning anchor points, 143-144 audio files, 102-104 Captions, 164-165 images, 203-206 Keyframes, 193-195

Keyframes, swapping, 212-213 Layers, 60-61 multiple Layers, 70-73 waveforms, 109 X-axis, 73-74 Y-axis, 73-74 Position Numbers, 73-74 precise Transitions, synchronizing, 117-120 Precision Preview window, 14, 38-42, 62, 65-66, 69, 71, 85-86, 94-95, 97-99, 137-38, 151-52, 176 applying, 197-199 editing, 38-41 Preferences, Work Area, 44-48 Adjustment Effects, 177-178 Caption Settings window, 162-167 Drop Shadows, 179 Interface and Work Area, 42-48 Internet, 47-48, 380 Presenter, 357-358, 372, 377, 379, 381-382 hosting on other Websites, 377-379 Preview Area, 11-12, 14, 44 Preview display, customizing, for working with Layers, 62-63 Previewing audio files, 102-104 Full-Screen Previews, 97–100 Live Shows, 313-314 Motion Effects, 138 Shows, 11-12 Show Motion Math option, 186 Slides, 27 Preview Mode, Live Shows, 314-315 Preview pane, 58 managing, 200-202 Preview Zoom, 202

Producer interfaces, 3-4, 42-48 Slide List, 307 Slide Options window, 13-15 Producer-Only Features, Appendix B producing Live Shows, 311-322 product comparison chart, 387-391 profiles, colors, 353-355 Projects, managing, 49-50, 309, 323-326, 327-331, 338, 341-342 PSD file extensions, 57 PSH (Photodex Slide Show) files, 51, 368 public domain images, 374 PX (Photodex Stream) files, 370

R

Random Image Settings dialog box, 312 rearranging Slides, 9-10 recording timing, 117-120 voiceovers, 121-124 **Record Slide Timing window**, 119 refresh rates, 79 registering accounts, 375 relabeling titles, 344 relationships between Layers, 200 re-linking tools, 197 **Remote Control Preferences**, 47 removing audio files, 102-104 Layers, 59 renaming Layers, 210 rendering Layers inactive, 61 markers, 201 output, 350-355 **Replacable Image option**, 304

replacing Lavers, 319 resizing. See also Zoom settings fonts, 133-138 Lavers, 64 resolution, 79 reusing Layers, 304 Revert to Backup command, 173 rotating, 80 Layers, 64, 65 modifying, 75 Morion Effects, 86-87 Precision Preview window, 198–199 Rotation Center command, 86 Rotation Effect, 86. See also rotating Rotation Setting controls, 88 rounding edges, 264

S

Safe Zones, 62, 69 sans serif fonts, 136 Save Audio Track window, 120 Save List button, 53 Save Menu Theme dialog box, 340 Save Show Template window, 306 saving files, 50-53 menus, 338-341 templates, 305-307 Scaling to fit in Layers, 317-319 values, 72 waveforms, 109 screen savers, 364-365 scrubbing Preview pane, 232 Timelines, 12, 20, 28 searching files, 50-53 Select File button, 15

Selecting Captions, 162-164 fonts, 133-138 handles, 112 Keyframes, 187 output formats, 350-355 Transitions, 8 sending Shows, 379-380 sequences audio clips, 104 Motion Effects, 217-222 serif fonts, 136 Set button, 19 Set Color control, 179, 227 Set Color dialog box, 290 Set Menu Title button, 328 Set Value dialog box, 193 Share Show window, 375 Sharing Shows, 372-373, 374-377 Sharpen control, 225 Shortcuts, see Appendix A; keyboard, 385-386 Show Files, 49 Show Motion Path option, 186 Show Options window, 49, 62 Shows copyrights, 373-374 Flash FLV, 381-382 output. See output personalizing, 341 Previewing, 11–12 sending, 379-380 sharing, 373, 374-377 uploading, 374 Show Soundtrack window, 9, 102 Show Templates option, 305 Show Title dialog box, 328 sizing fonts, 133-138 Layers, 64, 65 modifying, 75 output, 353

Skew setting, 169 skills, developing, 3-4 slicing, timing, 92 Slide List, 5, 44 Slide Options window, 13-15, 27, 58 Slides adding, 177 arranging, 9-10 Captions, adding, 138-140 copyrights, 373-374 creating, 5-6 fixed, configuring, 316-317 interactive, 160 Layers, matching, 94-97 Light Box Slide View, 44 managing, 9-10, 49-50 masking, 274-276 moving, 10 navigating, 13-15 overview of use, 55-56 previewing, 27 soundtracks, adding, 7-9, 121-124 Styles, 15–17, 21, 250 Synchronizing, 104 Templates, 304-311 Timing, 10, 26-29, 70 transitions, 6-7 Watermarks, adding, 346-347 Slide Shows, 5. See also Shows; Slides creating, 41-42 first Slides, creating, 58-64 history of use, 55-56 managing, 49-50 previewing, 11-12 Smoothing effects, 169, 182, 189-190 Sound Effects window, 122 Soundtracks adding, 7-9, 121-124 advanced sound controls, 106-120 audio files, 102-106 editing, 103, 111-112

interfaces, 105-106 managing, 102 menus, adding, 332-333 synchronizing, 117-120 volume, 120 working with, 102 source resolution, 79 Special Effects. See also Effects 1-2, 4, 7, 11, 13, 16, 17–21, 25–26, 30-31, 55-56, 63, 75, 81 Captions, 129-133 Keyframes. See Keyframes limiting, 197 overview of, 17-21 Specify Destination option, 167 speed, matching, 94-97 splash pages, 344 spotlight effects, 261 stacks Layers, 57, 59. See also Layers moving, 60-61 standards aspect ratios, 17 Video CDs (VCDs), 361-362 video clips, 359 Starting Position, 20, 34, 66, 70, 168-169, 263, Start points, soundtracks, 109–110 startup screens, customizing, 344 stencils, 270-274 styles. See also formatting bold, 137 Captions, 21-22, 162-164 gradient fills, 272 italic, 137 Motion Styles, 89–91 Slides, 15-16 support, output file formats and media types, 356-357 switches, toggle, 197 symbols, 136 macros, 146

synchronizing. See also matching audio, 104–105 Slides, 104 soundtracks, 117–120 Transitions, 117–120 Synch Slide to Track dialog box, 105

Т

target Layers, updating, 92 television, types of output formats, 355 Templates, 303 Applying, 304–311, 310–311 Creating, 305-307 Exporting, 310 Importing, 310, 316 Layers, 308 List, 310 Live Shows. See Live Shows Load Show Template dialog box, 316 planning, 309 tempo, modifying, 109 temporary video files, 370 text blending, 130-133 Captions, 21–22. See also Captions fields, 149 Text Effects, 21-23, 130-33, 140-42, 150, 153-55, 157, 162-63, 168, 171–72, 174, 176 textures, Captions, 163 themes, 327 editing, 251–253 Save Menu Theme dialog box, 340 Thumbnails, 323, 326. See also images customizing, 333-341 formatting, 327-330 Menu, 323, 325, 326-328, 330-331, 333-336, 339 viewing, 329

Tilted-T icons, 171 tilting letters, 169. See also moving Timelines Audio Timeline, 44 Keyframes, 35-38, 69-70, 170-176 modifying, 249 scrubbing, 12, 20, 28 soundtracks, editing, 111-112 Times Roman font, 137 Timing, 9-10 Captions, 168-178 Edit Fades and Timing dialog box, 107 Keyframes, 193-195 Layers, 29-38 recording, 117-120 slicing, 92 Slides, 26-29, 70 Iransitions, 26-29, 70 titles. See also Captions formatting, 327-330 relabeling, 344 toggle switches, 197 tools Caption Placement, 22 Captions, 133-138 Colorize, 19 Masking, 263 navigating, 326-327 Preview, 11 re-linking, 197 soundtracks, 118. See also soundtracks Track Controls, 106 Transitions A/B Fade Transition, 7 Basics, 7-8 Beginning and Ending, 30 Cut Transition, 21, 26, 29, 252 Layer, 70 Menu, 98 modifying, 29

Opacity control, 235, 237–240 selecting, 8 Slide, 5–7 synchronizing, 117–120 Timing, 26–29 Window (selections), 8, 179

Transitions menu, 98

Transparency Masking, 260–264

frames, isolating, 267–270 video clips, 298–301 Vignette controls, 264–266, 286–288 transparent ellipse Vignettes, 265 trimming audio, 107–108

Trim Video button, 297 types of files, 355, 367–370 of fonts, 133

U

Up arrow, 60, 74 updating target Layers, 92 uploading Shows, 374 user-defined Motion Effects, 158

۷

values, 67

Scaling, 72
Set Value dialog box, 193

Versions

Version 4, 2, 3
interfaces, 3–4
Slide Options window, 13–15

vertical composition, 317–319
Video CDs (VCDs) output, 361–362
video clips

Chroma Key, 296–301
standards, 359
temporary video files, 370
types of output formats, 356

Video Standard pane, 352 viewing Captions, 148-153 effects, 28 Flash FLV Shows, 381–382 Light Box Slide View, 44 markers, 201 thumbnails, 329 Vignette controls, 257, 264–265, 281–284, 286–287, 289, 293-295 borders, 281-283 effects, 283-285 Transparency Masking, 264–266, 286 - 288voiceovers, adding, 121-124 volume, 358 controls, 120 modifying, 112–115 soundtracks, 106, 120

W

Watermarks, adding, 324, 346–347 Waveforms, 102 moving, 113 positioning, 109 scaling, 109 Web. See Internet Wedding Caption, 159 white Chroma Key, 300–301 points, 18 White Balance adjustments, 322 White Point control, 225 widescreen aspect ratios, 17 windows Adjustment Effects, 223–226 Caption Motion, 168 Caption Settings, 162–167 Choose Captions Effects, 141 Choose Transition, 7, 29

Color Profile, 354 Copy Layers, 88 Create DVD Options, 358 Create Output, 350 Disc Burning, 346 DVD Format Burning, 360 Executable, 354 Insert Macro, 146 Menus, 325-326 Miscellaneous Preferences, 48 Music, 103 **Uptions**, 352 Precision Preview, 38-41, 62, 151, 197-199 Record Slide Timing, 119 Save Audio Track, 120 Save Show Template, 306 Share Show, 375 Show Options, 49 Show Soundtrack, 9, 102 Slide Options, 13–15, 58 Sound Effects, 122 Transitions, 8 Windows Explorer, moving files, 6-7 Windows/Fonts directory, 128 Wingdings, 135, 136 Wizard of Oz, The, 226 words. See Captions Work Area, 30, 37, 42-45, 327, workflow multilayer Motion Effects, 202 templates, 309 workspaces. See also interfaces customizing, 42-48 editing, 3-4 files, 370

Х

X-axis, 67 Captions, 143 Keyframes, 195–196 positioning, 73–74 Precision Preview window, 197–199

Y

Y-axis, 67 Captions, 143 Keyframes, 196 positioning, 73–74 Precision Preview window, 197–199 YouTube connecting, 382–383 types of Output formats, 355, 373

Ζ

Zoom settings, 17–18, 30–33, 38, 72, 75–80, 245, 248 See also sizing In Fly text effects, 141 Keyframes, 195–196 masking, 264 modifying, 206 navigating, 67–70 Preview, 202 values, 214 X/Y, 88